Moscow

TOPOGRAPHICS

in the same series

Moscow

Karl Schlögel

Translated by
HELEN ATKINS

REAKTION BOOKS

Published by Reaktion Books Ltd
33 Great Sutton Street, London EC1V 0DX, UK
www.reaktionbooks.co.uk

This book is a revised edition of *Moskau lesen. Die Stadt als Buch* by
Karl Schlögel © 1984 by Siedler Verlag, a division of Verlagsgruppe
Random House, Munich, Germany.

New Introduction and Conclusion © Karl Schlögel 2004

First published in English in 2005

English language translation by Helen Atkins © Reaktion Books Ltd, 2005

The publication of this work was supported by a grant from the
Goethe-Institut

Additional assistance from ZEIT-Stiftung Ebelin und Gerd Bucerius

Printed and bound in Great Britain by Biddles Ltd, King's Lynn

British Library Cataloguing in Publication Data
Schlogel, Karl
 Moscow. (Topographics)
 1. Moscow (Russia) – History – 20th century
 2. Moscow (Russia) – History – 21st century
 I. Title
 947.3'1'086

ISBN 1 86189 240 3

Contents

Introduction

No city in the continent of Europe has undergone such momentous change in the past one and a half decades as Moscow. Moscow has been the setting for the end of an empire and the rebirth of Russia; the scene of the transformation of the world's greyest capital city into a Babylon iridescent with colour; a place where time stands still and yet one of frenetic acceleration; the stage on which a whole epoch was ended and on which the new post-Soviet cast of actors made its first appearance.

In the last few years streets and buildings that had defiantly stood up to war and revolution have succumbed to the ruthless demolition squads sent in by the property speculators, while concrete and glass towers have shot up into the skies. Moscow has been shaken to the core by the collapse of the last utopias and an unprecedented reassessment of all values. On the positive side it has found, after decades of shortages, that quite ordinary foods can be obtained without the need for queuing. In a mere second of time, in historical terms, Moscow has passed through every conceivable stage of crisis: stagnation and death-agony, devaluation, hyper-inflation, the turning of the city into a gigantic bazaar, investment fever and speculation, a construction boom and armed confrontation. In Moscow the simultaneous occurrence of phenomena normally belonging to different eras has been apparent to the naked eye. Pre-Modernism returned to the city in time to coincide with the ironies of Postmodernism. In post-Soviet Moscow neo-Russian traditionalism rubs shoulders with the emblems of the globalized world, socialist realism with capitalist realism, the nineteenth century with the twenty-first.

Soviet Moscow was the capital of one of the last great multi-ethnic empires, while post-Soviet Moscow is becoming the multi-ethnic cosmopolitan city of a globalized world. The whole country works for Moscow – more than 70 per cent of Russian capital is now concentrated there – and yet Moscow is not identical with Russia. Moscow is almost a state in its own right, a city on a different planet. It is a place whose original, breathtaking growth was, almost inevitably,

accompanied by violence, yet which has now successfully avoided falling back into internecine conflict. In this it is something of a miracle.

Like all the world's large cities, Moscow is a great instructress. It turns its inhabitants into citizens who, like the populations of other great metropolises, have a masterly individual capacity for surmounting crises. In the Cold War era Moscow was distant, almost unreachable, barricaded behind bureaucratic obstacles. It was the command centre of the Eastern bloc, a dot on the Cold War map, a capital in a divided world, shielded by an Iron Curtain. Now, as an open city, Moscow has rejoined the community of great metropolises and re-entered the horizons of Europeans. Moscow is no longer a destination only for organized group travel or the tourism of delegations and politicians. The visitor experiences the most remarkable of all adventures here in the capital city of Eurasia: the adventure of time. He constantly has before him the double image of Moscow, as the setting for the dramatic history of Europe, especially in the twentieth century, but also as a place where the future is being fashioned, so to speak, before our eyes.

Karl Schlögel, 2005

Prologue: The eye of the beholder

*Moscow as a place where the most famous views
of the city, constantly reproduced, block your vision –
The dual functioning of the eye and the strange
coexistence of two points of view – How a reading
eye might overcome this.*

Speaking of what he calls 'essayism' in his novel *The Man Without Qualities* (*Der Mann ohne Eigenschaften*, 1930), Robert Musil remarks, quite rightly, that although the term 'essay' has sometimes been translated into German as *Versuch* – a mere 'attempt' – an essay is by no means something tossed off casually, or simply an offshoot of a scholar's more serious work. That would indeed be an underestimation of the essay. For this is not just a matter of creating a portrait of an unfamiliar city. Whenever we follow a trail of evidence into the past, we are also on the trail of ourselves, and the unfamiliar world that we encounter only becomes intelligible as we bring our understanding to bear on it, and use our knowledge and perception to take us beyond what is visible on the surface.

So it is with the picture that we have of Moscow and this attempt to draw a new one. It may not always have been the case, but at present it seems that the same images are served up to us over and over again, differing only in their technical quality or a different choice of camera angles from those used in the previous collection or the one produced by the rival publisher. There is no real change of perspective: the same subject recurs endlessly, slightly varied and retouched. Stereotypes have become established; coffee-table picture-books are laid out resplendently in bookshop displays, and hardly anyone notices that there is a layer of dust covering the magnificent photographs before the books are even distributed. Such stereotyped pictures are often like those reliefs that you sometimes find on war memorials, or well-loved sculptures in museums, where every visitor runs a finger along a groove or over a curve, just to prove that

he has been there, and the surfaces are visibly worn as a result of these continual, if fleeting, acts of homage. Impelled to give vent to their enthusiasm, people pay little heed to 'Do not touch' signs.

Something of the same kind happens to pictures of cities. Sharp contours are reduced to a vague impression, maze-like complexity is simplified to a few main outlines, the sharply etched image of a detail becomes a blurred snapshot. These pictures, ever the same but always slightly corrected or retouched, prevent us from knowing the city. Instead of showing it to us, they steer us past it. So any newcomer to Moscow has first of all the considerable task of clearing his mind of the visual clichés derived from brochures and guidebooks.

This is certainly not the fault of the photographers – neither the foreign ones nor those working for the country's own big state publishing firms. And there we note the remarkable fact that even in the sphere of photographic clichés the coexistence and rivalry between the Soviet Union and the West are reflected. In the picture-books produced by the Soviet state publishers such as Avrora or Progress, the city's radiance shines from the present back into the past, and Moscow in its very latest, modernized form is seen as the culmination of its development. History has, as it were, amassed the material out of which, with inexorable logic, modern Moscow has emerged. There is no room here for interruptions or obscurities. How extensively and how adequately the past is represented, how hazily or with what depth of focus, depends on how it is viewed in the light of the present.

Foreign producers of such volumes have very different preoccupations. They want to show what is 'different', 'unfalsified', 'genuine', as opposed to what is doctored or tidied up – the truth as opposed to Potemkin sham. But the outcome, as often as not, is a charming but false apprehension of the city, based less on its substance and the life of its citizens than on a personal notion of 'authenticity'. This is reactive photography that rarely goes beyond recording the history that has been preserved in stone. However, with photographers who follow the dictates of their own eye, stalk the fleeting subject like huntsmen and capture the passing moment, and are practised in deploying the power of an eye uninfluenced by prescriptive guidelines, the results are amazing, and are indeed achieved neither by the eye alone nor just by camera technology, but by the photographer's individual skill with the lens. Here, as ever, it is the exception that proves the rule, as witness Henri Cartier-Bresson's book of photographs from the early 1950s.

10

Our picture of Moscow is by no means one-sided: on the contrary, it is the product of two perspectives, that of the city as it chooses to present itself, and that of the visitor from abroad, observing it with a greater or lesser degree of interest and commitment. Only in rare instances has such a visitor learned to see Moscow in a way that is both lively and detached, spontaneous as well as historically aware and knowledgeable.

This may be seen as yet another illustration of the divided world, here taking the form of a divided viewpoint. I realize that at first sight this proposition seems far-fetched. And, after all, there have been images of unsurpassed precision: I am thinking here of Arthur Miller's book on Russia, with pictures captured by the unerring eye of Inge Morath (*In Russia, 1969*). And of course I am also thinking of Walter Benjamin's 'portraits of cities' and his *Moscow Diary*. However, those images and impressions belong to an almost pre-historic era of travel to Moscow, and are of greater interest to literary scholars than to travellers able to follow in their footsteps today.

There are thoroughly prosaic reasons why visitors to Moscow have come to adopt a standardized visual approach to the city. One of these is that, despite all the advances in tourism (though this still caters largely for organized group travel), and despite increasing involvement in international commerce and the huge number of visiting political and cultural delegations, Moscow is not a place where visitors can easily wander about at will. They have little spare time at their disposal, their arrival and departure are not things that can be arranged casually, and they do not just decide without further ado to stay at a given place. Visitors follow certain itineraries, not because these are prescribed but because they enable them to traverse this vast city in the little time they have available and to form some sort of impression of it. They quite naturally confine themselves to the principal thoroughfares and grand vistas, which undeniably constitute a part of the reality of Moscow as a city – there is probably not another city of this size in the world that has been subject to such centralized, top-down planning and construction. But even if one acknowledges these effects of organized tourism, this still does not fully explain why an image of the city that is not, in fact, its true image has become so firmly established.

Anyone planning to write about Moscow needs to take account of the city as a tourist phenomenon and define his own position in relation to it. It may safely be assumed that our way of looking at the city

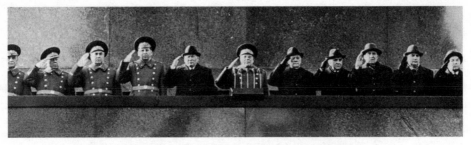

Soviet leaders on the speakers' platform of the Lenin Mausoleum.

has been greatly influenced in the past two decades by market forces
– by the wishes of foreign publishers and the interests of a tourist
industry that encourages the production of certain kinds of images.
It can be equally safely assumed that editors and publishers in
Moscow want pictures and books that capture not only the
'beauty' of the city and the 'Soviet' element but also what is 'authen-
tically Russian', and all in handy-sized volumes and at affordable
prices. The required blend of ingredients is predictable almost before
an outline has been submitted for one of these publications: the
Kremlin Wall in winter, and autumn leaves on the boulevards, but
also the Palace of Weddings and housing estates built in the 1960s
and '70s; the *babushka* sitting on a chair outside her front door;
Michelangelo's *David* from the Pushkin Museum; a fine shot of
Maya Plisetskaya on the stage of the Bolshoi Theatre; a snowy
winter scene with chess players on a park bench; some photographs
of the subterranean splendour of the metro stations; politicians'
heads, mostly wearing homburgs or fur hats, lining the balustrade of
the Lenin Mausoleum; a colourful picture of the May Day parade,
with a lot of red everywhere and masses of multi-coloured paper
flowers; and, of course, churches and gilded domes.

Visitors to the city are amazed at how well they already seem to
know it even if they have never been there before. The feeling of
unfamiliarity that is normal on arrival in a strange place is lacking.
They notice this after a few days, and cannot quite explain why the
sense of the unknown that so often heralds forthcoming discoveries
either fails to materialize at all or is so minimal that some local ways
of doing things merely strike them as slightly different: the doorman
checking you at hotel entrances; shops staying open until nine
o'clock at night; all the streets constantly being swept with short-
handled twig brooms; the extreme slowness of waiters to come and

serve you – while the absence of advertising has an almost physical impact.

Slowly but surely we become aware of a strong urge to escape the thrall of the charming pictures in our minds. It might be supposed that this urge would be strengthened, reinforced, by our contacts with foreigners who have been living in Moscow for some time. But, remarkably enough, this is not so. Foreigners who have settled in and become acclimatized seem to lose their capacity to resist the allure of superficial reality, and what was once new to them becomes commonplace, what they once found challenging changes in the course of time into their everyday ambience, and many of them clearly become impervious to anything impacting on their senses. This is partly because many – too many – of the foreigners have brought their own world with them to their new environment; too many of them stay – partly out of necessity, but partly because it is more congenial – in their own world, in the diplomats' flats on Kutuzovsky or Leninsky prospekt, in the apartment blocks where the correspondents and journalists have their homes, or in the offices of the business community. Obviously they have built up an extensive network of contacts and sources of information and there is a whole culture of reciprocal invitations, parties and small gatherings, in which they can live a quasi-extraterritorial life. In the case of diplomats, moreover, there is normally a prohibition against having contacts with local people, which admittedly does not necessarily prevent them from taking their own steps to make this alien territory their own. It goes without saying that members of the foreign community, particularly the diplomats and journalists, do have Russian friends and acquaintances, in fact good form and their own professional standards more or less require it. The visitor is all the more bound to wonder why precisely people of this type – who, despite their isolation, have the inestimable privilege of being on the spot and able to observe everything with their own eyes – have not been seized by an irresistible urge to sweep away the clichés and stereotypes, even those that are most firmly established.

Living in Moscow as a professional observer, correspondent or journalist should surely bring with it an awareness of the city's high-profile position: at the heart of the Eastern bloc's great power, at the intersection of two worlds and two cultures and in a place with a turbulent history extending right up to the immediate present. And yet little of the flavour of this setting or of Moscow's exciting aura as

the scene of historic events comes across in the daily fare provided by the news media. The atmosphere of the city which is both the source and the subject matter of the reporting becomes lost in the grey uniformity of agency reports. It seems to make no difference whether these originate in Washington, Tokyo or Moscow itself, and one should not underestimate the power of the daily reports from or about Moscow in the papers or on the evening television news to influence public perception. The political commentator's shorthand formula or brief assessment has the very same fault as the travel agent's brochure, though only the latter is mocked for it: both of them purvey information and ideas of Russia from which the end-lessly colourful and unruly character of reality has been erased. Above all, the media convey the suggestion that Moscow is a city like any other, albeit with a few peculiarities, and they often leave one with the impression that Moscow is essentially a history-free zone.

The strange absence of history from such reporting cannot simply be attributed to the nature of the mass media and of journal-ists, for whom the present is everything and the past and future count for nothing. Nor can it be put down to a lack of the kind of historical and analytical material that normally underlies any piece of reportage. It seems rather that commentators in this country con-sciously suspend their interest in history so as to avoid having to deal with the burden of the past.

Russia-watching has a history of its own, but history at present is being deliberately ignored and sidelined rather than actively exam-ined. Every change in the international climate has resulted in a shift of perspective, with inevitable reshuffles among the foreign post-ings. Now that a line seems to have been drawn under the disagree-able past on both sides – Stalin, Hitler, the Cold War – and many dynamic advocates of *détente* and coexistence have been appointed to the press offices, there is a sense of having been liberated from the oppressive weight of history.

However, the suppression of history is not the sole prerogative of commentators of this kind. Among conservative observers too there has been a failure of perception for a different reason: the conviction of having been right all along has made them blind to much of what has been really happening. The shock felt over the attack on a Europe that had grown old and continuing delusions of superiority have, in different ways, prevented observers from fully recognizing the emergence of a new civilization. Commentators on both sides

14

have their complementary ways of approaching history and of avoiding it. The same ambivalence can be observed in the way the present is treated: while a report on the Orthodox Church's Easter vigil purports to show a resurgence of religious faith, this effect is cancelled out by an account of a Vysotsky concert which suggests that young people have become too materialistic to have any use for the churches. All reporting from Moscow seems to evince this ambiguity of perspective, this stance of simultaneously accepting two contradictory points of view. The fact that in this city we find it so hard to get firm ground under our feet could be a pointer to one of two things: that we have stopped, or almost stopped, regarding Moscow as a part of our own cultural heritage, or that we no longer have the capacity to see it as such because we have lost any precise sense of our own cultural background. What a city signifies to us, actually or potentially, is perhaps clearer when we are in Beijing or Abu Dhabi, surrounded by a totally different world, be it one of bafflingly polite ceremonial and the exotic elegance of jade, or of fabulous riches appearing apparently out of nowhere in the midst of the desert sands. The city's meaning is less clear when we are in intermediate or transitional zones, on the margins where Europe merges into something else or is so encircled by a multitude of other influences that we cannot quite identify what there is about it that reminds us of home. Moscow is evidently a place of this kind, not only a centre but a membrane allowing two continents to diffuse into each other.

However, there is also another reason which has nothing to do with us, and that is the absence of history from Soviet public life itself. Such an assertion must at first sight seem startling, for there is hardly another country in the world with such a full and elaborate calendar of special days commemorating historical events, anniversaries and jubilees, starting with the Battle of Kulikovo Pole and including Borodino, the salvos fired by the battle cruiser *Avrora*, Stalingrad, and the first manned space flight. Yet this extraordinary number of official celebrations of the past has always been the sign of a problematic relationship with history. The intention is evidently to heal the violent rupture with the past by providing a huge quantity of carefully selected reminders of history. But beneath the bandage the wound has not healed. It needed daylight and fresh air rather than the tinctures prescribed by a procession of different physicians.

Nevertheless, a historical awareness of the city has survived in various fragmentary forms, despite imposed or self-imposed amnesia. It survives, first of all, as memory – the recollections of a host of individuals about how things used to be – and also as knowledge, of what happened where. The material for the reconstruction of the major and minor dramas enacted on the vast stage that is Moscow lies scattered in thousands of shards and splinters. It is handed down within families, it can be found in books that have long since ceased to be topical or have been deliberately withdrawn from circulation, it is recorded in official encyclopædias, but also in small newspaper items. Unpleasant truths find a place to hide in texts that are out of the way, insignificant, not meant for keeping. History is written afresh by each generation, and so a subject that one thought had been exhaustively treated and disposed of may, with a new light turned on it, take on quite a different aspect. With each new generation history, especially the most recent and most personal, is spoken of in a different tone of voice. Long before there is any radical change in the general line, the bibliography or the footnotes start to convey a message of their own; an interlinear translation or a subjective comment tucked away inside the main argument comes to be more illuminating than the main text.

Something similar happens with a city like Moscow. At first the stranger is presented with an image, a text. The text can be skimmed, and even this gives some pleasure. But on closer reading you find yourself pausing over particular passages, troubled by inconsistencies of content or style. And this is where a kind of decoding exercise begins, and as each new surface is revealed further layers become visible beneath it, in a never-ending process. 'Look at the world rationally and it will look rationally at you; the two things are reciprocal': this maxim of Hegel's holds true when one undertakes such a 'reading', even in times of well-founded scepticism about rationality in the context of history. If, as you look at a city, you are on the alert for clues to its history, it will reveal a good deal about itself. And even if the only outcome were to be the realization that intimacy with this city has eluded you, the attempt would still have been worthwhile.

1 Starting with the surface

The city as a geological deposit and a quarry –
The ambivalence of modernization and of ground
clearance.

All the buildings in this city have a sense of inevitability about them. Perhaps this only strikes one more forcefully here than elsewhere because it was not the earlier Moscow, consisting of an endless sea of wooden houses, that became a city, but the Moscow built of stone: only at this point did its history begin, a history that from then on no great fire and no conqueror could touch.

Here, more than anywhere else, each class has left its imprint on the city's successive architectural styles. No frenzy of uncontrolled urban building has hemmed in, eroded or swallowed up the representative buildings of different eras. There they stand as ever, highly visible, uncompromisingly solid, discordant. First the 'nests of gentlefolk', the aristocrats' town residences, impressively sized yet built with a strong feeling for proportion and domestic comfort, and each enclosed by its surrounding wall – country estate houses transposed to the city. Next, a touch of urbanity in the aspirational metropolis of Russian capitalism around 1900. And after that, mightiest of all, carving up the skyline and impossible to ignore, Stalin's giant constructions set out like the points of a star on the ground-plan of the city. The Moscow cityscape has something of the beauty of a stone quarry when you view it as a whole, without fixing your attention on any one part of it such as Red Square, Staraya ploshchad or a section of Strastnoy bulvar. The enormous *massif* of the city's built landscape reveals the deposits laid down over the centuries. The strata are clearly visible in their varying shades of colour. There are projecting sharp edges of harder stone, whilst other, softer layers have been worn down, weathered, washed away. The eye is lulled

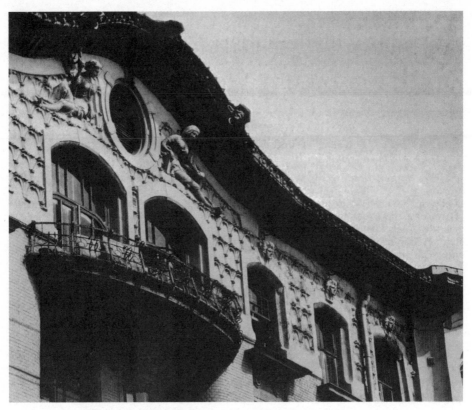

Isakov apartment house, architect L. N. Kekushev, 1906.

'With the beginning of the new century, or so it seemed to my childish perception, everything changed as if by magic. Moscow was suddenly gripped by the spirit of trade and commerce of the great capital cities.

In no time at all property dealers, speculating on the chance of a quick profit, were putting up huge tenement buildings which produced a good return. Before you knew it there were gigantic brick buildings soaring skywards in every street. At that moment Moscow – and not, as hitherto, St Petersburg – gave birth to a new Russian architecture, that of a young, modern, vigorous metropolis.'
Boris Pasternak, *I Remember*

by an endless sameness, not to say monotony, and then suddenly confronted with bizarre, contrasting formations.

Why does Moscow in particular suggest the analogy of a quarry? Perhaps it is because the corridors that have been cut and are still being cut through the city are more obvious than elsewhere, since even clearances here are planned on a large scale and carried through with the full force of centralist authority. The 'General Plan for the Reconstruction of Moscow', a strategic plan that was followed, and augmented, from 1935 onwards, gave rise not only to vast construction projects but also to demolition, naturally on an equally grand scale. The wounds that this inflicted on the city took a long time to heal and the scars are more obvious than in other cities. In the West, business people operate at their own risk; businesses have to flourish to continue running and frontages must be well maintained as an outward sign of a healthy turnover. Hence the constant rapid transformation of our towns and cities, which are dominated not only by the fetishes of advertising but also by the power of private initiative. As a consequence, anything old is more likely to disappear under the varnish of continual modernization. But in Moscow – and many will have seen the same thing in Prague or East Berlin – whole streets and districts still survive in their original state, untouched by modernization, redevelopment or restoration. In Moscow we come face to face with our own past, preserved not, in the main, because it is held dear, but simply as a result of stagnation.

Russian capitalism, a latecomer among its rivals, brought to the city the vitality of a class only just starting to make its mark, and the beauty – tending to extreme showiness, a sense of inadequacy expressing itself through excess – of Russian art nouveau. Moscow gives the impression of being a haven of art nouveau, though perhaps only because it is easily recognizable here and contrasts so starkly with the grey, standardized type of building that has been dominant for many years. Foreigners who complain about the monstrous size, anonymity and other 'abnormal' features of this city are all too well aware of this, and deliberately seek out those areas where it first became a city and where a traditional urban ambience has survived – the side streets of the Arbat, the district around Kuznetsky most, the old Kitay-gorod, or ulitsa Kropotkinskaya and ulitsa Metrostroevskaya in the south-west. Moscow possesses streets and districts that have preserved all their original character, with

balconies, wrought-iron gateways, staircases and interiors that prove that beauty truly took hold in the city and was not just something tried out experimentally. These buildings have never fallen out of use, which is why their very shabbiness retains an air of dignity. Even today they have not become mere museum pieces. Travellers to Moscow are familiar with what used to be the finest hotels in town – the National, the Metropol or the Tsentralnaya – but, as I have said, there are whole rows of other buildings that preserve the atmosphere and contours of an age that attempted to soften the harshness of a hard-working, hectic city existence by returning to a decorative style of architecture that incorporated exotic motifs and adorned gables with broad friezes and panels of mosaic. Bank buildings that adopted a new discretion about their association with money, villas whose owners and architects were seeking a reconciliation with nature even before nature in Russia as a whole was subjected to the din of machinery, theatres where presenting performances in an intimate space was always more important than social display – unlike the Bolshoi Theatre, these were not primarily arenas for the aristocracy to see and be seen in. This Moscow of around 1900 still exists as a substantial layer of the city's architecture, and it is almost impossible to imagine the meagre residue that would exist today if the plans drawn up in the late 1920s for the rational restructuring of the capital had in fact been carried out.

Why does this turn-of-the-century Moscow not figure more in our mental image of the city? Perhaps, like the nineteenth century, it has been largely forgotten. But, as we know, a revision of this situation is currently under way.

A visitor new to Moscow is often quite uncertain about the age of some buildings: does such and such a house date from the 'early days' or the post-Constructivist period? Can one really confuse art nouveau with Stalinist pomp? But there are more links between the styles of the 1910s and the 1930s than, with our awareness of the doctrinal background, we might at first be prepared to admit. One thing is common to both, namely the attempt to aestheticize people's everyday surroundings – though the premises underlying this aim, and the outcomes, were certainly very different. There is undoubtedly a connection between William Morris's Arts and Crafts movement and the demand in 1930s Russia for life to be made more aesthetic.

Though of course aware of the debates about the supposed 'inherent connection' between the Stalinist and the fascist aesthetic,

the visitor discards this notion, at least for the time being, as lacking any historical basis. How about a line reconstructing the true genealogy, which would include both Vladimir Tatlin and Ivan Zholtovsky of the St Petersburg Academy? A better historical case could be made for this than for that other link that people have been making for so long.

The architecture promoted by Stalin fed on everything else, even on what it superseded and abolished: the ornamentation of art nouveau, the Palladianism of the St Petersburg Academy, the boldness of the Constructivists with their blend of Bolshevism and Americanism. Other factors that helped to shape this architecture were, of course, Stalin's dominion of a Soviet Union that embraced many nationalities and races and needed a new style; his unbridled power over its citizens, who were to be reduced to mere pinheads; and the supremacy of the regime as the state contractor and universal landowner, now in a position to stamp its will on the city as a whole for decades to come. Who would dare to claim that the strong hand of those days is not palpable everywhere in Moscow? Vast thoroughfares slicing through the city like airport runways, wide boulevards instead of shady avenues, high-rise buildings (which are not, however, skyscrapers) with ornamental elements brought together from all points of the compass. Who dares argue that they have not stood the test of time? The Moscow of today would not be complete without those 'wedding-cake' towers, so often derided and so bemusing to the foreign visitor. It is the buildings of that period, the 1930s and '40s, that still give the city its character, and not the isolated experiments of the 1920s and early '30s, scattered around the city but always overshadowed by the generation of buildings that succeeded them. Moscow without its Stalinist buildings is inconceivable: everything that followed had to be visually subordinated to them. Even the imported architecture and the façades borrowed from elsewhere – those of the Mezhdunarodnaya or Kosmos hotels, for instance – somehow manage to relate to them. In the shadow of these Stalinist cathedrals it is difficult to develop an independent style, unless it be that of the unambitious, mass-produced buildings that are to be found in their hundreds of thousands in the city's suburbs.

2 High-rise buildings

A city of high-rise buildings, not of skyscrapers –
The silhouette of a bygone era, defined by churches
and bell-towers, resurrected in a problematic
but understandable form.

New York is the city of skyscrapers. Moscow is the city of high-rise buildings. What gives Moscow its characteristic appearance, strikingly different from that of any other city, is not St Basil's Cathedral or the view towards the Kremlin but the way that the entire area occupied by the city is visually articulated by the seven high-rise towers. From wherever you look, your line of sight will always end with one of these monumental buildings (illus. pp. 24–5). If you come as a visitor from the direction of the airport, your first sight of the city will be the topmost spires of the apartment block on ploshchad Vosstaniya; the same is true if you arrive at the Belarus railway station. When you come by train from Leningrad, the city greets you with a view of the Hotel Leningradskaya; when you arrive at Kiev Station, with the pinnacles of the Hotel Ukraina or the Ministry of Foreign Affairs on Smolenskaya ploshchad. Equally, if you start out from the centre, whichever direction you choose, one of the high-rise towers will always be looming up on the skyline. Looking from ulitsa Gertsena you see the block on ploshchad Vosstaniya, or from prospekt Kalinina the Hotel Ukraina. The Old Arbat is overlooked and shaded by the Foreign Affairs Ministry tower on Smolenskaya ploshchad. If you stand on one of the bridges over the Moskva, then far over to the east, where the Yauza River joins the Moskva, you will see the apartment block on Kotelnicheskaya naberezhnaya out on the eastern horizon, while in the opposite direction the furthermost visible point will be the Ukraina, or the University on the Lenin Hills to the south-west. Alternatively, if you come out of the Kirovskaya metro station

Schematic plan of Moscow,
project by El Lissitzky for
the erection of his 'horizontal
skyscrapers', 1923–5.

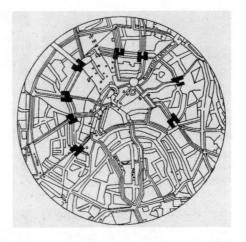

(through the entrance designed by the Rationalist architect Nikolai
A. Ladovsky), what confronts you is the high-rise block on
Lermontova ploshchad.

Better still, travel round the outer ring and you will immediately
understand the rationale for the positioning of these high-rise
buildings. Standing on Smolensky bulvar you have the Ministry of
Foreign Affairs to your right and the Hotel Ukraina across the river
to your left, and then further round the ring, again on your left, the
ploshchad Vosstaniya apartment block. Following the semicircle
round to the north of the centre you find yourself once again en-
circled by the Hotel Leningradskaya, the Transport Ministry on
Lermontova ploshchad, and in the south-east the apartment block
on Kotelnicheskaya naberezhnaya.

Travelling round the southern semicircle, you can make out the
turrets of the University in the distance. Best of all, choose one of
the public holidays when the city is illuminated and the celebrations
are rounded off with fireworks, and go up to the viewing platform
on the Lenin Hills. From there you can look down on the city as
though it were a town planners' model, and you will see that the
structure of the city is directed outwards and is inexorably defined
by those seven towers. They stand in exposed, dominating positions,
just as castles were formerly built on strategically advantageous
sites: on raised ground (the University), on peninsulas formed by
bends in a river (the Hotel Ukraina), at the meeting of two rivers (the
Kotelnicheskaya naberezhnaya block), at a gateway to the city (the
Leningradskaya, which stands on a square that has the termini of

23

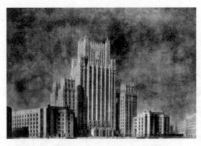

High-rise building on Smolenskaya ploshchad, project design by V. G. Gelfreikh and M. A. Minkus, 1948.

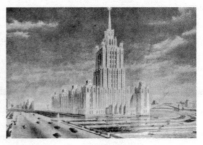

Hotel Ukraina, project design by A. G. Mordvinov, 1948.

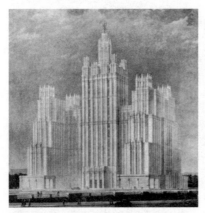

High-rise building on ploshchad Vosstaniya, project design, architects M. V. Posokhin and A. A. Mndoyants, 1948.

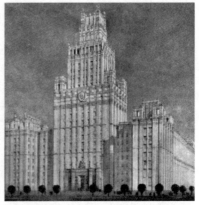

High-rise building on Lermontovskaya ploshchad, project design, 1948, architects A. N. Dushkin and B. S. Mezentsev.

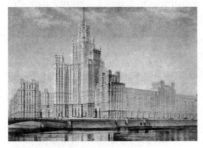

High-rise apartment building on Kotelnicheskaya naberezhnaya, project design by D. N. Chechulin and A. K. Rostovsky, 1948.

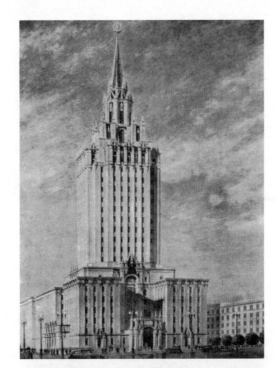

Project design of Hotel Leningradskaya, architects L. M. Polyakov and A. B. Boretsky, 1948.

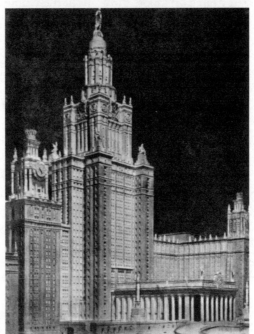

Moscow State University (detail), architect L. V. Rudnev, 1948.

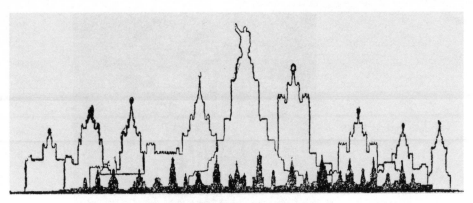

The vertical emphasis provided by the churches and bell-towers of Old Moscow was recreated in the skyline of Soviet Moscow.

three railway routes), or along a line of fortifications (following the outer ring: Lermontova ploshchad, Smolenskaya ploshchad, ploshchad Vosstaniya). What is inevitably a somewhat laborious account here in print becomes perfectly plain as soon as one looks at a relief map of the city.

However, the seven monumental buildings do not stand alone. They have offshoots throughout the whole city, lesser structures that cannot rival them in rank, height or splendour, but which could be their children: the Hotel Pekin, for instance, on ploshchad Mayakovskogo, or the mighty gateway between ploshchad Gagarina and Leninsky prospekt, or a multitude of buildings on ulitsa Gorkogo. In a word, the seven giants form a kind of gravitational centre, each holding together a particular district and drawing it closer, giving it a distinctive face.

Collectively, it is these seven buildings that give the whole city its face, as attractive or as ugly as any other face. It is quite wrong to dismiss the high-rise towers, which people like to refer to as examples of the wedding-cake style, as an exotic element – they are too firmly implanted and absorbed into the city's structure for that. It is wrong, too, to shrug them off, in the way that people do, as simply the relics of a bizarre era. A more interesting as well as more honest response is the admission by Muscovites, and by non-natives who have lived there for some time, that without these buildings – whatever one may think of them – the city would be faceless, colourless, even indistinguishable from any other. What is very revealing is the inconsistency shown by people who make fun of the architectural

style but would in fact give a great deal to live in one of the flats – sadly unattainable to them – in those solidly built blocks.

Any newcomer to Moscow will inevitably, I think, make these high-rise buildings the starting point of his attempt to form a picture of the city, and will probably not get very far. He will soon turn instead to the classical ensembles that he can make something of: the Kremlin, the neo-classical Old University, the art nouveau villa by Fyodor Shekhtel or the Vesnin brothers' Workers' Club for the Likhachev automobile factory. There he has architectural forms that he can understand, which fit into a familiar frame of reference. But he will inevitably be drawn back to those buildings that have made the city what it is today – a city that owes its distinct visual character to the General Plan of 1935 and the implementation of the recon-struction programme, and that of course includes these seven build-ings, which were erected following a 1947 resolution of the Council of Ministers. The face of Moscow is that of a city built in the 1930s and '40s; there are many modifications in detail, but the fundamental layout and the significant accents that determine the essential shape of the city, including its core, remain fixed.

These tall buildings are not skyscrapers but *vysotnye zdaniya*, or high-rise buildings. The distinction is significant, because the 1947 resolution expressly stated that there was no intention of imitating the silhouettes of Manhattan, Chicago or Detroit. These were to be 'original works of architecture which should not be a repetition of the kind of multi-storeyed structures found in other countries'. Just as Manhattan was seen as the symbolic embodiment of capitalist architecture and town planning, so these buildings were to give expression to the new Soviet way of life. There were to be no districts plunged into permanent shade, no streets reduced to dark gullies between tall houses, no uncontrolled proliferation of building, no baldly functional elevations. Instead, the high-rise buildings were to determine the development of Moscow as a whole, to act as land-marks articulating the city. As individual buildings, they were to block neither sun nor wind, and to be not merely functional but also beautiful.

This leaves the modern observer, standing at the foot of these gigantic creations, all the more baffled. What is one to make of a lan-guage of architectural forms that crams the vocabulary of different stylistic periods and cultural groups together in a single building? How does one cope with towers crowned with superstructures that

are neither Gothic nor derived from a cathedral in Kazan? How can crenellations borrowed from the Kremlin wall be reconciled with realistic sculptures? What is a larger than life-sized sculpture of workers and peasants doing above the vehicle entrance to a block of flats? And anyway, what is the point of having an arched entrance in the style of the Leningrad Building of the General Staff if it only leads to a back yard? Whatever could have prompted an artist and architect to unite in a single building elements of the Italian Renaissance and of Russian fortresses, the bizarre turrets of Tatar architecture and the solid round columns of Moscow Classicism? And what could have led him to fit out the vestibule of a hotel built in the second half of the twentieth century with heavy oak carvings and panelling in the nineteenth-century neo-Gothic style, with bull's-eye windows and roaring lions, even if – or perhaps because – the lobby leads to nothing more than a lift with heavy wooden pan-elling of its own? What inspired him to create a magnificent staircase which only leads up to the hairdressing salon? What meaning is to be found in the ceiling painting of a sumptuously stuccoed room which depicts, on the vault of its *trompe-l'œil* heaven, modern aeroplanes and a young man with a bicycle, along with flute and harmonica players, surrounding a Greek temple? What is the connection between a bicycling Young Communist and a Greek temple, or a flying machine and a flautist? And what is the sense of a building the size of a palace – the apartment block on Kotelnicheskaya naberezhnaya – containing, for the most part, only two-room flats? Or of a hotel in which only 22 per cent of the total floor space is available for accommodation, and a mere 7 per cent for the gastronomic side of the enterprise? Why does it need four lifts when each floor has no more than fifteen rooms? And why, to cap it all, are the rooms (which in any case are very small, often less than 110 square feet) set at an angle to the building? Just for the sake of the external appearance?

The construction of these buildings is said to have been a personal initiative of Stalin's. When it came to judging their merits, his suc-cessors made it easy for themselves – far too easy. Predictably, they invoked the empty formula of the dialectic of form and content, arguing that the form of these structures contradicted the content, that a hotel was a hotel and not a neo-Gothic museum, that an apartment block was an apartment block and not a *palazzo*, and so on. What they failed to do – as always – was to draw the barb of the

Hegelian-Marxian aesthetic, which would have been too painful an operation. For according to that aesthetic, form has its own truth, and there is an integral relationship between form and content. But what, then, is the truth of the form in this instance?

Criticism of these forms focused particularly on the financial aspect, and the architects and engineers responsible were unsparingly confronted with the figures. A single one of the apartment blocks cost as much to maintain as several 'normal' ones put together, while it was only in the Ministry of Foreign Affairs building on Smolenskaya ploshchad that the provision of office space had been successfully maximized. But the most damning criticism of all was that a country whose population was crammed together in those residential districts that had escaped the ravages of the war, and in particular a city that was bursting at the seams, could ill afford such profligate use of valuable materials like stone, concrete, cement, steel and marble.

By discrediting the style and its architects – especially the supreme architect, Stalin himself – the new planners opened the way for their own building policy, namely the construction of vast residential districts in the outlying areas and the development of mass-produced blocks of flats with standardized living accommodation for millions. Pioneering as it was in its way, this policy nonetheless suffered from a lack of ideas and the absence of any ambition beyond the most basic fulfilment of function, whether for housing or office space.

It is always curious to see how a later period applies its own ideas and values when judging and sometimes condemning an earlier one, because of course the planners in 1947 knew exactly what they were about. From the outset the overspend was allowed for in their calculations; they did not want to create featureless districts of mass housing or interchangeable office blocks. The arguments of the later critics would only have been justified if there had been a viable alternative at the time. But it was 1947, a year when the full extent of the destruction caused by the war had become obvious, a year of hope that the war's paradoxical effect of greater contact with the outside world might continue, but also a year when the course was being set for isolationism, the campaign against cosmopolitanism, and a wave of chauvinism that was no longer the response to a threat from Nazi Germany. The following year, 1948, saw the condemnation of the 'bourgeois formalists', the 'decadents', and the 'lackeys of Western Europe and bourgeois culture', and the hounding of writers and intel-

lectuals – especially Jewish ones – and of party members spared in earlier purges. That year marks the birth of a new patriotic self-image. Henceforth there was to be no doubting, not only that Russia was capable of anything she chose to do, but that the progress of mankind was inseparable from Russian, or rather Soviet, achievements, whether in genetics, rocket technology, philosophy – or architecture.

Moscow's high-rise buildings, which were not to be – were not allowed to be – Manhattan-style skyscrapers, represent an act of polemical self-assertion, which inevitably had something compulsive and desperate about it. How else can one explain the extraordinary accomplishment of putting up seven such buildings within four to six years? It was the final initiative of a system that had exhausted itself but still found the strength to stamp its mark on the city for all time. Only the very last of the buildings, which was to have bound the city's future for ever to the name of its overlord, was not realized: the Palace of Soviets, which was to have stood at the spot where lines projected from the seven buildings intersect.

However, if the architecture of these buildings had been wholly informed by ideology and not by their practical purpose of providing space and splendid interiors – in other words, had they not been designed to be useful – then by now they would be ruins or simply, as someone said to me in the Hotel Leningradskaya, 'architectural monuments'. But they are not. As far as I can judge by my own observation, the University on the Lenin Hills is a well-functioning machine for the production of science and ideology: so far, the building is doing its job. More than 6,000 people – students, research assistants and professors – live in this building with its long, hotel-like corridors and its apartments, complete with toilet, shower room and entrance lobby, concentrated in one block. Here, under a single roof, students have everything they need for their work and their daily lives: several cafeterias – even these, of course, have marble-clad columns and massive chandeliers – a photographer, a hairdressing salon, a shoe repairer, grocery shops and snack-bars, not to mention sports halls, concert and music rooms, a cinema, function rooms of various sizes, a swimming pool, and on each floor a common room with a television set. The central tower, which is capped with a gilded spire, accommodates the bright and airy lecture theatres, libraries, study rooms and the entire university administration. The building is huge, it is true, but considering that it is a town in itself it is surprisingly rational in design and not a

tiring place to be in. Its layout is clear and logical from the point of view of its separate sections and functions, though the residential part is anonymous and less easy to find one's way around in. However, in general it is the accommodation of choice: where else would you find such a high standard of building, the luxury of a single or double room, and a cinema, swimming pool and shops all under one roof? 'Knowledge is power' is the thought that the building seems to convey, particularly on special dates on the calendar when it is illuminated and appears before an admiring public like a man-made mountain range. If, as well as the power of knowledge, it also represents knowledge in the service of power, this would be no accident, for its architect was Lev Rudnev, whose work also included the Military Academy and who was adept at that kind of design.

Aware as you may be of the building's practical, Ж-shaped ground-plan and of the efficiency of a complex like this one which combines scholarship and student life, this cannot entirely banish a sense of puzzlement and unease as you make your way through the vestibules towards the exits, walking on stone tiles which are only now starting to become slightly rounded at the edges of the steps – the first signs of wear, after thirty years of use – and pass by great mirrors reaching up to the ceiling, and granite columns that reminded me of the picture of the palace at Knossos in our school history book; or when you sit in a cinema with a stuccoed ceiling, or cross the foyer towards a theatre auditorium obviously inspired by the Hall of Columns. For anyone living in this building it is impossible wholly to shake off a sense of uneasiness, a consciousness of the disproportion between function and décor. You are left feeling indifferent towards the over-rich ornamentation, though it was intended to be attractive; there is no escape from it but to ignore it.

The only way to cope with the impossibility of taking in all the wealth of detail, ornament and embellishment is to give the décor no more than a glance in passing. Otherwise it is all too exhausting and a distraction from the real and serious business of everyday life. In the metro the problem is greater still: the fact that you are moving more quickly exacerbates the conflict between the constant invitation to look and the speed with which the image vanishes.

The visitor's perception of these monumental buildings becomes more complicated if he engages in a dialogue with their architects. They are, after all, major figures like Vladimir Gelfreikh (or Helfreich) and Mikhail Minkus (Smolenskaya ploshchad), Aleksei

Dushkin (Lermontova ploshchad), Mikhail Posokhin and Ashot Mndoyants (Hotel Ukraina and ploshchad Vosstaniya), Dmitry Chechulin (Kotelnicheskaya naberezhnaya) and Lev Rudnev (the University). To these one should add the illustrious names of other architects who were responsible for no less puzzling buildings, and whose artistic background makes them even more incomprehensible to us: Aleksei Shchusev, Boris Iofan, Ivan Zholtovsky and Ivan Fomin. These architects were also artists; they trained at the St Petersburg Academy of Arts at the beginning of the twentieth century, and built villas and mansions for the St Petersburg aristocracy and the Moscow merchant class that were unsurpassed not only in splendour but often also in taste. These people were among the most sought-after stage designers of the St Petersburg theatre world, and proved able, apparently without compromising their sophisticated taste, to create original architecture in the modern Constructivist manner, such as Shchusev's Narkomzem building and especially his Lenin Mausoleum. How was it that these same men were willing to indulge in the most riotous and at first sight senseless flights of fancy, such as Shchusev's design for the Komsomolskaya metro station, Fomin's for the one at ploshchad Sverdlova, or Zholtovsky's 'Palladian' frontage for the apartment block near the Manège?

It is certainly true that an element of compulsion, and the danger that an architect might lose his livelihood by being banned from receiving commissions from the sole client, the state, played a considerable role. After all, as early as July 1932 the numerous rival architects' societies were dissolved and replaced by the single Union of Soviet Architects, and at the same time Socialist Realism was proclaimed, in place of the existing variety of styles, as the one acceptable architectural principle. Yet the pressure exerted on the architects does not explain their switch to Eclecticism, any more than Stalinism can be simply equated with the practice of terror. Saying this lays one open to the charge of being an apologist; but the widely accepted and frequently repeated assertion that the 1930s made a complete break with the 1920s, and that the emergence of Eclecticism in the 1930s and '40s was merely a reaction, or indeed a 'deviation', gets one nowhere at all. As we know, pressure is especially effective when it is applied to someone who is no longer sufficiently sure of himself. New certainties take root where old ideas have fallen prey to uncertainty and a loss of confidence, and a new

programme can take hold where an old one has run out of energy or where the conditions that gave rise to it are undergoing radical change. Familiar with the dates and the moments of hiatus in social and political history, we may often overlook the fact that developments in the microcosms of the artistic world follow their own separate logic. It is true that the Bauhaus was dissolved in Berlin in 1933, as had been its Soviet offshoot VKhUTEMAS (Higher [State] Artistic and Technical Workshops) in its later guise of VKhUTEIN (Higher [State] Art and Technical Institute) in 1930 – but does this alone account for the end of the era of Functionalism and Constructivism? The powerful advance, first of the neo-classicists and the advocates of art deco and later of the Eclecticists, must have had something to do with the vacuum left behind by the previous period. When people pay tribute to the architects of the 1920s and are quick to sneer at those of the '30s and '40s, this is not always wholly a matter of aesthetic judgement, but arises in large measure from a feeling of solidarity with the victims, from sorrow for those who were crushed under the wheels.

The great buildings of the 1930s and '40s – such as the Lenin Library, the Tchaikovsky Concert Hall, residential blocks numbers 4, 6 and 8 on ulitsa Gorkogo, the Vakhtangov Theatre on the Arbat, numerous metro stations and the seven principal high-rise buildings – could hardly have been executed if they had not been based on a thoroughly convincing idea. But the question is, convincing to whom and on what grounds?

The suggestion that this was a straightforward reaction, that after a period of being overshadowed the neo-classicists of the St Petersburg Academy came to the fore again as though nothing had happened, is not credible. A simple resumption of neo-classicism was an utter impossibility: the products of Soviet Modernism could not be ignored, and too many of the new generation of architects had been fundamentally influenced by the 1920s. If the buildings of the 1930s and late '40s express an aesthetic programme, it can be defined negatively as a rejection of unadorned, merely functional architecture, and positively as a search for a synthesis of the diverse styles and cultures to which the Soviet state believed itself the heir. The key to Eclecticism is that it is an attempt to work towards an original, autonomous language of architectural forms, not one imposed by decree.

Interpreting Eclecticism as a largely unsuccessful attempt to achieve a synthesis is a greater challenge in Moscow than in some

33

other cities. In Warsaw (with its Palace of Culture) or East Berlin (the former Stalinallee), the wedding-cake architecture is simply a monstrous import from the Soviet Union that does not even pretend to have anything to do with native traditions. In Moscow, on the other hand, it is deeply rooted in the city, and its emergence is in effect a resumption of the late nineteenth-century struggle to create a home-grown, neo-Russian style. Indeed, this Eclecticism can perhaps be best defined as the failure of a synthesizing process, the product of an artificially shortened process of growth, a forcible and externally imposed joining of parts which, whether by choice or necessity, were not given time to mature naturally. The artificiality of this undertaking is just another reflection of how the building of Soviet society was relentlessly driven forward; but societies too are not 'built', they have to grow.

However, blasé criticism of Eclecticism and the wedding-cake style very often either overlooks or derides the enormous, superhuman effort that was invested in it. It is all too easy to forget, when faced by an over-extravagance of decoration, that these stylistic currents are monuments to a synthesizing endeavour which, though forcibly setting an unrealistic pace, could still summon up sufficient self-confidence to act on the assumption of holding sway for all time.

In the Moscow of the 1920s the visitor was surrounded by a city of churches and clock towers. Walter Benjamin felt 'completely encircled by more than four hundred churches and chapels, that is to say by two thousand domes', and wrote of being spied on by an 'architectural Okhranka'. Nowadays the presence of the clock towers is no longer noticeable, and their strong upward thrust has been replaced by that of the high-rise buildings.

Note: almost all of the chapters in this book were written more or less in the order of my explorations and wanderings, with the exception of the present one. The reason is simple: you begin with the most obvious, the surface layer, which continuously resists you, and so you return to it again and again. This is why I have allowed myself to include a conclusion at such an early point in the book.

3 Strata

Moscow versus St Petersburg –
The two halves of a whole.

Is Moscow a city that has grown organically, where, as in other cities, the visitor can examine and interpret the phases of its architecture like the annual growth rings on a tree; a place where, helped by the experience and background knowledge that he brings with him, he feels a sense of continuity? Is it a place of market squares surrounded by burghers' houses, with the usual polarization between castle and cathedral on the one hand and civic institutions such as the town hall and guild houses on the other? A place where the old ring of defensive walls has been breached and ultimately obliterated by the unstoppable expansion of the town, leaving only the names of streets and squares to recall the old fortifications? Has its growth from a medieval town to a modern stronghold of industry been so organic that, whatever the disruptions along the way, one is chiefly conscious of continuity?

I do not think so. Moscow was the Old Russian capital in the era before Peter the Great and St Petersburg, and then became the capital again, first of modern capitalist Russia following the Great Reform of 1861, and then of the Soviet state, with all the central institutions that had once been transferred to the banks of the Neva brought back to the centre. But Moscow lacks one whole phase of history as a capital city (even if, tacitly, it always retained that status and was the only place where a Tsar could be crowned). Of course Moscow has its wealth of absolutist architecture – and indeed there are the styles actually known as 'Moscow Baroque' and, more famously, 'Moscow classicism' – but this was insufficient to determine the physiognomy of the city as a whole. The missing section of

35

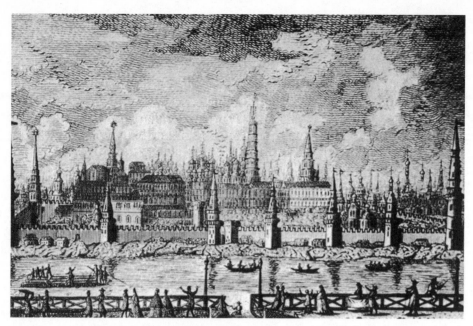

The Kremlin, engraving by S. Makhaev, 18th century.

Moscow's history is to be found elsewhere: on the Neva, where Peter the Great began building the Fortress of St Peter and St Paul in 1703; the imperial court moved there in 1712 and remained there until the Revolution of 1917. In St Petersburg, as in Moscow, the discontinuity is palpable. 'Sanktpiterburkh', as that city, conjured into existence out of the marsh, was at first known, had no antecedents, no link to any previous history. And after 1918, when the Soviet government removed itself to Moscow, Petrograd, as it was by then called, lost its status as capital and was thrust back into provincialism.

During the two centuries in which St Petersburg developed into a place of uncanny beauty, it was never quite able to throw off the phantom-like, insubstantial quality generated by the arbitrariness of its foundation. The protagonists of Dostoevsky's and Bely's novels convey a sense of the period and of what it was like to live in that not quite real city, while Nikolai Antsiferov recorded the myth that grew up around it in his book *The Soul of St Petersburg*. When visitors come to Leningrad it still takes their breath away, as it always has done, and most of them unhesitatingly prefer St Petersburg/Petrograd/ Leningrad to Moscow and feel more at ease in the former capital. To

36

most people, St Petersburg represents the quintessence of refined European urban culture.

However, perhaps this too comes from adhering to a myth. At first sight Moscow does not seem to offer much in the way of sophisticated city life. From the start of the eighteenth century until the late nineteenth it appears almost like a vacuum, an unoccupied space only waiting for the day when history will inevitably change direction, and with ample room to absorb, at last, the pulsating energies of a giant empire. Perhaps it was providential that the great fire of 1812 cleared the ground, leaving Moscow and its region unencumbered and all the more able to exact vengeance for having been so humiliatingly demoted.

Two cities, then, embodying two separate historical developments: on the one hand Moscow, first pre-Enlightenment, pre-Petrine, Orthodox and Tsarist, and then capitalist, enjoying an unparalleled boom; and on the other hand St Petersburg, the silver city, absolutist, enlightened, imperial: even the coming of the big capital concerns could not disturb the serenity of its neo-classical façades. On one side the appeal of rampant organic growth, on the other the magic of geometry.

Significantly, the image of 'two halves' was used by Lenin early in 1918 when he commented that Russia had adopted the most advanced political structure, the dictatorship of the proletariat. The complementary other half, an advanced economic basis, already existed, but only outside Russia, in the shape of the German state capitalism practised by Wilhelm II and Walther Rathenau. But what is the effect of having two cultures developing separately? What happens to the growth of an urban culture when different traditions and standards emerge in isolation from each other without the benefit of creative friction and mutual adjustment, and when (as has often occurred) people simplistically contrast the two cities, defining St Petersburg as the outpost of Europe, but Moscow – in the words of Mme de Staël – as the 'Rome of the Tatars'?

The superciliousness that has often been shown by St Petersburg towards Moscow, and the attitude compounded of envy and contempt adopted by Muscovites towards St Petersburgers, is like a coded mutual questioning; or, to put it more plainly, an attempt by the Russians of St Petersburg and Moscow respectively to pin down their own identity, to establish who they are and where they belong. The historical tension between Moscow and St Petersburg is subtly

perpetuated in the tensions and animosities that exist between the inhabitants of the two cities today, and this is no doubt the tension that is inherent in the concept of Russianness as such. If one were to trace the history of the expressions of hostility and of affection exchanged by the citizens of the two rival capitals over the centuries, one might be able to pinpoint the position of a Russian self-consciousness that lies somewhere between, and oscillates between, the two poles of East and West.

No one has more brilliantly delineated the features of the two capitals than Nikolai Gogol in his *St Petersburg Notes*, written in 1836, at a period when the character of both was already fairly well established. 'Where indeed has the Russian capital landed up – at the back of beyond! A fine trick of the Russian capital, to take up residence next door to the North Pole!' he exclaims in wonderment. And then he dashes off a phenomenological sketch which is still accurate even today if you make allowance for the provincialization that St Petersburg has undergone since then. He sees Moscow as having 'a full beard', while St Petersburg is a 'correct German'. Moscow 'sprawls all over the place', St Petersburg is 'erect, slim and elegant', Moscow he regards as a 'homespun woman', St Petersburg as a 'dandy'. St Petersburg is a punctilious individual 'who will check how much he has in his pocket before inviting people out for a drink; Moscow is a Russian nobleman, and when he sets out to enjoy himself he carries on till he drops . . . '. In Moscow the journals write profound pieces about Kant, Schelling, 'and so on and so forth . . . the only subjects of the St Petersburg journals are the public and having the right opinions'. St Petersburg is where writers earn money, while Moscow is where they throw it around. 'Moscow is a great merchant business; St Petersburg a bright and attractive shop. Russia needs Moscow, St Petersburg needs Russia. St Petersburg likes to make fun of Moscow for being crude and uncouth and having bad taste; Moscow sneers at St Petersburg for being venal, as well as unable to speak Russian.' Gogol has difficulty in summing up what makes St Petersburg what it is, and arrives at the cautious formulation: 'In a way the city is like a European colony in America, with just as little that is native and national, and just as much that is international and mixed and has not yet become fused into a new, firmly-knit body.'

For some considerable time now there has been a wave of nostalgia for the former glories of the silver city, but voices have also been

raised belatedly anathematizing the epoch of Peter the Great for having set Russia on 'the wrong path', as Aleksandr Solzhenitsyn claimed. This, like all such overstatements, contains a germ of truth: the very building of St Petersburg was made possible by the imposition of a ban on the use of stone for building houses in Moscow, to say nothing of the cultural and intellectual consequences. For centuries afterwards, Peter the Great's grand project continued to soak up energies in a way that inevitably led to inertia and a loss of vigour elsewhere. Hence it may be said without undue exaggeration that the founding of St Petersburg interrupted and held back Moscow's development as a city, and that it was Moscow that bore the cost of the Petrine reforms. Nevertheless, to speak of St Petersburg as the 'European' and Moscow as the 'Russian', or even semi-Asiatic, city obscures the fact that Moscow has always been the more truly European of the two. This needs to be stated bluntly if the stranglehold of the established myth is ever to be loosened.

Moscow in the Middle Ages possessed in almost complete form all the prerequisites, familiar to us from our knowledge of the rest of Europe, for the making of a city. It had a castle, as a place of refuge but also as the centre of that exploitation without which culture cannot develop; its layout was, not by chance, reminiscent of that of Paris; it was the seat of both the Tsar and the Patriarch, which provided at least the potential for the division of power and the rivalry between the spiritual and temporal hegemonies that in Europe proved so beneficial and productive (admittedly caesaropapism was not done away with, but there were heresies and Reformationist movements); and some of the ingredients of social unrest were present just as in the medieval towns and cities of Western Europe, even if Moscow did not experience the development of guilds with a republican structure.

It was in Moscow that the first Russian schools were founded, and in 1755 the first Russian university was established there, even though by that time St Petersburg was already the capital. And – most significantly of all – long before 1703 Moscow had close ties with northern Italy, with the European Renaissance, the 'rebirth' of Europe. Venetian and Milanese builders were at work in Moscow well before anyone had a vision of a 'Venice of the North'. Moscow is quite manifestly *not* the non-European city *par excellence*, any more than the age of the Enlightenment, and in particular the period of the French Revolution, can be equated with what is meant by

'European'. It rather seems as though, through the creation of two rival capitals, the potential causes of conflict that proved so fruitful in Western Europe were in Russia split apart, isolated and so rendered less productive. Whereas in France, for example, Versailles and the Third Estate of Paris were, so to speak, sealed inside a single pressurized vessel, their Russian counterparts were widely separated, with a consequent huge loss of pressure and energy. And when the vessel did finally burst, the explosion blew to pieces not just the *ancien régime* (Versailles, St Petersburg), but also liberal attempts at reform (Frankfurt's National Assembly, Petrograd's Constituent Assembly). This is no doubt the significance of the sequence of dates, 1789–1848–1917, so often cited by Lenin.

Moscow attempted to punish its rival by outshining it; how effectively is open to question. The geometry of St Petersburg cannot be recreated by means of a General Plan for the Reconstruction of Moscow; classicism can at best succeed again in the guise of neoclassicism. The transformation of Tverskaya into ulitsa Gorkogo may have outdone the Nevsky prospekt, but it could not equal it. That sounds fanciful, if not paradoxical; but the historical situation was in many ways paradoxical. Besides, one hears far more daring comments on the character of capital cities. Are there not some people who see Chicago and not New York as the most American of cities? To call Moscow the most Russian of Russian cities is a small matter by comparison. Russia's Chicago, then?

4 A rampant boom

In the stone landscape the areas of art nouveau
building have survived better than in other places,
despite the clearances made under the General Plan –
Moscow as the metropolis of the empire, but also
as a European metropolis.

How is it that everywhere in Moscow, even today, the elemental vigour of art nouveau, which is known here as *style moderne*, is not only present but leaps out at you, and is all the more captivating for being surrounded by other architecture that is bulky and either over- or under-embellished? The reason must lie in the ideas and driving forces that informed that style and which are nowadays recognized in Moscow too as its defining characteristics.

First, the international dimension: Moscow and St Petersburg shared in the general European unease about culture and its traditional forms. Here that unease perhaps burst out in a more elemental fashion because it was combined with the discovery of native sources of strength.

Secondly, the democratization of life: luxury, blossoming in so many different ways that life seemed in danger of being suffocated by it, was growing so rampantly that a need was felt to return to and reveal the basic contours of life, the ground from which everything sprang. From the pure aestheticism of *l'art pour l'art* to making people's lives more aesthetic: the ancient dream of making nature more human, and humankind more natural. However, this was not a 'back to nature' movement but a desire for the city-dweller to reconquer his living-space in the city.

Thirdly, there was a crisis of culture, that is to say the shattering of a culture that had become like a corset squeezing the breath out of life. There was a sense that the available styles – both classicism and the false trails represented by Eclecticism – were worn out, their possibilities exhausted (though in fact Eclecticism did much

41

to prepare the ground for the radical innovations of the *style moderne*).

Lastly, there was a rejection of technological form in favour of living form, a celebration of the organic and natural as opposed to the rationalistic forms on which our towns and our business activities are based. The rectangle ceased to be dominant, giving way to the natural shapes of plants and animals. The inner and the primary had precedence over what was external, secondary, 'cultured'.

The *style moderne* has not always been spoken of in Russia with approval and understanding. There was a lengthy period during which it was denounced as the embodiment of *décadence*, which was itself attacked as the swansong of a moribund class; or alternatively the *style moderne* was ignored and passed over in silence. (We should, however, remember that in Germany too there was a time when, as Dolf Sternberger reminds us, mockery of art nouveau 'had about it a note of brutal malice', 'the lingering reverberation of a destructive intent which dimly senses that it has not yet fully achieved its aim'.)

Moscow shared fully in the European art nouveau movement: there is ample evidence of close links with Munich, Darmstadt, Berlin, Vienna and Brussels. The public was kept up to date by periodicals such as *Mir iskusstva* (*World of Art*, produced by Aleksandr Benois and Sergei Diaghilev), *Apollon* and *Zolotoe runo* (*Golden Fleece*). Many artists who later branched out in quite different directions – Vasily Kandinsky or Igor Grabar, for example – knew the Munich and Vienna Secession at first hand. Ivan Fomin, who was to become the principal exponent of 'proletarian Doric', organized an *Exhibition of Architecture and Industrial Art in the New Style* in Moscow as early as 1902; among the exhibits were a salon by Charles Rennie Mackintosh and a dining room ensemble by Josef Maria Olbrich. It was Peter Behrens who, following his time in the Darmstadt artists' colony, was commissioned to design the German Embassy in St Petersburg; and no doubt El Lissitzky had his reasons for fixing on Darmstadt's Technical University for his studies abroad.

The participation of Moscow and indeed Russia as a whole in this movement was the more radical and extreme for being, as always, slightly belated. No word was more on people's lips in the years after 1910 than 'crisis', whether applied to literature, art or philosophy. It is no coincidence that Henri Bergson's *élan vital*, Nikolai Lossky's Intuitionism, Nikolai Berdyaev's Existentialism, and the re-evaluation

of values by the neo-Nietzscheans were so much in vogue here. In the chaos of new 'isms' not even the 'party of steel', which ultimately turned the crisis to its own advantage, remained unaffected, so closely was its own intellectual elite caught up in the radically destabilized climate of the times. A footnote to this, and one that is not wholly without significance, is that the author of *The Myth of the Twentieth Century*, Alfred Rosenberg, who was born in Reval (Tallinn), was studying architecture at the Moscow Polytechnic at this time.

'And that colourful, impudent style – the *style moderne* – appeared everywhere', wrote Valery Bryusov in 1909. Something of this impudence, freshness and sheer quality standing out agreeably from the surroundings forms part of the urban scene throughout Moscow, and is also to be found in those Russian provincial cities that were marked by the rapid industrialization of the late nineteenth century, such as Nizhny Novgorod (Gorky) and Samara (Kuybyshev), and Russia's third metropolis in those days, Odessa. There are concentrations of *style moderne* in the more remote corners of the Arbat, on Meshchanskaya ulitsa, Kropotkinskaya and Metrostroevskaya. In the two decades preceding the Revolution, particular kinds of building were favoured by architects for trying out their ideas: railway stations, public buildings, spacious apartment blocks for the well-to-do middle class, banks and villas. Perhaps the contrasting character of the two capitals also finds expression in these buildings. The examples to be found in St Petersburg – among them Tolstoy's house, the Yeliseev Building and the Singer Building on Nevsky prospekt – appear to me more restrained, northern, English, Gothic, whereas Moscow is, as usual, more unorthodox, colourful, flamboyant.

What makes *fin-de-siècle* architecture in Moscow so striking, even though it is completely hemmed in by other building styles, must be the way that the *style moderne* stands out as something very different from the historicism of the second half of the nineteenth century, which all too often had led to mere Eclecticism. 'What is happening is not a renaissance of the Renaissance, but a *naissance*', the Viennese architect Otto Wagner had written, articulating the revolutionary thrust of a movement to which the avant-garde of later years, despite its sharp criticisms of art nouveau, owed its being.

Despite all the changes made to the fabric of Moscow, the architecture of the two pre-Revolutionary decades has not been destroyed. It could not be: it had made too lasting a mark on the city's appearance, and contains within it too much of the energy of the capitalist

43

boom that dragged Russia and Moscow out of a remote provincial idyll into the modern world.

Moscow was a city long before it became a capital. Its location was unlike St Petersburg's: at the heart of the country, taking in and distilling all that was vital in its surroundings. And its structure was different, a central core open on all sides, with potential for growth and without the restrictions imposed by a classical chequerboard ground-plan. With these advantages, Moscow was the centre of the capitalist boom, even though the biggest industrial complexes like the shipyards and the Putilov and Obukhov factories were in St Petersburg. A nationalistic middle class gravitated to where there was sufficient space, where the connecting links to the history and the body of the nation were more direct and obvious, and where the bourgeoisie itself still showed signs of its origins. In some cases serfdom lay not at all far back in the family history. The Ryabushinskys, the Konovalovs, Tretyakovs, Morozovs, Mamontovs and Chetverikovs, leading magnates at the turn of the century, had only attained bourgeois status within the last two or three generations, having worked their way up from the peasantry.

However, the ascendancy of the self-made man of peasant origin was accompanied from the start by intimations of the bourgeoisie's decline. Mamontov, Ryabushinsky and others were masters of the city, although power was not yet officially in their hands. They shared in the culture of the aristocracy and were already well aware of that class's imminent demise and the reasons for it, notably the unproductive use of its landed estates purely as a source of income. Now the bourgeoisie's time had come, but only at the very moment when it was about to run out. Their sphere of existence was located in the narrow territory between the aristocratic *usadby* (country estates) and the businesses and factories that were springing up everywhere; their institutions were squeezed into the space between the Club of the Nobility and the office and stock exchange. The way they changed the face of Moscow justifies Lenin's observation that Russia's bourgeoisie had not only caught up with that of other capitalist-imperialist states but was actually among the most advanced.

The architectural legacy of the post-reform boom when, despite the slow rate of progress in ending serfdom after 1861, the 'freed' *muzhiki* poured into the city, is everywhere to be seen. This spate of building appeared wildly chaotic, as travellers of the day com-

mented, but also brought to the city something of the logic of capitalism: new stations were built around the ring railway line, notably the Briansk (Kiev) Station designed by Rerberg, the Kazan Station by Shchusev, the Yaroslavl Station by Shekhtel, and the Riga Station. Factories sprang up from nowhere, or existing ones were vastly enlarged: Tryokhgornaya, Bromley, List, Grachev, Michelson, Abrikosov. Foreign firms opened branches here. Churches, chapels, clock towers, bars, stalls and thousands of small shops were forced to make way for the new buildings. Banks, hotels, trading companies, impressive commercial buildings advanced on a broad front, heightening rather than reducing the chaotic complexity of commerce in Moscow, and if anything blending into it, given the hugely increased scale of the whole. This happened in Kitay-gorod, on Ilinka and Varvarka, in Myasnitskaya, on Kuznetsky most and in the district behind the Bolshoi Theatre.

Where capital leads, the workforce follows; people moved into the tenement blocks grouped around the factories, all of them outside the ring that encompasses the White City. Only a few examples of this type of tenement survive (on Varshavskoe shosse, for example), and nothing at all is left of the boundless sea of wooden housing still shown in every picture of Moscow dating from this period.

Ryabushinsky mansion, architect F. O. Shekhtel, 1900–2.

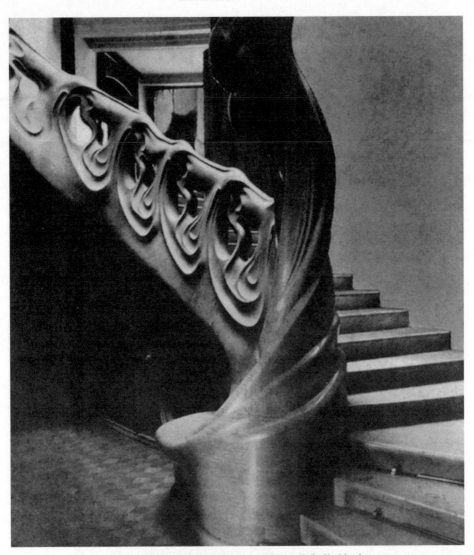

Staircase in the Ryabushinsky mansion, architect F. O. Shekhtel, 1900–2.

What has been preserved are the houses of the wealthy middle class. They rejected the model of the aristocratic *usadba*, and not solely on the grounds of expense. Their houses, lining the streets that were the scene of a newly emerging urban ambience and commercial activity, are up to ten storeys tall, thanks to the revolution in lift technology. They are built on a generous scale, with broad, sweeping flights of stairs and spacious stairwells, but the impressive size of their external elevations is broken up by a wealth of articulation – curving balconies and undulating grilles, or brightly coloured bands of majolica. These houses bring colour and rhythm to the appearance of the city. You need only to take the route B trolley-bus around the ring road, especially the Sadova-Triumfalnaya and Sadova-Kudrinskaya sections, to be convinced of the vitality and durability of this architecture, which owes its survival to more than just the excellence of the materials used.

It was in those years that the city truly coalesced into a city, though spontaneously rather than in a planned way. The tramway system entered into competition with the veritable army, tens of thousands strong, of drivers of horse-drawn vehicles. A more or less densely inhabited area developed into a city, a conglomeration of people turned into a society which needed to become structured in order to remain viable: hospitals were built, People's Houses (i.e., cultural centres), insurance companies, orphanages, the institutions of a society beginning to express itself politically. The new self-confidence of the Third Estate showed itself in museum buildings – such as Vladimir Sherwood's Historical Museum and Roman Klein's Pushkin Museum of Fine Arts – and the public controversies about their design. The spheres of production and consumption began to go their separate ways in a textbook division of labour straight out of *Das Kapital*, and in turn a whole circulatory system of distribution gradually developed. This led, in the central area of the city, to the appearance of huge department stores and shopping arcades like the Trading Rows (part of which is now the State Department Store, GUM) or the Petrovsky Arcade in ulitsa Petrovka – shoppers' paradises the size of whole neighbourhoods.

As business affairs and private life moved apart, and the intimacy of the aristocratic salon became too constricting for the new partners in the business of cultural and social activity, nurseries of a new form of social interaction emerged that allowed for a combination of intimacy with urbane anonymity. Hotels, cafés,

restaurants and clubs created a public setting for social interaction fundamentally different from that of the aristocratic mansion, though this new milieu in its turn was too narrow and exclusive to admit others who also had a contribution to make. Restaurants with club rooms are mentioned a number of times in the literature about Moscow in the 1910s: the Eremitage, the Shchorbaki and Velde restaurants, the Livorno, the Alpenrose on Sofiyka, the Slavyansky Bazar, the Eldorado, the Praga restaurant (which still exists today), the Hotel Berlin (which can also still be seen, though it has had several different names, including the Savoy), Dusseaux, and Billo (a German-owned establishment, which is no doubt why Richard Wagner stayed there in 1863). International-class hotels such as the Metropol, the Grand Hotel (facing the Metropol, behind the Hotel Moskva; now demolished), the National, the Luks, the Hotel Dresden, Hotel Paris and many more besides bear witness to Moscow's new level of integration into international travel, and an altogether new degree of mobility.

The metropolis that shot up around the turn of the century had its disreputable quarter – can one imagine St Petersburg with one of those? – centred on Sukharevskaya ulitsa, now Kolkhoznaya ploshchad, with its picturesque tower dating from the days of Peter the Great. (This was later pulled down, partly to make way for new large-scale development, but no doubt also to eradicate a monument to trade; especially the black market, because at the time of the 'New Economic Policy' Sukharevka was a byword for dubious financial deals and speculation.) Moscow was also home to the Khitrovka, the setting for Gorky's *The Lower Depths*, with all the taverns, lodging-houses and seedy bars that the writer Vladimir Gilyarovsky described from personal knowledge. Even as he wrote, the construction brigades were advancing, preparing to do away with this blot on the landscape. The city was to be made more beautiful!

Moscow had its natural belly, the food market area around Okhotny ryad, where the Hotel Moskva and Arkady Langman's Council of Ministers building now stand – a district that was resistant to official control, bewildering, impenetrable, with its smells, its noise and its tangle of deals both legitimate and shady. Peasant Russia fed the city, and for the children of the rich it was an extraordinary adventure to visit the market with Mamma or the governess and to gape in disbelief at this other Russia. Going there during Lent, the poet Marina Tsvetaeva's sister Anastasia saw wooden tubs full of

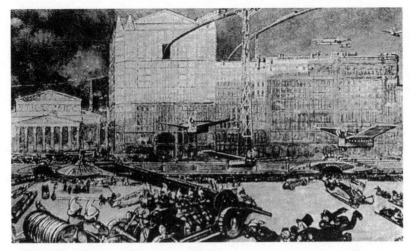

Moscow, Teatralnaya ploshchad, postcard from the series 'The Moscow of the Future', 1913.

'tiny smelt with their silvery scales. All around were the smells of bread rolls and blinis. Great tubs of dough and globe-shaped bottles containing *kvass* or hot, spiced honey drinks were being pulled along on sledges.'

This food market – which gave the city sustenance, and not only of the physical kind, for theatre folk also profited from this irruption of originality – has vanished without trace. Cars and buses roar along the multi-laned asphalt road, while pedestrians have been banished below ground.

A tiny inkling of what that chaotic district must have been like came to me one winter's evening as I was walking along ulitsa Zhdanova towards the metro, not far from the bookshops in Pushechnaya ulitsa. There in the failing light people were standing around in small groups, holding out a book or two under their jackets or overcoats to let a potential buyer know what was on offer. What made the sight so oddly reminiscent of the old underworld black market was the way they kept circling around, allowing a glimpse of the books' spines as they pushed past each other. But the location for these transactions changes constantly. That underworld no longer has a place in Moscow – or rather, it is starting to flourish elsewhere, in the new 'micro-regions', the neighbourhood housing units out on the periphery, where hundreds and thousands of people live with no adequate technological or social infrastructure; perhaps

these are the places where the problem of 'ungovernability', in its Soviet form, is most in evidence.

The attitude of modern Russians towards the achievements of the late nineteenth- and early twentieth-century bourgeoisie is more complex than is suggested by the formula, 'development of the bourgeoisie as an objectively necessary transitional stage'. On the one hand the history books are full of references to some Ryabushinsky or Tretyakov who not only 'exploited' the proletariat in the, as it were, objective terms of political economy but also laid himself open to criticism on the more subjective grounds of his individual morality; but there are other Tretyakovs and Ryabushinskys who are spoken of without hostility and given due credit as the pioneers of a reawakened Russian national culture. The paintings that they collected, the poets to whom they gave financial support, the villas they built (which nowadays often house embassies or have even been converted into museums), all have the approval of the victorious class. They are placed on view, albeit, slightly unsettlingly, without any indication of the background that produced them.

But how much more disturbing, to those raised on dialectical materialism, is a member of the bourgeoisie like Savva Timofeevich Morozov, who was one of the financial backers of the Bolshevist Party press and could claim to be a close friend of the legendary Moscow Bolshevik Nikolai Bauman! Or a manufacturer's son like Nikolai Pavlovich Schmitt, who introduced a nine-hour working day in his furniture factory in Krasnaya Presnya as early as 1904, before the Revolution, set up out-patient clinics, gave 20,000 roubles to the Moscow RSDRP (Russian Social-Democratic Workers' Party) to finance the periodical *Novaya zhizn*, and finally fought in person on the barricades. In 1907 he died in solitary confinement in Butyrka prison. What can people trained to view the world in the light of historical materialism make of a patron of the arts like Pavel Tretyakov, who collected paintings of social protest and of the misery of 'the humiliated and insulted' at a time when there was no interest in them, and then donated them to the nation long before there was any question of expropriation or nationalization? How are they to regard merchants, supposedly mere 'character masks giving a face to the circulation of goods', who established hospitals at their own expense, as K. T. Soldatenkov did in the case of the Botkin Hospital (designed by I. A. Ivanov-Shits and built in 1908–10)? Or the multi-

50

talented Botkin family, who made their money in tea and whose later generations came to be Russia's greatest collectors of Russian and Western European art, while another scion of the family, Dmitry Petrovich Botkin, became an outstanding and socially committed doctor?

The Shchukins, too, a dynasty that prospered in the textile industry, invested their money in ways from which the Soviet state still benefits to this day. Pyotr Ivanovich Shchukin donated his collection of some fifteen thousand items of Old Russian art to Moscow's Historical Museum in 1905. Sergei Ivanovich Shchukin brought an incomparable collection of works by Picasso, Matisse and Cézanne to Moscow, before going into exile in France in 1917. It is said that when he was urged to institute legal proceedings to reclaim his collection, he refused on the grounds that he had assembled it not for himself but for his country and his nation.

The Ryabushinskys, Morozovs and Mamontovs left a greater legacy than their triumphant heirs are willing to admit. The Ryabushinskys were merchants, bankers and manufacturers, of peasant and Old Believer origins (the founder of the family came from the Kaluga province). In 1916 they laid the foundation stone for the AMO automobile works, which later became the Stalin Automobile Works and then the Likhachev Automobile Works. The Mamontovs risked their money on the construction of the railways that opened up the country. The Morozovs – another family with an Old Believer and serf background – were among the founders of the textile industry that has played such a vital role in Russia.

What is astonishing about the rise to prominence of these families is that it is so like the American dream. A purely economic interpretation of their careers would be inadequate. It seems as if the Russian bourgeois, whose time for assuming an active role in civic life was cut short, was obliged to find a place in the world of the arts instead. Politically constrained by the autocratic machinery of government on the one hand, and under pressure from the impoverished but already organized peasant and proletarian masses on the other, he became active in the spheres of art and culture. Private initiative and patronage filled the gap left by a political system that had become intellectually and socially impotent. Would the Russian and later the Soviet avant-garde have been conceivable without the artists' colony that Savva Ivanovich Mamontov established on his estate at

Sergei Diaghilev,
with his nanny in the
background, painting
by Léon Bakst, 1905.

Abramtsevo, which brought together such men as Ilya Repin,
Mikhail Vrubel, Konstantin Korovin and Viktor Vasnetsov? Would
the blossoming of Russian theatre and musical theatre be imaginable
without Mamontov's initiative to create a 'Russian Private Opera'?
Savva Mamontov was a sponsor of music and a friend of Shalyapin
and Stanislavsky, but this was by no means all, for he both composed
and performed music himself, in his house at number 6, Sadovaya-
Spasskaya.

When historians are required at all times to condemn the 'declin-
ing classes', how awkward it is for them to deal with members of the
bourgeois class who chose of their own accord to advocate a new,
different, perhaps better world, and had the courage to say that they
would champion that new world but could not be a part of it. Savva
Timofeevich Morozov, a friend of both Stanislavsky and Gorky, was
the driving force behind the founding of the legendary Little Art
Theatre and provided funds for the underground press, while at
the same time initiating long-overdue labour legislation. In 1905, at
the height of the first Revolution, he accepted the consequences:

Morozov, factory owner and Bolshevik sympathizer, put a bullet through his own brain.

It is clear from this that the revolutionary and tempestuously productive character of the Russian bourgeoisie encompasses far more than is implied by the 'transitory mission' objectivistically assigned to it. Amongst other things, it was characteristic of these people that they made the most of the opportunities that were open to them, but recognized and in some cases positively accepted the limits of these possibilities, and did not pretend otherwise to themselves or to others. Their understanding of those limits, their unflinching acknowledgement that their position was unavoidable and that it had already become precarious, gave the best among them a sense of being in an unhappy, indeed a tragic situation. Diaghilev represents just one instance, though an especially poignant one, of this profound self-awareness. At a dinner given in his honour by Moscow artists, Diaghilev revealed to the prominent figures assembled there – including Mamontov, Serov, Musatov and Ostroukhov – what he, and probably others too, thought, though he was in a unique position to voice it without restraint. His extensive travels around Russia, 'in the gentle summer breeze', had convinced him that

> the time has come to take stock . . . The estates are in a desolate condition, the palaces fearful to look at in their lost splendour, and strangely populated by today's people of very small or moderate means who are quite unable to sustain the lavish style that was once seen here.
>
> And at once I realized that we are living in terrifying times of radical change; we are condemned to die in order to assist the resurrection of a new culture which will take over from us what remains of our tired wisdom . . . And therefore I raise my glass, without either fear or scepticism, both to the fallen walls of the beautiful palaces and to the new precepts of a new aesthetic. And as an incorrigible sensualist I will express just one wish: may the impending battle not make life less aesthetic, and may the death be as radiantly beautiful as the resurrection.

The place: Walcot's and Erikhson's Hotel Metropol, the newly completed, gleaming white ocean liner on Theatre Square. The time: 1905, amid the stormy seas of revolution.

5 A note on Shekhtel

I gave some friends a guided tour; when you are pointing things out to other people you notice less yourself, which is odd – you would expect the opposite. Shekhtel is not the only representative of early twentienth-century architecture in Moscow, but he is perhaps the architect who makes the best use of colour and subtle nuances. One ought really also to discuss Kekushev, Walcot, Erikhson, Klein and Shchusev, as well as neo-classical and neo-Russian styles.

Fyodor Shekhtel (1859–1926) started out in the neo-Russian style (as witness his Russian Pavilion at the Glasgow Exhibition of 1901), executed a neo-Gothic design (the Morozov villa, 17 ulitsa Tolstogo), taught at the Stroganov School and was president of the Moscow Architectural Society (MAO) from 1906 to 1922, years that included its most turbulent period. We visited the following Shekhtel buildings:

VILLA AT KROPOTKINSKY PEREULOK 13

Built in 1901, now the Australian Embassy. Probably one of the most attractive of all such villas. All four sides of the building are of interest, not just the street elevation. The focus is inwards, towards the centre, the large internal space visible through extensive glazing on the right-hand side of the building.

APARTMENT BUILDING, ULITSA FRUNZE 13

Built in 1909, with rounded bay windows, it is grey and distinguished-looking, almost forbidding.

RYABUSHINSKY MANSION, ULITSA KACHALOVA 6/2 (illus. pp. 45
and 46)

Built in 1902. From the photographs I had seen I was expecting a
uniformly white, restful building. In reality it is brightly coloured,
enlivened by the plant ornamentation on the mosaic frieze. The
walls, moreover, are pink. The iron grilles of the balconies and sur-
rounding railings are sinuously undulating. The villa is asymmetri-
cal on all its sides and yet sits as firmly on its plot as a cube. Inside
the house the undulating line truly reigns supreme: you are borne
up or down the staircase on the crest of a wave. You wonder how
Gorky felt while he was living here from 1931 to 1936.

MOROZOV MANSION, ULITSA A. TOLSTOGO 17

Built between 1893 and 1898, stylistically almost a companion
piece to another of the Morozov villas (prospekt Kalinina 16)
which is nowadays the House of Friendship with Peoples of
Foreign Countries.

Then a meal – and a very superior one – in the House of Architects.
Here Andrei Burov, with considerable élan, modified a villa built by
Erikhson by adding a quotation of Renaissance motifs. In the foyer
there are exhibitions and a variety of amenities for members of the
Union of Soviet Architects. Outside, in front of the building, a bust of
Shchusev that truly captures the likeness of the man, a Russian with
Tatar blood: the round, bald head, the vigorous features which really
show us what he was, one of the architectural General Staff directing
the reconstruction of Moscow.

THE LEVINSON PRINTING WORKS IN TRYOKHPRUDNY PEREULOK

(Incidentally, the Tsvetaevs – the father was founder and director of
what is now the Pushkin Museum of Fine Arts, his daughter the poet
Marina Tsvetaeva – lived at Tryokhprudny pereulok 8.) The house
puts you in mind not so much of a printing works as of an English
villa with Gothic oriel windows. It is colour-washed in green all over,
and the original front door is still in place, though varnished red. The
lane is in a district where there are buildings that represent the *dernier
cri* in more or less every architectural fashion of the period.

Utro Rossii newspaper building, detail of the façade, architect F. O. Shekhtel, 1907.

Proezd Skvortsova-Stepanova 3, directly behind the Rossiya Cinema on Pushkinskaya ploshchad. Built in 1907. A very different aesthetic programme is in evidence here. Unplastered clinker brick, very large windows admitting a maximum of light – an expression of bourgeois thrift and decisiveness. Other buildings that point in the same architectural direction, which one might call proto-Constructivist or proto-Functionalist, are the Ryabushinsky Brothers' Bank (ploshchad Kuybysheva 2) on the old Stock Exchange square, and the Moscow Merchants' Society building on the corner of Maly Cherkassky pereulok and Novaya ploshchad, in which there is now a cafeteria. Another building of this kind is the Stroganov School apartment house on what used to be Myasnitskaya (now ulitsa Kirova 21). All these buildings are captivating in their clarity of design, the quality of the materials and their stylishly rounded corners and door and window surrounds. They were quite evidently commissioned by people who had no need of ostentation and had left far behind them the tasteless excesses of the parvenu.

The courtyard of the Stroganov School apartment house (which at the time was in the midst of the banking and business quarter) opens on to a small square, a piazza with trees and a children's play area, a haven of tranquillity. The noise of the streets is distant, muted. You are in the heart of the city and yet sheltered from it. Such places cannot be planned, they have grown naturally. They are not relics of the uncontrolled development of pre-urban times, but the product of urbanization, the expression of a city's maturity.

Fyodor Shekhtel is buried in the Vagankov cemetery.

To round off the tour, coffee with cognac in the Rossiya's roof-level restaurant. Perhaps from here we may obtain a view that will lead us on to the Socialist Forum.

6 Buildings that were never built

*It is not just what was built that is interesting,
but also what was not – A revolution in architecture
and urban planning.*

Our picture of a city does not derive only from what was built –
we can often learn more from what was *not* built. Projects that
have actually been executed give us only a bare, unexplained out-
come, with few traces remaining of the conflicts that accompanied
its achievement. Plans and projects are a kind of foil against which
the finished product stands out, the solid core that remains when the
process is complete.

There is a design sketch by Ivan Leonidov of the building for the
People's Commissariat for Heavy Industry, one of the schemes that
were intended to bring fundamental change to the face of Moscow.
This building was among those commented on by El Lissitzky in his
discussion of the projected Red Socialist Forum, which was to have
the Kremlin at its centre. Leonidov's sketch shows a slender struc-
ture, a tower some 300 metres tall on a square ground-plan, and next
to it a companion tower, slightly less tall and round in section, rather
like a slim but enormously high cooling tower. In front of it – empha-
sized by the angle chosen for the drawing – St Basil's Cathedral
enters the picture with its profusion of domes and onion towers. The
exotic centrepiece of old Moscow has become, so to speak, a quota-
tion mirrored in the steel and glass skin of the elegant giant.

Although the project only dates from 1934, the drawing gives an
impression of how the city might have looked if the line of develop-
ment that had crystallized so impressively, starting in the early
1920s, had won through and been generally taken up. Instead of
being a massive range of stone crags with their peaks warmly gilded
by the sun, Moscow might now be a futuristic metropolis of steel,

58

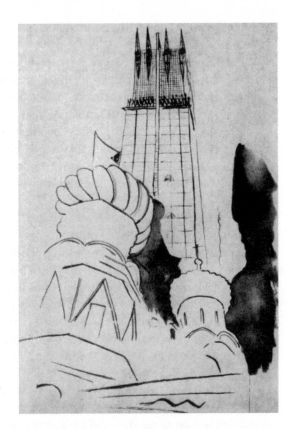

Ivan Leonidov, sketch for the People's Commissariat for Heavy Industry building on Red Square, perspective with St Basil's Cathedral, 1934.

glass and concrete. For it would not have been just in this one location – on the side of Red Square nearer to the Moskva – that the city's skyline would have towered up into the heavens in an enormous but elegant convulsion, but in many other places too.

On ploshchad Revolyutsii, on the site in the thick of the traffic where the Hotel Moskva now stands, the Palace of Labour was to have been built. For Lubyanskaya ploshchad a skyscraper was planned, to house the Supreme Council of the National Economy. On the Lenin Hills, on the site now occupied by the Lomonosov University, an Institute for Marxism-Leninism was to have stood, or rather to have hovered in the air, judging by the project model by Leonidov. On Kalanchevskaya ploshchad a Moscow central railway station was envisaged, while in various districts there was talk of building vast covered markets in the spirit of the times: incredible miracles of glass with skeletons of steel. And in the centre, on the apparently unremarkable site at present occupied by the Moskva

open-air swimming pool, the country's supreme building, the Palace of Soviets, was to be built.

'What ifs' and 'might have beens' make for interesting speculation, and have always served as convenient arguments for explaining away an awkward past. However, it is essential to keep to what was actually carried out, and to decode that to see how much of an original idea or dream was preserved. Then it becomes legitimate to ask, for instance, how far El Lissitzky's concept for 'horizontal skyscrapers' supported on piers above the city's main traffic inter-sections was carried over into the high-rise buildings commissioned by Stalin.

It is worth pausing a while over 'what if?' – not asking the direct and fruitless question, 'What would Moscow be like now if the lead-ing exponents of Constructivism and Functionalism had succeeded in shaping the city in their image?', but giving it a slightly different emphasis. Moscow, as it presents itself to us today, is not only an out-come, a result, as suggested earlier, but also a fact, in the literal sense of something done or made. It was given a particular shape, made in a particular way, in opposition to something else. Our glimpse of that other Moscow, the Moscow of the 1920s, not only remains fasci-nating and significant in its own right, but also serves to dissolve the solidity of the 'fact', revealing which forces won through and which had to give way. The solid certainty of the city as we now see it was, for the generation of the day, still in flux; for them, the space was not yet enclosed but wide open. It is no easy matter to take the mass of solid stone that we have before us today and retrospectively set it in motion once again.

Moscow's architects and planners never thought in terms of this or that building, this or that square in isolation, but were concerned with the whole picture. If we look at the projects and the debates of those days about what the capital city of the new society should look like and how it should be built, we scarcely know whether to feel intimidated or attracted by the planners' boldness. Certainly there would be little left of the city as we know it today. That would undoubtedly have been the effect of Le Corbusier's proposal of 1930, for instance, to replace Moscow's radial ring system with a rectangu-lar grid. The same is true of Ladovsky's structural plan to transfer the administrative centre to an ellipse around the periphery, and to break up the city into residential, industrial and green areas along a central axis open in one direction. And these are probably the most

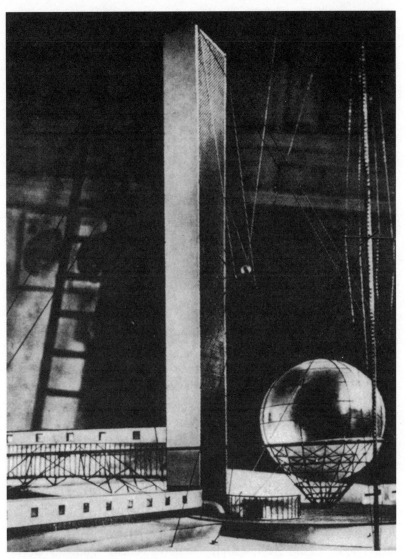

Ivan Leonidov, Lenin Institute, model, 1927.

'For the Russian, on the other hand, technology is a collective concept, an abstract idea which he adheres to even when it affects him personally, his house, his workshop. The technology is the prime concern, the accommodation only a secondary attribute. So great is his reverence for the new world of technology that it becomes interlinked with his political beliefs. In the project for a Lenin Institute the auditorium in the form of a globe, planned to seat 4,000, and the library tower designed to hold 12 million volumes symbolize the conception of the world that underlies his revolutionary credo.'
Erich Mendelsohn, *Russland, Europa, Amerika*

N. Ladovsky, scheme for the reconstruction of Moscow, early 1930s.

'All big cities in the world are constructed according to one and the same plan. Everything for the centre and next to nothing for the periphery: properly surfaced roads, lighting, drainage, a water supply, parks, theatres, cinemas, reading-rooms – everything is located in the centre, the spiders at the centre of the web suck in all the vital juices of the populace. And the working-class districts in the suburbs remain almost impassable for vehicle and pedestrian alike, unlit, neglected just as they were half a century ago. Only the power of the proletariat is capable of bringing radical change to the way that cities are built.'
L. S. Soznovsky, *Deeds and Men*

moderate of the schemes that featured in the debates around 1922 and 1929 – more extreme concepts like Kazimir Malevich's 'cosmic cities' and Georgi Krutikov's 'flying city' were also actively under discussion.

The controversies about the new socialist city were not concerned with matters of detail but with the status of the city as such. This had been coming under fire from two directions ever since the emergence of Ebenezer Howard's idea of a garden city and Marx's call for an end to the separation of town and countryside. All the radical proposals for Moscow would probably have deprived the historic centre of its functions and turned it into a pure museum, with new life flowing around it but no longer filling it. Moscow was spared the fate of becoming a second St Petersburg. Its existing layout stubbornly resisted change. The city was already too solid and

established to succumb to the kind of architects employed by Catherine the Great to draw up her chessboard colonial towns, such as Rostov on the Don.

The General Plan of 1935 effectively accepted as its starting point the structure that had grown up historically. But this acceptance was reached via the wide-ranging debates and arguments – embracing experiments both practical and fantastic – of the preceding years. If one concedes, however reluctantly, that the 1935 General Plan probably struck a happy medium between conservation of the legacy of the past and changes that were essential, this is not to overlook the advanced thinking of the Soviet avant-garde. Many of their criticisms of capitalist urban development and the novel alternative solutions they produced are still extremely topical and controversial today. The 'green city', traffic calming measures, intersection-free traffic flows, the creation of ensembles as opposed to individual buildings, the integration of production and leisure – these were some of the ideas they were working on, at a time when the concept of the 'inhospitable city' had not yet been invented.

But were the 1920s really a time when making a clean sweep was the order of the day? Did they not also continue earlier trends from the pre-war and pre-Revolutionary era? There is evidence that they did. The design for the Arcos Insurance Company building by Aleksandr Vesnin, the leading figure in the Constructivist school, owed much, both technically and aesthetically, to Fyodor Shekhtel's *Utro Rossii* building or Ivan Kuznetsov's Business Court. 'Red classicism' modelled itself on bourgeois neo-classicism. And even in projects for buildings with a social function, factories, schools, workers' clubs – where a new architectural environment was intended to give rise to the new man, as part of a revolutionary transformation of a whole way of life – one can follow the trails back in time to the 'People's Houses' in Moscow or St Petersburg, mostly paid for by bourgeois patrons (for instance the Shanyavsky People's University), and to the structures showing the extremely advanced engineering that Russia could already boast before the war.

Even though the stamp that Moscow bears today is not that of the architects of the 1920s, and that decade is remembered as a time of transition, this does not mean that it has vanished without trace. The Constructivist era is one of the great discoveries to be made in this city. Though not always well preserved, it can be seen better here than anywhere else; nowhere were more buildings created in this

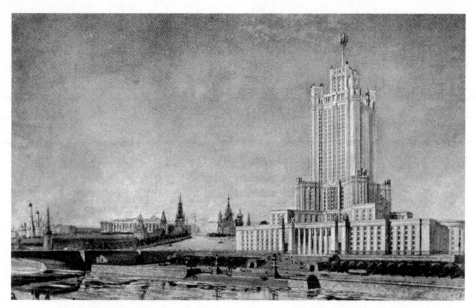

High-rise building in Zaryade, project design by D. Chechulin, 1948 (not executed).

style than in Moscow, Leningrad and Kharkov. In Kharkov one can still stand on the square partially surrounded by the House of State Industry complex and gain an impression of what a 'Constructivist city' might have looked like.

Where in Moscow are these traces to be seen? Topographically speaking, on the fringes of the present-day centre, in the old and reconstructed workers' districts surrounding long-established factories, and in various buildings with a social function: factory and institute buildings, factory kitchens, workers' clubs, department stores, public baths, stadiums, official buildings, communal housing, government apartment blocks and whole working-class districts. Wherever they are found, they stand out from their surroundings because of a quality that I have always thought of as 'openness'. Large, unembellished surfaces, big and plentiful windows, restful proportions and a felicitous combination of curve and right angle. But they are isolated, unconnected to each other, and no place in the city is dominated by them. Considering them collectively one can already recognize the stereotype of this style that never set out to be a style; if they were all gathered together in one location, they might well create the image for which these pioneers of Soviet Modernism were later condemned, that of an 'architecture of boxes'. So although

64

the projects were boldly conceived, the architects of these buildings confined themselves to slotting them modestly into existing gaps.

It was not only the abolition of ground rent and the free run that this gave to city planners and architects that turned the Moscow of those years into a Mecca for the international architectural fraternity. If Walter Gropius, Erich Mendelsohn, Le Corbusier, Max and Bruno Taut, Ernst May and Hannes Meyer all took an interest in Moscow, many of them actually making the journey there, it was because in Moscow they found extraordinarily gifted men capable of providing inspiration for their own work: the Vesnin brothers, Aleksandr in particular, and Moisei Ginzburg, Nikolai Ladovsky and Konstantin Melnikov, Vladimir Tatlin and Ilya Golosov, Nikolai Miliutin, Ivan Leonidov and Vladimir Krinsky. The reason they were able to engage in a fruitful exchange of ideas is that they all faced the same problem: the contradictions that had developed in cities under capitalism. This is not only true of political sympathizers, such as the November Group associated with the Bauhaus. There is a connection between Mies van der Rohe's design for the *Chicago Herald*

People's Commissariat for Heavy Industry building, model, design by the Vesnin brothers, 1935–36.

Tribune building, which was displayed at the Moscow Architectural Exhibition in 1927, and the designs by Soviet architects for the *Izvestia* building and the Moscow headquarters of the *Leningradskaya Pravda*. There was a common point of departure for the ideas of, say, Bruno Taut, who designed the housing developments in Berlin's Prenzlauer Berg and around Onkel-Toms-Hütte in Zehlendorf, and the new Moscow workers' districts in the Sokol and Dangauerovka suburbs, ulitsa Usacheva and ulitsa Shabolovskaya.

And yet there is a difference that should not be overlooked. The problems of the chief cities, Moscow and Leningrad, were only a few among the many problems facing Russia as a whole. The dilemmas resulting from urbanization were less pressing than those that needed to be overcome in the course of creating new urban centres. Constructivism gives the city a subtle touch of something that is alien and yet seems to belong, but that plays only a minor role despite the distinctiveness of its forms.

If Gogol is right in saying that architecture is a 'chronicle in stone' of the life of a society, then this architectural phase may be seen as marking a transition. The factors that brought about the end of the VKhUTEMAS experiments are the same as those that put an end to the New Economic Policy. Moscow and Leningrad are not Russia. The Russia of the NEP was a land composed of six extremely divergent forms of production, according to Lenin's analysis, and the strong hand that led the country towards industrialization and the destruction of the village did not spare the scattered products of avant-garde experimentation.

7 The shadow of an imaginary tower

The storming of heaven, and power in a quandary –
The antecedents of the Moskva Swimming Pool.

There are buildings that cast a shadow even though they were never built. Most people, on first discovering the Moskva open-air swimming pool on Kropotkinskaya naberezhnaya – almost in the centre of the city, and open both summer and winter – view it as the pioneering achievement of a form of town planning that, instead of creating a landscape of stone that is hostile to human beings, offers them physical exercise, nature, sunshine and fresh air. You can see the vast circle of the pool when you look down from ulitsa Volkhonka, and it is truly central, being only a few steps from the Pushkin Museum, hardly more from the Borovitsky Gate of the Kremlin and easily reachable by metro, using the Kropotkinskaya station. The idea of swimming in winter in the heart of an icy, snow-covered city, enveloped in clouds of steam that billow across the street, has something boldly fantastical about it, almost like deciding to pull down the Wall Street banks to make room for kindergartens. But in fact this huge round pool was merely an expedient. Where nowadays the little dots of the swimmers' bathing caps are lost in the swirling steam, it was originally planned that the new, overwhelmingly vast, indeed monstrous centre of Soviet power, the Palace of Soviets, should tower into the heavens. The plan was never realized, and although the cause was not a confusion of languages like the one that halted the building of the Tower of Babel, the course of events leading to its abandonment was not wholly unlike the failure of that earlier heaven-storming enterprise.

The Palace of Soviets (illus. pp. 68–9, 73) was not the first architectural project intended as a conspicuous symbol of the new society.

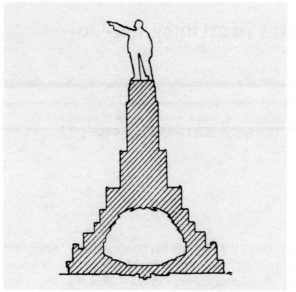

Palace of Soviets,
cross-section.

Tatlin's tower for the Third International and the Vesnin brothers' design for the Palace of Labour had achieved legendary renown in the early 1920s. For his tower, Tatlin envisaged three storeys rotating around a vertical axis and stacked one on top of another, all of them contained within a skeleton structure that spiralled around the outside; the overall height was to be 400 metres. This building never had a chance of being realized, but all over the world in the 1920s its combination of imaginative technology and revolutionary romanticism set the brains of architects in a whirl. The Vesnin brothers' Palace of Labour design, submitted in 1922 as a project to mark the founding of the USSR, made a comparable impact. Transparency, strict functionalism and the avoidance of all superfluous ornamentation – these were the watchwords of the fathers of Soviet Constructivism.

In 1931, when the so-called Great Leap Forward of the first Five-Year Plan was well under way, the idea of creating a congress building of imposing magnificence was taken up once again. The history of that project has been thoroughly researched by Anatole Kopp, Antonia Cunliffe and Soviet architectural historians. An architectural competition was announced, and the successive phases of it read like a condensed history of Soviet architecture – from Constructivism to neo-classicism, from modest functionalism to the

W. Gropius, design for the Palace of Soviets competition, 1931.

In the planning workshop for the Palace of Soviets in ulitsa Lenivka, 1934.

grandiose and overbearing style that, for want of a better name, is known as wedding-cake architecture.

The competition, organized by a committee with the somewhat Byzantine title of the 'Palace Building Committee' and headed by one of Stalin's most loyal collaborators, Molotov, was to be run over four rounds. The wording of the competition announcement was sufficiently vague to offer scope to the various rival movements. The functions of the building were defined as follows: it was to house the government but also provide a cultural centre; it was to be the venue for congresses and for sessions of the Supreme Soviet, but also for theatre and concerts. It was to have two congress halls seating 6,000 and 15,000 respectively, and four further conference rooms each seating 500. Aesthetic guidelines were kept to a minimum: the building must be monumental and of outstanding design, and must fit into Moscow's urban landscape.

The composition of the jury that framed the terms of the competition and which met in June 1931 is surprising. Of its twelve members, only three were Russians and the rest foreigners, among them some illustrious names: Le Corbusier and Perret from France, and Gropius, Mendelsohn and Poelzig from Germany. Of course the spirit of the 1920s had not yet quite disappeared, and lines of communication between Moscow, Berlin and Paris were still intact. Le Corbusier, Mendelsohn and Gropius not only entered competitions but were able to do a certain amount of building in Moscow. Among the Russians on the jury were Ivan Zholtovsky, a former member of the St Petersburg Academy and a Palladian, and Boris Iofan, a Rome-trained neo-classicist of sophisticated taste. So far, everything seemed open and undecided.

The response to the first open competition was overwhelming: around 160 designs were submitted, 24 of them by foreign architects. However, the contest was not wholly the province of professionals: a further 112 designs came from interested non-professionals, both blue- and white-collar workers, unknown brigades acting on their own initiative. In August 1931 the designs were put on display for public consideration. The whole phalanx of the schools still in existence at that time – the Rationalists, the Constructivists, the advocates of proletarian architecture – and the most eminent architects all took part, for it was clear to everyone that the design for the country's 'Supreme Building' would set the course for the future, determining architectural taste and perhaps even deciding the fate of

individuals. And the concepts and forms were accordingly varied: there were traditionalist solutions which borrowed from the Castel Sant'Angelo in Rome or the Doge's Palace in Venice; there were overtly symbolic compositions – a ground-plan in the shape of 'one-sixth of the earth', a designation given to the USSR at the time; there were plans that reflected a desire for the Palace of Soviets to remain open as a forum of the nations and which therefore used space in boldly innovative ways, working with movable walls, open amphitheatres, galleries, balconies and other means of access to the centre of power; and there were straightforwardly monumental designs which conceived of the building as a unified complex.

However exciting the ins and outs of the four rounds may have been, however difficult it was to reach a decision, on 5 May 1933 the Palace Building Committee resolved to accept the design by Iofan: a circular structure rising in four stages, each narrower than the one below, to a height of 220 metres, with colonnades ranged in front of it. Or, to be more accurate, this design was taken as a basis for the further development of the project. There must have been something about it that left the commissioners of the Supreme Building dissatisfied and troubled. Was it that the height was to be only 220 metres, while other countries could boast an Eiffel Tower measuring 300 metres and an Empire State Building measuring 381? There is no mockery implied in this suggestion. For the fact is that from the very outset the Palace of Soviets project was under enormous pressure to compete.

As far back as 1922 the ill-fated Sergei Kirov, who did not live to see the outcome of the project, had announced with an undertone of menace that a palace of the Soviet power must have nothing in common, even in its outward form, with the parliamentary façades of a world that was now in terminal decline. In architecture, as in other spheres, the workers' and peasants' state, despised as backward, must assert itself against the bourgeois West: there must be buildings 'such as our enemies cannot even dream of'.

In the early 1930s there was a direct rival – the League of Nations Building in Geneva. This, however, was often disparaged at the time as a parliamentary and pacifist talking-shop. The Palace of Soviets should, and must, be something quite different. But what? It is an achievement – if a dubious one – of the competition that in the course of it an understanding was arrived at of what architects should understand by Socialist Realism. The statements made on the

subject were fairly diffuse and couched largely in emotive terms. But people knew what and who was meant, or to be more exact, they knew what Socialist Realism should *not* be. During the competition controversy raged, and the architects who came under fire were soon no less on the defensive than the left-wing opposition, which had long since been forced to quit the stage. The style, it was said, must be 'national', even if this was only defined in negative terms: not modern, not modernist, not like the Bauhaus in Germany or VKhUTEMAS in the Soviet Union. 'Modernism' and 'Constructivism' had acquired a connotation of being non-national, rootless, cosmopolitan, intellectualist. Furthermore, it should be 'proletarian', though this was even more difficult to define, for it was precisely the 'left-wing' Constructivists who had contributed most significantly to the development of a markedly rational, functional and yet imaginative style of building dedicated to the service of the workers, and who had protested vehemently against pomp and extravagance. Lastly, there was the demand that it be 'monumental'. And since this notion was primarily quantitative, it could be translated into buildings of immeasurable vastness.

In the meantime, the unrealistic expectation of completing the Palace of Soviets within the current Five Year Plan had been abandoned. At the meeting of the Palace Building Committee on 10 May 1933 Stalin suggested that Iofan's building should be topped with a statue of Lenin far taller than the statue of the 'Liberated Proletarian' envisaged by the architect. Iofan was instructed, together with the architects Shchuko and Gelfreikh, to produce the definitive design by 1 January 1934; the whole edifice was to be virtually double the size originally planned.

The Palace was to be no less than 420 metres high, with a total volume of 7.5 million cubic metres. According to Kopp, the large conference hall in the podium was to seat 21,000 people. The palace was to be crowned by a statue of Lenin more than 70 metres tall. A passer-by would have to be an enormous distance away to take in even a portion of the building. And there was provision for this: the Palace was to be surrounded by a vast level area with imposing approaches, parade squares and triumphal arches.

There does seem to have been a definite purpose behind all this. Anyone coming here to attend a conference would feel, before he even entered the building, a shudder of awe at its sublimity. Any delegate raising his hand to vote would know that he was consigned

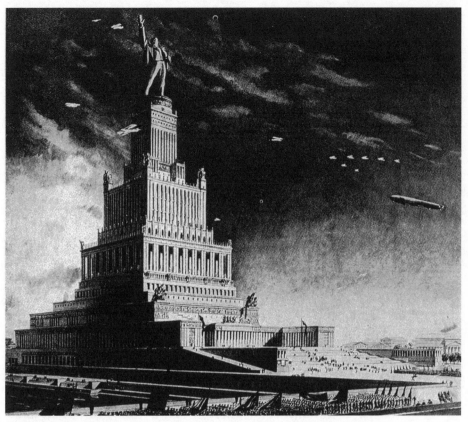

B. Iofan, V. Shchuko and V. Gelfreikh, design for the Palace of Soviets, 1934.

to the mere pedestal of a gargantuan symbol fashioned in concrete and granite. The building has about it something of an artificial mountain landscape, or a prehistoric tomb. Even what made little sense was still calculated to have an impact, for in what direction could the Revolutionary leader – positioned over 400 metres high, and hidden from the eye of mere mortals by a blanket of cloud – point the way, other than onwards and upwards to the clear blue sky and the twinkling stars? Even at the time, Igor Grabar, a high-ranking cultural official, made the cautious comment that it would probably not occur to anyone to place a sculpture by Michelangelo 400 metres from the ground. But the Palace Building Committee had its reasons for elevating the earthly leader of an earthly revolution into the realm beyond the clouds. And no doubt it also knew the effects that giant buildings of this kind can achieve. Gogol, better known for

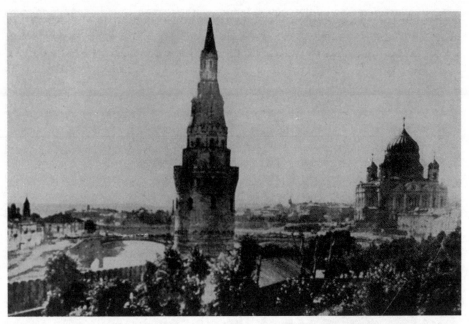

Cathedral of Christ the Saviour in Moscow, before its demolition in 1931, viewed from the Kremlin.

his novel *Dead Souls* than for his thoughtful commentaries on architecture, expressed something of the secret of buildings that burst the bounds of all human dimensions: 'Mighty, colossal towers are indispensable to a town . . . Not only do they afford an impressive sight, but they are necessary in that they act as lighthouses by which people can orientate themselves.' And again: 'They are even more essential in capital cities as points from which to view the surrounding area.' And finally, the aspect with which the Palace Building Committee must have been familiar from its own experience: 'The building should soar to an immeasurable height, directly above the observer, so that he stops short, struck with sudden amazement, his eyes hardly able to take in its whole height. People should stand close to its walls, their smallness intensifying its grandeur!'

Accordingly, at the plenary meeting of the Union of Soviet Architects in 1939, Arkady Mordvinov, one of the leaders of the group who favoured Stalin's preferred style, was effusive in his praise of that 'supremely ambitious' design, which had ultimately been achieved thanks to the wise intervention of the Party. His remarks ended, as was then customary, with a call to acclaim 'our

great and wise Party' and 'our leader, the great Stalin'. The minutes record: 'Thunderous applause, standing ovation'.

Elderly residents of Moscow can remember the start of the building work in 1939. Still older residents remember what preceded it: the demolition of the bombastic Cathedral of Christ the Saviour, which, occupying such a central position, stood in the way of this project that was of such prime importance. Then as now, Soviet art historians deliberately played down the artistic value of that building, writing only of *petit-bourgeois* kitsch and pomposity. In fact, this church was one of the emblems of Moscow right up to the 1930s; it was begun after the defeat of Napoleon, and took almost half a century to build. With its Byzantine-Russian splendour and its vast size – it could hold 10,000 people – it became a symbol of the Slavophile national awakening of Russia. Before 1930 there was hardly a picture postcard on which its dome could not be seen. Now it was demolished in a very short time indeed, demonstrating yet again the superiority of state planning – at least in the view of the former head of the Dessau Bauhaus, Hannes Meyer, who was staying in Moscow at the time. He remarked that in Geneva the search for a site for the League of Nations Building had taken four years, whereas in Moscow the choice of location had been settled within four weeks.

Here it is worth pausing and leaving 1930s Soviet history for a moment. Orthodox believers were certain even then that the demolition of that mighty House of God would not go unpunished, and God-fearing people today will still tell you that the failure of the Palace project must have been God's revenge for that crime against His church. Now, while we cannot investigate the content of such testimonies, we can look at the astonishing parallels that exist between the construction of that vast cathedral in the nineteenth century and the plan for an even more vast Palace of Soviets about a hundred years later. The history of the building of the cathedral seems in many ways to anticipate that of the Palace of Soviets project.

The fire that destroyed Moscow in 1812 also sealed Napoleon's fate. Russia appeared as the vanguard of the European movement of liberation against the conqueror and dictator, and with the enlightened Tsar Alexander I a new age seemed to be dawning. This period of new national self-awareness, of Romantic cosmopolitanism and inner ferment, clamoured for self-expression, with Russia in the role

of Europe's saviour from the monster who had betrayed the ideals of the French Revolution. This vision of hope and the dawning of a new age must be embodied in stone. Alexander I announced a competition for a memorial church, and Aleksandr Lavrentevich Vitberg was probably the architect who came closest to realizing the idea. The location favoured by Vitberg was Moscow's highest point, the Sparrow Hills – now the Lenin Hills – and the complex, consisting of three churches built one above another, was to symbolize the union of body, mind and spirit. We know a good deal about the project and the artist, Vitberg, from the memoirs of Aleksandr Herzen, who met Vitberg later when he was in exile in Viatka. In *My Past and Thoughts*, Herzen writes:

> Could any better place have been found for a temple commemorating the year 1812 than this, the furthest point of the enemy's advance?
>
> But not only that, the hill itself was to be refashioned to form the lowest tier of the temple – with a colonnade enclosing the ground descending from there to the river – and upon this base, three sides of which were formed by Nature itself, a second and a third temple were to be built, all three together creating a wonderful unity. Vitberg's temple, like the central doctrine of Christianity, was to be threefold and indivisible. The lowest temple, cut into the side of the hill, was in the shape of a parallelogram, a coffin, a human body.
>
> Above this tomb, above this cemetery was the second temple in the form of a Greek cross, its equal arms reaching out in all four directions: this would be the temple of outstretched hands, of life, of suffering, of work.
>
> Above it, crowning it, completing and perfecting it, was the third temple, a circular building. This temple, flooded with light, was the temple of the spirit.

But nothing came of Vitberg's project; that sensitive and subtle artist was brought down by court intrigues and forced into exile. However, his fall and the consequent abandonment of his project reflected a political shift that had taken place between the reign of Alexander I and that of Nicholas I: internally the Decembrist revolt had been suppressed, while abroad Russia, as part of the Metternich System, was beginning to act as what Marx termed a 'bulwark of feudal European reaction'.

When, under Nicholas I, work began in 1839 on the building of the cathedral, it already bore the stamp of the new administration.

Romanticism had been replaced by the Empire style, the gentle breeze of cosmopolitanism had been swept away by the fierce wind of 'nationality', and Vitberg had been succeeded by that master of a sometimes too insistently grandiose Empire style, Konstantin Andreevich Ton. The buildings designed by Ton that were erected over the next 50 years are characterized thus by Herzen: 'Without faith and without special circumstances it proved difficult to create something truly alive; all new churches bore the mark of artifice, insincerity and anachronism, like those five-part cruet sets that Tsar Nicholas and Ton built, with onion towers in the Indian-Byzantine style where the stoppers ought to be.'

What can be said about the Cathedral of Christ the Saviour, completed in 1883, is therefore, briefly, this: that the switch from Vitberg to Ton and from Romanticism to Empire reflects the shift from the reign of the enlightened Tsar Alexander I to the reactionary era of Nicholas I. Whatever problems the ideological aspect of the project brought with it, its sponsors had enough power and energy to realize their idea. This was not the case with the political overseers of the Palace of Soviets project, to whose story, by no means complete, we will now return.

The 'heaven-stormers' started their work, as we have said, in 1939. Barely two years later the construction process was interrupted by the invasion of the Soviet Union by Hitler's armies. There were now more important uses for steel, concrete and labour, and these were redirected to the front. But the plan was not abandoned, only deferred. Right up to 1957 the metro station closest to the site was called 'Palace of Soviets'. Around that time a sense of uncertainty must have crept in: the supreme builder had died in 1953, and cautious hints began to be voiced that perhaps rather than a palace it would make more sense to build some good solid housing, as Moscow was bursting at the seams. There was some equally cautious criticism of false pomp and the pointless, over-elaborate and above all expensive 'wedding-cake' buildings. In 1956, at the twentieth Party Conference, Khrushchev gave the first cues for 'destalinization'.

Building work at the Kremlin and on the bank of the Moskva was not resumed. Even within the logic of Soviet dialectic it was not so much the war that restrained the 'heaven-stormers' but rather the climate of reflection and self-questioning that followed the death of

the supreme builder – for ultimately it is 'internal contradictions' and not external ones that, according to dialectical logic, are the decisive ones. The argument that the groundwater level and the nature of the ground itself on the bank of the Moskva would not have 'tolerated' a building of such massive dimensions also looks like an afterthought, for normally the structural engineers calculate these things before building work starts – though of course it is doubtful whether the now deceased Father of the Nations would have been swayed by empirical arguments.

The idea itself did not immediately die; it had always managed to maintain its hold, given that the project was, after all, a test of the superiority of the system; a proof, in a sense, of the Union's own unassailable identity. Nevertheless the new leadership freed itself of the burden of enormous expectations, and discarded much ideological ballast. The choice of a new location alone was an indication of this. For the competition which was held between 1957 and 1959 the focus was shifted away from the centre, avoiding proximity to the historical core of the city, which Stalin had been so determined to put in the shade. Now the Lenin Hills, where the towering University building already stood, became the chosen site. Still more significant was the aesthetic distancing evident in the designs that were submitted – it was almost as though they could not get far enough away from the style of the Stalinist era that was now past. Nothing in these new designs recalls the earlier aim of symbolically embodying the future. They are almost indistinguishable from the Sports Palace or the pavilion for the World's Fair. But these plans too came to nothing. No doubt the new masters did feel in the end that the location, far away on the hills on the other side of the Moskva, was too remote to be acceptable.

What now ensued may probably be seen as the end of the original project, even if it was not a resounding finale. The architects were instructed to withdraw inside the walls of the Kremlin. Within two years, from 1959 to 1961, the Palace of Congresses took shape here, parallel to the north-west wall; it is a building of concrete, steel and glass which hides its uncommon size behind an undistinguished frontage. But inside the old fortress of the tsars the proportions are maintained: half of the building's volume is below ground level. This Palace of Congresses is familiar to every Soviet man, woman and child, because it is from here that Party congresses and sessions of the Supreme Soviet are broadcast throughout the land. It is

equally well known to almost every visiting tourist, since it is usually here, rather than in the permanently sold-out Bolshoi Theatre, that he or she manages to see *Swan Lake* or *Ivan the Terrible*.

And here the trail peters out. Nothing survives the dramatic momentum of the early stages of the project, to recall either Tatlin's utopian but seminal design, or the brutal, massively oversized monument that was to be erected in the heart of the city. Normality reigns, even if it only serves to mask an embarrassing failure.

But is there really no trace? Must not a building with which people so desperately identified themselves for almost thirty years have left some traces etched more deeply into the face of the city?

This question is not merely rhetorical. There is a trace, far more lasting than the swimming pool now situated where the foundation pit was once dug, far more impressive than the Palace of Congresses in the grounds of the Kremlin. But in order to gain a view of it you have to retreat some distance away. To measure the mighty shadow cast by a gigantic building you must step outside that shadow. The numbing effect produced by huge buildings is dispelled only by increasing distance. On this matter, too, Gogol had something to say: 'Let a person take up position at a great distance, and at once he will look down from above, and with great condescension, at the objects before him.' And there is a viewpoint like that: the platform up on the Lenin Hills, high above the Moskva. As anyone who has been there will testify, the panorama is 'magical'. In the distance there is the gleam of the golden domes of the churches in the Kremlin. Immediately in front of the viewer, on the opposite river bank, is the vast oval shape of the Lenin Stadium. Turning 180 degrees, he will discover behind him the curiously impressive mass of Moscow State University, standing 260 metres tall on the highest point of the Lenin Hills. The observer of this panorama, who of course has not come here wholly without knowledge, senses that he must be standing on some hidden line of intersection. He looks for some aids to orientation. The objects that catch his eye and direct his gaze are the seven high-rise buildings conspicuously towering up from Moscow's sea of houses; arranged like the points of a star around the edge of the city centre, they have entered architectural history as the supreme examples of the 'wedding-cake' style. They must be linked by a more intimate relationship than their stylistic kinship alone suggests. And indeed they are: the seven tower blocks, which to this day

still define Moscow's skyline, were built at the seven most impor-
tant, most prominent locations in the city. They all relate to a single
focal point. But this point is not the Kremlin but the Palace of Soviets
– a point, that is, which exists and yet does not exist. What is the best
way of expressing this? What image would be appropriate? A cir-
cumference without a centre? A chord without a dominant? Spokes
without a hub? In plain language, the imaginary axes intersect at
the site of the Moskva swimming baths. The viewer's imagination,
backed up, of course, by some historical research, knows better: the
seven high-rise towers that determine the city's profile only form a
complete ensemble when the eye, sharpened by historical knowl-
edge, supplies the missing central component, that 'supreme build-
ing' which was to have been both the tallest and the greatest. From a
study of materials from the 1930s and '40s it clearly emerges that the
Palace of Soviets was intended to be the very heart of a new, recon-
structed Moscow. But in the course of the planning process a shift
took place in that relationship: although at first the Palace was
envisaged as fitting into the city landscape, the acceptance of such
a gargantuan design meant, in practice, the opposite, and required
the city to be subordinated to the Palace.

So what traces really remain of that monument to the future? I
would put it like this: the command that is relayed by the wedding-
cake towers is still there, but the exclamation mark that should
accompany it is not; nor, above all, is the commander. But for a mon-
ument that was never built, and a commander who died long ago,
even that is trace enough.

A postscript: in Lion Feuchtwanger's *Moscow 1937: A Travel Report
for my Friends*, published by Querido in Amsterdam in 1937, I hap-
pened to find a section headed 'The Tower of Babel'. Feuchtwanger
is not referring to the actual Palace of Soviets, which he surely knew
about, but uses the Tower of Babel as a metaphor, extracting a differ-
ent meaning from the myth. He writes:

> The air that we breathe in the West is stale and bad. In Western civiliza-
> tion there is no longer any clarity or resolution. No one dares to defend
> himself against encroaching barbarism with his fists or even with
> strong words, it is done half-heartedly, with vague gestures, and the
> anti-fascist declarations by those in responsible positions are sugar-
> coated and hedged about with reservations.

He then describes his impression of the USSR:

You breathe a sigh of relief when you move from that oppressive atmosphere of phoney democracy and insincere humanism to the bracing air of the Soviet Union. Here they do not hide behind mystical-sounding, hollow words: instead there is a plain, down-to-earth ethos, truly *more geometrico constructa*, and it is this ethical rationality alone which informs the plan by which they are building up the Union. So they are building by a new method, and using wholly new material. But the experimental phase is already behind them. There is still rubble and unsightly scaffolding everywhere, but the outline of the mighty building is already rising up pure and clear. It is a true Tower of Babel, but one which aims not to bring human beings closer to heaven, but heaven closer to human beings. And the enterprise is succeeding, they have let no one bring confusion into their language, they understand each other.

After all the half-heartedness of the West it does one good to see an undertaking such as this, to which one can, with conviction, say 'Yes, Yes, Yes'. I could not easily contain this 'Yes' within my own breast, and that is why I have written this book.

8 A *mise-en-scène* for the moment

The most turbulent times leave the fewest
traces behind – Décor, not rebuilding.

The years 1917 to 1920 made history, but not urban architectural
history. It was too soon after the Revolution to start laying new
foundations. But although the new society was not yet being
forged, or the city rebuilt, an appearance of such change was being
staged. For all the hunger and misery, the energies that had been
released were so powerful, even among the masses, that the
strength was there to create an appropriate *mise-en-scène* for the
victorious class. These years did not see radical transformation and
rebuilding: instead, scenery was hauled into the existing setting
and alterations were made that required great dramaturgical ability
and already demonstrated a capacity for putting on a large-scale,
theatrically effective performance. It was an impetuous, voracious
seizure of the city's squares and public places, an act of taking
possession.

Mayakovsky had a similar thought:

Stop this half-hearted complaining,
Throw off your rusting chains.
The streets will serve as our brushes,
The squares as our palettes of paint.

But first the dead and the great pioneers of the struggle were
solemnly remembered. At the moment when history was most
absent, at the very instant when revolutionaries shot at the clocks
in the church towers, halting the march of time, heads were bowed
and the fallen honoured. As early as May 1917 a competition was
announced for a monument to the dead of the February Revolution.

The dead themselves were caught up in this drive for action. They were no longer given a hasty burial, but instead lay in state before being laid to rest in a necropolis of the Revolution.

In Petrograd the Field of Mars was turned into a Cemetery for Heroes, while in Moscow Sergei Konenkov won first prize in the competition for a monument commemorating the fallen of the October Revolution. At the spot on the Kremlin Wall where the mausoleum is now situated, Konenkov's relief sculpture in coloured ceramic, with its solemn-featured figures reminiscent of the faces in icons, was set into the wall. How it must have glowed in the morning sunshine! All around, the statues of the old rulers were being toppled from their plinths, and monuments to the fallen heroes erected instead. The tomb monuments were of course designed not simply as calls to reflection and reverence but as legacies for, and pointers towards, the future. The Vesnin brothers, for example, designed a necropolis with a speaker's platform on top of it, an arrangement later used by Shchusev for his Lenin Mausoleum. The dead are not dead.

The heroes of the day also set up the first memorials to themselves. It was they who had made history: history by itself had achieved nothing. These revolutionaries, previously forced to remain underground, now chose the most visible spots in the city to build their own memorials – not that these were to last for ever, as soon became apparent. The monuments to Marx and Engels were unveiled on revolutionary days of celebration, and the whole pantheon of the working-class movement and 'progressive humanity' was welcomed into the city: Robespierre and Heine, Verhaeren and Khalturin, Jaurès and Liebknecht, Galileo and Kropotkin. The generous mood of the hour allowed them all to be given equal prominence, be they the terrorist Sofiya Perovskaya or the German Social Democrat Ferdinand Lassalle. Later, when differences within the Party had hardened into opposing lines and were projected back into the past, the commemorative granite blocks also had to be moved.

However, the difficulties faced by sculptors are not always of a political nature. The Cubo-Futuristic sculpture of the anarchist Mikhail Bakunin on ploshchad Lermontova, bearing the inscription 'The passion for destruction is also a creative passion', was to be officially condemned for being 'formalist', but long before that it had to be protected by railings from an unsympathetic public.

Danton monument in front of the Hotel Metropol, photograph, c. 1925.

Utopia is an abstraction. The utopian idea embraced more than the concrete thinking of the moment could grasp and deal with, and this was to be the downfall of those who saw revolution in utopian or in romantic terms. It was the organizers in charge of the Party machine, the experts in matters of detail, who would take over the leadership.

Superficial things were changed, but not the underlying structures – that would only come with the 'revolution from above'. The emblems of tsars and princes were hacked out of their coats of arms and replaced with the Soviet star. Where icons had been, there were now posters and slogans such as 'Religion is the opiate of the people'. Walls bore messages intended for everyone to take to heart: he who does not work shall not eat. And there were performances, even if they were not all as brilliant as in red Petrograd, where the storming of the Winter Palace was re-enacted, with the movements of the surging masses being directed from a platform set up in the middle of Palace Square.

84

No trace of the acoustic dimension of those public events has been preserved. Arseny Avraamov's 'Simfoniya gudkov', or 'Symphony of Factory Sirens' (and of every conceivable instrument for making whistling, honking and other loud noises), was performed on 7 November 1922 to mark the fifth anniversary of the October Revolution, and has vanished for ever into the ether. On days of national mourning, such as Brezhnev's funeral, this experience of a collective expression of emotion, with a single outpouring of music enveloping the whole city, is a tradition that is still followed today.

There were no limits to the space that the architects and artists claimed as their own: not, at any rate, in Aleksandr Vesnin's water-colour designs for the October celebrations, where airships – the symbol of an age when gravity itself almost seemed to have been abolished – float, on their cable moorings, in the air above the Bolshoi Theatre.

A photograph from that period shows a further memorial, on the square in front of the Bolshoi (illus. p. 84). It represents the leonine head of Danton, lying on its granite block as though it has been chopped off. In the background the Hotel Metropol can be seen. Or, to turn the view round: given that the first Moscow quarters of the new government team were in the Metropol, this means that any of its members who happened to look out of the window would have received a stark reminder that revolutions can put not just other people's heads on the block, but one's own.

9 Let reason reign!

*On the trail of Vesnin, Melnikov and Golosov –
In Moscow Constructivism found its first arena
for experiment – There are more survivals of the
Modernist era than one might at first suppose –
Mendelsohn, Taut, Le Corbusier, and the Moscow
of the 1920s.*

You have to have a definite plan of action, otherwise the city simply swallows you up. Nothing reveals itself of its own accord, hence the need for a second, more or less systematic tour of exploration. With time you develop a feel for what can be discovered in which parts of the city. This tour will start with its grand finale, instead of reserving it for a dramatic conclusion: it will begin at the Palace of Culture of the Likhachev Automobile Works (Dvorets kultury ZIL, Vostochnaya ulitsa 4).You receive a foretaste of it even before leaving the Avtozavodskaya metro station, provided that you choose the right way out. The tunnel through which the escalator bears you upwards is not the usual shaft but a tube that widens progressively as the ceiling gradually recedes in a series of concentric steps, until it opens out to form the vestibule area. You are already in Vesnin territory!

The very location of the Palace of Culture is significant. The idea of bringing culture into close association with production has been taken seriously here. Leaving the metro station behind, you see on your left the smooth frontage of the Dinamo works, while at the road junction opposite is the factory kitchen and dining room. Behind it, half-hidden by the surviving massive corner tower of the Simonov Monastery, you can already make out the façade of the Palace of Culture with the entrance to the theatre auditorium. First we walk around the outside of the building. Although the original project was never fully completed, one is impressed by its size: it was obviously the biggest of the workers' clubs in Moscow (significantly, the name 'workers' club' was gradually replaced by that of 'House of

Temple of the machine-worshippers, drawing by V. Krinsky.

Palace of Culture of the Likhachev Automobile Works, vestibule, architects Vesnin brothers, 1931–7.

Culture'). The ground-plan is т-shaped, though not quite symmetrical. At the foot of the т, closest to the street, is the theatre auditorium itself, a huge space with a ceiling that, once again, recedes in concentric curves corresponding to the balconies. The interior is flooded with natural light which enters through the ribbon windows. In the stem of the т, the main axis of the building, the visitor finds pillared vestibules on several floors, with tall glass walls admitting daylight on both sides. The bar of the т contains numerous rooms to accommodate the various functions of the workers' club. Culture signified not only drama groups (on the day of our visit one such group was performing Aleksandr Ostrovsky's *Guilty without Guilt*), a choral society, Red cabaret and revue, but also preparation for industrial work, literacy classes, training in organization and lastly *fizkultura*, that is, physical training and sport. On the roof of the part of the building containing the library one can see the dome of an observatory. On the side facing the park, the foyer opens out to form a semicircular glazed conservatory. The floors are connected by a kind of spiral staircase reminiscent of the linking of the floors in Frank Lloyd Wright's Guggenheim Museum in New York. Externally the complex is coherently articulated by galleries, horizontal bands of windows, and slightly projecting stairwells on the principal elevation, which introduce the kind of curves that lend a touch of gracefulness to even the barest and most severe of façades. Both of these elements – an almost classical deployment of large areas of window, and the use of horizontal curves and arcs – are to be found even in early works by the Vesnins, such as the Kuznetsov apartment house, ulitsa Kirova 15, or the Junger Bank building at Kuznetsky most 13.

The architect Konstantin Melnikov built the Melnikov House (Krivoarbatsky pereulok 10), here in the better part of the Arbat, as a home and studio for himself and his family. Just now it is obviously undergoing renovation and is hardly visible behind the builders' hoarding, but one can gain an excellent view of it from the rear courtyard of an adjacent house. It is a cylindrical building; only the entrance area is rectangular. The wall of the cylinder is pierced by several rows of hexagonal windows. I find the building rather eccentric, and am tempted to see it as an individualist's challenge to his surroundings (and indeed a photograph shows Melnikov, together with his wife, looking very much the *grand seigneur* in a fur coat and slouch hat). The windows remind one of arrow-slits. This was certainly a refuge in turbulent times, a defiant self-projection of bour-

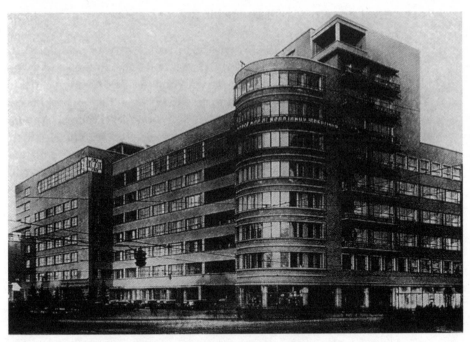

People's Commissariat for Agriculture building, architect A. Shchusev, 1929–33.

geois living in an increasingly socialist Moscow. The house was built between 1927 and 1929.

Next, the Mosei Ginzburg housing complex for the People's Commissariat for Finance, Narkomfin, on ulitsa Tchaikovskogo. The apartments are in the elongated six-storey main block, and on one side, connected only by a bridge at second-storey level, is the separate block of communal facilities containing the kitchens, kindergarten, etc. Apparently experiments were made here with movable walls, room dimensions geared to human needs and different types of lighting. In the 1930s the building was notoriously rat-infested.

Almost opposite, on the other side of ulitsa Tchaikovskogo, is another Vesnin building, the House of Film Actors, which up to 1934 was the Club for the Society of Tsarist Political Prisoners. It can be instantly recognized by its combination of box-like sections of building; after Constructivism had been elevated to a style in its own right, its use of 'interlocking boxes' was one of the features that attracted criticism, and here I think that criticism was justified. This building was also intended to house a museum of the Katorga (the system of penal labour camps established in imperial Russia), and

after the society was disbanded in the year of Kirov's murder, it was not completed.

The Planetarium (Sadovaya-Kudrinskaya 5) was completed in 1929 by the architects Mikhail Barshch and Mikhail Sinyavsky; the parabolic, aluminium-clad dome rises above an auditorium capable of seating 500 people. The stairs ascend between the outer skin and the inner ceiling. The upper floor is supported by a central column. From the main entrance it looks like the inside of a turbine.

There is another cluster of Constructivist buildings in the former business district around the junction of ulitsa Kirova and Sadovaya-Spasskaya ulitsa. Here one is struck by the Narkomzem (People's Commissariat of Agriculture building, now the Ministry of Agriculture) on Orlikov pereulok 1/11. Designed by Shchusev, it was built between 1929 and 1933. The impressive glass façade made us wonder how well suited this lavish use of glass was to climatic conditions in Moscow.

Where ulitsa Kirova meets the Garden Ring the different stylistic generations also meet. There is Shchusev's impressive Constructivist Narkomzem building, and some surviving blocks of flats overloaded with ornamentation; on the corner of Novaya Basmannaya ulitsa there is the Building of the People's Commissariat for Communications, restyled by Fomin; there is – impossible to overlook – the Krasnye Vorota administrative and residential tower block completed in the year of Stalin's death, and opposite it the pink-washed sea-shell forming the entrance to Lermontovskaya metro station, designed by Nikolai Ladovsky.

On this Sunday afternoon, ulitsa Kirova is as deserted as the city districts of Cleveland or Hamburg would be. We walk towards the city centre, and on the right-hand side, ulitsa Kirova 39, stands the Tsentrosoyuz Building (Central Union of Consumers' Cooperatives) designed by Le Corbusier and Nikolai Kolli and constructed between 1928 and 1936. From the street one cannot see why this structure, which was Le Corbusier's very first public building, should have caused such a furore. Nor can one understand why the long flank of the building, rising steeply and to a great height, is positioned so close to the road, underlining the ravine-like character of ulitsa Kirova. But Le Corbusier's intentions are difficult to discern, for the building is being restored to its original state and therefore has a wooden hoarding obscuring it. What cannot be seen from the street is that the whole central block rests on pilotis, enabling one

to look right through to the other side. At the rear an oval, roofed foyer opens to the outside, and from this side the building has a livelier and more vigorous appearance. But of course it is as impossible from here as from the front to see anything of the revolutionary interior structure. Today the building houses the Central Statistical Office.

As one continues along ulitsa Kirova towards the city centre, the street grows even narrower. Only at sunrise or sunset can the sun's rays find their way into the ravine. On the left-hand side, after crossing the Boulevard Ring, we come upon the Main Post Office. Its façade is in a style that was especially prevalent in seaport cities at the turn of the twentieth century, with a hint of exotic, Indian elements. The Vesnins were among the architects engaged here before the First World War, and they contributed to the design of the façade and vestibule. Opposite the Post Office, the dilapidated corner house, no. 21 (probably designed by Vasily Bazhenov, a leading exponent of Moscow Classicism), once housed the 'Moscow Bauhaus', VKhUTEMAS or the Higher (State) Artistic and Technical Studios.

At the end of ulitsa Kirova, in the small street immediately behind the Lubyanka Building – which incidentally also presents a mixture of Moscow styles of various periods – a striking building catches one's eye. The Dinamo Society housing complex, built in the late 1920s after plans by Fomin, is perhaps the most interesting attempt to combine Constructivism and St Petersburg Classicism under one roof: Red Doric made more sensitive by Constructivism, or Constructivism made more muscular by Red Doric.

Another area apparently used for experimentation is the one north of the Garden Ring, between the Belorussian and Riga railway stations. You can gain an impression of this district by getting off at the Belorusskaya metro station and going up Leningradsky Prospekt, heading away from the city centre. There the period that you are seeking readily meets your eye. On the left-hand side, at Leningradsky prospekt 7, is Moscow's earliest factory kitchen, dating from 1929, a modest survival amid the ostentatious façades that characterize the Prospekt as a whole. It represented a push for rationalization, for the socialization of housework and cooking, a conscious step towards the emancipation of women. The building looks like a cross between a factory and a pavilion and clearly had a rooftop dining room on its top floor; now it houses an institute for Slavonic Studies and the Moscow motorists' club.

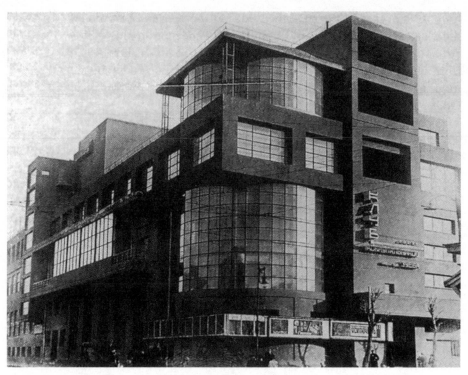

Zuev Workers' Club, architect Ilya Golosov, 1928.

A little further along the same side of the street is the 'Bolshevik' confectionery factory, which until 1917 was a subsidiary of the French confectionery firm of Siou & Co. In pre-Revolution Moscow, confectionery produced by Siou and Abrikosov was famous; nowadays the work is carried on under the auspices of a production co-operative called, in honour of the German communist Ernst Thälmann, 'Rot Front'.

Almost directly opposite, ulitsa Pravdy turns off from the Prospekt. Ulitsa Pravdy 24 consists of the old *Pravda* Building, erected between 1931 and 1937 from plans by Panteleimon Golosov, and the far bigger new building which continues the façade. The front of the seven-storey older building, though laconically simple, is once again lent grace by the continuous glass frontage, behind which are the stairwell and foyer, and by the massive elliptical roof over the entrance. The extension put up in the 1960s – when there was a reawakening of interest in the legacy of the Constructivists – is, despite the attempt to make it conform with the style of the origi-

nal building, more faceless, smoother and more conservative. The newspaper production takes place in the side wing of the old building, and through the low windows one can watch the operation of the presses – as even and regular, so it seems, as the design of the building itself.

On we go towards Lesnaya ulitsa. A pedestrian bridge takes us over the Moscow ring railway. This district is as densely built up as the industrial towns and cities of the Ruhr, such as Dortmund with its Nordstadt district. The predominant colour here is that of the warm red brickwork that you find in almost all of Russia's turn-of-the-century factory buildings. The Zuev Workers' Club at 18, Lesnaya ulitsa, built in 1928 to plans by Ilya Golosov, fits effortlessly into the street's line of frontages and directly abuts a factory building. Evidently the new architecture did not need to raze the area around it so as to impress people from a safe distance. No, this building achieves its effect entirely by itself, by its conceptual ingenuity combined with its discipline. The tension that irresistibly attracts the viewer is produced by the contrast between cylindrical and angular shapes, and between the materials of glass and concrete. The mass of the solid areas is made to seem positively weightless by the glazed cylinder which, as I later discover, forms the stairwell. The interaction between the contrasting elements has something of the perfection of a machine, but of a machine to which one feels quite willing to entrust oneself.

It is amazing how many different things are contained within the Club, which is still intact and now belongs to the Moscow firm Moslift. It has a number of theatres and cinemas; the ground floor and first floors are open, linked by the stairwell. Just now a band is rehearsing; in the evening there is to be a discothèque and the disco lights are being set up. On another visit, a children's ballet class is in progress, with the parents looking on from the first floor. According to a notice-board the activities on offer range from piano lessons and sport to poetry readings and classes in knitting and sewing. The staircase ascending to the top floor within its glass cylinder is as delicately wrought and finely curved as a seashell, but in a style that is technologically rational rather than art nouveau. The inspiration for it came not from a painter but from an engineer or a lathe operator. There is no mistaking the load-bearing function of the pillar around which the staircase winds its way upwards. And the brightness afforded by the glazing is softened only by the net curtains which, in

the old manner, are not drawn to the sides but pulled upwards on cords.

Wandering through the building, one can hear poems being recited; on the top landing, looking somewhat abandoned, stands a black-lacquered pianoforte. The piano is *the* Russian institution. What is pleasing is that every space, whether open or intimate, is on a human scale instead of having the vast dimensions that public buildings are felt to require nowadays.

A surprise in the late afternoon: the sunshine is already slanting down from the west, but a building lying like a ship tied up at a quay catches the light and reflects it back. This is how, travelling by taxi from Komsomolskaya ploshchad to no. 10, Stromynka, I am able to pick out Melnikov's Rusakov Club long before I reach it. The ship is moored at the Klub imeni Rusakova stop on bus route 42; its brightness is intensified by the snow. What sort of a building is it? Three balconies, facing in three different directions, tower up towards the sky, symmetrically arranged and all emanating from a single central point. Flights of steps at each side of the building lead up towards the balconies, and one can walk along a gallery across the façade, where the entrances and exits are. Between the balconies are panels of glazing extending the full height of the building.

But perhaps the image of a ship is inappropriate: while the prow of a ship strains forwards, the effect of the three jutting balconies is to refer inwards. The thrust of the three balconies, which are in reality only the outer casing of three huge combinable spaces, is towards the point forming the apex of the triangular ground-plan. It seems to require an exercise of strength to contain the expansion of this space and tie it to a single point.

Inside, it is the day before International Women's Day, and the *dezhurnaya*, the concierge, is in a good mood. I am apparently not the first today to want to see the auditoriums: there have already been some people from Riga. At first one can make out nothing in the dark, apart from an utterly inane American thriller of a kind that would never reach our cinema screens at home. When the light comes on one can see how the three balcony spaces could be combined with the large stalls area to form one big space, or could be separated off, according to need. The structure of the roof has been left exposed.

In designing this club, built in the years 1927–9, Melnikov envisaged a multifunctional space. The ground floor contains a large sports hall. The different levels of the club are linked by staircases

Rusakov Club, architect Konstantin Melnikov, 1927–9.

which turn the large foyer area into several individual foyers.
(Could these be the walkways and flights of stairs familiar to us from
Meyerhold's productions?)

At the end of my tour the *dezhurnaya* tells me that she has been a
Party member for 41 years and can remember very clearly when
work first started on this building. And although she was not a
pretty girl, she says, she successfully completed her first course of
dancing lessons here. She mentions in passing that Melnikov's lot
was not always a happy one. As a final gesture she gives me a big
slice of the *Prager Torte* which the Young Communists have pre-
sented her with to mark International Women's Day.

After some to-ing and fro-ing and getting lost in the district, I
went by taxi to 3-ya Rybinskaya ulitsa. There, opposite the
Burevestnik shoe factory, founded in 1924, is the Burevestnik Club,
designed by Melnikov in 1929, while a little to one side of it stands
the late nineteenth-century villa of the former head of the firm. The
two provide an interesting contrast. The most notable feature of the
club building is the almost separate glass cylinder that adjoins the
rectangular main section. The ground-plan of the 'glass tower' is
similar in shape to a Gothic rose window or a five-pointed Soviet
star. What is special about it becomes apparent only once one is
inside: five exceptionally light rooms, stacked one above the other,

95

Viktor Aleksandrovich
Vesnin.

glazed all around, and supported and unified by a central pillar. This
is spatial volume allowed to expand to its fullest extent.

But even in this space the echoes are those of a different age:
they are echoes of the pre-Constructivist world. Of course the
Burevestnik – the 'Stormy Petrel' – has sports halls, a library and
a lecture room for those interested in scholarly or scientific topics.
But the corridors resound with late Romantic chords, and little girls,
eight years old at most, with bows in their hair and ballet shoes on
their feet, come tripping down the stairs at the side of the entrance
hall. On the second floor of the glass tower the dress rehearsal for
a song recital is taking place: Rachmaninov's songs in the gypsy
style, accompanied by a man on the grand piano. In the empty hall
the singer performs to her imaginary audience, taking no notice of
the visiting stranger. Late Romantic music, still melodious, and
evoking the dignified ambience of the old upper classes, has always
been the music favoured by the new class, despite the best efforts of
the protagonists of a proletarian culture. The very term 'House of
Culture' cautiously implies a distancing from the proletarian legacy.

I became acquainted with a third club designed by Melnikov when I attended the dress rehearsal for a play by Shukshin. This was the 'Kauchuk' Factory Club, which is also situated in an old working-class district, at 64 ulitsa Pliushchikha. In the adjoining street (and easily visible from the Kauchuk Club) is the huge building of the Frunze Military Academy. This has the most rigorously severe façade one could possibly imagine – and yet the connection so often made between this 1937 building by Lev Rudnev and those designed by Albert Speer is utterly misleading, since the round section of building in Rudnev's design points unmistakably to elements much favoured by Erich Mendelsohn. The Kauchuk Club presents its rounded façade to the road junction before it. This curved façade is broken up by the vertical strips of glazing arranged at regular intervals, which admit natural light to the interior. A separate circular vestibule is set forward, close to the road, and a covered walkway leads from there to the curved frontage of the building proper. In addition, there are bridges leading from outside to the first floor. Inside the rounded club building is a theatre auditorium, with a curved back wall and three curved balconies, one above another. In the galleries and foyers there is enough room for 'individual artistic activity', as the hobbies with greater cultural pretensions are called here. Drama groups and Latin American dance enthusiasts rehearse unselfconsciously in front of visitors to the theatre. One room in the club has been allocated to students of Esperanto, and it occurs to me, looking at the plate on the door, that there was a time when membership of an Esperanto association might have led to accusations of cosmopolitanism and espionage. In the theatre it has been felt necessary to improve on the bare bones of the structure: the ceiling is now covered with painted figures framed in gold, very much in the style of the Bolshoi Theatre, except that instead of the Muses they represent workers, peasants and Young Communists.

On, in the late afternoon, to the Krasnopresnensky *univermag* (ulitsa Krasnaya Presnya 48/2), a corner building with a glass frontage facing the street. It is in poor condition, rather shabby. And because this store by the Vesnin brothers became the prototype for department stores in general, it no longer looks especially striking, since we can admire a number of other examples of this type in Moscow. This is the department store as one vast shop window.

Not far from the Donskoy monastery, at 8–9 ulitsa Ordzhonikidze, stands the Communal House, one of the most remarkable examples

of a residential complex, and one that set the tone for the debates in the late 1920s about the revolution that this type of building represented. Of course much more was at issue than merely a type of building. Just as the workers' club was supposed to supply the architectural answer to the question of precisely what form the worker's life, including his social life, should take, so for a certain period the communal residential building was intended to document, drive forward and constructively guide the gradual dissolution of the traditional bourgeois way of life. This meant the socialization of household management and also of the upbringing of children, leisure time and in the most stringent phase probably family life and sexuality too. It was the structure of this new way of life that was to be given tangible expression in this Communal House designed by Ivan Nikolaev, and this is indeed clearly discernible in the multi-storey residential section, the complex containing a recreation room, studios and a theatre, and the wing provided for cooking and laundry, which are all grouped around an inner courtyard.

Approaching the flank of the building one is rather startled by its length, which is further underlined by the continuous ribbons of windows. The building has the air of a student hall of residence or, to put it less kindly, of the type of prisons being built nowadays; I was reminded of the new wing of Berlin's Moabit prison. And my first impression was not so very wide of the mark. Today the Communal House is a hall of residence for students from the Third World studying at the nearby Patrice Lumumba University. The communal lifestyle had to contend with resistance based on both the old bourgeois individualism and the new individualism of the Stakhanovite generation. So the socialization of private life was unable to gain general acceptance and become the social norm.

How is it that when you least expect it – and on that evening it was already half dark, nothing more *was* to be expected – you suddenly sense that the weight of your surroundings, the mass of the house fronts, is dissolving, although it is indubitably there? What is happening in the atmosphere? It is simply that the interruption of the regular façade produces an effect of extraordinary lightness when one has grown accustomed to feeling crushed by the weight of overloaded façades. Here in ulitsa Usacheva, only a few steps away from the northern exit of the Sportivnaya metro station, the road is lined by a complex of residential buildings that are spaced far enough apart for you not to feel hemmed in, while being close

enough to one another to create the sense of an enclosed space. The human scale of it gives you a sheltered feeling. Only afterwards do you realize that the complex is actually very large. It is hard to define what it is that draws your attention to these simple buildings, what gives them their nobility. Perhaps it is only their kinship with the Karl-Marx-Hof in Vienna or the housing developments designed for Berlin by Bruno Taut.

In any case it was the air that blew in the district around ulitsa Usacheva that impelled me to go in search of more of the same, more from that era, in Moscow.

10 VDNKh

Beauty in dispute

Today, no less than in the past, opinions differ on what should be regarded as beautiful. The VDNKh (the initials refer to the Exhibition of the Economic Achievements of the USSR) is a case in point. What is it that draws crowds of visitors to it; what makes others pass it by? It is Saturday morning, and the VDNKh metro station is surprisingly busy; across the road, not far from the exhibition's main entrance, looms the huge semicircle of the Hotel Kosmos, a hive of activity. On Sundays, and above all on public holidays, one may be sure that the exhibition ground, with its constant trickle of music relayed by loudspeakers, is even busier than it is today. And how much more so in the summer!

In order really to enjoy yourself here, you need to be free of history, unaware of any connections or associations. Perhaps you need to be as uninvolved as if you were at a fairground, strolling among the booths with a child holding your hand, explaining to him, as he rushes from one attraction to another, that the monsters are not alive any more, only stuffed. But it is not so easy to detach oneself from the illusion that is presented here, it is too concrete, too powerful, too significant for that – not an illusion, in fact, but an anticipation of the utopia of a better and more aesthetic life. No doubt there are people, even a whole generation, a whole class of people, who find that this collection of buildings gets under their skin to an intolerable degree, or at any rate gives them a feeling that what is on view cannot all be encompassed in a single impression. You should not just stand in front of the VDNKh, you should go in!

The main entrance is a triumphal arch that must be a good 50 metres high, with five symmetrical openings between the columns;

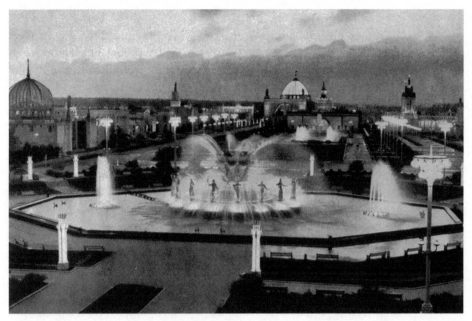

Exhibition grounds of the VDNKh, photograph from the early 1950s.

at the centre is a huge hammer and sickle and on top a man and woman holding a sheaf of corn; but instead of walking through the arcades you enter at the side, through an automatic gate similar to those in the metro. Ahead of you is a broad avenue bordered by fountains, which leads to the central pavilion. The bottom tier of this building is adorned with massive white columns, the second is a cube, and the uppermost one is topped by a golden needle; workers and *kolkhozniki* (collective farm workers) face in all four directions. Passing this pavilion, you enter a huge open space around which are other pavilions in the most varied of styles. At the centre is the gilded Fountain of the Friendship of Peoples, in the middle of which is, once again, a sheaf of corn.

The fountains have not yet started playing, and the benches are still unoccupied. One is startled not only by the agglomeration of different styles but also by the combination, the hybridization of different styles in a single building. The white columns of Moscow classicism, flights of steps like those leading up to the Pergamum altar, a little Uzbek temple containing a fountain, a northern Russian wooden house alongside reddish Caucasian granite, glazed tiles from Samarkand and constructions of reinforced concrete, ornamen-

tal motifs like those on a carpet from the Silk Road, balustrades with columns, elegant domes from the era of the glass palaces but with entrances in the form of triumphal arches, and golden mosaics inspired by the apses of Ravenna churches, but without the twelve apostles; instead, over and over again, peasants and workers, the labouring man and woman in agriculture and industry.

Today's visitor is likely to be more troubled by this than a visitor in 1939 would have been. The idea that each republic should present itself in its own style has been watered down if not wholly abandoned. Nowadays the pavilions are divided into 'Agriculture', 'Industry' and 'Science and Culture', and in between them are shops, restaurants and cafés. The original conception is visibly at odds with this change of function. It makes no sense that the building decorated with the patterns of Bukhara and Samarkand should house, of all things, the display entitled 'Soviet Culture'.

Even in their heyday, however, these buildings did not just represent the republics' own conception of their traditions and national architecture, but also the image of them harboured by the architects of the central organizing body in Moscow. Exhibition architecture is always to some extent an anticipation of the future, and no doubt here it was anticipation of the unity of the Soviet people, the great synthesis. Such a synthesis cannot simply be 'made', one can only summon up a semblance of it and leave it at that, placing one's hopes in a future in which a synthesis may gradually be achieved. My own slightly confused, even uneasy, feeling stems, I think, from a sense that there is something here that is contrived and artificial.

There is also another aspect that prompts an instinctive reaction of irritation, and that is the triumphalist message that forces itself upon you at every turn: farm women lifting sheaves of grain high into the air, workers setting driving-wheels in motion, idealized figures pointing the way ahead. There is nothing to focus attention on any objects of interest, any exhibited items: pure pride in achievement takes precedence over the actual evidence of it. This will not necessarily always have been found inappropriate. It would not have seemed disagreeable or over-insistent at a time when patriotic feelings were still running high. But people have moved on, and nowadays they will probably only be attracted by the individual styles of the different buildings and perhaps by some noteworthy exhibit – the first Sputnik, or a demonstration of the latest milking machine.

The visitor finds himself in very strange territory: he can stride past the façades of temples, or have a glass of coffee on a classical balcony where Cæsar and his retinue would not look out of place. Even a prosaic pavilion like that of the meat industry has a picturesquely bloodthirsty air: on the top, instead of the stamping hooves of four horses pulling a chariot, you see a mighty bull being restrained with difficulty by a muscular gladiator of a butcher. There is something faintly comic about the frieze of severed bulls' heads that runs around the building.

The architects had an impossible task. The laconic vocabulary of plain exhibition architecture was not acceptable, but the style of the new era was not yet mature, the language of ornamentation not yet elaborated, the national idioms not only not wiped out, but in fact only just starting to develop. How, under these circumstances, could an architect even begin to lend form to the idea?

The incongruity of attempting to evoke a 'more beautiful' future life by depicting peasants and workers as heirs to a rich and luxurious past has become increasingly apparent with the passage of time. Just imagine the juxtapositions: a temple, and beside it the rocket motors that shot the first man into orbit; the glazed dome of a mosque, and facing it a transformer station. Even at the time there must have been a palpable contradiction between the overturning of the old world, the thinking of those 'Henry Fords with Bolshevik instincts', and the retention of the old splendour. Today every crane that drives around the exhibition ground, giving the frontages their spring-clean and polishing the gold mosaics to a shine, seems like an affront to the old world. Two workmen in their hydraulic cradle reach out to grasp the outstretched hand of the *kolkhoznitsa* beside the entrance to the 'Agriculture' pavilion; they miss it, are lifted higher and start their work. The inscription, ZEMLEDELIE, has already been cleaned as far as the first 'L'.

11 Classicism and Romanticism

The estate owner as city-dweller –
Classicism, usadba *and dacha.*

The city has a certain physiognomy and structure which, far from having been obliterated by the great fire, much less by the General Plan, seem to remain indelibly present, even in the new appearance and layout that are supposed to have replaced them. Without wishing to deny that Moscow is the city of the high-rise buildings, the observant visitor is bound to feel, as he walks around, that a qualification of that description is long overdue. For in what other city does one find such a superabundance of colonnades, modestly fitting into their surroundings, façades with timelessly harmonious features, or semi-circular carriage entrances to palaces? Where else are the great avenues bordered, seemingly as a matter of course, by garden portals? In what other city are supporting columns so widely used, vigorous yet slender, elegantly proportioned, white, solid, casting different shadows with the changing hours and seasons? The column, the façade, the ornament do not overtly draw attention to themselves, but are quietly welcoming. Wherever the eye encounters this combination of classical elements – the epitome of simplicity and clarity, whether in noble white or warm Habsburg yellow – it finds a point of calm and repose. And this is often in the most ordinary of locations – scattered here and there in a long row of buildings lining a street unbroken by any major landmarks; in the deep, recessed façade of the Old University; on the island formed by the Manège, where a torrent of traffic rushes by on either side; on both sides of ulitsa Gertsena; on the boulevards, or on Theatre Square. A pleasant feeling of tranquillity, emanating from buildings that possess a natural, inherent peacefulness, pervades us as we contemplate classical Moscow.

Some places in the city are as refreshing as the sight of a forest glade at the height of spring. I am thinking, for instance, of the square in front of the University, or the one in front of the Bolshoi Theatre; streets like the present-day Kropotkinskaya and parts of the Boulevard Ring; and individual houses – works of architecture that are dotted around the whole of Moscow and once constituted the fabric of the city, even if there is only a small sprinkling of them left now. The masters whose signature is imprinted on them so unobtrusively and yet so firmly are Matvei Kazakov (1738–1812), Vasily Bazhenov (1737–1799), Giacomo Quarenghi (1744–1817), Domenico Gilardi (1788–1845), Afanasy Grigorev (1782–1868) and Osip Bove or Beauvais (1784–1834).

One place that has preserved the flavour of the period prior to the great fire of 1812 is the Hall of Columns in the House of Unions (which was formerly the Club of the Nobility, and was rebuilt after the fire): a room that, not by chance, is used to this day both for great events and for disturbing ones. Its pleasing proportions and gleaming

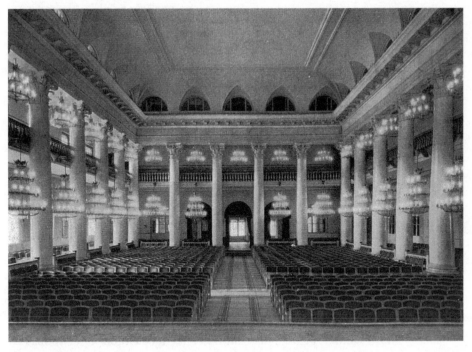

Hall of Columns in the Club of the Nobility (now the House of Unions), architect M. F. Kazakov.

white columns lend it an air of grandeur and solemnity, and while large enough for official occasions it does not have the feel of a vast, impersonal hall. Here, turned inwards, are the colonnades that elsewhere face outwards: on the front of the Golitsyn Hospital, on the Demidov and Dolgorukov mansions (the latter in ulitsa Kropotkinskaya), or on buildings by Vasily Bazhenov: the Razumovsky Palace on prospekt Kalinina, the Yushkov mansion in ulitsa Kirova and the Pashkov mansion on a hill next to the new Lenin Library building. Other buildings also dating from this period include Domenico Gilardi's building for the Guardians' Council and his Lunin and Gagarin mansions; the Sheremetev Refuge designed by Giacomo Quarenghi; and Nikolai Legran's Military Commissariat.

Of course Moscow Classicism is not only embodied in individual buildings but also created great ensembles such as Manège Square, Theatre Square, Kropotkinskaya and the Boulevard Ring. And yet one has to ask what it was that made the landscape of Moscow so anarchic. The ambitions that turned St Petersburg into a unified dream-city never gained a firm foothold here, but neither did they fail to leave any mark at all. It is a further irony that Moscow became Moscow precisely because St Petersburg was destined to become St Petersburg. In a sense, Peter the Great's edict of 1714 forbidding any new stone buildings in Moscow and other towns saved Moscow from the utopia of the planned city. Another state *ukaz*, by which Catherine the Great exempted the nobility from military service so that they should concentrate their efforts on agriculture and trade, had the effect of encouraging initiatives from below. The new buildings in Moscow showed a colourful diversity, because no one style was prescribed and so wealthy families were able to give free rein to their imagination. Furthermore, the architects of Moscow Classicism did not have a *tabula rasa* before them, but a varied and picturesque city filled with soaring towers. How could this have failed to impress and influence them?

The sense of calm that emanates from the buildings of Moscow Classicism is inevitably somewhat different from that conveyed by French classicism, which took its inspiration directly from the ancient world. In Moscow the classical buildings are almost always of the same type, and art historians like Igor Grabar have remarked that there is a degree of uniformity here. But what constitutes the type? It is the house of a rural landowner, transposed from the coun-

Razumovsky *usadba* (estate house), architect M. F. Kazakov, 1790–93.

try estate to the city. A symmetrical portico is topped by a dome and flanked on both sides by projecting wings, forming an inner court-yard with portals embracing a carriage driveway. The internal layout is generally the same in all these houses: at the centre the reception rooms and bedrooms; in the side wings drawing-rooms and studies; on the garden side the stables and servants' quarters. The ground-plan of the estate owners' *usadba* became the ground-plan of the urban *usadba*, and then of the town house in general. The key to the criticism that Moscow has never been anything but a village lies in this type of building and the unplanned way in which it proliferated and shaped the appearance of the city.

This rural impression is heightened by the abundance of green space provided by the parks, a certain randomness in the location of the houses and the anarchic merging of the *slobody* and districts. The description of Moscow as a village is usually uttered with an under-tone of the disdain felt by the more civilized for the more backward. What a misconception! The estate owners' chosen environment, the stone 'nests of gentlefolk', have preserved something of the indepen-

dence, open-handedness and objectivity of the landowner, and often – despite all the wealth and splendour – a simplicity that bespeaks country roots and closeness to the soil. The characteristics of the urban *usadba* of Moscow Classicism, and indeed of Moscow Classicism as a whole, are certainty and firmness of form, an emphasis on what is useful and constructive, the outward expression of a certain status, and a formal mastery that achieves elegance without allowing it to become an end in itself. Grabar remarks somewhere that Russian Classicism is *the* Russian style. There is much to be said for this view, especially when one sees in what condition – alienated from itself, sometimes desperately run down – it has tenaciously survived through changing times. The fact that even the most elegant façade still possesses that same vigour and regularity, and sometimes also a hint of the provinces, of the native soil, inclines me towards Grabar's thesis.

Of course, it is not helpful to make a linear association between classicism and the revolutionary bourgeoisie or, later, between the Empire style and Bonapartism. Those who were building here in the second half of the eighteenth century and the first third of the nineteenth were not the bourgeoisie but aristocrats, many of whom were only too happy to live a life funded by income from their estates and knew little of the land and of peasants and cart-drivers except from hearsay and the horse auction. And yet the spirit of the working people found its way into the houses of the property owners – if not always, perhaps, as directly as the 'museums of serf art' would have us believe. As always, the linear associations are inappropriate, because here in Moscow the radical propositions of 1789 and the liberal thinking of the Union of Welfare reformist society were discussed not in the political clubs, but in the salons of the best families.

Even such figures as Pyotr Kropotkin and Mikhail Bakunin still have something about them of the Russian countryside and the estate houses. Anyone who conceives of changing the world so drastically has to have experienced the gulf that lies between the gleaming parquet floors and great rooms and libraries lit by chandeliers and the miserable, filthy hovels. A person who can regard the world as so completely 'his own', subject to no one, must have had practical experience of being subordinate to nothing and nobody. The concept of anarchy had its origin not in the stale air of nihilist circles but in the way of life of someone who has been able to develop fully as an individual and who is accountable to no one but himself.

Arkhangelskoe estate, near Moscow, colonnade surrounding the palace courtyard, late 18th and early 19th centuries.

The liberal initiatives undertaken by the best families came to nothing, and the accession of Nicholas I in 1825 was followed by a turn towards Romanticism and mysticism which is also reflected in the appearance of the city. Perhaps it was the very fact that society was based on the landowning way of life that allowed the gentry to continue in that way until they eventually lost all capacity to care about the fortunes of the country. And so the palaces ended up providing the outer shell for what came later: the summer palace at Neskuchnoe for the Academy of Sciences, the Ostankino Palace for the rehabilitation of serfs, the Club of the Nobility for the activities of the trade unions.

A visitor to one of those dream landscapes, for instance Arkhangelskoe, might easily lose himself in the dream and forget where the sustenance of salon society came from, by the work of whose hands it lived. One should not use the word 'dream' without defining what one means by it, and in the case of Archangelskoe I am not merely referring to the harmonious proportions of this country seat, the palace first of the Golitsyns, then of the Yusupovs, or to the superb quality of the interior décor – of the music rooms, the studies, the hunting-room – or the magic of the statues in the gardens. It is something else: humanized nature. Wherever the visitor chooses to place himself – in the oval-ended courtyard enclosed by a colonnade, where he can look out at the terrace and, through a line of statues and busts, into the distance where the plateau falls away to the Moskva; or by the little Tea House pavilion; or else by the 'Colonnade', somewhat further off, built in neo-classical style by Roman Klein in the first year of the First World War and intended as a family mausoleum – wherever he looks, the white stone, the soft ochre, is animated by the interplay of elements in the park, the juxtaposition of ever-changing nature and man's dwelling-place which is cast in stone. The dream-like charm lies in the effortless relationship achieved between man and nature, in which the contrast between *Hercules and Antaeus* and the stone lion on the terrace, and the fresh green of the woodland in spring, its dying red embers in the autumn or the snow-covered landscape in winter, becomes almost imperceptible, though ultimately it remains insurmountable. A curious progression has taken place: having found their way from the country estates to the city and acquired urban refinement and sophistication, the *usadby* have returned, or perhaps escaped, back to the countryside.

Every weekend sees the start of a different kind of escape, which is most noticeable at the big railway stations, on the platforms from which the suburban trains leave. Moscow is setting out for its dachas. These too have their own individual styles. Only the modern way of building them, using prefabricated sections (imported from Finland, perhaps), is now making them look alike. A dacha is not just a weekend cottage but a way of life: the owners do not come just to stay here for a couple of days, they equip themselves for a different kind of life under free and 'natural' conditions. They dig the garden, hoe the weeds, and look forward to harvesting their crops. Some dachas have entered literary history, like Pasternak's in Peredelkino; Solzhenitsyn too, when most beleaguered, withdrew to the Rostropovich family's dacha in Shukhovka. A dacha settlement is more than a colony of allotment holders, but less than a wealthy suburb; it represents space to be oneself, agriculture in miniature, a place of retreat for harassed city-dwellers and a sphere of activity for farmers who have missed their vocation. It is impossible to describe the woodland smells, and the scents of lilac and peonies released by the sun, which however never quite succeeds in warming you; impossible to capture in words the swirling smoke of the many bonfires, the comforting warmth they give, the romantic camp-fire light they cast while at the same time fulfilling their practical function of burning rubbish. *Usadba* and dacha are not merely buildings but whole styles of living. An embodiment of continuity, notwithstanding the difference between a four-in-hand and the *elektrichka*, they give the lie to the separation of town and village, which here cling to one another tenaciously.

12 On the edge of an era

The Boulevard Ring – The interior of a city
before it became inhospitable.

Some buildings, some streets are lucky: they survive simply because they are in no one's way or just happen to fit in with later planning. This must have been the case with Moscow's Boulevard Ring. What might have happened if it had attracted the same sort of attention as ulitsa Tverskaya does not bear thinking about. Tverskaya, the present ulitsa Gorkogo, was originally the thoroughfare by which St Petersburgers entered their Moscow; after the new Soviet masters had come to power, it was made to enter into competition with the rival city's aristocratic Nevsky prospekt. No effort was spared in the 1930s and '40s to put the former capital in the shade – much to the detriment of Tverskaya, which has become a street of ostentatious grandeur, whilst bearing the name of a writer of sensibility overlaid with bitterness.

This was probably inevitable, for Tverskaya led straight to the centre of power. As you drive down it, heading for the heart of the city, your eye is at once caught by the dull gleam of the cobbles in Red Square, and even from a long way off you can see the hump in the square between the Historical Museum and St Basil's Cathedral. Under the direct glare of power, Tverskaya – at one time, we may suppose, spacious and peaceful enough for shops and *flâneurs* – has become quite different. Now it is one of the few avenues in Moscow to be so full of traffic that its width appears justified. One can understand why pedestrians have had to be banished to underground subways. It is a street of wildly over-ornamented residential buildings. The preserved buildings of the nineteenth century were aligned with them only by the very costly expedient of moving them

'On this boulevard, this long, gently curving street, perfect for a relaxing walk,
no bomb explodes, no rifle cracks, and no dictatorial eye flashes. It is a very peaceful
place, a promenade for strolling couples, sauntering Red Army soldiers, and people
on their way home from work. There is laughing and joking, problems are aired,
hole-and-corner deals transacted in whispers, women courted. This ring-road,
all green and brown, is freely used by Moscow's citizens as a place to walk,
sit or stroll. Alone or in pairs, solemn or merry, bowed down with cares or with
a jaunty bearing.'
Alfons Goldschmidt, *Moskau*, 1920

back the necessary distance, mounted on rails. It is a street lined with
shop windows in which the goods are displayed apologetically, as
the unobtainable fiction that they are; a street where the name-plates
at almost every door present a roll-call of eminent occupants. But it
is not the Nevsky prospekt, for all that.

No such fate befell the Boulevard Ring, which was built in place
of the wall that had enclosed the inner city, the Bely Gorod or White
City, up to the great fire of 1812. As an inner ring road it fitted in with
the growth of the striving new metropolis after the Revolution and
so was not threatened by the centralism of the new capital. It was
accepted and left alone: for the most part, at any rate. What was
destroyed was not the boulevard itself but its status. Today it no
longer segregates the White City from the suburbs, but has been

demoted to being simply one of the ring roads without which the city would have physically ceased to function. The magical boundary separating and shielding the centre from the suburbs has lost its significance. A whole urban vascular system, a complete cosmos of urban culture, has become a museum piece: too big to be broken up into pieces and carted off to the museum, too soundly built to be dispensable, given the desperate housing shortage.

To this day the old residential buildings in the former White City bear witness to the fact that those who were once, in Dostoevsky's words, 'the humiliated and the insulted', have taken possession of the bourgeois interiors. Not, of course, that the factory workers moved into the spacious apartments on Chistoprudny bulvar just as they were: the space was reorganized and subdivided, and whole floors were converted into communal flats, which some of them still are. Perhaps a time will come when the homes of the former bourgeoisie will be restored to their old form, freed of their cramped shared corridors and kitchens, and handed over to those who have already started collecting antique furniture in the hope of eventually being able to arrange and display it in its proper setting. Here as elsewhere, the policy of removing the local people to the suburbs and refurbishing the 'old building stock' is being implemented, not quite in the same way, and possibly more slowly and laboriously. At night, when the spaciousness of the rooms, the stuccoed ceilings, the delicately wrought banisters can be seen from the street, one could well imagine that these former homes of the expelled property-owning class are just waiting for their new owners to move in and take them over.

Yet the Boulevard Ring works its magic even on the visitor who knows nothing of what goes on behind the façades. It runs in a half-circle around the centre, in the following sections in anticlockwise order: Pokrovsky, Chistoprudny, Sretensky, Rozhdestvensky, Petrovsky, Strastnoy, Tverskoy, Suvorovsky and Gogolevsky bulvar. What is a boulevard? Neither a street nor a square – or rather, both at once. Broad enough to be open to a wide expanse of sky, but not so broad that you forget that the space is bounded by buildings, dwellings, human places of business; open at both ends for the flow of traffic, the pulsing blood of the city, but sufficiently enclosed and self-contained not to be a mere thoroughfare. A background of noise reminds you that here, in the thick of the city, you are not far from the all-powerful centre, but it is not so loud as to drown out the varied sounds of children at play, so that residents are able to feel

that this place belongs to them and not to the shops. Perhaps Moscow's Boulevard Ring is an outdoor version of the idea of the shopping arcade as exemplified in the indoor arcades of GUM or the Petrovka. Those comfortable, welcoming shops overflowing outwards into the 'street', which is actually a covered space, the artificially lit arcade imitating the daylight of the real street, form a counterpart to the boulevard.

POKROVSKY BULVAR

The number 3 tram passes over Ustinsky bridge and climbs a slight incline as it enters the Boulevard Ring. On the left, near the first tram stop on the Ring, is a corner house, no. 18/15, which before the great fire belonged to the merchant I. I. Karzinkin; the writer Nikolai Teleshov lived here from 1913 until his death, and his Wednesday literary gatherings were attended by the cream of the artistic world, from Shalyapin, Andreev and Gorky to Bely. Further along, on the right, is a rather broad classical frontage, for the Boulevard Ring can perfectly well accommodate even forceful, independent façades like this; nowadays it belongs to the Academy of Military Engineering.

CHISTOPRUDNY BULVAR

This extends as far as the Kirovskaya metro station. On the right is what is now the Sovremennik Theatre; this was built by the architect Roman Klein before the First World War, though at that time the theatre in this white neo-classical building was the Coliseum. Further on towards the metro station the boulevard briefly loses its definition: in places it has been altered unnecessarily and greatly to its detriment. Next to the central pond, the Clean Pond, is a restaurant that almost seems to have been built of prefabricated sections and glorified corrugated iron. Its patrons are able to sit on a balcony that resembles the diving-boards at a swimming-pool.

SRETENSKY BULVAR

Looking down ulitsa Kirova to the left you see the slate-grey façade of the Main Post Office; looking up Kirova to the right, away from the centre, you can make out the two wings of the Tsentrosoyuz building. Facing the square there is now a showy new concrete mon-

strosity, and some empty plots waiting to be redeveloped. One can already picture what will go up there: the square is so restricted for space that it will not be possible to create an open view towards the city. There is no choice but to build upwards. Further on, the boulevard gradually pulls itself together again: on both sides there are commercial and apartment buildings, which are over-ornate and boast gargoyles inspired by Notre-Dame, though here they are not designed to discharge water. But in this section of the Ring, as along its whole length, the predominant style is Moscow Classicism and neo-classicism, not the forms of art nouveau, still less British imitation Gothic or the neo-Russian style. The boulevard is still the creation of the aristocratic rebuilders of the city after the great fire.

ROZHDESTVENSKY BULVAR

Moscow really is built on hills, though perhaps not on seven as people claim. The boulevard makes a handsome and graceful descent to Trubnaya ploshchad. And here one gains the kind of panoramic view that was so often described by early visitors to Moscow: churches, pinnacles and spires, bell-towers, jagged-topped walls in red, green roofs – yes, even those green roofs, that up to now I have searched for in vain, can be seen from here. It is also evident that the boulevard was lined with churches and monasteries. After all, monasteries and convents gave their names to the boulevards, and since they were there first it was their position that determined the course of the Ring, and not the other way around. Now, with the sun shining down on the boulevard, one can imagine what it was like when Moscow had, as we are told, four times four hundred churches, and when the air at Eastertide was filled with the clanging and booming of the bells.

At the bottom of the hill, in the valley, is Trubnaya ploshchad, not really a square – nowadays, at any rate – but an open area that extends further on the northern side. To the right of the junction is a building that looks like one of the grain silos in the ports on the Río de La Plata or at St Louis; nowadays it is probably a silo of science and knowledge, storing data, housing some Soviet institute. Actually the name of the square alludes to what lies beneath it. The Neglinka was banished underground and carried in a *truba* (pipe) through an opening in the now-demolished wall of the White City.

This square, then, is a piece of ground wrested from the forces of nature. If you go up Tsvetnoy bulvar, a surprise awaits you: on the right is a corner building which, with its windows rising in a spiral, looks at first sight like a roll of film; on closer inspection it proves to be a multi-storey garage built in the 1920s, and of course its function had to be apparent from the outside. On the left, set back behind a fence, is the Puppet Theatre and Theatre of Miniatures, and a little further on a pavilion whose construction has the elegance of a bent-wood chair, and which in appearance is rather reminiscent of a Chinese summer-house. The Eremitage Garden must have been, in the years before 1914, a kind of Luna Park. Nowadays the park has lights in the shape of flowers, and loudspeakers pouring out music.

The Eremitage Café, which I had intended to visit, I find is elsewhere; at Neglinnaya ulitsa 29/14. And what is Trubnaya ploshchad's other claim to fame? Here, on 9 March 1953, the crowds of people in the grip of grief and hysteria were supposed to form orderly columns before being led to view the body of Stalin, lying in state in the House of Unions. But while they were still in this square the stampede began in which hundreds were killed – the precise number has never been officially divulged. A deadly bottleneck, too small to contain the violent emotion of a crowd numbering hundreds of thousands.

PETROVSKY BULVAR

My memory here is of single-storey and two-storey buildings, built on soft ground, which instead of cracking and falling apart have gently subsided, changing the classical straightness of the façade into a wavy line. Once again, on the left, at the junction with ulitsa Petrovka, there is a monastery with a cluster of churches and bell-towers; but access is barred by metal panels.

STRASTNOY BULVAR

This is the section of the Ring that has been debased in every possible way. In the 1960s the point at its western end where the Strastnoy Convent once stood became the site for a monument to mindless tastelessness, the Rossiya Cinema, which turns its back towards the boulevard. This tall, ugly lump of a building casts its shadow over

what is perhaps one of Moscow's most precious buildings, the printing house and editorial offices of the former *Utro Rossii* newpaper.

PUSHKINSKAYA PLOSHCHAD

It is difficult to form an idea of what this intersection of the Ring and Tverskaya ulitsa used to look like. Tverskaya was greatly widened, and highly regarded buildings (for instance Ivan Sytin's Printing House) were moved. The southern side probably remains much as it was, while the most notable feature on the northern side is the Izvestia building (erected from 1925 to 1927) by G. B. Barkhin. The square's charm derives wholly from the people walking about there or spending time sitting on the comfortable benches, smoking and reading newspapers and books. Pushkin's statue, moved here from its previous location, is a popular meeting-point. This is one of the squares whose mood is not set by shoppers in a hurry or people with urgent business to attend to. But for this, it would inspire only despair. The Rossiya Cinema, charitably described by one expert as representative of the 'period of searching for a style' in the late 1950s and the '60s, seems to me to be nothing more than a clumsy exercise in the use of glass and concrete, in which the architects mistook reality for their drawing-board: on the drawing-board this perfectly legitimate experimental design could have been erased, but once it was in the real world there was no such option. And the Strastnoy monastery is lost to us.

As we pass the junction with ulitsa Gorkogo, we are obviously leaving the higher part of the Boulevard Ring behind. From now on we seem to be heading downhill in a broad curve towards the Moskva, passing through the well-kept district between Tverskoy bulvar and the Garden Ring. This is something of an island of calm in the big city, and there are lawns in front of some of the houses. We walk straight through this district, aiming for a particular pond, which is still half covered with ice. This is the place where the character Berlioz in Bulgakov's novel *The Master and Margarita* fell under the wheels of a tram, Providence having caught up with him. This square too has something of that air of refinement that belongs to a big city. Then back to the Boulevard Ring, via ulitsa A. Tolstogo – with the Morozov and Tarasov houses – to approach the Ryabushinsky mansion from the rear.

This begins at the Nikitskie vorota, still one of the most beautiful intersections in Moscow, though thrown slightly out of balance by whichever Moscow master of concrete construction it was who left his signature here in the form of the TASS building. But across the road, facing this, is the corner house where the revolutionary Nikolai Ogaryov lived as a child and where, according to cinema buffs, good films are shown. But the right-hand side of the end of the boulevard is of greater interest. There Gogol lived and died, in house no. 7a, and in the courtyard of the building, which is now a library, his monument still remains. What a Gogol! Sitting on a block of granite, leaning forward so that his nose protrudes even further, giving his face a look of anguish and despair. This monument is important because up to the centenary of his death in 1959 it was 'the' Gogol monument. The new Gogol, the Gogol of the Soviet period, can now be seen at one end of Gogolevski bulvar, where he stands erect, more like the statue of a political leader, pointing ahead to a future that he did not know or perhaps did not want to know. A comparison of the two statues would no doubt provide material for a small treatise on the reinterpretation of literature and its appropriation by later generations.

We cross prospekt Kalinina, an intimidating post-war thoroughfare which is so open and flat that it is impossible to say whether it is a square or an avenue. It is flanked by the buildings that constitute the second architectural crime of the 1960s, the tower blocks that forced the Old Arbat to retreat to its back courtyard. With these blocks, inspired by the shape of open books, the bureaucrats took possession of the Arbat and its quaint nooks and crannies, made room for the wind to whistle across the open space and ensured that all who lived here would feel the 'inhospitableness of the city'. There is no comfort or consolation here. Nor is any to be found in the view of the distant mass of the Hotel Ukraina or the Foreign Ministry tower on Smolenskaya ploshchad. The Praga Restaurant stands apart, denuded, like a skeleton stripped of its flesh. The Old Arbat is not to be missed, a neighbourhood, celebrated in song, which offers a homely feeling of shelter and protection within the city. And indeed you can still see it, alongside the 30-storey blocks that line the avenue like a row of taut sails; you can see it in the truncated façades, in the blocked-off rear courtyards of the beautiful houses,

which now seem off-balance and do not properly relate to anything, but which clearly hint that they were once part of a greater ensemble, a fabric that has been cruelly cut through – and for what? For shoppers getting nothing out of life, just running themselves into the ground? For pedestrians who could travel a whole stop on the metro in the time it takes them to cross the Prospekt using the subway? So far from drawing back from the more extreme planning concepts of the 1930s and '40s, prospekt Kalinina has taken them to the very limit, and yet the result lacks interest or vigour. To me this is the epitome of 'the inhospitable city': it represents an attack on the need of human beings for surroundings that they can relate to and the deliberate creation of a sense of exposure and vulnerability. Some say that the Muscovites have learned to love their New Arbat. I have yet to meet any who have – but it is possible that a new perception is developing.

We continue along Gogolevsky bulvar, which goes down as far as the Kropotkinskaya metro station. Until the 1930s this was where the Boulevard Ring came to a stop close to the Cathedral of Christ the Saviour, and those who commissioned the Palace of Soviets, which was to take its place, planned to include the boulevard in the scheme as a kind of approach road. Today it leads instead to the wide open space that is occupied, *faute de mieux*, by the Moskva open-air swimming pool. The Boulevard Ring has continued to be a period, an epoch in its own right, resisting all presumptuous attempts to incorporate it into something else. Even today it invites the visitor to adopt a different style of walking, a different way of moving about. Now that the stately 'A' tram no longer exists – the tram from which the young Konstantin Paustovsky was able to explore Moscow from the vantage-point of a conductor – there is much to be said for returning to the ways of the *flâneur*.

13 Railway stations

*Moscow as the centre of the empire – Different times
and cultures coalesce – The station and the railway
viewed in terms of cultural history.*

Time that is not synchronized. The ironing out of time differences.
The harmonious drawing together of a gigantic empire that strains
apart in all directions. The daily point of intersection for the move-
ments of millions. Whole army camps, mountains of bundles of
goods essential to life. Facial types of the hundred different races.
The departure point for trips lasting a day and the point of arrival
for train journeys that have taken a week.

Moscow's nine railway stations are all termini. They open the way to
the various regions of the country, and link the most distant regions
with the centre. Every day the Belorussian Station receives travellers
from the West, from Paris, Berlin, Prague, Warsaw, Minsk and
Smolensk, and sends others back in the same direction. From Kiev
Station passengers leave for the Ukraine, Bulgaria, Romania, Budapest
and Vienna. The Paveletsky Station gives access to the south and the
Donbas. Kursk Station – its old building vanished, apart from a pitiful
remnant preserved as a monument beside the glazed canopy of the
main hall – is the point of departure for the route to Kursk, Oryol,
Kharkov, Rostov on the Don and the Caucasus. Riga Station serves the
Baltic. The status of the capital is most forcefully emphasized by the
cluster of stations on one square, Komsomolskaya ploshchad, which
is enclosed on its north-western side by the Yaroslavl and Leningrad
stations and on its southern side by the Kazan Station. The framing of
the square is completed by the towering 1940s Hotel Leningradskaya.
 Termini. This means that instead of everything being reduced
to a homogenized mixture, individual elements preserve their own

character right up to the point of entry to the city: the regions and the passengers that they dispatch to the capital retain their own local colour, their own way of moving. These waves of mankind break only after their arrival, when they are sucked in by the city, or flow off into the shafts of the metro, are swept away by the lines of waiting taxis or hurled into the suburban trains and deposited at another station or one of the five airports. Not a place simply passed through, then, but a pause, a delay in moving on, a brief stop. In a sense time stops too, for here the time is Moscow time and watches have to be reset; eight hours' difference for travellers from the furthest city, and a number of hours, if not quite as many, for those from Central Asia. And yet despite Moscow time the clocks are not all in step. Moscow's stations represent a gathering together of every part of Russian, no, of Soviet soil, hourly, daily, year in, year out.

Where the rails point towards Kuybyshev and Omsk, and towards Samarkand and Dushanbe – at the Kazan Station – you see the hustle and bustle, but also the calmness that these travellers have to summon up as they prepare for the days they are about to spend in a railway compartment. The long journey to Moscow has been worthwhile, evidently, for the quantity of luggage is such as most of us would have perhaps once in a lifetime – when forced to flee with all our belongings, or moving house suddenly without proper transport. Moscow has carpets to offer, curtain rails, oranges by the kilo, ski poles, a plastic bath for the baby in Irkutsk. Tied up in bundles, skilfully stacked to form a tower of cases, boxes, bags, the goods wait on the already snow-covered platforms and in the main hall of the station; a station whose appearance still reflects the turbulent era in which it was built and the times it has seen.

Crowning the station and looking like a mighty and insurmountable city wall, in dark red picked out with lines and areas of white, is a pointed tower. It is in the Kazan style, with oriel windows, curious clock-faces and spiky points everywhere, as if to ward off attack. A visitor cannot help thinking of the conquest of Kazan under the protection of the Madonna, and feeling that at any moment fire and sulphur may come shooting down from the battlements, with a sharp trumpet call sounding from the tower and Tatar horsemen suddenly bursting forth, brandishing their lances.

There is indeed something of those lance-wielding horsemen to be seen in the station: sharp-featured dark faces, young Red Army soldiers in their olive-green twill, belted and with army caps set at

an elegant angle; some of them are so young that they could almost be children. They are speaking Kazakh, Uzbek, Tungus, or so the passing foreigner surmises. There are the old warriors with their medals, some of them leaning on crutches, and the mighty baggage-train of women, children and luggage that has quartered itself here for half a day or a night. In the side hall, which has rows of red plastic chairs, queues of people have formed in front of them, hoping to get a seat for the long wait. The people here simply wait: there is no strolling about as there is at the stations in Germany that Italian, Greek or Spanish workers have adopted as the one place where – in the open and yet sheltered from the elements – they can recreate the feel of their native piazzas, where the newspapers from their home countries first arrive, where they can see films and strike up acquaintances. Here there is none of that activity, but rather a concentration of the mind in preparation for a long journey.

The Kazan Station is also the place where a certain Vladimir Ilich Ulyanov, en route from Samara to St Petersburg, first set foot in Moscow. That was in late August 1890, when the station was still called the Ryazan Station.

Despite its façade, this gateway to Kazan is a modern creation, as is immediately apparent from the steel and concrete construction of the vaulting above the main hall. The building work started in 1913 under the supervision of Aleksei Shchusev. The neo-Russian façade not only bears witness to a new national consciousness but also shows a flight from the brutality of Modernism, whose construction principles the building nevertheless employs.

Nowhere is the civilizing mission of railway construction more evident than in Russia. It is expressed even in the terminology. In *vokzal*, the Russian word for 'station', the attentive ear detects Vauxhall, while the literal translation of *zheleznaya doroga*: the Russian word for 'railway', is 'iron way'. This term suggests far more than a mere means of transport; it is a determined refusal to bow to the near-impassability of the terrain, the bogs and the flood plains, a challenge to the age-old subjection to the country's climate and geography, which are so inimical to effective communications. Peasants from central Russia migrating to do seasonal work in the south-west used to take as long to reach their goal as European emigrants took to cross the Atlantic and reach the New World. It was in truth the vascular system provided by the railways that helped to set the country on the path of becoming a fully formed society.

But the development of the railways was not achieved without imposing pressures and inflicting shocks. The building of the line between Warsaw and Vienna in 1839 was seen as an obvious necessity in that more advanced, western border territory. Similarly, the opening of the St Petersburg–Moscow line in 1851 can be seen as the long-overdue linking of the two capitals undertaken by a regime that wanted to appear modern. Railway building on a large scale only really began under the impact of the annihilating blow of defeat in the Crimean War, which was also a defeat for feudalism. Now railway lines were seen to be needed for troop movements; means of transport were required to bring Russian corn and wood on to the world market; properly functioning arteries were vital to link together the industrial centres that were springing up everywhere, so as to foster trade between them. In huge spurts, with peaks in 1871, 1899 and 1915, Russia was propelled into the 'age of iron'. One region after another was opened up, and thereby drawn into the cyclical crises inherent in capitalism. And in Russia the railways were so much the domain of private, often foreign, capital, that Alexander III thought it necessary to warn against the 'petty railway kings in their railway kingdoms', seeing in them a threat to Russian autocracy (as discussed by E. Ames and V. T. Bill). The railways were brought under state control.

It is not surprising that a writer like Dmitry Mamin-Sibiryak, who described the gold rush atmosphere of that period, is one of the most widely read authors today: Russia too had its pioneering age with all the excesses of America's Wild West. But though Russia is the classic land of the railway, a cultural history of the shock-waves spread by the *chugunka*, as the iron monster breathing fire and steam was popularly known, has yet to be written.

As the nerve-fibres of this vast country, the railways were naturally particularly sensitive: they were the pathways not just for the transportation of freight but also for the transmission of social ferment. The railway workers were part of what was probably the most politicized and most disciplined segment of the proletariat. Thus it is no coincidence that close to the Kazan Station we find the 'Central House of the Railwaymen', a workers' club designed by Shchusev, built in the 1920s but disguised by a neo-Russian façade in order to associate it with the station. It is perhaps also not coincidental that the 'great initiative' of voluntary communist activity, so highly praised by Lenin, began in the workshops of the Kazan line. In 1923

Yaroslavl
Station,
architect F. O.
Shekhtel, 1902.

the workers of the Ryazan–Urals line, as it then was, repaid this recognition by making Lenin the official engineer of locomotive number U-127. It was the same locomotive that, a year later, brought Lenin's body from Gorki, near Moscow, back to the capital.

Something of the spirit of the pioneering days has survived on the platforms of Kazan Station, for the passengers waiting here, already enveloped in the smell of charcoal emanating from the heated carriages and smoking a last cigarette, have not yet taken on the manners of the big city. Dramas are played out in public without inhibition. Screaming and crying, a blonde woman tries to pull away from two men. The spectators crane their necks: anything to pass the time.

This place has also seen dramatic events that are not spoken of. I am thinking of 17 January 1928, when Trotsky set out from here for exile in Alma-Ata; and of 11 May 1970, when General Pyotr Grigorenko, a prominent dissident, was deported from Moscow, leaving from this station in a barred prison wagon.

The Yaroslavl Station at the eastern end of the square also shows an

125

Circle of friends: Gathering at the home of S. I. Mamontov. From left to right: I. E. Repin (seated), V. I. Surikov, S. I. Mamontov, K. A. Korovin, V. A. Serov, M. M. Antokolsky.

Leningrad Station, Moscow, architect K. A. Ton, 1849.

attempt to temper the clash between the 'age of iron' and Russian tradition. Only an architect of Shekhtel's standing would satisfy Savva Mamontov, the owner of the Northern Russian Railway Company. In Shekhtel's building, dating from the beginning of the twentieth century, the architecture of northern Russia appears as a quotation embedded in the forms of art nouveau. Curving lines predominate, and the design is asymmetrical. The rounded arches of the entrance contrast with the straight lines of the window section, just as the slate grey of the roof contrasts with the white-painted walls. Running around the building is a frieze of green ceramic tiles with inserts of bright majolica. Yet there are also elements that could have come from a fortress or a monastery.

What Mamontov built was not merely a railway line: it was a line to the Russian North, that belatedly rediscovered – and already legendary – focus of Russia's sense of its own strength. As a man of taste and sensitivity, he arranged that the artists whom he engaged to decorate the interior of the station hall should first travel to that region. But the pictures by Konstantin Korovin depicting the landscape to which the line leads have vanished from sight. A lower ceiling has been built in the hall, together with a monster of an escalator. The names of some of the towns that the line made accessible and which now appear on the arrivals and departures boards – Arkhangelsk, Vologda, Vorkuta, Tayshet – have since lost their ring of innocence. Too many people were forced to make the acquaintance of these towns close to the Arctic Circle, as a result of some unfathomable decision. It is barely 30 years since they returned.

The building of the Moscow–Arkhangelsk line and the Yaroslavl Station marks the end of the era of Mamontov and, with him, of that type of railway magnate who revolutionized transport in the second half of the nineteenth century – self-made men like Derviz, who was from a peasant background, ascetics like Samuel Poyakov, the philanthropically minded Ivan Bliokh, who, like Poyakov, was of Jewish descent, or the engineer Karl von Meck. Savva Mamontov met his downfall during the building of the line to the North. He was accused of bribery and detained in prison, and although subsequently acquitted of the charge he was ruined. In Butyrka Prison he wrote the libretto for the opera *The Necklace*, translated Mozart's *Don Giovanni* into Russian and made sculptures of the prison warders. After the nationalization of the Yaroslavl line and all his property, he withdrew to his pottery workshop at Abramtsevo,

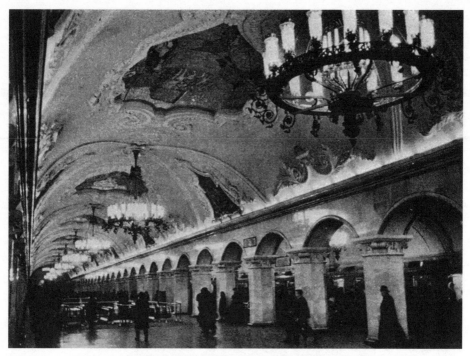

Komsomolskaya metro station (Circle line), architect A. V. Shchusev, 1952.

where a number of future great artists gathered in his 'colony' (illus. p. 127). A comparable fate befell another individual who had emerged as a powerful force in the building of railways. Count Sergei Witte, the strategist of Russian modernization and the first Prime Minister after the revolution of 1905, also had to go. Autocracy could stomach neither the drive of the dynamic bourgeois nor the expertise of the enlightened technocrat.

Moscow's Leningrad Station saw the opening of the first Russian railway line; with increasing traffic, this seemed to act as a transfusion tube delivering to the old, disempowered capital the strength that, after the Revolution, made it the legitimate heir not only to St Petersburg but to Constantinople as well. The station building itself represents not so much Moscow as the city that the traveller has chosen as his destination. There is something of the lustre of the old capital in the delicate Empire-style façade, an unmistakable homage to the still-dominant metropolis on the Neva. In those days it was not Moscow that dictated the taste reflected in the façade, but the

silver city by the sea. However, only the façade and the vestibule remain. The interior has been changed, though the Soviet renovators in the 1960s and '70s struck the right note (were they perhaps architects from Leningrad?).

Here, in contrast to the Kazan Station, people do not wait around: the concourse is lined with boutiques and neon signs, and there are snack bars; people can expect to find trains that run daily and hourly; their destination is within easy reach. The express takes only six hours to reach the former capital, so there is no need for them to make preparations for sleeping overnight on the train. The journey seems to take no more than a moment; the distance is not a major obstacle to be overcome. The passengers, too, are different: they have no bundles, only travelling bags, and there are no hordes of people sitting clustered together and waiting. The concourse is filled with the sound of purposeful footsteps, and the statue of Lenin, commemorating the move of the Soviet government to Moscow on 11 March 1918, stands in the middle looking rather isolated and forlorn. This is a Moscow station, and yet one could equally well say that it is an outpost of the former capital, of its manners and its once brisk pace of life.

As well as the three stations above ground on Komsomolskaya ploshchad there are two more below ground. Here the metro's Kirova–Frunzenskaya line intersects with the Circle line. The platforms in the underground station halls are almost always crammed with people, especially at weekends. Even here there is the smell of garlic and the more powerful smells which are perceptible only on the eastward-bound railway lines. But the transition from the one mode of locomotion to another, from that of the 'age of iron' to that of the underground, is made as gentle as possible. Shchusev, whose plans were used for the construction of the Koltsevaya line station in 1952, left his personal signature even on the underground: the hall could be that of a railway station, with an impressive vaulted ceiling and, along each side, a series of piers of pale marble (illus. p. 128). The ceiling is adorned with Baroque scenery: a painted heaven populated by the armies of Aleksandr Nevsky, Dmitry Donskoy and Mikhail Kutusov, and the parade of 7 November 1941. The creeping stucco foliage which I noticed up above in the restaurant is almost more luxuriant and conspicuous down here. Ceiling mosaics glint with gold. Shchusev, himself an oriental, eased the new arrivals from the East gently into their experience of the city. Only when the train

129

comes rushing in, pushing and compressing the air before it, are the newcomers forced to recognize that things proceed at a different pace here.

Postscript

At the Kazan Station even the most ordinary things acquire a mystical aura. Looking from the main hall through some large windows made up of bull's-eye panes, one can see a room that must be of huge dimensions and sumptuously coloured. The melamine-covered door below the windows bears the word *Restoran*. And in truth the restaurant resembles a church rather than a place designed for travellers, pressed for time, to get something to eat. It is a large hall about 12 or 15 metres high, with vaulting smothered with white ornamental stucco on a blue background. The stucco is so thickly laid on and three-dimensional that it suggests ferns spreading luxuriantly across the blue background. Here and there, spaces have been left free for some ceiling paintings, which appear to represent the achievements of the pioneers and the days of the first Five-Year Plans – these too in the mixture of bright colours and dark tones that we find in some Baroque churches in Germany. Down below, beneath this extravaganza of a sky, are several rows of tables with fine white tablecloths, napkins folded into the inevitable pointed cones, and sparkling china and glasses. On the walls are mirrors, too high to reflect anyone and serving only to make the room seem even larger; at one side a bar draws a few people together. Those who come here have plenty of time. This place is the very opposite of a cafeteria or snack bar; it is not situated where the mass of people pass by, but is a kind of artificially protected zone for those who can afford to spend time here. Perhaps, indeed, it only survives at all because of a preservation order.

14 Second-hand bookshops

What can be deduced from the titles that sell well in second-hand bookshops? – What was the nature of the city that once produced and read such books? – Clientele, neo-Kantianism, and the south-west German school of philosophy – Revolution in cover design, and non-sellers.

One way of discovering the nature of a city is to see what books are produced and read there. Ever since my first trip to Prague I have used a visit to the second-hand bookshops as an introduction to an unfamiliar city. Since then the bookshops on the Moat and on the Old Town Square have become terribly overrun, more by souvenir hunters than by knowledgeable bibliophiles. A visit to out-of-the-way shops like this initiates a sort of dialogue with whatever elements of the past have been preserved in the old books. In time I learned from experience that second-hand bookshops have a definite topography: in Vienna the selection of books on offer enables you to reconstruct the sphere of influence of the 'imperial and royal' Austro-Hungarian empire and its disintegration; in Berlin you notice the gaps left by the book-burnings and the wartime bombing; in Prague the mixture of German, Czech and Hebrew works bears witness to what was once a functioning symbiosis, and the position of books in the piles documents the historical sequence: the Austro-Hungarian period, Masaryk's republic, the Protectorate, and the flooding of the country with mass-produced Marxist– Leninist literature. The bookshops of Antwerp, Amsterdam or Strasbourg show that these towns were destinations or transit points for refugees, a fact indicated by the small volumes published by the Malik or S. Fischer publishing houses. A different kind of escape has left its traces in the second-hand bookshops of Istanbul, where Jack Kerouac, Allen Ginsberg and Timothy Leary lie gathering dust in cheap paperback editions.

Moscow's second-hand bookshops are different, as are the ordinary bookshops, and indeed the whole approach to books here.

131

There is none of that Western supermarket atmosphere, which is a reflection of both over-abundant supply and the public's perplexity when faced by too much choice. Here some books are sold out even before publication: the print runs of the classics are too small for their insatiable readers, crowds of whom queue almost weekly in front of the bookshops on Kuznetsky most or Pushechnaya ulitsa. So a book is often a rare item from the very first day – though this does not apply to the mass of ideological literature, especially collections of speeches and pronouncements by this or that leading politician.

The bookshops are always busy. Here buyers are searching for books, not the other way around. A barrier separates the customer from the books, the objects of his desire; he cranes his neck, he twists it to read the titles on the spines; he lifts his glasses to see better through the edges of the lenses. The saleswoman reluctantly puts down her own reading to pass across the counter the book he would like to look at. Making an impulse purchase as a result of wandering along the shelves, leafing through one book, immersing yourself in another, is something that can hardly happen here. The customer is passed the book that he specifically asks for. To this end there are card indexes on the counter, all classified with admirable rigour. The stock is organized with clarity, according to the Marxist–Leninist division into periods, and such discipline assists the seeker. What matters is not the author's name but the period to which he belongs, the movement or school of thought that he represents or to which he is assigned.

If people are eager for new books, they are even more eager for second-hand ones. It seems to me that people buy because there is no other way to get at the books, since often titles are published just once and then never again; they are prepared to pay the high prices asked, not so much out of a passion for books – though of course that does exist too – but out of respect for the work that is otherwise unobtainable, amid the general dearth of publicly disseminated ideas. The books offered in second-hand bookshops have rarity value not only because of historical circumstances but because going back to the original edition is often the only way of getting hold of the text at all.

One thing at least can be deduced from these second-hand books: the prices show how popular the ideas that they contain are, how high or low their stock is. If you compare them, the outcome is curious but has a certain logic. Thus for example the four-volume

collected works of Schopenhauer published in St Petersburg costs 250 roubles. That is ten times what you would pay for the collected works of Plekhanov, also second-hand, in the yellow-bound Ryazanov edition dating from the 1920s; and even the 40-volume fifth edition of Lenin's writings weighs lightly in the scales, as far as price goes, against Schopenhauer.

What is more interesting, though, is to see what types and periods of books appear here, and which of these are currently attracting interest. The collection of books might appear haphazard, but presumably it is not. The past, placed in a glass case or on a shelf, offers what the present veils in silence – and a great deal more. I see Vasily Rozanov's study of sects in nineteenth-century Russia, and parts of the Russian edition of the complete works of Sigmund Freud, published by the Psychological Society of Moscow University. And I see the anthology entitled *Suicide*, in which Lunacharsky, Rozanov and others attempt to diagnose the causes of the wave of suicides that marked the period of Stolypin's reactionary policies. The whole of German neo-Kantianism and the south-west German school are there under the glass of the display case. There, for example, is Wilhelm Windelband's *History of Ancient Philosophy* (St Petersburg, 1902); Wilhelm Wundt's *Problems in Ethnic Psychology* (Moscow, 1912); Wilhelm Dilthey, Alois Riehl and Wilhelm Ostwald in a combined volume (St Petersburg, 1909); or Oswald Külpe's *The Philosophy of the Present in Germany* (Moscow, 1903). What is striking is not that there are so many eminent German professors – one could add other names that mean less to us today, Ziegler, Pfänder, etc. – but that they reflect the fact that before the First World War the two Russian capitals were possibly more significant centres of the German philosophy of life and of south-west German neo-Kantianism than Freiburg and Marburg ever were. Readers were thoroughly up to date with current thinking, the Russian editions appearing very soon after the original ones. The reception of these works was internationally synchronized, so to speak. William James's *Pragmatism* appeared in Russia almost in the same year as it first came out in America. We remember the distinguished pilgrims who went to study at German universities, for instance Boris Pasternak, who was a disciple of Hermann Cohen in Marburg.

The second-hand material now lying lifeless in the glass case, and handled without much care or respect by the saleswomen, was once the stuff of lively controversy among the upper classes, eagerly read

and eagerly reviewed. And what an experience it was. Here we come face to face with the Viennese professor Ernst Mach; it was the Bolsheviks who resurrected him and built him up into a monster of the new Idealism. His book, *Knowledge and Error: Outline of a Psychology of Research* (Moscow, 1909), lies there peacefully under the pane of glass. Not quite empiriocriticism, certainly, but nevertheless one of the tools used to attack materialism . . . Naturally his Russian fellow combatants, or, to be more precise, the independent thinkers who were significant enough not to need to associate themselves with one of the European schools of thought, are also represented here: Gustav Spet, Vladimir Solovev and Nikolai Lossky. And Schopenhauer again: three editions of *The World as Will and Idea*.

Our view of that period would be unreliable, and in particular we would have a very inadequate understanding of the revolutionary social changes taking place then, were it not for the survival of at least some of the flood of magazines and the like poured out by the better end of the popular press. These are represented here by journals of popular science, magazines for devotees of naturism, sport and physical training, ladies' and fashion journals, and magazines dedicated to racing or to ethnological expeditions. Some of these publications are in colour. In among them, like rubble lying between collapsed pillars, there are oddments from the stocks and libraries of an imperial finance department, a theological academy, a seminary, a People's House.

The moral anxieties of those days emerge quite clearly – although in the field of the 'problem of the sexes' and the pathology of human desires the authors are mainly foreign. More than once I encounter Professor August Forel's *The Sexual Question*, published in St Petersburg; another pioneer of psychology, Dr Richard von Krafft-Ebing, is represented by his *Psychopathia Sexualis*. Between these lies a magnificent copy of the sixth volume of Dr Heinrich Graetz's *History of the Jews* (Odessa, 1905). Several of the titles indicate how much interest there was in Eastern religions. I count five titles on Buddhism alone.

And what is the price asked for Vasily Rozanov's *The War of 1914 and the Russian Renaissance* (Petrograd, 1915)? One hundred roubles! A hundred roubles for a slim volume in which that catastrophic conflict is described as the great opportunity of rebirth for the collapsing Russian Empire!

The pre-Revolutionary period presents an impressive array of names that have retained their resonance: the art historian Wilhelm Hausenstein, the Austrian writer Peter Altenberg, Vasily Rozanov, the authors Dmitry Merezhkovsky and Zinaida Hippius, and the historians Aleksandr Kizevetter, Mikhail Lemke and Vasily Klyuchevsky. That period still has an aura of luxury and an unshakable certainty that life will go on serenely unchanged, as evidenced by well-produced travel guides to German spas, to Peterhof, Venice, Nice or Yalta.

Times change, and books change with them – but here this evolution can be followed only up to the early 1930s. It may be that what was produced after that is not obtainable second-hand but is available for use, with the full sanction of the authorities, in libraries, reading rooms and archives. I cannot imagine that there would be no demand for it on the antiquarian market. Of course there has already been a boom in *stalinistica*! Very high prices have been paid for rare items such as the eulogy on the builder of the White Sea–Baltic Canal, Feuchtwanger's over-sanguine travel report written in 1937, and even Stalin's *Short History of the Communist Party of the Soviet Union*, of which millions of copies were printed. And higher prices still for the protocols of the trials of the Trotskyites and others accused of 'duplicity'.

Today's censors censor those of yesteryear. In one antiquarian bookshop I overhear an exchange between the saleswoman and a man wanting to sell his thirteen-volume edition of Stalin; she refuses outright, saying that it cannot be done.

When I tell an acquaintance how amazed I am at what can still be found in the Moscow second-hand bookshops, he says that far more has been saved in Russia than in Germany, not just because books are respected but because the Stalinist machine simply did not work as perfectly as the efficient Nazi apparatus.

In the years following the Revolution there must have been an immeasurable flood of books. The Revolution dissolved the libraries of the aristocracy and bourgeoisie, sometimes even burning them down, as in the case of Aleksandr Blok's library. The inhabitants of Petrograd and Moscow, dying of cold and starvation at the time of the Civil War and the foreign intervention, were forced to overcome their scruples about books and use them as fuel in their stoves, simply in order to survive; and some of the revolutionaries had never held a book in their hands and so had never had the chance to

Publishers' imprints from the period 1910–30: I. D. Sytin, 'Skorpion', 'Krug', Workers' Central Publishing Company (Moscow), State Publishing Company, World Literature, Land and Factory, Academiya.

'From about 1907 onwards publishing houses were shooting up like mushrooms. There were more concerts of modern music, and art exhibitions followed each other in quick succession, put on by the *World of Art*, the *Golden Fleece*, the *Jack of Diamonds*, the *Donkey's Tail* and the *Blue Rose*. The *Golden Fleece* exhibitions, which were held in rooms dimmed by curtains and with hyancinths placed all around giving off an earthy greenhouse smell, included paintings sent in by Matisse and Rodin. They had the young people on their side.'
Boris Pasternak, *I Remember*

develop a reverence for books. The Bolsheviks themselves were men of the pen to a greater extent than any group of political leaders in the whole previous course of history, having for the most part grown up in a milieu where a cultured familiarity with books was natural and normal; they were obliged, however horrified they might be, to stand helplessly by as such 'excesses' were perpetrated (though these were not really excesses, but simply an expression of the destructive potential inherent in any major revolution).

While an aesthete like Vyacheslav Ivanov was still declaring that the abolition of the hard sign , ъ, by the revolutionary language and spelling reformers was a scandal of the first order and preparing to fight to the death for it, the contents of the libraries, which in Russia were revered as places of culture, indeed holy places, were scattered to the four winds. In the 1930s the NKVD unit ordered to search the house of Gustav Spet took a full two weeks to comb through the polyglot scholar's superb collection of books. The phenomenon that was noted in the antiques market following the Revolution in Russia

– the flood of exquisite furniture, effects and priceless objects that appeared, far exceeding the similar spate released by the French Revolution – no doubt had its parallel in the market for antiquarian books. This seems to me the only possible explanation for the range and quality of what can now be seen in Moscow.

The new age began with new-style book covers. Concentric squares, black on a white background, grace the small volume of texts by O. Molchanova accompanying woodcuts by Dmitry Sobolev. On Boris Pilnyak's cover for his 'American novel' *OK* we gaze into the canyons between New York's skyscrapers (or is this some of Malevich's Suprematist architecture?). This is the time when the neat gold edging breaks up and scatters, and cable patterns and garlands are removed, leaving the bare white surface of plain card. One can recognize the seminal influence of a single work by Lissitzky, his cover design for Mayakovsky's *For the Voice*: a complete rethinking of packaging and of the word, a design made with the reader in mind, distilled down to its essentials, like a poster. But alongside this there is still the free-spirited art nouveau style of decoration, showing how the period was swept along by radical change even before 1917. (There are also some cloyingly sweet designs, like the cover for *Blood Red* by Merezhkovsky, Hippius and Dmitry Filosofov.) The bareness of the design of slim volumes by Anna Akhmatova, Aleksandr Blok and Eduard Bagritsky is not merely a response to the scarcity of paper, it is also a programme, an expression of confidence in the power of the word, which needs no visual flourishes and no ingratiating appeal to the eye of the purchaser.

And what an abundance of names, of authors but also of publishing houses: Petropolis, Alkonost – Andrei Bely's *Queen and Knights*, published in St Petersburg (how obstinately the name still clings on, even in 1919) – or the Berlin houses publishing in Russian. You find things you would not have dared to hope for, for instance, four issues of the periodical *The Modern West*, with a highly up-to-date and representative survey of cultural developments in the West. Kasimir Edschmid, Jakob van Hoddis, Jean Cocteau, the whole bunch of the Dadaists, Bernard Shaw and also Oswald Spengler, all presented under a cover that shows a world bursting into pieces (cubes, squares, angles, on brown cardboard). Of course the favourites among Western social critics are also represented: Theodore Dreiser, John Dos Passos, Upton Sinclair, Frans Masereel, Käthe Kollwitz, and Arthur Holitscher's *Autobiography of a Rebel*.

Though the paper was often of poor quality, books were produced that are still objects to be picked up and handled, pages on to which the letters have been printed so firmly that the surface of the paper is roughened and the letters are in relief, a kind of Braille – so different in quality from much of what is produced today, where the printed word on smooth brownish paper with a high wood-fibre content is often hard to make out. (How amazed and delighted Russian friends are by the 'India paper editions' published by such houses as the Insel-Verlag: such miracles from the world of book publishing apparently no longer exist here!)

Eventually I strike lucky. Leafing through the card indexes on the counters, I actually find the first issue of *Parthenon*, a small volume of essays by bourgeois intellectuals who in 1922, at the start of the NEP, believed once again that the new era for which they too had fought had dawned after all. The volume is tattered; its cover shows a snake (what snake, I wonder?). In the book, Yevgeny Braudo writes about the crisis of music in Russia and in the West; Aleksandr Izgoev – persistent and outspoken as ever – about the tasks facing the *intelligentsiya*; and there is a review of Oswald Spengler's *Decline of the West*. The pages are yellowed, the cover is torn around the edges and the binding has come apart; there was probably something wrong with it even when it came new from the press, because the sheets are unevenly cut. But the design and layout are done in the old style, which had reached a high level of excellence in pre-Revolutionary publishing – Lissitzky could never have created his own revolution in book design had it not been for the culture of the so-called thick journals of the pre-1917 period.

Not everything that one would like to buy is for sale, and in fact the foreigner cannot buy anything at all, even though he is the one most able to afford it. The exporting of antiquarian books is not allowed. One is almost glad to learn this – it is quite disturbing enough to think of the many other treasures that people with hard currency have carted off for want of other consumer goods. It is an uncomfortable regulation, but there is a lot to be said for it: it means that these fragments of national culture, though not always highly regarded, at least stay in the country. This effective prohibition on buying anything makes a visit to the city's antiquarian bookshops doubly unreal – perhaps that is why it is so hard on the nerves! Every round of the bookshops leaves you feeling as though you have been in a battle, or taken part in a hunt where you sighted the quarry but were not allowed to go for the kill.

Covers: *Press and Revolution* (1927), LEF, *L'esprit nouveau*, Mayakovsky's poem 'Lenin' (1923), *Book and Revolution* (1929), *Russkaya Mysl* (1905), *The Golden Fleece* (1908), Samizdat publication of Aleksandr Urusov's *Cry of the Distant Cranes* (1965).

This time a passing glance did open up a trail to follow. In the 'House of the Book' on prospekt Kalinina I really only meant to have a quick look at the slim volume of illustrations of Moscow by Dmitry Sobolev. But then I could hardly believe my eyes, for there, listed on a hand-written notice, were a host of issues, if not quite complete annual runs, of the periodical *Zolotoe runo* (the *Golden Fleece*), published between 1906 and 1909 by the artist and patron of the arts Nikolai Ryabushinsky, who belonged to one of Moscow's prominent families of industrialists and bankers. The last year of the journal, no longer bilingual, can be had, complete, for 250 roubles, the equivalent of almost 1,000 German marks. Not something to buy, but rather to look at and admire. There they lie, large-format, square magazines bound in grey, reddish or brown board, imprinted in gold letters with *Zolotoe runo* (there is a brand of cigarette, one of the more expensive, aromatic brands, that still uses this luxurious-sounding name) and *La Toison d'Or, Journal artistique, littéraire et critique*. What I had previously seen only in the library's rare book department was

here simply being offered for sale. Among the contributors are Aleksandr Benois, Valery Bryusov, Konstantin Balmont, Maksimilyan Voloshin, Sergei Gorodetsky, Dmitry Filosofov, Konstantin Syunnerberg, Aleksandr Blok. In each issue an artist is featured, with reproductions that are of respectable quality even by today's standards, each protected by a sheet of rice paper bearing the *Zolotoe runo* stamp. Luxuriousness as a style. The issue featuring Viktor Borisov-Musatov's bathing ladies, park landscapes, spring scenes and rococo boudoirs dates from 1906, while the Revolution was still going on – but the periodical's style does not change even when thousands are condemned to death and the waters of the Moskva are red with blood. If anything it becomes even more ostentatiously luxurious. This does not, however, prevent the magazine from printing the text of Blok's sensitive and self-critical lecture, 'Russia and the Intelligentsia'.

Where the *Golden Fleece* rides the waves, the periodicals of the Argonauts and their successors cannot be far away. And so it is: the same department of the 'House of the Book' is also offering incomplete runs of *Apollon*, the last issue dating from March 1917. This journal is less showily produced, but also square in shape, though a little smaller, and the price for a single issue is up to 45 roubles. The list of contributors is undoubtedly even more impressive than that of the *Golden Fleece*, sometimes seen as its rival. By 1917 it was already in its eighth year of publication; among that year's contributors were Maksimilyan Voloshin, Sergei Makovsky, Abram Efros and Nikolai Punin, with Yevgeny Braudo for music, and Anna Akhmatova, Yurgis Baltrushaitis, Aleksandr Blok, Nikolai Gumilyov, Osip Mandelstam and Boris Eikhenbaum for the literary section. The March issue opens with a colour reproduction of Meyerhold's portrait of the painter Boris Grigorev, showing him in top hat and tails, gesticulating, in front of a male oriental dancer in red. Further on there are reproductions pasted in, of pictures by Ilya Repin and of the studies of Versailles by Aleksandr Benois. The Revolution that had just taken place is not reflected in the journal at all, except in its calendar of events section. The arts, which had long anticipated the Revolution, took their time before reacting to the immediate course of contemporary events: they had no need to do so. In another issue, this time from 1915, there is a major study by Punin on Japanese engraving, with excellent reproductions, together with an essay by Osip Mandelstam, and correspondence from Kiev, Odessa, Moscow,

View along Nikolskaya ulitsa, a centre of the book trade (now ulitsa 25 Oktyabrya), 1886.

Paris and Italy (letters, that is to say, from Kandinsky, Benois, Diaghilev . . .). A man goes up to the counter, asks about the availability of specific issues, takes down the details in his notebook and disappears again. Probably to telephone his wife and discuss whether or not he should buy them while he has the chance – whether their household budget will stand it.

To me all this seems incredible, and I ask the saleswoman whether periodicals of this kind are often on sale; she suggests that I should go and look in 'Voennaya kniga', a bookshop specializing in militaria, on the Old Arbat. I go there and find a queue of people already waiting; as soon as the shop reopens after lunch, they rush inside, for only a certain number of people at a time are allowed past the counters. Here too I cannot believe my eyes. Among the items offered for sale are issues of the magazine LEF dating from 1929, a study of Moscow student life reprinted in 1918 – describing the 'deliberately exotic type', the *'bon vivant'*, the 'Bohemian', and so on – the sixth volume of Graetz's *History of the Jews,* and on one shelf whole volumes of the 'thick journals' *Vestnik Evropy* (the *Messenger of Europe*) and *Russkoe bogatstvo* (the *Russian Treasure*), most of them from

Cover of the journal *Mir iskusstva* (1903), edited by A. Benois and S. Diaghilev

libraries. (In many cases the bindings have been reinforced, so the covers are not as they originally were.) The majority are in very good condition. The volumes (of up to 400 pages, as is only fitting for a 'thick journal') cost 3.50 roubles each. In one issue I find the significant article 'Sectarianism and Psychiatry'. However, there is no sign of the most important liberal journal, *Russkaya mysl* (*Russian Thought*). There is a great press of people, and they are impatient; those behind me want me to hurry, and in my haste I leave my umbrella behind.

The landscape of Moscow's new and second-hand bookshops is nowadays deeply fissured; the original centre where these shops were concentrated from time immemorial – in and around Nikolskaya ulitsa, now ulitsa 25 Oktyabrya, where in 1564 Ivan Fyodorov initiated the age of Gutenberg in Russia – still survives in part. Thus Kuznetsky most, Pushechnaya ulitsa, Stoleshnikov pereulok and ulitsa Arbat have remained streets dedicated to books. What have wholly vanished are the great names of Russian publishing houses and publishers: those of Kushnerev, in whose printing works Kandinsky undertook a period of practical training, Mamontov, Sytin, the Sabashnikov brothers or the St Petersburg publishers Suvorin and Wolff.

In an antiquarian bookshop on Kuznetsky most the unthinkable happens yet again. In addition to *Apollon* and the *Golden Fleece*, there are three issues from one year of the periodical *Sofiya*, once again with magnificent reproductions, and with articles on the rediscovery of Old Russian architecture and on Asiatic art. The sales assistant urges me to buy all three issues, which I decline to do, saying that this is not my field of interest. Would that that were the only reason! And then I ask casually whether they have *Mir iskusstva* (*World of Art*), and without turning a hair she replies that they have, but unfortunately only two issues. And she hands me issue no. 7 of the year 1904, perfect in its design and layout, with a pattern in pastel shades rather reminiscent of a wallpaper. This issue, edited by Diaghilev and Benois, is devoted to Moscow Classicism; the main essay accompanying the splendid reproductions is written by Ivan Fomin, who exactly 20 years later was to become the protagonist of a proletarian classicism in opposition to the Modernism of Ginzburg and the Vesnins. Here, in association with Diaghilev and Benois, Fomin is still able to subscribe wholeheartedly to the fairy-tale of Moscow Classicism; and how obvious it is here that not just one path, but many, led from the *World of Art* to the 1920s. The Palace of Versailles, Piero della Francesca, the dream of St Petersburg, Peterhof – all these, as well as Malevich, are part of the legacy inherited by the 1920s.

The succession of startling finds keeps fatigue and exhaustion at bay. And what greater contrast could there be to the forms and the music of decorative styles than the posters of the first Five-Year Plan, with their forceful colours and strong shapes, the cranes, the gaping shafts of the metro, the excavated pits for construction work, the sportsmen, the collective farmers, all depicted here in a naively emotive manner, without the stylization that came with the later 1930s. It was all still unadulterated enthusiasm – at least so far as the official interpretation of this aspect of industrialization was concerned (and yet the general offensive against the village was already beginning!). But there was still the rhythm of Aleksandr Deineka, and Kuzma Petrov-Vodkin's use of colour; one has to bear that in mind when thinking about this period. Already, perhaps, the portrayal of the New Man is forced, but not unduly so. Volumes like this remain unbought, despite being well produced and despite the quality of the painters, not just because of the price but because, in the era of the tenth Five-Year Plan, there is little interest in art from

Hotel Metropol.

'The foyer of a hotel like this is still the old foyer. But beyond that there is no longer anything about it, or indeed in it, of the foyer that one expects to find in a major city. The elegant lounge chairs which used to be occupied by women smoking, dashingly turned-out officers, fat provincial merchants, manufacturers, tourists, etc., have disappeared. The mirrors are wholly or partly clouded. One large stairway mirror in the Metropol still has a bullet-hole from the fighting at the time of the Revolution. The zealous hotel commissionaire with his cane no longer exists, the haberdashery, confectionery and newspaper stands are only a memory, and there is no grand prince taking whole suites of rooms. Everything is matter-of-fact and businesslike. On the other hand, you do not get fleeced . . .

Naturally the rooms in these Soviet hotels still have their splendid furnishings from the old days. But these furnishings, the Empire-style sofas, the plush-upholstered chairs, the little Rococo tables, are all fading, just like the bourgeoisie itself.'
Alfons Goldschmidt, *Moskau*, 1920

the time of the first Five-Year Plan. If other periods – periods of affluence, of the rejection of asceticism, of luxury, of highly sophisticated art – are highly sought after, this tells us something: there is a fertile soil for the reception of such art, evidently because people feel a need for it.

Though the book as an object appears so passive and wholly dependent on being picked up by someone interested in it, it would be wrong to try to deny that it has, in a real sense, a life of its own. Books, too, have lived their lives, in most cases they have

144

experienced remarkable odysseys, narrowly escaping death on more than one occasion, and they bear the scrapes and scars of all this. Only rarely do they have the good fortune to return to the place where they were conceived, produced and sent out into the world. This thought occurred to me in the second-hand bookshop on the street side of the Hotel Metropol. Here the shelves still held issues of the periodicals the *Scales* and the *Gryphon* – damaged but saved, battered but not discarded – in the very building that housed the editorial offices of these very journals, before the Revolution. But their journey through time is not yet at an end.

What makes us feel that we absolutely must have a particular book? I do not think it is simply that one is moved as one is by the sight of ruins; it is rather the hope that through owning, taking direct possession of the book we may be able to make contact with the author who has taken on this material form. Nor is it merely a question of quality – a reprint could offer us more perfect quality. It is ultimately the hope that something of the lustre or the spirit of the times may descend upon us, upon the temporary owner who makes the book he has bought part of his own personal world. This is one of the ways in which, having summoned that past age back again, we try to encompass it, to make it stay with us – such is our illusory dream – for ever.

What constitutes a rare or precious book is a matter of contention, because such things are relative. In the world of the book, as elsewhere, there is a divergence of views. The kind of books that are sometimes sold at knock-down prices in the big department stores in the West – and that includes the writings of St Augustine or Trotsky's biography of Stalin, just as much as cheap crime novels – are inaccessible here. The piracy or self-publishing that was so common in the days of our student revolt and which over the course of time actually gave our large Western publishing houses an intellectual blood transfusion, goes under the name of *samizdat* here in Russia. To possess *samizdat* literature is risky, to produce it hugely so. How, then, is one to set a value on books in a world that has turned its back on Gutenberg? The world of books reflects what ranks high or low in the structure of society, what is judged to be valuable or valueless.

I shall not venture an opinion as to what should be held in the highest regard here. Among intellectuals the answer is fairly clear: Mandelstam, Gumilyov, Fyodorov, etc., etc. So to them the material that I collect seems rather eccentric and not worth keeping. This

includes apparently unimportant accounts of the Stakhanovite movement as seen by a Moscow worker; a very committed account of Moscow's internationalist outlook; documents of the struggle of the Party against the post-Revolutionary underground political parties; a history of industrial architecture in Moscow, and similar things. But among my collection I find a picture of the German communist worker Hans Klemm, who played a part in building up the new society (I wonder what became of him?); I find photographs of the bourgeois women detailed for labour duty in 1920; I find any number of pieces of evidence about the period, some of them in language that conceals nothing and has nothing to conceal, for instance the reminiscences of veterans of the metro construction work. For them this was the most heroic phase of their lives, when they invested all their strength in building a world that in their eyes is still intact today. They can point to many achievements, they can tell their stories at great length and come up with details for which there would be no room in large-scale historical accounts, or which would mean little in that context.

A period that speaks confidently of itself provides us with different information, and in a different way, from one that is already ashamed of its past.

15 The strong man and the hero

The differentia specifica *between sport in Moscow and solitary joggers lowering their stress levels in Central Park – Bodies as text: the baths, and the bemedalled uniforms of war veterans – Youth and decadence in Shostakovich.*

Any visitor to Moscow is aware that the Soviet Union is the dominant power in almost all forms of sport, and that in some it has had an uninterrupted monopoly for decades. It is also well known that these records have been achieved, or so it is claimed, on the basis of the principle of mass participation. There is evidence in plenty: the lists of record holders, and of course the results of successive Olympic Games and all manner of world championships. And booklets on these subjects provide endless statistics.

In this numbers game Moscow itself is no exception; in fact, it is the leader. The city has 60 large stadiums, more than 2,000 sports halls, 45 swimming pools, 400 football pitches and a vast number of athletics arenas and sports palaces. There is almost no social institution, no factory of any size, that does not possess its own sporting organization; around 3,200 'physical training collectives' and more than 100 clubs – among them such famous names as Torpedo, Hammer and Sickle, and Spartak – bear witness to the 'mass participation in sport' in which about a million of Moscow's inhabitants are involved.

With an acquaintance from abroad I discussed my first impressions and the question of whether sport really is practised here differently and on a larger scale than in, say, Germany or America. In those countries such statistics are not generally available, if only because they do not fall within the ambit of social organizations, given that participation in sport is largely an individual activity.

Despite the statistics and the acknowledgement of the qualitative difference between 'sport for the masses' and 'bourgeois elitist

sport', an unresolved question seemed to be left hanging in the air. One thing that is certain is that *fizkultura* (physical culture) and sport are a component of public life, and therefore fall within the sphere of state politics, to a far greater extent than in almost any other country. The central importance of sport is reflected in the physical layout of the city. Sport is not squeezed out to the edges, to the marginal tracts of land unsuitable for building or industrial development, or the islands left where motorways and railway lines intersect in the suburbs – in other words, to areas of unused and unusable wasteland. Instead, sport is practised in the most visible places. This is true not only of the Lenin Stadium, located in the south-west of the city, less than ten minutes by metro from the Kremlin and still within the loop of the Moskva, but also of the other sports facilities, large and small. This approach is already evident in all the drafts for the 1935 General Plan for the Reconstruction of Moscow. (Thus for instance the main sporting locations envisaged by Le Corbusier's outline plan more or less correspond to those that exist now – the Luzhniki and Dinamo stadiums, and the Olympic Sports Complex on prospekt Mira.) It is also noticeable that the smaller facilities are deliberately correlated with areas of residential and industrial development.

The association of physical training with the political sphere (a phenomenon that may at first seem strange to us) can be traced, together with the history of Soviet sport in general, in the small but interesting Museum of Physical Culture and Sport at the Lenin Stadium. Inevitably it was Lenin, once again, who signed the first decree to speak of the physical training of the proletariat – no longer was it to be regarded as a mere leisure-time indulgence – and to point to the close relationship between physical effort in sport and at work, the strengthening of the will, and so on. Illustrations tell the story of the first Workers' Olympiad held in Omsk in 1920; there is a copy of *The Ant*, the 'central organ of the Central Council of Proletarian Associations for Physical Culture'; there are pictures of Feliks Dzerzhinsky, the head of the Cheka, as honorary president of the Moscow Proletarian Sports Organization (MPSO); a massed rally of proletarian sportsmen and women in the Dinamo Stadium in 1925; and Nikolai Podvoisky as president of the Red Sports International, which was founded in opposition to the bourgeois and 'yellow' sports organization and was intended to set traditional workers' sport, which up to then had been the domain of Social Democracy, on the Bolshevik track of revolutionary October. There is

148

plenty of evidence for the conscious integration of physical culture into the new world that was being built. In what political arena did weight-lifters and wrestlers and the like give demonstrations of their prowess? In Red Square. The ski relays over the 10,000 kilometre course from Khabarovsk to Moscow in 1928 or from Moscow to Oslo in 1927 were inspired by more than just sporting ambition. Another exhibit is a 1927 Berlin poster, in German, announcing: '24.8., 6 o'clock, on Vorwärts-Süd-Platz. Leningrad, Putilov Works'.

The football team of the Petrograd bastion of the Revolution, actually in Berlin! By the same token, the conquest of the highest peak in Pamir was not solely a sporting achievement, or else why would the climbers have chosen to name it Pik Lenina?

Over the course of time there were changes in sport's publicly cultivated image. Immediately after the Revolution and in the 1920s the aim was to present proletarian mass sport as a counterweight to bourgeois elitist sport, and the first proletarian Spartakiad in Moscow in 1928 was in deliberate competition with the Amsterdam Olympic Games in the same year. Unintentionally – and this is evident in the pictures too – there was a fusion here of elements of the Wandervogel and Zugvoge hiking movements and the culture of open-air activities (all of largely Social Democratic inspiration and dating from the period before the First World War) with a naïvely internationalist view of labour.

The statistics of the organized sporting movement are impressive: between 1924 and 1927 the number of clubs rose from 2,842 to 13,803, and the number of participants from 311,200 to 911,000; most of the participants evidently came from the urban proletariat, for in 1924 there were 295,200 from towns and cities and only 16,000 from the countryside. The naivety of the 1920s shows itself in the way sport was pursued for its own sake, with the setting of records only a secondary issue. This plainly changed with the coming of the Five-Year Plans and industrialization. The Spartakiads became more disciplined, discarding all that had to do with mere play or exercise for its own sake; the Stakhanovite principle seemed to spread into sport as into other areas; and the object now was to produce outstanding achievements (the conquest of the peak in Pamir, the flight over the North Pole, the flight from America to Russia) in the name of the homeland of the working class. It was a time when every boy dreamed of becoming a pilot.

The contest: photograph by Georgi Selma, Moscow, 1935.

A few years later the connection made between work-related and sport-related physical activity was replaced by that made between physical strength and strength for combat, and between the cunning and tactics employed in the military and those employed in sport. Rowing proved to be a useful preparatory training for army engineers throwing bridges across rivers; climbers became mountain soldiers; and it was a short step from wrestling and fencing to close combat and fighting with bayonets. 'Red sport: seize the enemy, crush him, destroy him!' and 'Heroes remain heroes' are headings found in sporting magazines from the days of the Great Patriotic War against Hitler.

The post-war period saw the integration of Soviet sport into international sport, and the second part of the museum tells of its successes – from Helsinki in 1952 to Moscow in 1980. But this was not a return to the internationalism of the proletarian sports movement: the Spartakiads were eclipsed by the Olympic Games and became an internal Soviet affair or else an arena for the countries of the socialist bloc.

The museum is also a museum of trophies: Polish porcelain plates and Venezuelan pistols, objects made of Dortmund steel and other

presentation pieces where what counts is not the quality of the design but only the plaque engraved with the title and year. The museum itself is evidence of the special status of sport. Physical training is much more than an activity pursued by people as private individuals: it is *a priori* a social matter. The competitor's sweat is expended, as it were, for the benefit of society and by the same token is rewarded by society.

And yet this is not the thrust of the museum's whole collection. It also has a file documenting the history of sport in Russia before the Revolution. This file accurately shows the aristocratic lineage of pre-revolutionary sport: riding, sailing, rowing and, only at a much later stage, football and skiing. It also covers the beginnings of the sporting movement among the bourgeoisie, and points to the importance of traditional forms of sport among the common people. We learn that the writer Vladimir Gilyarovsky, that unique Muscovite with an unparalleled knowledge of the Moscow scene before the Revolution, was one of the founders of the Moscow Gymnastics Association; another was Anton Chekhov.

Predictably, the era of bourgeois sport is represented by a mere handful of pictures. Most of these show either aristocratic sports or sports that have all the characteristics of a hobby and often a tendency towards acrobatic performance, as in the pictures of the wrestler and weight-lifter Chaplinsky, and those showing the athlete I. M. Potrubny – the 'Pride of Russia' – or the display team of the St Petersburg 'Sanitas' gymnastics club. One cannot help being reminded of the 'strong men' and human prodigies of the circus ring, and one can imagine that Potrubny must have caused as much of a sensation in America as Shalyapin did in his day. So these are pictures of amateur, acrobatic or aristocratic pursuits, and not of bourgeois, let alone capitalist mass-participation sport. One might see this as a further sign that the bourgeoisification of Russian society was interrupted before it had got into its stride.

However, I am not concerned with this as a historical matter, but in terms of how it relates to my impressions here and now. It seems to me that sport here still has a great deal to do with the exercise of strength and physique, with the gauging of physical resistance, with bodies engaged in combat, in other words with an attitude to sport that at first sight is submerged beneath the more visible preoccupation with officially promoted Olympic sport. I think that here there is as yet no rift, still less an actual opposition, between

strength and intelligence, 'body and mind', individual will and imposed discipline, friendly association and sporting combat, light-hearted rivalry and serious competition. One might describe it as a state of affairs in which the solid reality of contact with the soil and the strike of hammer on anvil is still palpably present, and the strength driving the body is not merely a redirection of energies that would otherwise find no outlet. As evidence of this I could point to the long-standing supremacy of Soviet sportsmen and women in all those sports that require elemental strength. Soviet sportsmen and women originally achieved this dominance not on the basis of scien-tific or Taylorist training and building of strength, but simply because that strength was present in them as a natural reserve which had not yet been subjugated to the machine and the Protestant work ethic. Perhaps this statement reinforces a deep-seated piece of con-ventional thinking of the kind that I am trying hard to avoid. But let me say this again in a deliberately overstated way, as a spur to fur-ther reflection: capitalist mass sport is an attempt to restore the unity and integrity of human motivation that has been destroyed by the division of labour, Taylorist principles of scientific management and the internalization of discipline. Performance is achieved by the denial of natural drives – it is 'physical *culture*' in the strictest sense. 'In the sweat of thy face shalt thou have dominion over the world, including thine own body.'

In Russia, on the other hand, the division of labour and Taylorism are not yet sufficiently advanced, and discipline is still too much imposed from outside and from above to have been able to subju-gate the 'inner man or woman'. The enormous external pressure cor-responds to an inner nature that is still relatively untouched by internalized social compulsion. Sport has not yet become an attempt to reconcile divisions of motivation, but is the spontaneous activity of the human being who is still integrated. It is not inner discipline or an inner compulsion that drives an individual to put his strength to the test, but the confrontation with a stronger opponent. 'In the sweat of thy face canst thou gain dominion over the world and espe-cially over thine antagonist.'

In the case of the Western European, inner factors determine his outer performance. Because he expends energy in controlling his inner nature, that energy is not available to him when he is in con-tention with an opponent. In the USSR the development of sport in a bourgeois direction may still lie in the future, but when it comes it

will threaten to destroy the pre-bourgeois attitude to physical activity. A jogger in Manhattan's Central Park and one in the Luzhniki Park near the Lenin Stadium may appear to be doing exactly the same thing, but this appearance disguises the *differentia specifica* between them.

Shostakovich is a master of quotation: he draws upon tango, foxtrot or Charleston with all the assurance of a pianist who has himself spent more than enough time accompanying silent films in the dark. He lets us sense not only the pianist's ironical attitude towards his instrument, so unsuited to the new medium of film, but also the detachment of one who is expected to participate in building a new world. That, at least, is the first impression given by a performance of *The Golden Age*, the ballet composed by Shostakovich in 1929, which, after long neglect, the Bolshoi Theatre has revived with some minor modifications.

In this music Shostakovich gives expression to the conflict of youth with the feeble caricatures of an enfeebled old world, the struggle between the decadent world of the NEP bourgeoisie and the daredevil militants of the Communist Youth Movement. Here the strong man is not only contrasted with the body that is in decay, but is a cult figure representing the future: Boris, the leader of a gang in Odessa and an activist in the Komsomol, has nothing in common with the prostitutes and NEP men amusing themselves in the Golden Age Café. Naturally this is a love story: the girl, Rita, is rescued from the lures and the leers of the NEP men. But, strangely enough, the most powerful scenes are those that show the bourgeoisie: we see a tango in which every movement freezes; bodies bending and pressing up against each other and yet remaining strangers; a circling ritual of two-step and foxtrot. Everything is just as George Grosz drew it – angular, pointed, evoking slogans and posters. Shostakovich was creating music in the spirit of Grosz; again and again there is the mocking laughter of clarinets, the braying of saxophones, the schmaltzy swaggering of the piano, interjected notes on the flutes that call everything into question, and again and again the collapse of rhythms that started out with so much *élan*, and finally a strident *con sordino*.

The picture is credible, at least from the historical point of view. But the strong man is undermined by the genre itself: even the Black Sea sailor loses something of his turbulent impetuosity when – as

far as I can judge from my own impression – he has to conform to the choreographic canon of classical ballet. And Rita, despite all attempts to achieve 'naturalness', cannot avoid awakening associations with Giselle. What is quite unsuccessful, to my mind, is the Agitprop group, which impresses more by its undulating sea of red flags than by any futuristic choreography. The sailors' brawl, the *valse triste* in the 'Golden Age', the splendid Master of Ceremonies in the guise of a harlequin: taking all the scenes together, it is the bourgeois world that comes off better because it is more adequately portrayed. It has a kind of acceptable malevolence – acceptable because the chronological distance gives every conflict the patina of remote history – and yet it seems more accurate and convincing.

Shostakovich, who grew up in St Petersburg and was shaped by its manners, and who was the most physically fragile and yet the most resilient musician in the Soviet Union, must always have felt within himself both a respect for self-doubt and an awareness that with artistry founded in self-doubt one could achieve little in the historic times in which and for which he lived; a deep-seated fear of coarseness and violence, and yet at the same time an almost envious view of the type of man who is as strong as an ox and knows no uncertainty. One can perfectly well believe his confession that he envied Tukhachevsky – the army general who not only took violin and composition lessons with a pupil of Shostakovich's but also became an outstanding violin maker himself – for his unshakeable good health. Yes, he envied the general, who was able to sit a person on a chair and lift both into the air. Tukhachevsky was executed in 1937.

Perhaps this composer's whole œuvre may be seen as a continuous battle between the strict, disciplined principle of form ('St Petersburg') and the inexhaustible vitality of the Russian nation.

At that time the idea of the strong proletarian Renaissance man was not merely a myth, and it need not be one today. What would happen if that scenario from the distant 1920s were transposed, with its familiar clichés and myths, to the present day – for the themes are sufficiently universal to be transposed without any of the violence that is often done to older works in radically modern productions. Where are the present-day battle fronts between the old world and the new, between the heirs of the NEP bourgeoisie and those of the youth of Odessa?

At that performance on 4 May 1983, the attention that would normally be focused wholly on the stage was somewhat diverted

154

Baths, oil painting
by Ivan A. Puny.

by the presence, in what used to be the Tsar's box, of eminent
personages – Erich Honecker and Willi Stoph, Andrei Gromyko and
Nikolai Tikhonov – who stayed to the end of the performance. The
guests rewarded the ensemble with magnificent bouquets. It was
not ever thus: almost exactly 50 years earlier, Stalin had walked out
of the Bolshoi Theatre during a performance of Shostakovich's *Lady
Macbeth of Mtsensk*.

People's bodies, too, provide us with texts. These need not take the
form of tattoos, though tattoos are very popular here, whether as
a token of eternal love on the back of the hand, a memento on the
upper arm, or a substitute ring that can never be taken off the finger;
a tattoo is, of course, a statement in itself, a promise delivered by
one's own body, one's own skin, for as long as the body lives. Nor
do I mean the naked body itself, though here it perhaps tends to be
more muscular, broader, stronger, more peasant-like, still, than in
our Western societies.

No, what I have in mind, having come to know the *banya*, or
public baths, is something else: a relationship to the body that is still
untroubled, unsullied, indeed chaste, where there is no social disap-
proval of touching another person's body and no trace of the sort of
attitude that turns into prudishness. This is nakedness as a given
state and not as something regained with a conscious effort. It is the
handling of another's body – soaping it, 'whipping' it with birch or
oak twigs to stimulate the circulation and induce sweating, in short
the whole accepted ritual of the Russian steam bath – not compli-
cated by any automatic association of nudity with intimacy. It is also
an act of self-assertion by the body, which demands to be cared for

155

and consciously experienced, and has its own requirements, like a natural material that needs to be treated regularly in order to withstand the weathering effect of the elements. The habit of the *banya* is something that the child of barely four learns from his father, and which even the war invalid approaching 80 declines to give up despite his shattered leg. For the bath you need time, leisure, company. It is a communal activity, where all the functions of bodily care and treatment are still integrated and carried out without division of labour – and certainly not by machines. For the bath to be successful, you need to have left all stress behind: it will not have the desired effect if undertaken as a duty. Perhaps this is why it is as different from our own regular routine of swimming and bathing as the jogger in Central Park, whom I mentioned earlier, is from someone going for a run on the Lenin Hills.

Of course even here there is some division of labour: there are the manicurists, the hairdresser, the masseur. In the whole extensive ritual – applying the soap, rinsing it off, sitting in the steam room, using the switch of twigs one has brought along, cooling off in the pool, resting in the lounge area – it is not hard to recognize the relaxed atmosphere of the village *banya*, which Muscovites have refused to relinquish even though they have become city-dwellers. More to the point, it is a survival from the past, and communal bathing on this scale will inevitably fall out of fashion as bathing facilities in people's own homes become the norm and reach a higher standard. I suspect that in any case the procedure is not entirely accessible to a non-native. For all the advice and information you are given, you can never gain a complete understanding of the experience because the baths are an achievement of a particular cultural phase from which decades, at the very least, divide us.

What the Sandunov Baths are like cannot, perhaps, be adequately conveyed by describing their physical appearance. A sumptuous interior in an imposing building dating from 1894, with a vestibule rich in gilding (now dulled), turquoise, and heavy stucco work, where on each side small flights of stairs curve upwards to a circular lobby. At the top of the stairs, at the entrance to the actual baths, a stern cashier sits at a desk with compartments for her papers and money. Then comes the resting area with a carved and gilded ceiling, with rows of seats reminiscent of Gothic choirstalls; along the two side walls, cubicles with wooden carvings on the doorposts and curtains of threadbare brocade; the inevitably dirty toilet, and the discouragingly

Reunion on 9 May (Victory Day) of the veterans of the Great Patriotic War of 1941–5.

dirty foyer for smokers. The bathing room itself offers stone benches with plastic bowls on them, a dripping ceiling and leaky pipes, and a pool surrounded by columns as in a Pompeian atrium. And in the corner of the large washing area is the Holy of Holies of this temple – the steam room. There they sit, the sweating bodies, by the light of dim electric bulbs, like some illustration for Dante's *Purgatorio*.

The Sandunov Baths represent a kind of synthesis, though in this instance it is not between Russian and Byzantine but rather between Russian and Turkish elements. But, as I have said, it is not the physical reality of the baths that indicates what the *banya* really means to Russians. One would have to look up 'bathing' in a history of the culture and social manners of the Middle Ages. The public bath, as can be seen, was a place of communal enjoyment and harmony with nature. This was before Rousseau – or indeed one might say that the times were such that a Rousseau was not yet needed.

There was an age of heroes, and it returns every year – on 9 May, Victory Day, when the square in front of the Bolshoi Theatre, Red

Square, Gorky Park, and indeed all squares and spaces that the city has to offer, become filled with the survivors of the struggle against Hitler (illus. p. 157). How great a distance must separate those wearing medals on their chests from those who no longer even know what the medals mean; how great must be the gulf between those parading once more on Theatre Square in their faded old olive-green army tunics and the hundreds of people circling round them armed only with cameras, pointing them out and telling their children: there goes a hero of the Great Patriotic War! What we see here is not only the difference of the generations in the biological sense, but something like the juxtaposition of those who have made or lived history with those who know it only by hearsay or from war films.

It is not an easy matter to join the clusters of people that have formed around the heroes and heroines with their decorations. This is not so much because of the thronging crowds, but because of the music that is in the air. It is the kind of music that sets you trembling, that moves you, sends a shiver down your spine – the sound associated with collective experiences such as parades, 'historic moments', marches, where for a moment the individual feels united with all those others, where from a single focal point the same emotion spreads to affect everyone present. It may seem strange that an outsider who is not in any way involved should feel like this, but it really is the case. It seems to me that even among our generation of 1968 the anti-emotionalism and distaste for heroes was a consciously acquired attitude. They merely expressed their emotions – including their sense of the heroic – in a different way, at demonstrations and in mass confrontations with 'the enemy' behind the plastic shields – and they were able to do this at limited personal cost, without great danger or sacrifice. At the very least they had no conception of the risk taken by, or forced upon, those who were not merely engaging in ideological skirmishes but who fought real battles in peril of their lives. Moreover, in Germany the cause with which military activity had been associated was discredited. Even naïvely idyllic brass band music had become ideologically suspect, and for people whose ear had become desensitized in this way it was hard to tell the difference between ordinary Bavarian band music and the 'Badenweiler March', appropriated and misused by the Fascists. Many of us remember what a jolt would be sent through the ranks of the young anti-emotionalist generation by even such inoffensive tunes as *Schwarzbraun ist die Haselnuss* ('Black-brown is the hazel nut . . .') or

158

Erika. But this was, as I say, an acquired response, which is not to say that there was not good reason for it.

Here at the Victory Day rally the collective emotion can be freely expressed, not only because the music is good, especially the marches, but also because it is associated with a cause that no one can easily take exception to – the liberation of a country from an occupying force. Here, not everything military is automatically tainted with the odour of militarism. Heroes are still heroes, and the emotive language in which they are honoured has not been undermined – even if there are often disapproving looks when heroes of the Great Patriotic War push their way to the front of queues for goods that are in short supply, and are given preferential treatment. Despite such signs of annoyance, this is a fetish that goes largely unquestioned.

They were all just doing their duty, and they became heroes. Elsewhere, others – my father, for instance – were also just doing their duty, and yet later generations regarded them almost as accomplices in the crimes of Nazism. At the very least they found themselves permanently in the position of having to justify themselves. Here it is different. Why? What these Soviet veterans experienced daily for four terrible years has become a legend. Again and again they relate what happened, in the Kursk Bulge, during the Siege of Leningrad, at the Battle of Stalingrad (which they never call Volgograd) or in the fortress at Brest. And they are never short of an audience: people stop – and not merely out of politeness – when a woman in a grey tunic bedecked with medals, standing to attention and peering through her thick glasses, instructs them: this is how it was.

Who, knowing about the Soviet general turned to a block of ice at Mauthausen, and about the heroes of the Young Guard, would ask at such a moment whether this is the whole story, or whether it is not a fact that many of these heroes were sent straight from a labour camp to the front, or, worse still, returned from the front only to be sent to the camps? And what visitor from the country of the wartime enemy could possibly ask such an impertinent question? The heroes must be given their due: flowers of remembrance. In the Alexander Gardens an endless queue of people, winding back and forth several times, moves slowly forward to make its offerings at the Kremlin Wall to those who fell at Brest, Kerch, Kursk or Volgograd (here it *is* called that), and to the Unknown Soldier. And is it only by chance that the largest

159

quantities of flowers are piled up on the tomb of the dictator with whose name, rightly or wrongly, the victory is indissolubly linked?

Who can doubt that these men and women, who risked life and limb and staked their entire future, know well enough what war is never to want to experience another! Yet this annual revival of the spirit of the campfire, which perhaps counts for more in people's memory than reflections on the historical events, has something disturbingly rigid and static about it. At the veterans' gatherings in hotels, at the events held in the Red Army Theatre or in Gorky Park, in short, at the entire grand reunion of these former fighting men and women, time stands still – and yet times have changed. Since then there have been the tanks in Berlin in 1953, tanks in Budapest and Poznan in 1956, and the army of the erstwhile liberators in Prague in August 1968. (On the evening of 9 May the Czechoslovak ambassador gave a speech of thanks for the liberation of Prague.) For quite some time there have been the military advisers in Cuba, Angola and Ethiopia, and now there are the troops occupying Afghanistan.

However great the sufferings and sacrifices of the surviving heroes genuinely were, their suffering and heroism are used as window-dressing to legitimize aggression. The aggression inevitably looks like just an extension of the country's self-defence – it is aggression without an aggressor's bad conscience. This is more effective than any propaganda, and it greatly hampers the development of a 'peace movement', drawing attention to specific outrages that are committed. Such a movement runs the risk that in pillorying today's aggression it may appear to be calling into question that heroic period in the past, a time that secured the continuing existence of the USSR in a far more enduring way than either the Revolution or the Civil War. But perhaps a peace movement faces similar tasks wherever it is: in Germany it needs to rid itself of unthinking anti-fascism, and here of a no less unthinking patriotism.

16 Vsya Moskva

*Directories as historical documents – The Revolution
reflected in the directory, unpersons who became
persons, and persons who became unpersons –
Advertising, restaurants, hotels, salons.*

Vsya Moskva – The Complete Moscow – is the title of the Moscow direc-
tory that was issued annually in the years before the Revolution by
Aleksei Suvorin, the press magnate and publisher of the conserva-
tive newspaper *Novoe Vremya*; the 1909 edition was already the six-
teenth. Behind this simple title and the mundane purpose of the
publication – to offer the residents of the aspiring metropolis, as well
as foreigners who had settled there, concisely presented and system-
atically arranged information about who lived where, what was
happening where and when, and what could be obtained where –
the city's whole physiognomy is revealed. The first section, follow-
ing the pages advertising Siemens & Halske, Dunlop and others,
presents the Moscow of industry and commerce. Factories and banks,
all in strictly democratic alphabetical order. Only in the second section
are the city's imperial, governmental and public institutions listed.
For *Vsya Moskva*, 'tout Moscou' would be an inappropriate transla-
tion, so slight is the presence of the French, or the French spirit, in
this city. If any foreigners stand out at all, it is the Germans: Kunze,
Leib, a German choral society, a hospital bearing the name of Knie,
the AEG company, the German Club, Scheffer, Schwalbe, Moscow's
Deutsche Zeitung, or Werner and Pfleiderer, occupying premises at
Myasnitskaya ulitsa 22.

Every self-respecting citizen had a telephone if he could afford it.
The telephone and telegraph are indicators of the extent of commu-
nication with the world at large; and in fact they were cheaper to use
in those days than they are now. This is shown by a list of tariffs for
long-distance calls: making a call to Germany cost a mere 11 kopeks

per unit, to Austria-Hungary the same, and to either Switzerland or Belgium 17 kopeks. That is very little, and it tells us something about how heavily the lines must have been used when we compare it with the cost of a call to the Far Eastern, 'Asiatic' part of Russia – no less than 32 kopeks per unit.

One can well believe what Andrei Bely says about the telephones constantly ringing in the editorial office of the *Vesy* (in the Hotel Metropol, apartment 23, telephone number 50-89). The journal's writers and correspondents in Brussels and Paris would spare no effort to be included in the next issue, because Moscow was Europe, and a journalist who got into print in Moscow would also be read in Vienna, Munich and Paris.

What else can the directory show us? The proliferation of consumer goods to suit all tastes, and an endless range of what are called services. Summarized in an alphabetical list is a whole geography of specialist shops offering everything from ladies' lingerie to riding gear, from mushrooms and books to zoological supplies, as well as courses at a language school by the name of Berlitz – everything one could possibly want.

And it is a real delight to scan the restaurants and entertainments section. Here we find the Akvarium Theatre on the Bolshaya Sadovaya; the Salomonsky circus on Tsvetnoy bulvar (its directors are called Truzzi, Kremser, Treimann and Will, the sort of colourful names that one expects in the theatre and circus world); the Eremitage Theatre on ulitsa Karetny ryad; the *Teatr Buff* on the corner of Tverskaya and Sadovaya; not to mention the famous Korsch Theatre on Bogoslovsky pereulok; and the Art Theatre – which numbers among its ensemble Nemirovich-Danchenko, Moskvin, Kachalov and Stanislavsky himself – in the former Lyanozov Theatre in Kamergersky pereulok.

The directory has more than two pages of *traktiry* (bars and restaurants), providing a kind of semi-public, semi-private ambience that unfortunately barely exists nowadays. Among them are better-class establishments, including some that Bely mentions in his memoirs: the Eldorado in the Chesnokov building in Zhukovsky pereulok; the Alpenrose on the Sofiyka; and other major establishments such as the Hotel Paris, the Hotels Frantsiya, National or Kontinental, and the Dekadenz restaurant in the Anker Insurance building in Neglinny pereulok.

At some of these meeting-places the mood of the time was crystallized, history was anticipated, apocalyptic scenarios were

planned and revolutionary theatre rehearsed. One such place was the Café Pittoresque (Kuznetsky most 12), where Tatlin exhibited his first relief sculptures and where Mayakovsky was wont to offend the ear of public taste; but there were also a number of hotels where figures like Turgenev or Chekhov stayed, placing some distance between themselves and the kind of human being that this new age was producing, in order, no doubt, to observe him all the better.

On page 32 of the 1900 issue of the directory there is a noteworthy advertisement: a 'Russian Society for Insuring Capital and Income, founded in 1835' is offering its services. The address: Malaya Lubyanka 20. The accompanying picture shows the building which was to go down in history not as an insurance company office but as 'the Lubyanka'. The parquet flooring and central heating described by prisoners who were held there in the 1930s may well date from around 1900. At the time of the advertisement it was still an insurance agent who could be contacted at that address, on telephone number 933.

A directory lays bare the social and cultural topography of a bygone city in an abstract form, through closely printed lines and columns. This, rather than volcanic ash, is the medium in which the past is preserved in the post-Gutenberg era. Even by 1917 nothing much has changed in the directory's pages. German firms and the German community are a little less prominent, the paper is of wartime quality, and the repercussions of the war can be seen to a limited extent: some of the institutions of government have moved to Moscow, and the administrative offices, departments, archives, etc. previously located in Warsaw – which had been Russian territory until then – have been evacuated to the Russian metropolis. Even so, the war against the Germans is not being waged in the directory: Junker & Ruh (sewing machines and stoves) and the Berlin firm of Karl Flohr (familiar to us nowadays as part of the Flohr-Otis group, and even then a world leader in the manufacture of lifts – an important commodity for a Moscow aspiring to ever taller buildings) are still promoting their wares to an eager clientele. Those who are sceptical when Lenin writes about a conspiracy on the part of international capital and declares war on it internationally should take note of the advertising pages of this period – in Berlin and London, as well as Moscow – and of the stock exchange reports.

Advertising by
prestigious hotels
and restaurants
in a German-
language guide
of 1882.

Advertisement by the publisher M. O.
Wolff.

Cover of the *Almanach de St Pétersbourg*
of 1910.

Advertisements in the *Almanach de St. Pétersbourg* of 1910.

Hunting calendar from the *Almanach de St Pétersbourg* of 1910.

The directory is informative in other ways too. Some may wish to search for the revered figures who have shaped their historical and philosophical consciousness, and they should by all means do so: those heroes, or their relatives, can be found here, for instance the painter Leonid Osipovich Pasternak and his wife Rosa, a pianist, living at ulitsa Volkhonka 14, flat 9 – in other words, Boris Pasternak's parents. Or the Vesnin brothers, Leonid and Viktor, listed at Denezhny pereulok (now ulitsa Vesnina) 12, telephone number 514-85. And in a city that fails to build a memorial to a famous son, it is worth discovering his father's address. The building in which Nikolai Ivanovich Bukharin was born on 9 October 1888 is to be found under the name of his father, Ivan Gavrilovich Bukharin: it is the Samoilovich House, in Novinsky bulvar (nowadays ulitsa Tchaikovskogo).

In the directory for 1917 there is as yet no hint of the whirlwind that will very soon throw all the information in its columns, the street names, the telephone numbers and the long-established addresses, into disarray.

It is striking how the very different character of St Petersburg finds expression in *its* directory. The contrast between the silver city and the motley confusion of Moscow is palpable as soon as one picks up the *Almanach de St Pétersbourg 1910*.

The publisher, the Société M. O. Wolff, presents the addresses in the imperial city in a red leather binding with gilt edging and on fine-quality paper. The volume is in no way flamboyant, the art nouveau ornamental motifs are used with restraint, and in such proximity to the court, advertising is absent. The focus here is on rank, titles and the names of prominent families. The advance of democracy is limited to the listing of the names of the leading families in alphabetical order. And they live not in St Petersburg but in St Pétersbourg. There are Russian names here, of course, such as Dmitry Modestovich Retsvoy, but always written in the French manner. There is also a good deal of French and German blood: Cte. Vladimir Evstafievitch de Reutern, with a second residence in Ringen (Courlande), Cte. Georges Ivanovitch de Ribeaupierre, and Vadime Nikolaevitch Repnine, of Nürnberger Platz 4, Dresden. The von Benckendorff and Benningsen families fill more than one page in the directory, and of course in the annals of history too.

St Pétersbourg is the city of waterways: Quai Nicolas, the Fontanka River. There is a profusion of distinguished addresses.

Calendrier de chasse (Jagd-Kalender)

Époque de la chasse ouverte : ☐ Jagdzeit.
Époque de la chasse fermée : ▨ Schonzeit.

Genre de gibier :	Janvier	Février	Mars	Avril	Mai	Juin	Juillet	Août	Septembre	Octobre	Novembre	Décembre
Aurochs, vache d'élan, biche, ainsi que veaux et faons de ces races. Auerochsen, Elenkühe, Hirschkühe, Ricken und Kälber dieser Wildgattung.	▨	▨	▨	▨	▨	▨	▨	▨	▨	▨	▨	▨
Élans. Elenhirsche.	▨	▨	▨	▨	▨	▨	▨	▨15				
Cerfs. Hirsche.			▨	▨	▨	▨	▨	▨15				
Chevreuil. Rehböcke.	▨	▨	▨								▨	▨
Saïga (Antilope des steppes) du nord et du sud, boucs noirs et autres chèvres sauvages des alpes. Nördliche und südliche Steppenantilopen, schwarze Böcke und andere Bergziegen.					▨	▨	▨15					
Coq de bois et coq de bruyère. Auer- und Birkhähne.				15▨	▨	▨	▨15					
Bécasses. Waldschnepfen.						▨	▨15					
Oies et cygnes. Gänse und Schwäne.					▨	▨29						
Canards mâles et petits paons sauvages dits „soldats'' ou „tourouhtáni'' (турухтани). Enteriche und Kampfhähne.						▨29						
Canards de toute espèce, bécassines, doubles bécassines, petite bécassine (чаршнепы), bécasses de toute espèce, vanneaux (чибисы), râle de genêt dite râle de terre, râle rouge ou roi (ou mère) de caille (дергачи) et autre gibier d'eau et de marais. Enten aller Arten, Becassinen, Doppelschnepfen, Haarschnepfen, Schnepfen aller Arten, Kiebitze, Schnarrwachteln und sonstiges Wasser- und Sumpfwild.			▨	▨	▨	▨29						
Perdrix et perdrix rouge. Feld- und rote Berghühner.	▨	▨	▨	▨	▨	▨	▨	▨15				▨
Perdreaux du Caucase. Kaukasische Rebhühner.	▨	▨	▨	▨	▨	▨	▨	▨				▨
Faisans et lièvres. Fasanen und Hasen.			▨	▨	▨	▨						
Poule de bois et poule de bruyère, gélinotte, gélinotte blanche, perdrix blanche, outarde et caille. Auer- und Birkhühner, Haselhühner, weisse Birkhühner (Schneehühner), Trappen und Wachteln.			▨	▨	▨	▨15	▨					
Toute espèce de gibier à poil et à plume, excepté les bêtes et oiseaux de proie. Alles übrige Lauf- und Flugwild, ausgenommen das Raubzeug.			▨	▨	▨	▨29						

Hunting calendar from the *Almanach de St. Pétersbourg* of 1910.

Theatre Square, Tsarskoe Selo, Marienhof. Names like these have outlived the titles, hierarchies and status symbols associated with those addresses: special telephone lines and railway links, membership of the Royal Yacht Club, the Academy of Arts or the Imperial Regiment. There are names of people who disappeared from the scene, and of others who survived or even achieved prominence later on, like the illustrious artist Ilya Repin (his name too appears in a Frenchified form), who painted the famous picture of the Zaporozhian Cossacks. Modern-day admirers of Pyotr Kropotkin would be able to see here that the family of that aristocratic anarchist had one of the best addresses in the city. The *Almanach de St Pétersbourg* is a weighty volume, and everything about it suggests taste, quality, a sense of order and style. Financiers and the promotion of goods and services make no more than a marginal appearance, and then only if they can show the emblem indicating that they enjoy the patronage of the imperial court.

Advertising is frowned upon. The hunting calendar, on the other hand, is *de rigueur*, with its tables of close seasons for Caucasian partridges and deer. The almanac of 1910 obviously seeks to maintain a posture that is already under threat from the broad current of social change. St Petersburg is being put on display as though the world of the landed aristocracy, the crown and the leisured class were still intact. Yet who can wonder that this city also came to be the centre of the Age of Silver, the city of the Symbolists and Acmeists, and altogether of a sophisticated culture and an extreme sensitivity towards an inevitable future? It was no accident that Andrei Bely, author of the novel *Petersburg*, Aleksandr Blok, 'the poet of an entire era', Anna Akhmatova and Osip Mandelstam were later accused of both bourgeois decadence and aristocratic reserve – if not worse. How could it be otherwise in a city where not only the court but the Putilov works too were firmly entrenched? But the 1910 almanac contains no hint of any of this. It sets its seal on the immutable daily round of balls, fruitless petitions and noisy parades of regiments with their gleaming accoutrements.

We have all found ourselves, in the course of looking up something quite specific in a reference work or reading some particular article in the newspaper, being sidetracked and forgetting what we are about. Instead of concentrating on the leading article we have been suddenly captivated by the small ads. That is how it was with me as I read the directories. But with them, luckily, there is a sharp

Advertisement for the State Automobile Trust, Moscow, 1926.

break in continuity that it is virtually impossible to overlook as one is reading or leafing through – and that is the year 1917.

How does a revolution impinge on so mundane an object as a directory? To put it more precisely, what effect does the impact of a revolutionary process have on the system of addresses, and how is this reflected in a directory? Have 'high' and 'low' been renamed and nothing more? Do the new titles merely conceal the old hierarchy, without anything really having changed?

To start with, a revolution intent on turning everything upside down has no time to waste on publishing a directory. In the years of the 'onslaught of the Red Guards' and of the Civil War, *Vsya Moskva* simply did not appear – the editors could hardly, in any case, have kept pace with the speed of change and the chaos of improvisation. It was only in 1923, when the New Economic Policy was already in its second year, that *Vsya Moskva* was published again, though no longer by the press magnate Suvorin but by the government publishing agency. The foreword declares candidly:

'With this 1923 issue, the state publishing agency is resuming publication of *Vsya Moskva*, after a long interruption, in the same form as before the Revolution. Every effort has been made to ensure that the information provided in this reference book is complete and accurate. This has not been easy to achieve, however. The Revolution has produced a complete upheaval in the governmental, political and social spheres. Not a single institution has remained unchanged; every institution has seen changes to its structure and personnel, and consequently to its addresses. Moscow, solely a centre of commerce prior to the Revolution, has now become the capital of the Republic, and the organs of government have been transferred here from Petrograd. Moscow has become the political and economic centre of Russia.

The editions from the 1920s show that by this time the new system has succeeded in stamping its own emblems on the city. The directory is still printed on the poor quality paper used during the First World War and the Civil War. The titles of government bodies are designed to sound functional but at the same time impressive. To mention just the most familiar ones: TSIK SSSR, Sovnarkom, STO, GOSPLAN, Narkomindel, Revvoyensovet, VSNKh, Narkomtrud, Versud, OGPU, Narkomvnutorg, Narkomsobes. One could easily find even

more impressive-sounding abbreviations, and some of those mentioned have become internationally known, GOSPLAN and OGPU, for instance. The columns of abbreviations printed in bold type symbolize the ambition to organize society and its political superstructure in a transparent, rational and clearly defined way, from the highest level at the centre down to the local bodies at the grass roots.

The guiding principle of the political structure is also evident from the hierarchy of addresses: the list starts with the Central Executive Committee, which has now returned to the country's real centre, the Kremlin, and ends with the social and mass organizations. The position formerly occupied by banks and businesses is now taken by the offices of Moscow industrial firms, or the trade union headquarters of the railway workers, leather workers or tram conductors. The theatres already in existence have been joined by newly established ones, such as Proletkult Theatre Number 1, and the many workers' clubs.

This is the period of the New Economic Policy, when the capitalist market has been readmitted but is strictly regulated. Hence there are pages of advertisements featuring Ford, Simca, AEG and their agencies in the Soviet capital.

What is most obvious in the directories after 1917 is the concentration of institutions. Since the dethronement of Petrograd, Moscow had not become in any way more Russian, but had turned into a Soviet city. Places that until a few years earlier had been emblazoned with the tsarist eagle were now painted over with revolutionary slogans. Where formerly autocracy had reigned supreme, in the nobles' palaces and mansions and in the Kremlin, the new system had taken over. Before long Lenin roundly attacked it as 'bureaucracy embalmed in Soviet oil'.

For years people in other countries went on deluding themselves that there would be a *coup d'état*, that the Soviet state represented only a temporary phenomenon. But once a system is in a position to publish directories, there is no longer anything temporary about it: it is here to stay. Nothing could demonstrate this more clearly than a handbook of this kind for everyday use. Where even everyday life is running on new lines, the days of temporary arrangements are over: people have drawn a line under the past and are getting on with the normal business of life. This too is reflected in the directories, for instance in the changes made to street-names. Names of grand dukes, tsars, imperial office-holders and saints have all but van-

ished. Anything that could be a public reminder of the past has been swept away – all the Mikhails, the Alekseis, the Nikolais. Street-names without offensive connotations are retained: Veterans' Street, for instance, or New Village Street, Narrow or Broad Street, and the like. Some streets are rededicated to the heroes of the 1860s or '70s – Herzen and Chernyshevsky are among those honoured in this way. Street-names expressing the great ideals, such as 'Great Communist Street', are as yet only rarely found in these 1920s directories. Nor, significantly, are there as yet any streets bearing the names of the new leaders. The age of the personality cult still lies in the future.

As you turn over the pages of the 1926 directory, the claim by the new system to be in touch with the people appears entirely plausible. The individuals listed under the rubrics of institutes or public bodies are still well known in their own right; indeed their names are often better known than the institution to which they are attached. It would be unthinkable today, but here they are, listed with their full name and place of work and a telephone number. Kalinin, for instance, the head of the Central Executive Committee, can be telephoned on Kremlin 211, and his secretary on 212. On the lines to the Presidium one can ask to speak to the trade union leader Mikhail Tomsky, or to Kamenev, Yenukidze or Smidovich. The *crème de la crème* of sociologists, statisticians and economists of the old school, for example Nikolai Kondratev and Aron Wainstein, are assembled under the heading of the Scientific Research Institute of the Timiryazev Academy. In the entry for the 'Communist Academy' in ulitsa Volkhonka we find the elite of the Bolshevist party intelligentsia: the economist Preobrazhensky, Bukharin, known as 'the party's favourite', the historians Bubnov and Kritsman, and in the Law Department the theoreticians Stuchka and Pashukanis. And the Marx-Engels Institute, as it was then still called, was the workplace of Ryazanov and Deborin. The figures I have mentioned enjoyed (albeit briefly) a revival of public interest and esteem in Germany and elsewhere, first through pirated editions issued by the 1968 revolutionaries, and then by courtesy of some major publishers who sensed that there was money to be made out of them. The 1926 directory does indeed contain a notable list of distinguished personalities, intellectuals of some standing – many of whom, however, were not to survive beyond 1937.

What catches your eye as you continue to turn the pages is the internationalist element, even though the doctrine of 'socialism in

one land' had already been promulgated. Alongside Bukharin on the council of the Institute are the Hungarian Béla Kun and the Germans August Thalheimer and Clara Zetkin. Further down on the same page, admittedly only as a member of the council of the Lenin Institute at Dmitrovka ulitsa 24, is Stalin, telephone number 1-72-69.

There can hardly have been another city where so many prominent foreigners were 'government officials': Moscow at that time was the headquarters of the Comintern. Before long, new official linguistic usage was to turn the various institutes and secretariats into 'dens of anti-Soviet conspiracy', nests of 'sabotage and wreckerism' and of 'active terrorism': they were allegedly the bases from which the scattered economists directed the unrest among the kulaks and set out to organize a putsch. And what sort of a putsch might a Hegel specialist like Abram Deborin instigate – why, a 'Menshevist–Hegelian deviationist' one, of course! They would all – Bukharin, Deborin, Ryazanov, Tomsky and the rest – be excised from later issues of the directory, and it would not stop there. Most of them would be liquidated; not only that, but they would never even have existed, they would become 'non-persons'. Into the offices under the old addresses came new people, nameless people. And so a directory, a work designed to serve the mundane purposes of day-to-day living, intended for the passing moment and not for history, is unexpectedly promoted to the dignity of a 'historical document', because it contains evidence of names that are not acknowledged to have existed.

And this is where the unyielding present caught up with my pleasurable browsing. I do not mean the kind of problems that have been reported in the international press, with telephone lines being cut off, or telephones being tapped, as in the case of Andrei Sakharov. It was something far less dramatic. In the photocopying department of the Lenin Library in Moscow I handed over several volumes of the directory with a very modest order, but the lady behind the desk informed me that the decision as to whether I could have copies of the pages I had selected was not hers to take – I would have to come back again the next day. Thus forewarned, I was not too shocked to learn on my return that permission would not be granted. Clearly, then – or so I deduce – these people are well aware of the stuff of which history is made.

The allure of these directories may tempt some readers to construct a theoretical basis for their happy perambulations through the

pages and the years, and to turn this pleasurable form of reading into a stick with which to beat established approaches to the writing of history. Some such attempts have been made, generally with the aim of promoting the 'history of the common man', but these efforts to create an 'alternative view of history' are too obviously forced to carry conviction.

Similarly, the faction that focuses on the structural development of societies and institutions almost to the exclusion of any living, human element – a deliberate reaction against history based on great men and great events – has long been in decline. What was formerly self-evident, namely that there can be no historical action without actors, has once again become the accepted view.

I will therefore simply make the following points regarding the value of the old directories as a source of knowledge.

To begin with – and this is a relatively trivial point – they are indispensable for reference and information, particularly in the case of historical figures who have been erased from the annals of history, either temporarily or permanently, for having (in the jargon of the day) deviated from the 'course of history'. Many of those who were later executed, and some who have not been rehabilitated even now, can be found there: N. I. Bukharin, 2nd House of Soviets, apartment 229, Tel. 5-29-00; I. T. Smilga, Sretensky bulvar 6, apartment 18, Tel. 83-25; L. P. Serebryakov, Kremlin, Yenukidze's room; A. M. Deborin, 3-ya Meshchanskaya 3, apartment 4, Tel. 62-30; V.E. Meyerhold, Novinsky bulvar 32, apartment 45, Tel. 93-23; N. I. Trotskaya, Kremlin, Tel. 1-44-86. And so on. (From the 1923 edition of *Vsya Moskva*.)

Secondly – and this is a less trivial point – these are volumes that provide a picture of a city, that is, of an agglomeration of human beings. Despite the enormous changes between 1917 and 1923, it is amazing to see the extent to which Moscow remained true to itself. Revolutions move mountains, but not cities. In many respects, when you compare the hotels, cafés, cinemas and theatres in the 1917 and 1923 directories, it seems as though life is going on as before, as though nothing has changed. The lists of people attached to the renamed institutions indicate who has found a niche or tried to make his peace with the new system; the absence of important names often signifies exile, whether short-term or permanent. Thus in the various sections of the Academy of Arts at 32 ulitsa Prechistenka (ulitsa Kropotkinskaya) we find Kandinsky, A. Efros,

A. Vyshinsky,
the USSR's Chief
Prosecutor,
1935–9.

G. Spet, B. Vysheslavtsev, B. Griftsov and M. Gershenzon – all luminaries of pre-revolutionary Moscow's intellectual life.

The solid mass of a city exercises its own gravitational pull. It is salutary for the historian, who is always operating retrospectively, to be exposed to that pull from time to time. The confrontation with events as they happened is a reminder that history is a narrative, and this enables the historian to gain a view of the past undistorted by the projections of later generations. Who, in 1923, could have imagined that the A. Ya. Vyshinsky listed under the heading 'College of Defence Lawyers' with the address of Bolshaya Gnezdikovskaya ulitsa 10, apartment 716, would rise from the insignificance of this entry to become the personification of Stalin's brutal justice system? History that comes without a knowledge of the future is still open-ended and capable of different twists and turns.

It is quite instructive to ask whose names appear, who has an address (and what address), who is concealed behind the best

addresses. Not even the most soaring intellects spend all their time communicating ideas to kindred minds: alongside, or below, that sphere of activity they are attached to bodies, have districts where they choose to live, and places where they foregather. Even the most abstractly conceived political power occupies a space and a location. Power has an ambience, a dwelling with an actual, as it were physical décor. And if the many nameless ones have no place in the directories, that too is a kind of truth: they are still waiting to have their say, they have chosen to remain silent, or they have been silenced.

Vsya Moskva continued to appear for another fifteen years, until, like so much else, this institution that symbolically bridged the divide between Russian and Soviet history was brought to an end by the events of 1937.

Postscript

'The Complete Moscow': the phrase suggests something that is still whole, and unaffected by the break between generations. All the same, the following roll-call of names and addresses does not aim at completeness:

M. P. Artsybashev, Yermolaevsky pereulok 27, apartment 4 (1923 directory)
M. A. Bakunin, Botkin House, Petroverigsky pereulok 4
V. G. Belinsky, Rakhmanovsky pereulok 4
A. A. Blok, Arbat 55 (A. Bely), ulitsa Gorkogo 15 (Hotel Madrid)
V. Ya. Bryusov, Tsvetnoy bulvar 22, 1-ya Meshchanskaya ulitsa 30
I. A. Bunin, ulitsa Vorovskogo 26
A. P. Chekhov, Sadovaya-Kudrinskaya 6
K. I. Chukovsky, ulitsa Gorkogo 6
F. M. Dostoevsky, ulitsa Dostoevskogo 2
A. P. Dovzhenko, Kutuzovsky prospekt 22
I. G. Ehrenburg, ulitsa Gorkogo 8
S. M. Eisenstein, Chistoprudny bulvar 23
V. N. Figner, Vaganovsky pereulok 8
M. O. Gershenzon, Nikolsky pereulok 13, apartment 4 (1923)
V. A. Gilyarovsky, Stoleshnikov 5, apartment 10 (1923)
A. Ginzburg, Bolshaya Polyanka 11/14, apartment 25
F. V. Gladkov, Soimonovsky proezd 5

N. V. Gogol, Pogodinskaya ulitsa 12

A. Gramsci, prospekt Kalinina 1

A. S. Griboedov, ulitsa Tchaikovskogo 17

B. A. Griftsov, Trubnikovsky pereulok 8, apartment 8 (1923)

A. I. Herzen, Sivtsev Vrazhek 27/9

V. V. Kandinsky, Prechistenka 19 (Kropotkinskaya ulitsa) (1923)

V. P. Kataev, Mylnikov pereulok 4, apartment 2 (1923)

M. Y. Lermontov, Malaya Molchanovka 2

O. E. Mandelstam, Tverskoy bulvar 25 (1923)

V. V. Mayakovsky, proezd Serova 3/6 and pereulok Mayakovskogo
 15/13

V. E. Meyerhold, ulitsa Nezhdanovoy 12

D. F. Oistrakh, ulitsa Chkalova 14–16

B. L. Pasternak, Volkhonka 14, apartment 9 (1923)

K. G. Paustovsky, Kotelnicheskaya naberezhnaya 1–15

S. S. Prokofiev, ulitsa Chkalova 14–16

V. I. Pudovkin, ulitsa Vorovskogo 29+31

A. S. Pushkin, ulitsa Nemirovich-Danchenko 6

A. D. Sakharov, ulitsa Chkalova 48b, apartment 68 (currently Gorki
 137 Shcherbinka 2, ulitsa Gagarina 214, apartment 3)

F. I. Shalyapin, ulitsa Tchaikovskogo 25

A. N. Skryabin, ulitsa Vakhtangova 11

D. D. Shostakovich, ulitsa Nezhdanovoy 8/10

A. Sinyavsky, Khlebny pereulok 9, apartment 9 (currently in Paris)

G. G. Spet, Dolgorukovskaya ulitsa 17, apartment 2 (1923)

L. N. Tolstoy, ulitsa L. Tolstogo 21

M. I. Tsvetaeva-Efron, Borisoglebsky pereulok 6, apartment 3 (1923)

I. S. Turgenev, Gogolevsky bulvar 10

A. T. Tvardovsky, Kutuzovsky prospekt 1/7

N. I. Vavilov, Leninsky prospekt 33

Y. S. Varga, Leninsky prospekt 11

S. A. Yesenin, Kropotkinskaya ulitsa 20

I. V. Zholtovsky, ulitsa Stankevicha 6

17 Red forum

*The inaccessibility of the Kremlin, its initially alien
nature – The sudden discovery of a means of access
by way of the layout of Paris, the fortress walls of Milan,
and El Lissitzky.*

One thing that makes me conscious of the gulf that separates me, as
a foreigner, from this country is the realization that I cannot share the
emotions of Russians when they see the Kremlin – to them the very
heart of Russia. It does not make my heart leap or beat faster, and in
a way this saddens me: does it mean that I have failed, after all, to
grasp its essential nature? Is it actually impossible for me to under-
stand it as I would like to?

I cannot say precisely why it is that I find the Kremlin so inaccessi-
ble. Is it because of the splendid and immaculate condition in which
this historic complex is displayed to visitors, like an exhibit in a
museum? Is it because one does not sense the pulse of the times beat-
ing here, however much the black limousines driving fast through the
gates with their blinds pulled down may give a false impression of
important business? Is it just my instinctive refusal to approach it as a
member of a tourist group and see it with the eyes of a tourist? All these
factors have a part in my attitude to the Kremlin, and yet they do not
fully explain my lack of enthusiasm for it. It was really more to clarify
this for myself, and then only after quite a long delay, that I prowled
round the outside and finally went inside. But this very need to work
consciously at overcoming my lack of enthusiasm shows how far I was
from being able to relate to the Kremlin naturally and effortlessly.

The first point that I would make is this: as far as I am concerned,
this setting where so much history has been played out is, to
my mind, no longer a scene of action. It is just a seamlessly harmo-
nious ensemble, an explanation leaving no questions unanswered,
a perfect piece of presentation.

178

Demonstration procession through Red Square, 1 May 1932.

Of course, when you stand further off, at various different points in the city, and see the literally golden domes shining, it is a wonderful, indeed a wondrous sight. Their radiance is never extinguished even on a dull day, and on bright sunlit days it blazes forth, transcending itself. There are vantage-points from which the tsarist city up on the hill looks like a fairy-tale wrought in stone; one such point is the *naberezhnaya* Maurice Thorez, where from down at sea level, as it were, you look up towards the rising slope on which the fortress stands. An orgy of colours confronts you: the dark red of the crenellated wall, the green and turquoise glazed tiles on the corner towers with their Russian helm roofs, the white and ochre of the Kremlin palaces, the white bulk of Ivan the Great's soaring Bell-Tower, and everywhere the green-painted roofs – and up above, always fully extended in the wind, the blood-red banner flying above the Senate building. Bright yellow, brilliant white, flashing gold, grass green, velvety green pine trees, deep red brickwork – all the colours are drawn to a single point where, concentrated as in a prism,

179

heightened to unbridled intensity, they are reflected outwards again by that most exotic of buildings, St Basil's Cathedral.

I doubt whether the sense of distance that I feel in relation to the Kremlin can really be overcome. Perhaps an insurmountable remoteness is an intrinsic part of its aesthetic quality. It is hard to imagine the Kremlin buildings surrounded by traffic, urban noise and the shouting of headlines from newspaper kiosks. It is almost impossible to visualize them, like the Houses of Parliament or Capitol Hill, as the focus of demonstrations, with hundreds and thousands of marchers staging a sit-down protest on their steps. We are all familiar with the images of eyeball-to-eyeball confrontations between anti-war demonstrators and National Guardsmen armed with bayonets, the faces with pleading and outraged expressions and the splashes of blood symbolically shed. All such protests are unthinkable here. The Kremlin was and still is a fortress. I admit that this is a foreigner's view, influenced, moreover, by television images. I associate the Kremlin and Red Square with the parades of rumbling tanks, the elegantly finned but menacing rockets being towed over the cobbles, the unfailingly serious expressions beneath the fur caps or hats of the party leaders making their appearance on the reviewing platform of the Lenin Mausoleum. But it is impossible to rid oneself of images so long as there are no new ones to replace them.

Nor can I shake off the impression that Aleksandr Gerasimov's painting, *Stalin and Voroshilov on the Wall of the Kremlin* (illus. p. 191), makes on me: the spikes of the railings recede sharply, and the city appears a long, long way off. The Kremlin is indeed a fortress, and the sounds of the city only reach it from afar.

I felt at less of a remove from the Kremlin when I saw *Boris Godunov* in the magnificent, naturalistic 1948 production by the Bolshoi Theatre – yes, that production is still current, in this land where fashions are not constantly changing! But why? Because the element of sound was added. In other words, the Kremlin with its churches, its dominating bell-tower and the broken bell at the foot of the tower, but without the *sound* of the bells, is not truly the Kremlin. And what a sound it was, what a sound it must have been: the ponderous notes of the great bells booming out as they swung in a wide arc, and countless other bells of every size down to the smallest, each with its own timbre, and all of this in a chaos of rhythms, a confusion of notes and dissonances wholly unlike the speech of our own church

towers. Only the music of Mussorgsky or Ravel can still give us some impression of it, albeit in a domesticated and refined form. Walter Benjamin commented in 1927 that the silence of the bells made him feel cheerful, or, at any rate, spared him the melancholy that our Sunday church bells induced in him: it seems that even by 1927 it was no longer possible for him to experience that overpowering clamour filling the air.

All that has remained of that sound are the chimes from the Saviour's Tower, broadcast at midnight and in the early morning across the whole of the Soviet Union and followed by the national anthem (once upon a time it was the 'Internationale' that was played).

People say of St Petersburg that it is beautiful, but that they would not like to live there. Similarly, it can be said that the Kremlin is beautiful but leaves one cold. Perhaps they have something in common, the Kremlin, which I feel to be like a museum complex, and St Petersburg, closed down as a capital and now also reminiscent of a museum. It seems to me that the Kremlin has suffered as badly from being made into a museum as the former capital has from being reduced to a provincial outpost. The Kremlin is an admittedly imposing but merely historic façade, with real life happening somewhere else. It is not in the Kremlin that decisions are taken, but in the Central Committee building on Staraya ploshchad, in the ministries, in the new high-rise buildings of the various trusts, banks and institutes – buildings surrounded by hustle and bustle and the scramble for parking spaces, with gold inscriptions on black plates beside their entrances – and on the many floors, neon-lit on winter afternoons, of the tall office blocks on Smolenskaya ploshchad or Oktyabrskaya ploshchad on the Garden Ring.

The Kremlin as a centre of power both old and new is linked with St Petersburg by the hidden bond of their destinies. There was a price to pay for Peter the Great's hasty Europeanization of Russia: his fantasy project, St Petersburg, was built at the expense of Moscow, though Moscow was both too vigorous and too sacred to be entirely ruined by this demotion. But the fact that the step from the fortress on the hill down to the market-place was not taken sooner in Moscow (and that, when taken, it was ineffective) is tied up with the 'anomaly' that led to a proletarian Petrograd emerging from the aristocratic and imperial St Petersburg, whilst the development of Moscow as a city was set back for a long time, even

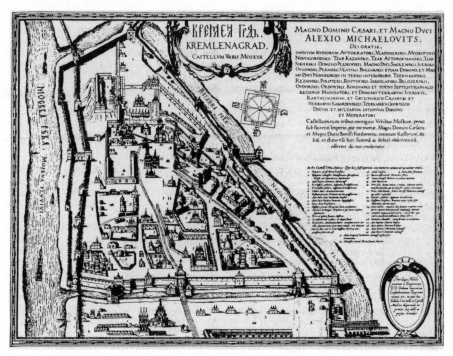

Plan of the Kremlin after J. Blaeu, mid-17th century.

though all the prerequisites for such a development were here, cheek by jowl.

The Kremlin was the scene of conflicts, riots, pillage and threats from the districts outside its walls long before the Putilov workers marched on Nevsky prospekt and mobilized the newspapers, indeed long before St Petersburg had even been founded. In 1947, during the celebrations marking the 800th anniversary of its existence, Moscow was able to point to past events that, though not inevitably leading by 'historical logic' to the October Revolution, were nevertheless part and parcel of the anti-feudal plebeian movements of the Middle Ages. On more than one occasion the Kremlin was seized and held, at least temporarily, by Moscow artisans, traders, *posadniki* and Streltsy: in 1382, when the city was defenceless against the Tatar hordes; in 1547 after one of the devastating fires that threatened the lives of the citizenry; in 1648 in reaction to an increase in the salt tax; in 1662 as a protest against the collapse of the economy and the devaluation of the currency; and in 1682 and 1698, when the Streltsy staged revolts.

182

Kremlin wall (detail).

The impression one gets, that the Kremlin is a castle of the classic type, is borne out by the facts. Despite numerous straightening and levelling operations, one still senses what a history of the site records, namely that the Kremlin was originally surrounded on all sides by water and was accessible only by means of drawbridges. On the southern side there was the Moskva, on the north-western side of the irregular triangle formed by the Kremlin the Neglinka (which has now vanished under Alexander Gardens), and on the Red Square side, close to the wall where the tombs now are, a moat was artificially created. This is highly significant, at any rate to me: there are some moats that cannot be made to vanish by filling them or covering them over.

Every history book and every reasonably detailed guidebook says that the Kremlin acquired its present form in the second half of the fifteenth century, and, moreover, under Italian influence. And yet by simply looking I cannot easily make out exactly where the Mediterranean Renaissance joined forces with the new self-confidence of the Muscovite principality. There are, to be sure, the churches and palaces that are familiar to everyone, with their equally well-known Italian architects. However, identifying the work of these men is not always as easy as it is in the case of the Faceted Palace, built in 1491 by the Italian architects Marco Ruffo

Faceted Palace in the Kremlin, detail of the façade, architect Pietro Antonio Solari, 1487–91.

and Pietro Antonio Solari. It is more difficult – for me, at least – to recognize the hand of the Milanese architect Alevisio Novy (or Nuovo) in the Cathedral of St Michael the Archangel (1505–9), or of Aristotele Fioravanti in the Cathedral of the Assumption (1467–79). To art historians the link between such buildings and the Doge's Palace may be obvious. To me it is less so, because of the extent to which the northern Italian architects took the Russian masters as their models – and in any case both groups, the Venetians and Milanese just as much as their colleagues from Moscow or Pskov, shared the same ultimate model: Constantinople, Byzantium.

Where I can see evidence of Moscow's role as the most easterly outpost of Renaissance Europe is in something that is generally regarded as being thoroughly oriental, namely the Kremlin wall. Here too anyone with an interest in the subject knows that it was built according to plans drawn up by Italian architects. But, as always, simple knowledge of the facts does not suffice for a full understanding. Our eye is so accustomed to the bizarre 'tent' roofs and all the points and spires that we cannot visualize the Kremlin at all without these strange appurtenances. And yet this wall, which surrounds the whole complex and lends it so much of its character, shows us most graphically how intimately Moscow is bound up with our own history. The 1,045 'Ghibelline' swallowtail crenella-

Kremlin wall.

tions that top the Kremlin wall are a clue that points in one direction only: to the fortress walls of Montagna, Cittadella, Castelfranco or Milan. Even so, it takes a considerable imaginative effort to bridge the gulf between the known facts and our mental image: one has to remove, whether by peeling away, excising or retouching, whatever has been added to the original structure. I achieved this with the aid of a series of sketches on some postcards dating from 1979. The artist shows what a photographer could not: the points where two different epochs and cultures meet, the unity but also the discrepancy between original building and addition, substructure and superstructure. Those with greater knowledge may find the operation that I undertook for my own benefit somewhat heavy-handed, but it gave me valuable insight. I dismantled the various later accretions to the Kremlin towers.

Borovitsky Gate Tower: named after the woodland at the confluence of the Neglinka and the Moskva. The gate tower was erected in 1490 by

Pietro Antonio Solari, and given an octagonal crown in the seventeenth century. It is 54 metres high.

Water Tower: this provided the water supply for the Kremlin. Built in 1488 by Bon Friazin. Damaged in 1812, and restored by Osip Bove. Height: 61 metres.

Annunciation Tower: built in 1488, tent roof added 200 years later. Height: 30 metres.

Taynitsky Gate Tower: the oldest of the towers, erected by Friazin in 1485. Razed to its foundations in 1773 as part of Catherine the Great's construction of the Great Kremlin Palace, and rebuilt three years later. Height: 38 metres.

First Nameless Tower: served as a munitions store in the sixteenth century, repeatedly destroyed. Height: 34 metres.

Second Nameless Tower: received its present tent roof at the end of the seventeenth century. Height: 30 metres.

Peter's Tower: destroyed by the Poles in 1612, demolished for the building of the Kremlin Palace and then rebuilt; blown up again in 1812 by Napoleon's troops, and subsequently restored by Bove. Height: 27 metres.

Beklemishev Tower: constructed by Marco Ruffo in 1487 at the point where the moat reached the Moskva. Given a tent roof in the seventeenth century. Height: 37 metres.

Constantine and Helena Tower: erected in 1490 by Pietro Antonio Solari. Upper section added in 1680. Height: 37 metres.

Nabatnaya Tower: built in 1495, with the tent-roof superstructure added in the seventeenth century. Served as an alarm tower. Height: 38 metres.

Tsar's Tower: the last of the towers to be built, set on to the Kremlin wall in 1680. Height: 16 metres.

Saviour's Gate Tower: built in 1491 under the direction of Pietro Antonio Solari and Marco Ruffo. Tent roof added in the seventeenth century. Gothic upper tier containing the carillon constructed in 1625 by the English architect, Christopher Halloway. Height: 71 metres.

Senate Tower: erected in 1491; the tent roof dates from the seventeenth century. Sergei Konyenkov's 1918 bas-relief memorial for the victims of the Revolution was formerly located at the foot of the tower. Height: 34 metres.

St Nicholas Tower: built by Pietro Antonio Solari. Given a circular upper tier and a Gothic tent roof (designed by Rossi) in the course of the general overhaul of 1780. Destroyed by the French in 1812, and

reconstructed in 1816 by Osip Bove. Height: 70 metres.

Corner Arsenal Tower: built in 1492 by Pietro Antonio Solari, and given a tent roof in the seventeenth century. Height: 60 metres.

Middle Arsenal Tower: erected in 1495; upper tier added in the seventeenth century. At the base of the tower, in 1819, Osip Bove built an artificial ruin. Height: 39 metres.

Trinity Gate Tower and Kutafya Tower: built in 1495, with a drawbridge across the Neglinka to the Kutafya Tower. Tent roof added at the end of the seventeenth century. Rebuilt after the fire of 1812. Height: 80 metres.

Commandant's Tower: given a tent roof in the seventeenth century. Height: 41 metres.

Armoury Tower: acquired an upper tier in the seventeenth century. Height: 32 metres.

This rather laborious procedure could have been replaced by the simple statement that the towers and walls were designed by the master architects from the cities of northern Italy. And yet that statement, concise and accurate as it is, would not convey how more detailed knowledge can make the scales fall from your eyes. Clearly this approach was necessary here to make what was unfamiliar become comprehensible, an objective that could not be attained simply by looking.

I was very much struck by the findings that resulted from this operation, as I was, too, by a phrase that I found in Arthur Voyce: 'the Italian Kremlin'.

The model for the superstructures that turned the 'Italian' fortress into a Russian one is close at hand: the Church of the Ascension at Kolomenskoe, near Moscow. This is the source of the octagonal tent roof, or *shatyor*, the form that gives the Kremlin towers their definitive, unmistakable appearance. This phenomenon too is covered by the term 'Renaissance': the ambition of newly emerging states and nations to find their own individual mode of expression.

Until the second decade of the twentieth century the Kremlin remained a closed city within a city, the preserve and quite literally the bastion of reaction, in the midst of a Moscow seething with the energies of capitalism and cosmopolitanism. It did not take the exchanges of fire between revolutionaries and the monarchist regiments to show that the days of this bastion were numbered. Long

before this, the city had been besieging the walled citadel like waves breaking against a cliff. On old photographs this is plain to see: bank and office buildings vie with the church towers, and the tram rattles disrespectfully along the side of the Kremlin wall. From the three main shopping streets of Kitay-Gorod that converge on Red Square – Nikolskaya, Ilinka and Varvarka – a steady stream of humanity pours down into the square and its teeming traffic. There was plenty of hustle and bustle on the south-western side of the Kremlin, too, around the city's (then) new emblem, the Cathedral of Christ the Saviour.

The fact that the aura of sanctity surrounding the Kremlin hill was not dispelled, but merely changed its nature, can be attributed to the same cause as the failure of the bourgeois revolution in Russia. What we call the civic spirit was not sufficiently strongly developed; it did not have the vigour to secularize this area and claim it for civic affairs. Red Square had always provided a natural focus for public life: it lay between the merchant city and the city of the tsars, where the trade routes to and from Tver, Vladimir, Kazan and Astrakhan met; it was a place that had seen acts of national resistance and national self-assertion, and also a place of humiliation and executions. All these factors are reflected in the composition of the square: on the two long sides the Kremlin wall and the Trading Rows, at one end St Basil's Cathedral and at the other the Historical Museum, both of the latter documenting, in historically different ways, the same mood of national self-assertion. After Lenin's death the mausoleum designed by Shchusev was added, its stepped pyramid of red granite giving the square a further element of cohesion.

When the planners of the 1930s started to think about the reconstruction of the city, the Kremlin, together with Red Square, was naturally included in their considerations. 'Together we are shaping an extraordinary period – the beginning of a new phase of history for human society', declared El Lissitzky in 1934, in his contribution to the debate about the competition to design the People's Commissariat for Heavy Industry building that was to replace the GUM building. 'Before us is a programme of construction that, both in its dimensions and in its significance, outstrips all that has been created by the cultures of the past, even at supreme moments of their flowering.' Lissitzky was quick to warn against tastelessness and provincialism, and against mere bombast and theatricality. However, his own vision of the 'first Red Forum' was so ambitious

188

Church of the
Ascension in
Kolomenskoe,
built in 1532.

that, for all its boldness of imagination and technical mastery, it was incompatible with the existing ensemble of buildings. Should we be glad that the projects of the avant-garde were not realized, and that Red Square has in essentials been preserved to this day in its traditional form?

The planners of 1934 were not the first to measure their skills against this symbol of the nation's destiny. Each of the buildings around the periphery of the square reflects an anxiety to fit in with what was considered the nation's heritage. So it was with Vladimir Sherwood, to whom, after a long struggle, the design and execution of the Historical Museum was entrusted. As we can still see today, the controversy was resolved in favour of a restrained neo-Russian style, avoiding any extreme elements of that idiom. It is impossible now to imagine Red Square without the museum, and indeed its dark red brickwork, with the strange spires and white roofs, has contributed not a little to the shift in interpretation of the square's name, Krasnaya ploshchad, from the original meaning of 'beautiful' to that

189

of 'red'. The western side of the square was always sacrosanct, though plans dating from before the Revolution show that an elevated railway was planned to run where the tombs of the honoured dead and the mausoleum are now situated – this would have been a further incursion by the forces of secularization.

With the building of the mausoleum, this side of the square naturally became inviolable once and for all. There was great controversy about the form that the mausoleum should take. In the end Shchusev prevailed with his bold and original concept of making the mausoleum seem to embody Lenin's legacy by giving it the form of a speaker's platform, rather than pursuing an initial idea inspired by Schliemann's work on Mycenae and Troy. He also prevailed against the arguments of Mayakovsky, for whom the idea of embalming Lenin and displaying him as a kind of idol in a mausoleum was unthinkable: Mayakovsky believed that the only way of keeping alive Lenin's legacy was by actively continuing the work of communism and achieving radical social change. The mausoleum is seen, no doubt rightly, as a particularly successful piece of work, because its granite cube provides the square's slightly domed contours – and what seems to the pedestrian its vast expanse – with a centre, a focal point, an element of repose.

The area at the southern end of the square has not always remained untouched by controversy: the fate of that extraordinary riot of shapes and colours, St Basil's Cathedral, was apparently in the balance more than once before the demolition experts were finally sent packing. However, it was the arcades, the temples of trade situated on the eastern side of the square, that were the main focus of attention. The terms of the competition of 1934 allowed in principle for this site and an extension of it reaching far into Kitay-Gorod to be redeveloped.

This historic area was to be treated far more ruthlessly at a different period – a period that did not fall within the era of the Stalinist dictatorship. It was the late 1960s that saw the demolition of the southernmost part of the square, the section of Kitay-Gorod adjoining St Basil's Cathedral and the Moskva embankment. You do not need to be an expert in architecture to feel physically revolted by the monstrosity that is the Hotel Rossiya. Seen from the opposite bank of the river, this gigantic eyesore tears Kitay-Gorod open, breaching what had been a kind of defensive wall formed by the huge nineteenth-century houses. For the sake of the hotel the whole surround-

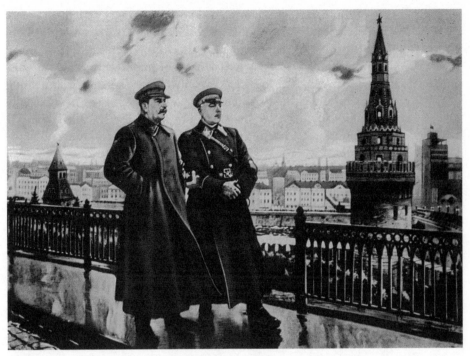

Stalin and Voroshilov in the Kremlin, painting by A. M. Gerasimov, 1938.

'And then the Kremlin. No longer a two-star affair in Baedeker, but a fortress
and a place where the rulers are isolated, well protected by Red Army soldiers and
the elaborate checks made on visitors. Once aware of the medieval character and
oriental spirit of Moscow, one cannot forget it. The Kremlin really is the Castle
dominating the city.'
Paul Scheffer, *Sieben Jahre Sowjetunion*.

ing area was also flattened, with the exception of the fourteenth- and
fifteenth-century churches and boyars' residences, which now sit
there like something being served up on a tray, and have the effect of
emphasizing rather than mitigating the desolation. Viewing that
corner from the side of Red Square itself, one feels that the new
building has somehow blown a hole in the square and disrupted its
unity.

In the 1930s the price of modernizing the square seemed too high
and major steps too hazardous, and so it was left untouched. It
would indeed have been irresponsible to take the risk. At one fell
swoop the old nucleus of the Kremlin would have been attacked, as
it were, from two sides: from the east by the People's Commissariat
for Heavy Industry, and from the south-west by the mammoth struc-

191

ture of the Palace of Soviets. And so everything was left as it was. The square did not become a forum, but the reasons for that did not lie in the areas of planning or architecture. The term 'forum' must, after all, signify a place where matters of public importance are discussed in public. The 'masses' can only take possession of something architecturally if they have already taken possession of it socially and politically. And by that I do not mean the so-called one-day demonstrations, but a free play of energies that is habitual and taken for granted.

I have witnessed such one-day demonstrations and the assembled masses on various occasions. On the evening of 1 May, the evenings of 8 and 9 May and the annual celebration of the Revolution, hundreds of thousands of people come flooding into the city centre, converging on the square and packing the bridges (which have been specially closed to traffic) to watch the taking of the salute and see the firework displays, which set a hundred thousand voices cheering. But the crowds do not move like people with a purpose, people making a demand or an accusation – this is the *gulyanie*, a semi-organized stroll with the children, involving ample quantities of beer or vodka. Then the great, rounded expanse of the square fills with people and the air buzzes with their conversations as they saunter up and down. The long evening is further extended by the festive illumination that bathes the Kremlin in an unreal-seeming light and spreads outwards, gradually diminishing in strength, over the central area of the city. The crowds who have watched the fireworks from the bridge now pour into the square, tens if not hundreds of thousands of them. They come up against the stone plinth on which St Basil's Cathedral rests, and here, where they are forced to divide, they see the uniformed men posted on the plinth above them, eerily silhouetted against the harsh floodlighting and the lime-green of the trees – all the more uncanny for the unobtrusiveness of their presence, standing to attention, in perfect order, while the people stream untidily past. But in the square too nothing untoward happens, they stream across it, it is vast enough to swallow up any singing, any talk. The people may not be reverent, but the atmosphere certainly is.

Reverence! That was most palpably the attitude engendered by the square on the day when tens of thousands joined the queue to file past the tombs in the Kremlin wall. It was reverence for the fallen heroes, as well as the restriction of movement imposed by being in a

queue, that made people increasingly quiet and disciplined the nearer they drew to their goal. They were admonished to remain two abreast; they were conscious of the deference they owed to this square. It is a mistake to expect Red Square to be a place of political activity like a parliament, a market-place, a town hall or a Place de la Bastille, or to search for the purposeful movements and gestures associated with such locations. It would be more appropriate to think in the following terms: this is a fortress, this is a holy place with golden domes and silenced bells, a mighty pantheon, a Champ de Mars, a wall with tombs, a place of solemn celebration, a parade-ground.

What enormous courage, what selflessness, must have inspired those individuals who on 25 August 1968 staged their brief sit-down demonstration and unfurled a banner bearing the slogan 'We protest against the occupation of Czechoslovakia'. This was a challenge to a sacred place, and those who intervened so swiftly were not simply the guardians of the law but the guardian angels of a holy of holies. Only for a very few moments were Larissa Bogoras, Pavel Litvinov, Vadim Delone, Vladimir Dremlyuga, Viktor Fainberg, Natalya Gorbanevskaya and Konstantin Babitsky able to cling to the *Lobnoe Mesto*, the circular platform that historically has been – both a speaker's dais and a place of execution.

18 Proximity and distance

Despite its striking points of emphasis, Moscow is somehow like an ocean without a shoreline. The shore from which you embarked on your journey is now far away; only occasionally do you glimpse it as a thin stripe on the horizon or in the form of a familiar dialect. The shore on which you wanted to tie up briefly, no more than that, is not in sight, or rather, it eludes you every time you think you may be near to it. Your interest in your home shore, your daily need to know what is happening there, dwindles; the papers with news of home are slow to arrive, but it is not just that. There are other reasons why you no longer assiduously read the feature articles every morning: the home context, the smell in the air, the surroundings against which you would judge the paper's truthfulness, are missing; the screen on to which you project your own worries and expectations has been retracted. And your present surroundings are so compelling, sometimes so intangible and yet at other times so overpoweringly concrete, that they confuse your perceptions. Into your camera drifts a subject, perfectly defined, only to be lost again immediately.

Again and again you find yourself exhausted and defeated, and this is when you feel tempted to resort to artifice, to use some kind of intellectual rope-bridge to help you over all those inexplicable and irreconcilable impressions and bring you to your satisfactory conclusion, your unified picture, your coherent summary. But perhaps this is precisely what you cannot achieve. As a foreigner, you are like a tiny shadow in front of a gigantic screen with a film showing on it. At drive-in cinemas you sometimes see how on the vast screen, with

the huge sky behind it, the rapid succession of images just about conveys a comprehensible sequence of action and plot, provided that you are far enough away; but for the tiny individual close up to the screen, enveloped in sound from the loudspeakers, there are only lines that merge into each other, surfaces, explosions of colour, fragments of detail cascading over him. From a distance a city has a distinct physiognomy, a country has a definite outline. But seen from close up, the contours blur, the colours previously separated by fine lines run into each other and become indefinable, the coloured surface breaks up into separate dots which come menacingly close.

If a person chooses to observe something from very close by, he is overwhelmed by the coarse grain of the image, and can only escape its powerful hold by retreating a few steps, creating a distance and refusing to surrender himself to it. This is the moment when he feels the need for tranquillity, when the disruptive power of the image viewed at too-close quarters yields to the need to turn inwards, into the mind, where the images and impressions can be brought into proper focus – the need to bring order to things that resist comprehension.

At such moments one also senses the impossible and illusory nature of the wish to be no more than a prism for what one has seen, without the frailties inherent in being a stranger, without either the deficiencies or the advantages of someone standing in a no man's land, trying to adopt a position that does not involve judging good and evil, justifying or condemning, choosing critical detachment or positive commitment. Close, perhaps excessively close observation of an unfamiliar country disrupts the framework of ideas that the visitor brings with him; this is the only valid basis for the common assertion that one returns from one's travels a wiser person. But 'wiser' can mean anything or nothing. It can mean that one gathers experiences that concretely confirm one's existing ideas and develop them further; but it can equally well mean that one's way of seeing things is turned upside down, and that the impressions one receives have implications too far-reaching to fit easily with the opinions and theories one had set out with.

It is in the nature of impressions that they can cancel each other out. If you try to summarize them, you risk ending up with a colourless compromise and capitulating in the face of the problem of 'rival truths'. I could quote endless instances of how two different truths can go hand in hand.

Working in the Lenin Library, you discover that the ethos and conduct derived from the best tradition of Wilhelm von Humboldt coexist here side by side with the most petty-minded censorship. Looking at the appearance and general manner of the scholars sitting at their desks in the library's Number 1 Reading Room, I feel naturally drawn to them. Many of them have the sort of faces that we know only from histories of ninteenth-century science and learning; almost invariably they wear suits and ties, spectacle frames of a kind no longer seen in the West, and sometimes a short beard that we would feel has long since gone out of fashion; but there are also physiognomies here of a type that one finds among American East Coast intellectuals, with that familiar touch of intellectual aristocracy accompanied by a physical bearing acquired through the pursuits of baseball and sailing. Then there is a man, some 70 years old, his face framed by a bushy white beard reminiscent of the Orthodox Startsy of Old Russia; utterly absorbed in the books and manuscripts piled up around him, he is quite unaware that he automatically answers every cough in the room with a cough of his own.

Here there is absolute concentration within the pools of light directed on to the desks by the green lampshades. The reading room would have something about it of the *scriptoria* of medieval monasteries, were it not for Shchuko's and Gelfreikh's art deco interior. The fact that there is no air conditioning, and that in lieu of this the windows are opened every half-hour by hand, also gives it a certain premodern charm. Here you re-learn the art of taking notes, because photocopying is not as cheap and convenient as at home – added to which, not everything can be obtained in photocopy form.

Intimately associated with these impressions, however, there are other very different and disturbing ones. It is not just that the catalogue is incomplete – the names of particular scientists and scholars are missing from the general catalogue, regardless of how much they published, and how influential their writings were in their day. Nor is it only the unappetizing way the food is served in the canteen, or the huge contrast between the long-established scholarly culture in the reading rooms and the filthy toilets in the same building. What is really striking is what the orchestrators of the nation's enlightenment expect the most enlightened of their subjects to accept without protest, namely that the most simple, basic means of informing oneself by reading the international press is denied them. Anyone excluded from the privilege of access to Reading Room Number 1

has to make do with the *Morning Star* or the West German commu-
nist paper, UZ (*Unsere Zeit*).

The following is an example of how people can, quite justifiably,
have opposing views about the Stalin era. On the train to Vienna I
found myself in a compartment where vodka, bread and Siberian
bacon were being handed round. In the course of a very friendly
conversation, one of the passengers, an engineer from Omsk on his
way to Kiev, drew a big colour portrait of Stalin from his bag. As he
did so, he launched into a panegyric: those were the days, when
towns were conjured out of nowhere – there was nothing like that
going on nowadays. One of the other passengers, a worker from
Kiev, gave him an unexpectedly brusque answer: in those days no
fewer than six members of his own family had been in labour camps,
so the engineer could just put his picture back where it had come
from. What would the foreigner think? (In the course of their alterca-
tion they also argued about whether the foreigner should actually be
allowed to stay and listen to an 'internal disagreement'.) What some
remembered as a time of youthful commitment, of getting on and
even having a career, was for others a time of deadly menace.

Another occasion when one can observe the irreconcilability of
opposites is 9 May, the day of victory over Hitler. Who would set out
to wound the pride and sense of achievement of old warriors, or add
to the pain of their memories? And yet any reference to the occupa-
tion of Prague in 1968 or of Afghanistan today – historical fact, not
propagandist fable – must seem to them like sacrilege. The former
defenders of the homeland are reluctant to accept that their country
has now become an occupying power itself.

What I wrote earlier about the 'strong man' created by the Soviet
system must now be qualified. When I penned my observations, I
was not aware of what the study by Murray Feshbach and
Christopher Davis, based on Soviet records, has recently shown,
namely that in the Soviet Union the infant mortality rate is rising. In
addition, the average life expectancy has been declining in the last
two decades, especially among men, reversing the achievements of
the health revolution in the first half of the century. Perhaps the
impasse that the Soviet system has reached in recent decades shows
itself most startlingly in this area, where the system impinges on a
breed of human that at first sight seems indestructible. As a matter of
fact I have always felt that it is Soviet woman who is the true embod-

iment of the new, 'strong' individual. She attends to the home, but is also happy to be seen in that role in public. There would be scope here for another phenomenological study, to get behind the clichés of the traditional matriarch and the emancipated woman.

Here, by way of conclusion, is another of my observations. In the metro and other places where large numbers of people are thrown together and good manners are put under particular strain, the question that came into my mind was this: how is it possible to survive – in such concentrations of people, at any rate – without some framework of ingrained politeness? Does politeness collapse under the weight of such numbers, or is it just that the Protestant ethic has never been sufficiently internalized, absorbed into the bloodstream as it were, for it to cope with the most stressful moments of daily life? I have encountered far more warm-heartedness here than at home, and it takes you by surprise because it is expressed so directly, with no beating about the bush, as though people have known you for a long time: that can be very comforting and can compensate for a day full of tribulations. The downside of this directness is a kind of insensitivity, or even brutality, which is as hurtful as the warm-heartedness is comforting. What is missing is that happy medium of cool, conventional friendliness that makes for a degree of impersonality, but by the same token affords you the protection of distance.

Something similar seems to apply at the level of conversation. A direct or even didactic way of speaking can often make a refreshing change from 'elaborated and reflexive discourse' – but at the same time how unbearable such direct speaking soon becomes in its inability to adopt a moderating subjunctive mode or to depart from formulations on the level of 'the general opinion'. Here you sense the persistence of the hierarchical attitude to thought and knowledge, and of the habit of subsuming the individual under the collective. This in itself makes communication difficult and laborious, even before you come to the actual topic under discussion.

It is so easy to make the assumption that the Protestant ethic has not yet taken hold in Russia and that the notion of self-discipline has barely started to have an impact on the country and the people. It is equally easy to make precisely the opposite assumption, namely that Russia has already developed its own 'specific type' of behavioural patterns, capable of absorbing other, alien ones. Neither is the case. Where phenomena from the pre-Soviet past can be identified, they at

once cease to be separate fragments or particles but act as cement in a larger context. And if you scrutinize this context, the 'Soviet mode of life', it shows itself to be brittle, full of cracks, and reliant on borrowing models and ready-made concepts from the other cultural sphere. The proposition that what we encounter here is a new and entirely different civilization is as false as the suggestion that we as foreigners can discover a wholly familiar world here.

You put yourself in an exposed position here – but you are inevitably in an exposed position. You wander around in a forest of preconceived ideas, including relatively sophisticated ones, and at every step you are proved simultaneously right and wrong. You are struck by the normality of things, and yet it is a normality that neither admits you freely nor releases you unscathed. You are conscious that a way of thinking quite different from your own is taken as natural and normal, yet you constantly see evidence of a sense of inferiority and painfully obvious efforts to compensate. As a foreigner you feel guilty of presumption when you judge life here against your own home standards and criteria, but there is no escaping the outlook with which you have grown up.

If one undertook a visit like this with an absolute determination to understand both worlds, I do not know what the outcome would be. It might be a mental state like that of a schizophrenic who has to accept mutually incompatible things as equally real in his mind; or a more complete acceptance of where one originated; or alienation from one's origins. A foreigner who had been living here for some time once told me that he had made many friends here and that since he was getting to an age where making new friends was difficult, this was where he planned to stay. This is possibly a more enlightened way of thinking, focusing on the personal. But a problem arises as soon as someone who personally feels comfortable and at home here is confronted with realities that do not directly affect him because they do not apply to him, but which his whole nature finds repugnant. How far can one go with a willingness to show understanding, before the integrity of one's own identity is lost? How far can one go in accommodating a different way of thinking and living, without being untrue to oneself?

The only answer I can think of is Luther's declaration: 'Here I stand, I can do no other.'

19 Inscriptions on a black background

*The labelling of the city – Emblems of power
in a code for the passer-by to decipher.*

As a newcomer gradually begins to feel at home in a city, or at any rate starts to be carried along by the current of its daily life, everything falls into place and can be comprehended in his increasingly casual glance. Individual objects lose their arresting and recalcitrant quality and slip by almost unnoticed. One possible measure of this lessening of intensity – a welcome respite for his eyes and his other equally overtaxed senses – is the reduced amount of attention he pays to the black plaques, inscribed with gold letters, words and abbreviations, that can be found next to more or less important-looking doorways in almost every street: his initial interest in them fades until finally he learns to ignore them. Before long they have become simply part of the street scene, like advertisements and the names on company, office or research institute buildings in our Western cities. But such a bald comparison overlooks the very different nature of these black plaques with their gilt initials. It is not their way to assert their individuality or parade eccentricity in motley colours and experimental styles: they consist, literally, of gold characters on a black or red background, and vary only in size.

For example: *Izdatelstvo Muzyka* (Music Publishing House), *Ministerstvo kultury SSSR* (Ministry of Culture of the USSR), *Verkhovny Sud SSR* (Supreme Court of the USSR) or *Moskovsky finansovy institut* (*MFI*) (Moscow Financial Institute). You gradually learn to register such unambiguous titles subconsciously. But you cannot do that with those unpronounceable abbreviations which mean nothing unless one is directly concerned with the institution in question. Examples of this might include Glavvostoktruboprovodstroi (ulitsa

Plaques with gold lettering on a black background flanking the entrance to an old building in Moscow.

Kirova 22), which is short for *Glavnoe upravlenie po stroitelstvu truboprovodov v Vostochnoy Sibiri* (Chief Directorate of Pipe Construction in Eastern Siberia). Or Soyuzstrommashina (prospekt Kalinina 23), short for *Vsesoyuznoe promyshlennoe obedinenie po mashinam dlya proizvodstvo stroitelnykh materialov* (All-Union Industrial Association for the Construction of Building Machinery). Or Rostransekspeditsiya (ulitsa Ostrovskogo 13a), short for *Respublikanskoe proizvodstvennoe obedinenie transportno-ekspeditsionnykh predpriyati* (Republican Production Association of Transport Companies). Or, finally, *Moskovsky ordena Trudovogo Krasnogo znameni institut nefticheskoy i gazovoy promyshlennosti imeni akademika I.M. Gubkina* (Leninsky prospekt 65), which is the Gubkin Academy of the Oil and Gas Industry decorated with the Order of the Red Banner of Labour.

If these monster words were few and far between you would not give them a second thought. But you can put together whole cadenzas of them, like this:

SOYUZSTANKOLINIYA

SOYUZSTANKOPROM

SOYUZSTANKOREMONT

SOYUZSTEKLOMONTAZH

SOYUZSTROIINSTRUMENT

SOYUZSTROIMONTAZH

SOYUZSTROIMASH-AVTOMATISATSIYA

SOYUZSTROMMASHINA

SOYUZCHETMASH

SOYUZTVERDOSPLAV

SOYUZTEAPROM

SOYUZTEKSTILMASH

SOYUZTELEFONSTROI

SOYUZTEPLITSA

SOYUZTOPLOVOSPUTMASH

SOYUZTEPLOKONSTRUKTSIYA

SOYUZTEPLOSTROI

SOYUZTEKHNOPRIBOR

SOYUZTEKHNOPROM-AVTOMATISATSIYA, etc., etc.

This cadenza could be extended, but the point is that it becomes readable and audible, capable of being understood like a musical score. *Soyuz* in these expressions obviously signifies the status of an All-Union institution; these first two syllables function as a kind of key signature. The syllables that follow indicate the area, the discipline, the specialism. You could presumably transpose the melody into a different 'key', in other words to the level of the republics or the regions or districts, assuming that the given institution has an equivalent at the lower level.

There were interesting debates, dealing with fundamental issues, about the transformation of the Russian language in the wake of the October Revolution; the controversy surrounding Nikolai Marr's theory of class-based language and Stalin's letters on this question are the best-known, though perhaps not the most significant contributions to the discussion. One vital element of the post-revolutionary language was the desire to provide a rational form of expression for the intended rational organization of society. One may rail at the monstrous nature of such abbreviations, or deplore their standardizing effect as a piece of linguistic levelling-down, but they undeniably stem from an aspiration to achieve rationality in a society that was to

Центральные Правительственные Учреждения.

Institutions of central government in the *Moscow Directory* of 1926.

be built not on private ownership and its distinguishing marks, but on neutral, objectivizable social relationships – and they make sense within that context.

Admittedly, Konstantin Paustovsky, in his memoirs, saw matters differently:

> At that time, after the Revolution, all that nonsense with the abbreviations started. Within a few years this dreadful practice had assumed such disastrous proportions that it was threatening to turn the Russian language into a sort of international gibberish.

This language of abbreviations was a way of rationalizing terminology, but perhaps it also reflects a feeling that the proliferating social institutions could only be tamed if they were reduced to these stunted monsters. But at all events they represent an intelligible code.

I confess that this idea about the decodability of the pattern of formulae used in the abbreviations only came to me when I saw them gathered together in a concise directory of present-day Moscow. Presented in this way, the hitherto confusing mass of letters and syllables appeared logical and even enticing, and one might reasonably claim that the orderliness and transparency of this system of government and the social organizations is a direct expression of what a Hungarian philosopher has called the 'hyperrationality of real existing socialism'.

Now I see the reason for the profusion of black plaques in the city: Moscow is at once the capital of the Union, the seat of government of the RSFSR, and a self-governing city subdivided into districts or 'regions' which in turn are broken down into 'micro-regions'. So Moscow is the hub of all these concentric circles. And this means, in simple terms, that the control centre of every one of these circles is here: the Supreme Soviet of the USSR, the Supreme Soviet of the RSFSR, the soviet of the Moscow region, the Moscow city soviet, the Moscow district soviets.

Similarly, there are the People's Inspection Committees for the USSR, for the RSFSR, and so on. It goes without saying that all the major institutions of the USSR have their headquarters here: not only the Party, the government, trade unions, the youth organization, the courts and the ministries, but also archives, all the social and international organizations, scientific academies, institutes, laboratories,

research centres, publishing houses, newspapers, sporting organizations, the arts, theatre, film, and of course the state trusts and the industrial associations and enterprises. Not to mention the armed forces.

What does this clearly tell us, without our having to consult a sociological analysis of the composition of the Moscow population? That the great majority of the people setting out for work in the morning are heading not for factories but for offices, for the workplaces of the white-collar workers. Moscow – as can easily be demonstrated sociologically – has ceased to be the city of the proletariat and of industrial work geared to production.

In 1977 something over 30 per cent of the working population were employed in the primary sector, with the remainder divided between the secondary and tertiary sectors. Compared with 1965 there had been particularly high rates of increase in the following areas: jobs in health care provision and sports facilities (50.7 per cent), education and culture (35.4 per cent), science (40.8 per cent), credit and insurance institutions (41.4 per cent), the provision of essential services (56.4 per cent), and the administrative apparatus (68.1 per cent). By contrast, the number of industrial production workers had gone up by only 2.7 per cent. This is, incidentally, completely in line with trends in the non-socialist economies.

The code inscribed on the black plaques reveals something else, too: not just the hierarchical structure of the levels of power and decision-making, but, at each level, the parallel strands of power – truly a multi-stranded 'democratic centralist' structure. There is the strand of the state institutions: the Supreme Soviet of the USSR, the Council of Ministers, the ministries, etc. Then the strand of the Party, extending from the Central Committee of the CPSU right down to the regional committees. There is the strand of the Communist Youth organization, with a structure corresponding to that of the Party itself. And there is the trade union strand, starting with the All-Union Central Council of Trade Union Associations and going all the way down to the trade union committees in individual towns and factories. Who, contemplating this organizational network, could harbour any doubts as to the organizational skill, the state-building capability of the Bolsheviks? Who, in the face of the transparency of such power structures, could doubt that the dialectics of enlightenment had made considerable headway! Marx once remarked that social science is forced to abandon the test-tube that the chemist is

able to use for his analyses and depend instead on the power of theoretical abstraction. Perhaps for once that movement from the concrete to the abstract might be reversed: one could make a map and mark on it all those 'signs on a black background', and they could then be given different-coloured flags and joined up accordingly. The result would be a Moscow topography of power and influence, and it would show such a massive accumulation of organizational power and expertise that one would fear that it could only have been achieved by denuding all the rest of the country. And perhaps that is the very reason for its chronic impotence.

Cadenza no. 2, *ad libitum*:

VNIIPROMGAZ	VNIISSOK
VNIIPRKH	VNIISTROIDORMASH
VNIIPTUGLEMASH	VNIISTROIPOLIMER
VNIIPKHV	VNIIST
VNIIREA	VNIISHT
VNIIS	VNIISE
VNIISS	VNIITGP
VNIISI	VNIITORMASH
VNIISINTEZBELOK	VNIITP
VNIISMI	VNIITR
VNIISNDV	VNITEILESPROM, etc., etc.
VNIISPV	

20 The Conservatory

Quality of sound in a historic setting –
The indomitable spirit of pure music –
Conductorless orchestras and performances
by distinguished conductors –
Plato's directives.

Once again I am near the Moscow Conservatory. Time for a quick scan of the posters announcing the concerts for the next ten days, displayed outside the Conservatory and on other buildings in ulitsa Gertsena. The posters are individually hand-produced, with fine lettering in bold red and black on a white background. Unlike the theatre posters, these really are done by hand, at least the ones for the Conservatory's vestibule and forecourt. What a labour of love!

Today I am after tickets for an evening concert: Natalia Gutman and Oleg Kagan playing Brahms's Double Concerto, and a performance of Alfred Schnittke's Requiem. The box-office lady, who is always very surly, pulls down her roller blind, although she is not normally supposed to have a break at this time. But people are used to it. They stay where they are; somebody has heard some mention of a 'funeral'. We stand and wait for our tickets for Brahms and the Requiem; a well-informed lady, the elder of the two queueing behind me, explains to a stranger why people prefer the Conservatory's auditorium to the Moscow Philharmonic's Tchaikovsky Concert Hall on ploshchad Mayakovskogo: the Conservatory's acoustics are unbeatable, she says. The other lady is troubled by the foreign-sounding name Schnittke and asks whether he is 'one of ours'. Oh yes, comes the reply, and the Requiem is really interesting.

Suddenly we hear solemn music being played by a brass band. At first no one is surprised, because there is always the sound of music around the Conservatory, drifting through the open windows in the summertime, and sometimes out into the cool blue night in the

207

autumn. It is almost part of the setting. This time, however, we recognize the ponderous notes of the Funeral March from Chopin's Sonata in B flat minor. And now there are people coming out of the Great Hall, quite a large number of them, some carrying wreaths, and at the head of the procession someone is carrying a tray covered with a red cloth, with medals and decorations laid out on it. The men have removed their hats and are walking arm in arm; a woman with a tear-stained face is supported by those around her. Kisses are exchanged. Some of the people have their briefcases with them. One woman lights a cigarette as she comes out. There is solemnity but also a touch of informality. The solemnity comes from the music, which is being played, even more slowly than usual, by a military band drawn up just outside the entrance. Then any lingering doubt is removed: in the middle of the procession that is making its way through the vestibule, past the queue at the box-office – here too people have taken off their hats – a red-lined coffin covered in flowers is borne past. Six men are carrying it on their shoulders, and it is obviously an effort for them: no doubt they are professors, unused to carrying heavy loads – colleagues of the dead man, who can just be glimpsed in profile. They are followed by Conservatory students carrying the red coffin-lid, and behind them more wreaths. Everybody has joined the procession, not just the colleagues and students of the deceased, but the cloakroom attendants, our box-office lady and the usherettes. Some are weeping. The dead man is departing from the scene of his professional activity, the focus of his life's work, and they are seeing him off. As soon as the mourners have climbed aboard the buses that will take them to the cemetery, and the wreaths have been loaded in too, the box-office blind is raised again. There are still plenty of tickets for the Requiem, says our lady, surly as ever.

Death is a little less terrible when the dead person is genuinely mourned by his former associates and the public display of grief has not become a meaningless show. And a person departing like this from the Conservatory shares something of the aura of that institution which holds such a revered place in the cultural life of Moscow and the whole of Russia.

An aura cannot be artificially created. It is either there or it is not. In the Moscow Conservatory it is the aura of pure culture, a musical culture that has grown up over the course of a long history. It is probably true to say that such a culture depends not only on the particular character of an orchestra's playing, but also on a concert hall that

208

Orchestral rehearsal in the Great Hall of the Conservatory.

can guarantee a certain minimum standard. In a Europe first ravaged by wars and then rebuilt and modernized, there are only a few concert halls still in their original condition. Among these are the Moscow and Leningrad Conservatories, the Musikvereinssaal in Vienna and the Rudolfinum in Prague. And then there must also be a community, a core of faithful audiences withstanding all the vicissitudes of changing times to establish a culture of listening.

Almost every evening the Great Hall is filled to capacity, as is the Small Hall where chamber concerts are held. There is not always quite such a rush for tickets as there was for the visits of the Dresden State Orchestra or the Leningrad Philharmonic under its conductor Yevgeny Mravinsky. But its houses are regularly well filled – this is taken for granted, a matter of routine, which makes the exquisite performances, by contrast, even more effective. It has been my impression that the concert-goers here are far more diverse, socially more heterogeneous than in the West, because here it is not just an elite of connoisseurs and subscription-holders who see music as high art. There are many in the audience who have come straight from work, and a good number are in uniform.

The violinist Leonid Kogan. Cello lesson with Mstislav Rostropovich.

Like so much else here, musical performances typically have an educational element to them. As soon as the orchestra has sat down in front of the massive organ, a lady in a black evening gown steps out on to the stage and gives the audience details of the composer, with the date, opus number and key of the work that is to be played. And the music is listened to in a different way, more reverently, I suspect, and with fewer pretensions to critical judgement. It reminded me of the mood of people going to church: for a while they are free to be alone with their thoughts, for a few moments they can escape from noise and cramped surroundings. Here in Russia the concert hall does not yet face a challenge from those modern catacombs where individuals can experience a musical high all by themselves thanks to the latest sound system, and this means, too, that people do not have to find their way back to the concert halls after becoming used to a different habit of listening.

The Conservatory is rich in symbols of a tradition that seems absolutely unshakable. Alongside the staircase leading up to the Small Hall the names of winners of the Gold Medal of the Conservatory are engraved in gilt lettering, among them Sergei Rachmaninov and Aleksandr Scriabin, Sviatoslav Richter and Leonid Kogan. Above the proscenium arch of the Great Hall is the bas-relief profile of Nikolai Rubinstein, on whose initiative the Conservatory was founded on 1 September 1866 and who was its first director; at the opening concert Tchaikovsky performed at the piano. However, teaching did not begin in the present building until the academic year 1871–2. On the side walls of the Great Hall are portraits of the composers to whom musical life in Moscow feels

most indebted: Bach, Beethoven, Mozart, Schubert, Schumann, Wagner, Chopin, Glinka, Dargomyzhsky, Tchaikovsky, Mussorgsky, Borodin, Rimsky-Korsakov and Rubinstein. For a relatively short period in the long life of the Conservatory these portraits were taken down, according to the violinist Yuri Yelagin (himself a graduate of the Conservatory): this was when the Association of Proletarian Musicians was in the ascendant and the Conservatory was renamed the Felix Kohn School of Music. It was not until 1932, after the disso-lution of the Association, that the portraits of the classical composers were restored to their former places.

It would have been a miracle if the Conservatory had not been touched by the upheavals of the period, though these were felt less here than in other areas, notably the theatre. Even as late as 1922 the teaching rooms are said to have had icons hanging in them. And yet the actual founding of the Conservatory was undertaken as an act of new social and national awareness. As early as 1861 Rubinstein had drawn attention to the need for Russia to have its own, national system of musical training. Tchaikovsky and Rimsky-Korsakov had never made a secret of their support for giving the musical life of Moscow a stronger national emphasis. And when Moscow was caught up in the first Revolution in 1905, the Conservatory could not avoid being involved. In March 1905 the Conservatory students voted by 208 to 117 in favour of a solidarity strike in support of Rimsky-Korsakov, who had been fired from his post in St Petersburg. The Conservatory was closed. There was criticism of the autocratic style of its administration and of the teaching methods, unchanged since Rubinstein's day; and during the fighting on the barricades the Conservatory even became a temporary field hospital for the wounded. A weapon used in the fighting in nearby Malaya Bronnaya ulitsa was spirited away and concealed in one of the pipes of the Conservatory's great organ.

However, even before the Revolution the Conservatory had never been a rigidly aristocratic institution; well before 1917 it welcomed all initiatives to combine a high standard of musicianship with the most inclusive social basis that could be achieved. It was probably a sign of unwavering determination, rather than obliviousness to the real world, when at the height of the revolutionary turmoil three of the Conservatory's professors – Orlov (piano), Dulov (violin) and Sabaneev (organ) – sat down together in the Small Hall on 25 November 1917 to give a concert of works by Johann Sebastian Bach.

The Conservatory, photograph, *c.* 1925.

What is described by the Soviet musicologist Yuri Keldysh as the 'Sovietization of the Conservatory' during the years following 1917 was actually less homogeneous and more interesting than that rather ugly term might suggest. Here, as elsewhere, there was a period of open-minded experiment, of challenging old ways on many fronts. The Conservatory threw open its doors: in 1918 free educational concerts were held; the sons and daughters of workers, peasants and soldiers were given preferential treatment; and in 1927 professors and students jointly organized a 'Sunday Conservatory for workers' and also played in workers' clubs and factories. 'Bourgeois specialists' like Myaskovsky, Glière and Gnesin were temporarily suspended. Virtuosi and the teaching system that produced them were attacked, and that personification of 'bourgeois authoritarianism', the conductor, was done away with. From 1922 onwards the Conservatory was home to experiments by the conductorless orchestra Persimfans (short for *Pervy simfonichesky ansambl*, meaning First Symphonic Ensemble). The participation of Conservatory students in international piano or violin competitions became one aspect of Soviet Russia's challenge to the 'old world'. The revolutionary theory of the 'withering of the school' spread to the Conservatory too.

212

Nowadays it is easy to blame the 'ultra-leftists' for the 'ruination' of the Conservatory, and to discern an 'upturn' at the beginning of the 1930s, given that the achievements of the avant-garde of the earlier period are never even mentioned, let alone performed. Composers acknowledged in the West as forerunners or actual pioneers of twelve-tone music – Arthur Lourié or Nikolai Roslavets, for instance – have not been performed in Moscow for the last sixty years. Everyone talks about Honegger's *Pacific 231*, but no one ever mentions Aleksandr Mosolov's homage to the machine, *Iron Foundry*. And even Lenin's approbation of the thereminvox, a precursor of electronic musical instruments, has not preserved its inventor, L. S. Theremin, from oblivion.

The two major tendencies in Soviet modernism (called 'linear' and 'late Romantic modernism' by the German musicologist Detlef Gojowy), which both, in their different ways, tried to move on from their 'bourgeois father', Scriabin, found their way barred in the 1930s. Following the *Pravda* article 'Chaos instead of music' (28 January 1936), the avant-garde – both the 'ultra-leftists' and the great names already held in high regard the world over, Shostakovich, Prokofiev and Stravinsky – were proscribed as 'formalist' and decadent. Nowadays those three great composers, at least, have been rehabilitated.

Yet there is a noticeable reluctance to discuss what happened between then and now. In my programme for the performance of Shostakovich's Fourth Symphony in the Conservatory's Great Hall (which to my great surprise was only half full, something almost unheard of), I was puzzled to read: 'This symphony has an unusual history. In the spring of 1936, when the newly completed piece was in rehearsal with the Leningrad Philharmonic, the composer unexpectedly cancelled the performance. The reason given was apparently the composer's own doubts, exacerbated by criticism of his works at the time.' That is, to say the least, putting matters back to front. The symphony was finally given its première – at the Conservatory – a full quarter of a century later, on 30 December 1961, under the baton of Kirill Kondrashin.

However, the relationship between music and politics (a highly charged one, as Plato pointed out long ago) also has its more pleasant sides. Who could forget the moment when the American Van Cliburn, winner of the first Tchaikovsky Piano Competition in 1958, and Khrushchev, the proponent of the policy of 'peaceful coexis-

tence', gave each other a bear-hug on the stage of the Great Hall! A political idea alone could never have induced such a state of euphoria without the hope and encouragement that music brings. Perhaps it was the liberating sense of being able to share once more an undivided cosmos of music, whereas thirty years earlier the term 'cosmopolitan' had been applied to a certain kind of music in order to condemn it and halt its development.

The Conservatory continued to be the workshop of the European avant-garde until the early 1930s, and the fame of the performers and the composers whose works were performed in Russia in those days has far outlasted that of the pianist from Texas. To cite only the most distinguished of them: Pierre Monteux, Fritz Stiedry, Arthur Honegger, Otto Klemperer, Friedrich Wührer, Ernest Ansermet, Hans Abendroth, Hermann Scherchen, Bruno Walter, Arthur Schnabel, Edwin Fischer, Wilhelm Backhaus, Josef Szigéti, Hans Knappertsbusch, Paul Hindemith and Béla Bartók. There were performances of works not only by the Soviet avant-garde, but also by Schreker, Strauss, Krenek, Hába, Poulenc, Berg and Schoenberg.

The Moscow Spring of the 1950s and '60s never matched Soviet modernism's period of revolt and experiment in the 1920s. And since that thaw there have been some cold spells, as we know. Professor Mstislav Rostropovich, whose name still appears in a history of the Conservatory as a winner of the Lenin Prize and who in 1956 introduced the work of Villa-Lobos and others to the Conservatory, now lives in exile. It cannot by any means be bad music that Plato has in mind when he writes in his *Republic*:

> In a word, the policy of the guardians of the state, to be enforced at all cost, must be to allow no illicit innovations in respect of music. One must be careful not to introduce a new kind of music, because this may endanger the whole system; for it is impossible to change the modes of music without at the same time undermining the most fundamental laws of the state.

21 Proletarian stronghold

*Krasnaya Presnya – citadel of Red Moscow with
workers' dynasties, real battles and working-class
myths –The faces of the revolutionaries –
From the early factories to the Great Leap Forward.*

Krasnaya Presnya is the red citadel among the working-class districts of Moscow. Nowadays it is too close to the centre to be able to preserve its working-class character, though even before the Revolution the fringes of the district, towards ulitsa Gertsena and the Arbat, were already favoured as residential areas for middle-class professionals such as doctors, lawyers, writers and musicians, and there was even a 'Latin quarter' centred on the Malaya Bronnaya.

The bastion of the proletariat of Krasnaya Presnya, the Tryokhgornaya manufactury, founded by V. I. Prokhorov in 1799 and thus the oldest factory anywhere in Moscow, is now surrounded by three buildings, all equally intimidating in appearance: the Hotel Mezhdunarodnaya built by the Americans, the Postmodern building of the Council of Ministers of the Russian Federation, and on the other side of the Moskva the monumental wedding-cake structure of the Hotel Ukraina. The 'Tryokhgorka', as the working people call the factory, confronts all three defiantly. The factory complex looks rather like an old steamship, overhauled and refitted many times over, and with various outgrowths of superstructure, but still serviceable and seaworthy. Other districts – the whole of Zamoskvoreche, for instance – seem to have been more successful in preserving their original character.

Krasnaya Presnya has a museum that is more than just a local museum: it is a gateway to the history of Moscow's working class, or rather the history of Krasnaya Presnya's working people, which has ramifications beyond Moscow. Situated not far from the old Prokhorov factory, the Tryockhgornaya, it has the merit of all small

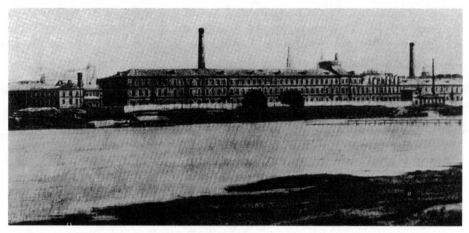

Prokhorov factory, photograph *c.* 1890.

'The Prokhorov works are a model factory. After the guided tour we were invited into the conference room of the factory committee. We were offered refreshments. A member of the former owner's family was present, one of the Prokhorovs, who were once a very rich and powerful family of textile manufacturers. He had adapted to the new situation. But he was no longer in the position of a private host: the hosts were the work-force, and he along with them. It was a completely new form of hospitality, it was revolutionary hospitality, hospitality of the new age. We were given fish, tea, small helpings of jam, bread, sugar. Fish, tea, bread, sugar, on the authority of the proletariat, by the free determination of the workers. For me this really was the new world.'
Alfons Goldschmidt, *Moskau*, 1920

museums: they may be overshadowed by the history of great events, but they shed more light on the secondary scenes of action. Here one is challenged to learn the truth about the backyards of those days, and there is also an element of local pride – and quite rightly so.

Why did Krasnaya Presnya play such a prominent role among the Moscow working-class districts? First and foremost because of the concentration of capital there. In the nineteenth century numerous large factories sprang up here cheek by jowl: the Prokhorov factory, Mamontov's paint works, the Danilov sugar refinery, Schmitt's furniture factory, the metal works belonging to Grachev and Co., factories owned by Martin Vehn and Smit and Company; while to the north were the workshops of the Brest (now Belarus) railway station. Where capital was concentrated, there was soon a concentration of labour, of 'factory hands'. In the museum, a map designed to show how social-democratic underground work in Moscow developed has the secret bases of revolutionary activity marked with little red

216

flags. They advance across the map as they might in a strategists' war game where the aim is to encircle the heart of the city. The encirclement began in the mid-1890s, starting with the new centres of production, the Prokhorov factory, the Grachev works, the factory of G. List, the Kazan railway station, the Dobrov and Nabgolts factory, the Bromley and Gopper factories, the Danilov refinery, the firms of Guzhon and Weichhemd, Dangauer and Kaiser, the Kursk and Brest railway stations, the pastry and cake-makers Renomé and von Einem, the Pereund firm, the gas works, and Kushnerev's printing works. The map also shows the locations of the *skkodki*, the workers' meetings held outside Moscow, in the nearby woods – in the Tyufelev woodland on the side of the Moskva opposite the Danilov refinery, for example, or the Sokolniki woods where workers assembled during Russia's first major wave of strikes in 1895.

Concentrations of little red flags clearly show the centres of the movement: Krasnaya Presnya, the island formed by the Moskva and Moskva Canal, the areas around the Kursk railway station and the group of three railway stations, and of course the tram depots, the pressure that which could paralyse Moscow's transport system.

The 'Tryokhgorka' with its workforce of 6,000 is not typical of Moscow's industry and Moscow's proletariat. Moscow had no equivalent of St Petersburg's Putilov works, one of the biggest and most modern metalworks in the world. In St Petersburg/Petrograd two-thirds of the proletariat were metalworkers, 30 per cent of all of Russia's metalworkers were concentrated there, and on average each factory in St Petersburg employed close on 1,000 workers. In Moscow, on the other hand, it was the textile industry that was pre-eminent, followed by metalworking, but also with the food and transport industries strongly represented. The factories were smaller, with an average workforce of barely 200. Most of those who poured into the city to work had their families still living in villages and often owned a small piece of land. This inevitably affected their 'class psychology', and it was Lenin who expressly drew attention to this:

> It is well known that Moscow is more petit-bourgeois in its make-up than St Petersburg. That Moscow's proletariat has far closer links with village life and a far stronger affinity with peasant feelings, and is more in tune with the mood of the peasants in the villages, is a fact which has consistently been confirmed and is beyond any shadow of doubt.

Home-made bomb as used by the
Moscow proletarian guard.

N. E. Bauman, photographed in 1902.

The hazardous day-to-day life of the illegal activists of the period
has now found its way into the museum's display cases: there is, for
instance, a letter from Lenin to the revolutionary Nikolai Bauman
(who was murdered in 1905) concealed in the picture-frame of a
reproduction of Murillo's *Virgin and Child* (in the Pitti Gallery in
Florence), and there is the Russian version of Lenin's *What is to be
Done?*, published by J.N.W. Dietz's successors in Stuttgart in 1902.
Other exhibits include informers' reports found by the revolutionar-
ies among records kept in the police district offices and the Interior
Ministry, political pamphlets, communications about cases of
denunciation, notes from meetings (written out on forms! – with
what complacency, what casualness the old regime tried to file the
Revolution away under 'Low Priority'!). Also on display is a ribbon
from the cap of one of the crew of the battleship *Potemkin*, a photo-
graph of Nikolai Schmitt, the manufacturer's son who went over to
the side of the insurgents, and a cartoon showing Moscow illumi-
nated by a blood-red rainbow and the Moskva turned into a river of
blood. But there are also more concrete exhibits, shell splinters that
lodged in the timberwork, home-made bombs, time bombs and col-
lection boxes for the solidarity fund.

The portraits showing the faces of Moscow workers and intellec-
tuals from 1905 are very striking. Whichever of them I study more

closely (for instance, the series of working-class revolutionaries including T. N. Rozanov, V. P. Drogin, I. M. Vinogradov, A. N. Rozanov, S. M. Zuev and G. K. Krylov, or the series of pictures of the intelligentsia) I find them impressive and likeable. These are open and yet forceful faces, and the men are well groomed, often with a neatly trimmed beard and a tie: in type they are neither the established official nor the familiar worker-functionary; they have the eyes of men who know that they have right on their side and are fighting for a just cause; their expression shows not the bitterness of 'superfluous men' but the determination of those who have got through the dress rehearsal and are saying 'We'll get you next time'. They are the intelligent, vigorous, energetic faces of men who have been able to benefit from contact with the better aspects of the bourgeois world. They have nothing about them of the heroic *praktik*, the former worker turned leader. Nor do the intellectuals have any trace of that dejected, anguished, even despairing and also sometimes emaciated physiognomy that we have seen in other contexts. This is the flower of those among the Russian working class and intelligentsia who refused to give in. Some questions immediately spring to mind, of course: what became of these faces? Which of these men died a natural death? And how has the physiognomy of the working man, and that of the revolutionary intellectual, changed since then? Nowadays such faces are less often seen in the ranks of the Soviet government – this is not a nostalgic remark, simply an observation – and more likely to be found among those driven into exile.

That too leads on to further thoughts. The Butyrka prison features in several of the displays. In connection with Nikolai Schmitt, for example; or with prisoners being marched off into exile, under guard, some of them already with their heads shaved on one side, others wearing shackles on their ankles. Several different kinds of knout are exhibited, reminding me of the whips of the slave-traders, with their short handles and long lashes of plaited leather. There is also a strait-jacket of the type used on particularly dangerous prisoners. And finally a bill, the original, for the cost of carrying out the death penalty: 5 roubles and 70 kopeks. This was in 1908; in 1907–8 no fewer than 26,000 men and women were given sentences, 5,000 of them condemned to death, as if it were not just a question of making the offenders pay the price but an effort to exterminate once and for all the core of a revolt that would most probably happen again. But the scale of that task was too enormous: this was a minority that

could not be exterminated. And what is one supposed to think, looking at these exhibits and knowing that even now the Butyrka is anything but a museum?

The rooms labelled 'February – October Revolution – Civil War' show the bill being drawn up for the other side to pay. Here time has been halted in its tracks: there is a reconstruction of the room where the revolutionary war committee of the Krasnaya Presnya district held its first session during the night of 26–7 October 1917, and another room, with bentwood chairs, a bookcase and a typewriter with the brand-name 'Mercedes', shows where the Krasnaya Presnya Bolsheviks carried out Party work.

The further sections of the museum, which come closer to the present day, are perhaps less relevant for someone interested in the more turbulent moments of history, though not for anyone who actually lived through these more recent times. What is shown here is the normality of a period of reconstruction and the settling down to a mundane everyday existence; involuntarily, I speed up, as though I were already familiar with all this, as though the period that succeeded the days of 'blood and thunder' had nothing more to offer than the products of the Dukat cigarette factory, and award certificates and diplomas that now bear, alongside Lenin's profile, the sharper features of Stalin. But that is a mistake.

The workers of Krasnaya Presny had stamina. They formed separate battalions of their own to march to the Civil War fighting fronts in the north-west and the south-east; they provided a core division for the 'Twenty-Five Thousanders' who went out into the countryside to persuade the masses to accept the idea of collectivization; they formed their own units to fight against the Nazi armies, and they moved out into the rural areas again in 1954 to support the opening-up of new agricultural land (and founded the 'Krasnopresnenskaya' state farm). What all this shows is that the workers really did make the Tryokhgornaya factory into a revolutionary stronghold that the Bolsheviks could depend on; that it was they, with their organizational talent and their discipline, who were in a position to sustain the first measures towards changing society; and that they could provide the organizational and technical knowledge – which was a rare commodity in Russia – needed by the new political system. Is it any wonder that almost none of this dynamic 'core section' of the proletariat survived? Is it any wonder if the stronghold fell and new generations followed who knew nothing of

the struggle against Prokhorov and autocracy except from the legendary accounts given by the veterans? And where are the veterans now? They must still be around – that can be shown statistically – the veterans who witnessed the events of 1917, the veterans who fought in the Civil War and made up the cadres for the first Five-Year Plans. They must still be around, and I imagine that they are not different in their outlook from those workers one still occasionally encounters in the West, rare as they are: uncowed despite experiences that have cowed the masses, intellectually receptive as a result of a schooling such as few generations are privileged to receive, namely a dramatic acceleration of history in which they briefly had the opportunity to 'make history' themselves. Workers who have never stopped thinking for themselves – and who are sometimes, it is true, inclined to mythologize their part in history, but why not? Workers who have every right to view the present generation at best with forbearance, and even with a degree of contempt.

Much is done to cultivate a dynastic continuity of working-class consciousness, and not only for obviously political reasons. Thus the factories have a 'House of Culture'; the Tryokhgornaya hosts a concert by Mikhail Pletnyov; a kind of internationalism is fostered (and the Thälmann plaque presented by the visiting SED delegation is a testimony to it). In the light of this institutionalization of the old working-class movement, it is pointless to go in search of a 'pure proletariat'.

But supposing one did, one would have to look somewhere quite different – among the huge factory and industrial complexes whose sheer size made it impossible to locate them anywhere but in the outlying districts. It is not just a different order of size that is to be found there – concerns like the First Ball-Bearing plant, Kaliber, the ZIL automobile works or the Electro-Mechanical factory each employ a workforce of several thousands, if not tens of thousands – but their architectural style too has nothing in common with the neo-Russian red-brick Gothic of the first wave of factory-building. These factory complexes, of bold design, shot up as if from nowhere during the second phase of industrialization. Most of them were built between 1930 and 1937 (some to replace older buildings). They no more resemble the older style of industrial buildings than the millions and millions of peasants proletarianized by the first Five-Year Plan resembled the militant, organized proletariat of Petrograd or Krasnaya Presnya during the revolutionary era.

State ball-bearings factory, built 1929–31.

If the scale of the factories grew to immense proportions, so too did the brutality with which the second wave of industrialization was enforced. Nowadays what came into the world 'dripping with blood from head to toe' functions as mere 'material in the metabolism of man and nature'.

When I tell Russian friends that I spent almost three hours looking round the museum, they give me a quizzical look: 'Why that museum in particular?' and 'Whatever for?' I try to explain that I was not being eccentric and pursuing the obscure just for the sake of it, but looking for anything that would help us to a better understanding of where we see eye to eye and what causes us to differ. This of course led to a dispute about Marx and Marxism, every bit as unpleasant as similar disputes with today's left-wingers in the West. Here, as in the West, the debate is mainly over Marxism, though of course it is informed by very different experiences. The crucial difference is that here people know what the guiding light of Marxism led to – or what happened in its shadow. If there are signs that they think in terms of opposed ideological camps, at least they do so in the knowledge of those other, real camps.

22 Museums

Preservation of a 'bygone age', the aura of the
surroundings and the genius loci *– A different*
kind of relationship with the past – Museums
as educational institutions.

There comes a point when, as a stranger visiting Moscow, you lose
your anxiety about entering a museum – in fact a point comes when
you feel a need to visit a museum several times over, if only very
briefly. This happens when you have stopped thinking that you
absolutely must see this or that, and are quite at ease with no longer
having a sense of guilt about *not* having seen it. Developing a certain
degree of indifference means that you no longer approach a museum
in a spirit of undue reverence.

One evening, near the Paveletsky railway station, I came across a
villa in the Russian style of around 1900, with a red-brick façade
behind iron railings and trees. The vestibule immediately puts a
spring in your step. You are surrounded by a neo-Gothic interior, but
one decorated in the riot of colour so beloved of the Russians. This is
the Bakhrushin Theatre Museum.

Aleksei Bakhrushin, the scion of an important Moscow leather-
manufacturing family, founded this, the first Russian theatre
museum, in 1894, and donated it to the Academy of Sciences in 1913.
He lived and worked here from 1898 to 1920, and his personal taste
as a collector and occupier of the house is still in evidence even now.

Although the history of the theatre is arranged here, as is usual,
by period, what is attractive about the collection is the mingling of
important and less important items. There are posters announcing
the première of *L'Oiseau bleu* by the Symbolist Maurice Maeterlinck,
who is frequently performed even today, but also posters for
Chekhov's *Seagull*. There are designs and models for stage sets by
Léon Bakst, Aleksandr Golovin and Ivan Bilibin. And memorabilia

Nijinsky as the Faun,
poster by Léon Bakst,
1912.

of the legendary productions of Diaghilev's Ballets Russes, group pictures of the ensemble from the 'Saisons Russes' in Paris, and Léon Bakst's poster for Nijinsky's performance in *L'après-midi d'un faune*, an incomparable evocation of rapt contemplation.

The period of 'Theatrical October' is less well documented, but here too the stage sets for productions by Meyerhold and Tairov illustrate how the explosion in theatrical creativity did not turn on the year 1917: long before that date, things that could not yet be voiced in society were anticipated on the stage, and long after it the ingredients of pre-revolutionary ferment continued to be a productive inspiration. How is it that precisely in Russia the theatre has achieved a position of such towering prominence? Was it a substitute activity in a world that it seemed impossible to change?

The great figures of the Russian theatre, starting with the serf theatrical troupes established by the aristocracy and continuing right on to Yuzhin, Olenin, Yermolova, Kachalov, Pavlova and Komissarzhevskaya, are lined up here to form a gallery of honour. But the details interest me more: the poster announcing an appear-

Exhibit in the Central Lenin Museum: the bullet fired at Lenin by Fanny Kaplan on 30 August 1918 and removed on 23 April 1922 in an operation at the Botkin Hospital.

ance by Eleonora Duse, the picture of Isadora Duncan, a pair of ballet shoes belonging to Matilda Kseshinskaya. And everywhere there is Shalyapin, to whom a special room is devoted: Shalyapin in his golden robes as Boris Godunov, pale of face and gesturing expansively; Shalyapin on his travels between the Teatro Colón and the Fair building in Nizhny Novgorod; Shalyapin being enthusiastically welcomed back from abroad in the Great Hall of the Conservatory during the Civil War years of 1918 and 1919; Shalyapin showing off his fine physique; Shalyapin the *grand seigneur*, the Renaissance man who sings, plays musical instruments, paints, writes and sculpts a superb portrait bust of himself; Shalyapin the popular hero, whose extravagant behaviour in Monte Carlo the people readily forgive. Shalyapin's actual voice can be heard, here in this villa which could have been his.

Another museum that might make a good starting-point for understanding the history of the city is the Museum of the History and Reconstruction of Moscow. Unfortunately at the time of my visit only the second floor was open. What I was able to view there were the exhibition entitled 'Wealth as a vast accumulation of consumer goods' and surviving mementos of Moscow's atomized bourgeois class.

Here one can see the aesthetics of consumer products hovering on the threshold of emancipation from the aristocratic model. Tea caddies made by the famous Moscow firm of A. I. Abrikosov; larger tea

boxes of remarkable workmanship, as though it was hoped that with the colourful printed designs one could also import the atmosphere of the place of origin – Hangzhou or Harbin; sweet boxes from the big chocolate and confectionery firm of F.T.K. von Einem, bearing a picture of the (later demolished) Cathedral of Christ the Redeemer, a showpiece that evidently also helped to sell sweets; a modern medicine chest from Ferrein the pharmacist's; and a biscuit tin from the firm of François Capitaine. All of this confirms that Moscow at that time was already the centre of Russia's production of foodstuffs and confectionery. However, the 'age of iron' is also advertised here: Emil Liphardt and Co., a firm dedicated to revolutionizing agricultural methods, has elfin maidens, with their gentle touch, demonstrating its steam-powered ploughs and threshing machines. The various firms show off the award certificates and plaques they have won, documenting the fact that they have joined the world's leaders. The Emil Zindel company displays the prizes it received at the Nizhny Novgorod trade fair in 1899. Michelin is here too.

It is remarkable how the simple passage of time promotes mundane objects to the status of museum pieces: a Hammond typewriter from New York, Merkur and Kodak cameras, gramophones. And even tradition appears in new guises, as with the art nouveau and neo-classical samovars that are on show.

The companies that produced the goods exhibited were modernized and adopted new names long ago. Nowadays they call themselves 'Red Proletarians', 'Red Front' and the like, while the old owners and their technical personnel and family members survive only in photographs. You see them in group pictures, with the factory owner seated like a patriarch in the middle, beside him his technicians and senior managers and around them, lined up on tiers of benches, the whole workforce. There are some children in the front row. Exhibited in a glass case is the punishments book, a relic of feudalism amid the modern production methods.

From the period after the Revolution, too, it is things of lesser importance that are most striking: pages of the city council's minutes penetrated by shrapnel during the October fighting, a few of Mayakovsky's posters for ROSTA (the Russian State Telegraph Agency), and then – evoking a multitude of associations – a poster designed for the 27th anniversary of the Revolution in 1944 and bearing the slogan, 'This is Moscow! – This is Berlin!' The poster shows Berlin reduced to rubble, with no prospect of recovery from

its devastation, while Moscow, with the terror behind it, is ready to stride forward into the future.

What was it that ensured the survival of the Donskoy monastery, when other Moscow monasteries were not preserved? (The Simonov monastery, for instance, was demolished to make way for the building of the Dinamo factory.) Certainly not just its walls, though they are a reminder that on several occasions Moscow itself survived only thanks to the fortified monasteries. Two things weighed in its favour: first, the monastery became a branch of the Shchusev Architectural Museum, and secondly, the monastery's cemetery contains the graves of men and women who played an important role in Russia's history. The museum itself provides a chronological survey from the eleventh-century Cathedral of St Sophia in Kiev and the later cathedrals and churches of Novgorod, Chernigov, Pskov and Suzdal to the buildings of St Petersburg and Moscow dating from the turn of the twentieth century. Perhaps more than is the case elsewhere, the history of Russian architecture can be seen as a process of the translation of forms into stone.

As one studies the pictures that trace the development of St Petersburg and Moscow, it becomes clear that with every passing century mankind's direct contact with the earth, with the actual soil, becomes more and more tenuous. On a picture showing the intersection of Okhotny ryad and Tverskaya at the beginning of the nineteenth century, there is a vast stretch of apparently impassable boggy terrain. Look at the splendid model of a monastery in Novgorod, where the wooden houses on the extensive area of land belonging to the monastery are connected by a network of log paths and roadways. More than in other countries, consolidating the ground, the substratum, is the prerequisite – itself demanding artifice and ingenuity – for all higher culture. Draining the marshland is the first act of culture, while other nations are born with firm ground under their feet. In other pictures, too, the eccentric solutions forced upon architects and garden designers by the challenge of nature are plain to see. The picture of the Neskuchnoe manor dating from 1753 shows a dainty palace with an enormous park that appears to have been laid out with the sole intention of demonstrating that even the intractable Russian landscape can be tidily dissected into geometrical forms. Everything has a slight air of exaggeration that can only stem from the satisfaction of having tamed nature itself, the pride felt by people who have taken the first, costly, step towards culture. Nothing has

come easily, nothing has fallen into their lap; this being so, I would imagine that their enjoyment of luxury, too, is a different experience, has extra piquancy.

Museums in Russia have always had a different function from those in Western Europe, which have been places for gathering together the accumulated riches of the artistic past, showing off valuable original works of art and parading ownership of what is unique. Here in Russia, on the other hand, the aim has clearly been a different one: primarily to make art known to people, to display it so that anyone can become personally familiar with it; to exhibit works not so as to convey the original values but as an invitation and opportunity for people to cultivate their own aesthetic taste; and to be of service both to students of the art academies and to members of the general public, whether already knowledgeable or complete novices in matters of art.

This aim has the benefit of freeing you, the visitor, from the usual obligation of admiration and reverence for the 'unique' work of art, and leaving you relaxed enough to take in its actual substance. Which of us, in any case, can tell an original from a copy nowadays, especially if it is a good copy? Experiencing the aura of a work of art is not the same as knowing how old it is (or is it?). Here in Russia museums are educational institutions, created with the intention of training and cultivating people. This is underlined by two factors: first the chronic shortage of relevant material in book form for people to buy and take home for private study, and secondly the canonical view of the historical process as a series of stages, the clearly drawn lines of world history as a whole, the black and white judgements about what is progress and what is regression – in short, the often helpful simplification of the tortuous paths of history in general and art history in particular that enables the willing learner to gain an overall view. The classic example of this venerable Russian tradition and its adoption by the educational dictators is the Pushkin Museum, but another that springs to mind is the Shchusev Architectural Museum on prospekt Kalinina. In a word, the Moscow museums not only display the fruits of the unrestrained zeal for collecting and learning shown by past generations, but also offer the visitor a most agreeable and concrete learning opportunity.

Whole districts of the city can be museums – open air museums. The Old Arbat is bisected like an orange. The ends of the houses and

Anatoly Lunacharsky's writing-desk in his apartment in ulitsa Vesnina.

side-streets separated by the prospekt Kalinina still look as if they could be fitted together like two neatly cut halves. The more the new avenue has absorbed and channelled the flow of life and activity, the more undisturbed the adjacent areas have remained. Once again we have the familiar paradox that the Soviet style of grand-scale clearance leaves the untouched neighbourhoods high and dry and thereby unintentionally preserves them. Such neighbourhoods are still alive only because life has been diverted around them. Something of the structure, the character, the fabric of the Arbat is still discernible if you regard the surviving elements – the museums, for instance – not as museums but as points in what was once a living organism. I found myself making the connections between these reference points partly deliberately, partly by chance – the fact that they are almost within sight of each other naturally suggested the idea of connecting them.

To begin with, I was interested to see what had become of the house and studio of the Vesnin brothers in the street named after them (formerly Denezhny pereulok). The clue was the presence of the big studio windows in this solidly built middle-class house.

Inside, a spacious staircase leads upwards, and the large windows and door frames suggest that the apartments here were large and stately. On the top floor I rang the bell, the door opened and a huge black dog gave me a fright. But I was right: this was the studio where the three brothers lived together until Viktor married and their little community disintegrated. The studio is in good hands again, after standing empty for almost twenty years – a painter works here. The studio space is on two floors, with a wooden entresol elegantly leading upwards and light streaming in through a tall window. I learned that before my visit some journalists had been here to prepare a feature about this studio for the GDR's *Freie Welt* magazine.

As a plaque outside indicates, the theatre director Yevgeny Vakhtangov once lived here, in an apartment on the first floor. Soon the apartment is to be made into a museum. It was only later that I discovered the significance of another plaque with a bas-relief of Lenin's head but no inscription to say what it was about. By consulting reference works I learned that on 6 July 1918 Lenin and Yakov Sverdlov paid a formal visit to the German Embassy in the building opposite (which now houses the Italian Embassy). The reason for their visit was the assassination of the German ambassador, Count Wilhelm von Mirbach, by Left Socialist Revolutionaries. In the 1920s the assassin, Yakov Blyumkin, lived not far from this building, in a small flat furnished, according to Victor Serge, with nothing but rugs and a splendid saddle, the gift of a Mongolian prince.

Diagonally across the street is a recently renovated five-storey building which was once a middle-class apartment house. A plaque records that Anatoly Lunacharsky lived here from 1924 until he was sent as ambassador to Spain in 1933; he died in France on his way there. Naturally he too occupied an apartment on the fifth floor, where a big studio window suggests that the creative intellect requires a very special working environment. The stairwell is spacious, if a little run-down – it is reminiscent of houses on the Kurfürstendamm or in Clausewitzstrasse in Berlin – and there is a separate servants' staircase tucked away behind glass next to it; this is unmistakably the house built in 1912 that belonged to the Moscow merchant Mandelstam. The museum was closed for repair – it had the disappointing *Na remont* sign on the door. However, a suitable enquiry enabled me to gain the interest of the lady on the door, and she opened up the rooms and took me through them, even though there were dust-covers on the furniture and paint-pots standing

around everywhere. The place was filled with Lunacharsky's personality, expressed not only in his study with the Empire-style writing desk (illus. p. 229), but above all in the spacious reception room – on two floors, again with an entresol reached by a small staircase. He had a semi-circular divan built around the stove, and in the corner was a grand piano. One can very well picture how Lunacharsky, the People's Commissar for Education – short-sighted, elegantly dressed, fluent in French and German as well as Russian, always ready to engage in polemical or philosophical discussion – 'lived and worked here', as the commemorative plaques say. This apartment was home to a special way of life, a culture still retaining some traces of the salon but adapted for revolutionary times. Anyone on the periphery of this salon, even if he was only tolerated rather than fully accepted, had a chance of finding a niche somewhere. In Lunacharsky, who was much sought after in the salons and social circles of St Petersburg, figures who had once been leading lights in the formation of literary and public opinion, but who had been eclipsed by the changed circumstances, found a new patron and protector. This is no mere myth. Lunacharsky was the kind of Bolshevik who was later accused of being too old for the new challenges of the revolution from above. The artists who frequented this apartment would leave their works here, not merely as a token of thanks but because the master and mistress of the house genuinely appreciated them: these regular visitors included Natan Altman, Yuri Annenkov and Filip Malyavin, while it was not unusual for Shostakovich or Prokofiev to perform on the piano. There is nothing to be seen of all that now. Instead, I learned from my conversation with one of the two lady attendants, who seemed themselves to have quite a soft spot for Lunacharsky and his home, that I could find Meyerhold's and Osip Brik's first theatre just round the corner from here.

The corner house, Arbat 55, reasonably well preserved on the outside but very decrepit inside, is where the Bugaevs lived around the turn of the century. The son is better known by the name of Andrei Bely. Between 1903 and 1907 this corner house was the focal point of the Symbolist revolt. The Sunday meetings of the 'Argonauts' were attended by Andrei Bely himself, Ellis (Lev Kobylinsky), Sergei Solovyov, Mikhail Ertel, Valery Bryusov, the painter, poet and composer Yurgis Baltrushaitis, the painter Viktor Borisov-Musatov, the composers Nikolai Medtner and Sergei Taneev, and finally Aleksandr Blok. In the present shared flats there is nothing left to

recall those days when fiery debates raged about Schopenhauer, Nietzsche and Baudelaire.

Places of this kind cannot exist in isolation. Where there is a focus, there must be other ignitable materials, kindred spirits, close at hand. I am not thinking of Pushkin, who occupied the house next door after his marriage (that house is being renovated just now), but rather of the painter Mikhail Nesterov's studio at number 43 in the next street down, Sivtsev Vrazhek pereulok. A little further away, at Vakhtangovsky pereulok 11, almost opposite the Vakhtangov theatre, is the house of the composer Scriabin. Renovation is in progress here too. It is surely no accident that the intellectuals living in this area almost simultaneously developed comparable ideas – independently of each other, though reacting to shared experience – and that all of them chafed at the dividing lines between the various art forms and yearned to break down the barriers standing in the way of the *Gesamtkunstwerk*, the unified work of art.

It would be false to maintain that in these largely preserved streets and lanes one can still hear the sound of Bely's verses or Scriabin's piano pieces – nevertheless, this *is* their locality. There are direct traces of them in the antiquarian bookshops on both sides of ulitsa Arbat, and also in the Praga Restaurant (though the current style of pretentious service there shows little feel for this heritage). The Praga, which has seen many alterations, was given a magnificent art nouveau interior by Lev Kekushev in 1902. Here, momentarily at least, one feels that something of the ambience of middle-class social life still lives on.

The concentration of such prominent names within such a small area – Scriabin, Vakhtangov, Meyerhold, the Vesnins, Kekushev, Nesterov, Lunacharsky and the 'Argonauts' – conveys some idea of what the Arbat was like as a focus of intellectual and artistic activity before its flame was extinguished.

In order to discover traces of those legendary days one has to go not to the theatres that are most highly regarded nowadays, but to lesser ones like the Vakhtangov theatre on the Arbat, because they survive by preserving the legend. But even the Vakhtangov has not remained unscathed since the great *Turandot* production that was put on in Mansurovsky pereulok and the MKhAT studio. My programme says 'Production by Yevgeny Vakhtangov (1922)', but it immediately adds 'in a new version of 20 April 1963'. If one simply

Carlo Gozzi's *Turandot* in the production by Yevgeny Vakhtangov, 1922.

compares the 1922 production photographs with today's, there is not too great a difference. The maskers – Princess Turandot, Adelma, Zelima, Timur, Kalaf, Pantalone, Truffaldino and Brighella, but above all the Wise Men of the Divan – have all remained astonishingly unchanged from Vakhtangov's originals as seen by the Berlin theatre audiences of the 1920s. The music too, so I am told, has preserved the old sound, a rather grotesque effect produced on combs wrapped round with silver paper, half silky, half cheap. For a piece that presents its main plot straightforwardly in three acts with six stage sets, this comedy by Gozzi offers great possibilities. The *kapustniki*, topical allusions which are always received with much laughter, particularly when delivered by the Harlequin figures, do not get in the way of the plot. The fairy-tale of the capriciously cruel Chinese princess who finally has to yield remains intact despite such interpolations. Traces of Vakhtangov are not easy to spot beneath the slave-girls' dance of the veils (strongly reminiscent of a Soviet folkloric event), the senile and not always funny prattle of the ancient Pantalone, or the caperings of the Grand Chancellor. Yet those traces are there, sometimes popping up quite unexpectedly as though the performers had suddenly remembered to give a nod of respect in Vakhtangov's direction. They are the moments when Vakhtangov suspends the theatrical illusion: in the actors' costume-change

233

scenes, first at the beginning of the play, after they have been intro-
duced by their own real names as they stand by the footlights, and
then at the end, when they transform themselves back from the
fairy-tale figures to themselves, to bring the audience down to earth,
back to reality; in the stylized, rhythmic movements of the Wise Men
of the Divan (an allusion to the *akademiki*, the members of the
Academy); in the telegram-style messages shown on banners as
interjections or commentaries on the action; and in the over-acting,
which is not just a reminder of the Italian *commedia dell'arte* but delib-
erate exaggeration intended to distance the audience. And of course
the staging has remained basically the same, as the pictures in the
foyer demonstrate.

There are good scenes, where the *commedia dell'arte* and
Vakhtangov are given their head, notably the suicides induced by
love, farcically mimed in front of the curtain. They get a good laugh
from the audience, who are enjoying themselves. I think that there is
a deep affinity between the Russians' passion for a style of acting
tending towards exaggeration and grotesquerie, and the exuberant
humour of Italian popular theatre. Be that as it may, a performance
by an Italian street-theatre troupe would show what can be done
nowadays with Gozzi, and maybe with Vakhtangov too.

Mayakovsky's *Misteriya-Buff* ('Mystery Bouffe') is being staged at
several Moscow theatres. In this work too a legend is preserved –
with different nuances at the Vakhtangov Theatre compared with
the Mayakovsky or Taganka theatres. Once again I deliberately
chose the most conservative of the theatres in the hope of seeing a
production that retained many of the old features. And it paid off,
especially in terms of understanding Mayakovsky's work: you have
to hear his verse sung, bellowed, stomped to be able to enter into the
world-view of those days, with such a clear division between good
and bad. How simple everything is, above all history itself: here
Russia is staged as a semi-colonial land, as a ship of state and 'round
table' (in the form of a semicircular platform rising towards the back
of the stage, on which and within which everything happens);
Russia weaving from side to side; Russia seduced by the 'Kadet'
liberal orators and demagogues in February; Russia pushing the
conciliators aside and scattering the Constituent Assembly; Russia
asserting itself against the Entente. It is clear who plays what role.
On the one side the American, French and German couples, the
Abyssinian negus who is made Tsar, the Russian speculator, the lady

emigrant taking herself off now to Constantinople, now to Berlin, now to Paris. And on the other side, equally clear-cut, the working man and woman, the miner, the textile mill worker, the day-labourer and his wife, the engineer and the seamstress, the Red Army soldier and the cleaning woman. The attempt, unsuccessful of course, to blur class differences is represented in the play by the 'compromising intellectual'. Thus everything is able to run its preordained course and reach its wholly satisfactory conclusion in the sight of God and the chief devil. However, alongside the pounding rhythm and the contrasting of the 'Man of the Future' with the 'rubbish-heap of history', there is much that appeals purely because it strikes a false note: the proletarian springing from the emblem on the workers' banner and launching into an over-emphatic denounciation of God; the routine and unimpassioned utterances of the militant atheists; the rather clumsy theft of the divine thunderbolt by the Promethean engineer – all of this seems contrived and overdone.

The prospect of a future earthly paradise was made more credible at that time by the feebleness of the old world and the openness of the horizon. If only Vakhtangov and Mayakovsky could be with us today to direct their fearless mockery at a future that is now behind us! But so long as recent Russian history cannot be put on the stage, this mystery-play version of the downfall of the old world will, no doubt, continue to find an audience.

23 An excursus on excursions

Ekskursiya – this Russian word for a sightseeing tour crops up every-where. Tours and excursions are organized all the time: tours of the Kremlin or of the so-called Golden Ring towns, excursions to Abramtsevo or Zagorsk, or themed tours, such as one following the trail of the Moscow Bolshevik underground movement, or another guiding its customers 'From the First Spartakiad to the Olympic Games'. They are offered either by special agencies – what we would call travel agencies – or by organizations such as trade unions, the student council at the university, and the like. The solo traveller is still the exception. The norm is the tour group, crowding round a guide who has been trained for the particular route by taking a spe-cial course (it would not surprise me if this actually included an introduction to the methodology of excursions). The sort of knowl-edge that guides at home, like those at Neuschwanstein or Linderhof – who are often pensioners – pick up more or less casually to begin with, is completely systematized here in Russia; even anecdotes and jokes relating to a particular feature or exhibit are taught and learned with academic earnestness.

What am I doing, though? Nothing less than making an excursion of my own. So the question is, how does my alternative excursion differ from those provided by the state agencies? There are the obvi-ous differences, of course: I am managing on my own as best I can, visiting places that are not regarded as worthy of a tour, and adopt-ing an oblique, 'sideways-look' approach from the outset. But I think the following aspects are important, too.

An officially organized excursion is one way of gaining familiar-

ity with a historic place, and an encounter with the *genius loci* is regarded as being particularly effective in promoting a historical consciousness. Insight is not only to be gained through words or by using one's imagination: here are Pushkin's inkwell, Tolstoy's sofa, Lenin's bookshelves, a knout that you can actually pick up and hold, the gravel path where the delegates to the International strolled for relaxation after the congress debates – all of this is far more powerful than images that have to be created in the mind. It amounts to breathing in the very air of history, 'acquiring a knowledge of the revolutionary tradition' with the help of tangible, concrete objects.

How do the state-organized tours manage this process in practice? The attitude that they bring to the exploration of historical places is sometimes overpoweringly pedagogical. Not 'How was it?' or 'How might it have been?' but 'That's the way it was'. And everything is considered from the perspective of 'That was the lesson of history'. With the result, of course, that the lesson is conveyed, but not the silent reality linked with the object under the protective glass cover. An excursion is essentially a kind of dialogue, but here there is no dialogue, only a lecture; so much information is imparted that from sheer overload the ear ceases to be receptive and the eye grows weary – too weary for that vital 'sideways look'.

The vocation of the tour guides should be to rescue from their silence places whose significance has faded as history has moved on; to make turbulent times audible again (a task that has now, of course, been delegated to mechanical dioramas); to sensitize people's ears to the creaking in the roof timbers of the world. In principle this activity should be one of reconciliation and aggression in equal measure: reconciliation, in restoring a voice to those who are now silent, and aggression to overcome the resistance of the present day and the intervening era. But both of these elements are absent from a set routine which is almost always closely adhered to. When *is* there a departure from the script? Only on occasions when the objects affect someone directly – when they evoke the death of a relative at Stalingrad, the return of a father from East Prussia, or the knowledge that an uncle helped to build the metro. In other words, when history comes close to home. So an excursion may mean no more than treading a well-worn path and being taken through a version of history that no longer holds any surprises.

24 Intermediate worlds

*What kind of 'culture' comes into being at the points
of contact between the Western and the Soviet modes
of life? – Hybrid forms on the border-lines: hotels,
hard currency shops, communities of foreigners,
the ambivalence of self-relativization.*

In Moscow you can find shops where almost anything that Western consumers regard as essential can be had for foreign currency. In Moscow there are artificial paradises in whose gardens and halls no one needs to queue up and where the subtlety of the lighting seems designed to fetishize the commodity. In Moscow there are whole areas of human contact where you could forget the major role played in public and private life alike by the tape recorder.

Yet this is only so at first sight. The juxtaposition of the Soviet and Western modes of life could be represented, on a superficial view, as a simple opposition of pure forms which remain wholly separate. But that is not the reality. The collision of two different modes of life and behaviour produces an artificial hybrid form with all the hybrid's characteristic peculiarities, distortions and lapses into taste-lessness. The two ways of life cross-infect each other, creating a climate that is neither one thing nor the other and giving rise to equally inauthentic behaviour. Naturally this occurs where the two worlds come into contact with each other – where consumers from the consumer society find themselves in shops that, though intended for them, are not their own; where people in the sphere of the press and public opinion know that sometimes they are obliged to depart from their normal professional standards and behaviour; where the Soviet citizen has to acquire ways that are not his own. Perhaps there is one area where the specific difference vanishes almost completely, and that area – or so I would guess – is the sphere of politics and of the official, bureaucratic vehicle of political exchange, diplomacy.

Of course this overlapping of two worlds goes back a long way:

after all, the whole history of the Soviet state, with its watchword of 'catching up and overtaking' the West, has shown its tacit recognition of the need to have some sort of understanding with the enemy – though not for ever – and even, in the shorter term, to learn lessons from that quarter.

Instances of such hybridization are everywhere. It is not easy, however, to find a term that covers them. If you say 'mixed culture', that places too much emphasis on the word 'culture', even when you mean no more by it than patterns of social intercourse, civilized behaviour and taste. And you certainly cannot talk about 'bourgeois' and 'socialist' culture, given that – especially in Germany – anything bourgeois has long been ashamed to speak its name, while socialist culture is visibly unable to cope with its chronic inferiority complex. For the phenomenon that I have encountered in Moscow I can think of no better term than an 'intermediate world'.

Nothing could be more misguided than to set out on a quest for somewhere where time has stood still, in the naive expectation of discovering the spirit and breathing the air of the *fin de siècle* or of pre-revolutionary Moscow in all its unalloyed, authentic purity. The last place where you will find the aroma of a bygone era is in some spot from which all life has departed. Where you do get a scent of it is where people have tried to make the past their own, and there the incongruity of different forms gives a glimpse of how things may once have been.

The classic case, if you want to spare yourself a fruitless search for lost times, is the Hotel Metropol on the former Theatre Square (now ploshchad Sverdlova), a 'White Square', if you like, representing all that is civic, profane, non-sacred. Entering the Metropol, which was built between 1899 and 1903, you do not need to know that during the October fighting it was used as a base by the Whites, that the new Soviet government was housed here in the first few years after 1918, and that later on H. G. Wells and Anatole France stayed here. It will be enough to let your eye roam over the façades, the public rooms and the movements of staff and guests. Added on to the frieze of this remarkable building, though barely legible now, is the motto 'Only the dictatorship of the proletariat can liberate mankind from the oppression of capitalism'. What is noteworthy is not so much the fact that the new class stamped its mark of ownership on this prime hotel of the bourgeoisie, but the form in which it did so: the lettering, in the manner of the early years of the Soviet republic, still harks

Hotel Leningradskaya: interior.

'I was given good food and drink, always had a car with a driver at my disposal, and asked my interpreter to read me extracts from the Soviet Russian literature on Wagner, which, as I discovered, copied freely from the chauvinistic Herr von Glasenapp – and I ruminated on how I could ever get to know the Soviet Union even just a little.'
Ludwig Marcuse, *Mein zwanzigstes Jahrhundert*

back to the flourishes of art nouveau.

The foyer shows less of this kind of synthesis: deep, comfortable armchairs line the wall, with its panels of marble. But as you gaze around at the art nouveau windows and the beautiful chandeliers, your eye is distracted by a cashier's booth with chipboard cladding. A fountain plays in the middle of the grand salon, which is covered by a dome of coloured glass; disposed around the room are red-upholstered chairs and armchairs among tables decked in white with quantities of glassware. The calm demeanour of the many waiters might be thought to reflect the composure of a restaurant functioning with smooth efficiency – but here, as everywhere, the service is slow and sullen. There is the sound of music, but this is neither a group playing the usual pleasantly banal coffee-house repertoire nor a jazz band, but something called a *dzhazovy bend*. The loudspeakers boom, people get to their feet – and at least they dance in their accustomed way. But it is all quite foreign to the setting designed by William Walcot.

What we have here is not a confrontation between the ambience and something totally alien to it. Such a thing *did* happen here in the past, as can be verified from old photographs. There we see the people's commissars in their leather coats, with the snow on their boots melting and forming puddles on the carpets; and the commissars' respectable suits. What is so striking today is both the failure to recapture the style of the hotel's heyday *and* the loss of the self-confidence that the new rulers once had: instead we are left with a colourless, inadequate substitute. It seems clear that those responsible for the blaring electronic music have lost any instinctive feel for the 'old order'; but equally clear that they have not acquired any sound new basis for their musical taste. As the second and third generations of the new masters take possession of the old world and the old days, such places have been overlaid with a kind of spurious Soviet sheen. This did not happen in the eras of Lenin or Stalin: the confrontation with the old culture was still too immediate to admit of such a cosy relationship. And today the nervous rehabilitators who have ultimate control of the restorations lack the confidence to let the genuine lustre of the old days be seen to full advantage. And so the provocative (I will not say delightful) charm of such interiors consists not in the conservation or revival of a past age, but in the hybrid forms of an 'intermediate world'.

The search for a bygone era might strike lucky, if at all, in quite a different setting: for instance where the concierge of a 'House of

Culture' is suddenly seen to be sitting behind a real antique of a desk; or where the ticket clerk at the *banya* shines a light on to his receipts from a lamp that has been doing service in this very same place for perhaps seventy years, never exposed to the predatory eye of an antique dealer, never in danger of disappearing into a museum. And these working people sit on ancient chairs which go on serving their purpose, shabbily venerable, unrecognized. This is where the past, being useful, carries on living its life – anonymous, proudly wearing its traditional, good-quality, threadbare suit.

It was a chance visit to the Moscow Main Post Office in ulitsa Kirova that almost made me change my mind about the question of *temps perdu*. We all remember films where directors have made strenuous, sometimes desperate efforts to create the right period setting for the hero or heroine, and we can all think of instances where they have failed by a hair's breadth to get the period and its style quite right: for the film-goer the experience is somehow embarrassing. Although the Main Post Office, as the communications centre, has repeatedly been fought over and was quite literally a barricade both in 1905 and in 1917, it is nevertheless the locus, discovered after long searching, of *temps perdu* – and without any help from restoration initiatives. It preserves the casual-seeming, more leisurely tempo of another age. Admittedly I went there on a Sunday. But the tranquillity that reigned here was the product not just of the day but of the place. The doorman told us that the vestibule had been conceived in the Venetian style by the Vesnins – though there was nothing particularly special about that, he said: he himself had seen any number of such buildings in Philadelphia! Passing through the vestibule, which has a gallery on slender columns right round it – noting only the hammer and sickle added on a plinth above the doors – you enter the counter hall where a glass dome lets in natural light. This main hall has several galleries, connected by tiny, delicate-looking spiral stairways of the type that were once common in cramped offices: you can almost hear the clattering shoes of clerks hurrying down from above. In the middle of the hall, and at the sides, are the counters. But what counters! Not enclosed, though set behind massive wooden barriers and separated from each other by brass frames and from the public by glass screens. The whole thing gives an impression of gleaming cleanliness and almost homeliness, so that you almost think you must have come to the wrong place. Homeliness: naturally the favourite plant of Soviet Russian public

242

Hairdressing salon
in the Petrovka.

spaces is not absent – the palm. There it stands, the inevitable con-
comitant to good solid wood, sparkling glass and brasswork with its
aura of modest elegance. Even the chairs are not of vinyl or plastic.
And lying on the tables, as though they were not worth any special
protection, are heavy brass trays containing inkwells and pens. The
inkwells are full, intended for everyday use. That is the difference.
Here the *temps perdu* is not lost at all, but still going on effortlessly.

As we leave, the doorman tells us that this building too is in line
for restoration. We cannot see why, since it is in perfectly good con-
dition. Possibly the technology is not fully up to date; but I fear that
after the restoration the *temps perdu* that I have just rediscovered will
indeed be lost for ever.

To return to the intermediate world, another part of it is repre-
sented by the Beryozka stores, where goods can be bought for hard
currency. These stores are as remarkable for what they have as for
what they do not have. The Beryozkas that specialize in food are
bathed in the excessively bright light of the American supermarket
(in the Hotel Mezhdunarodnaya, at any rate), and foreign currency
will buy items that are likely to be far beyond the tastes and purse of

243

the average consumer. However, the occasional absence from the shelves of the simplest and most everyday food line – a particular kind of spice, perhaps, indispensable to the foreign palate – shows that such stores are like artificial islands, cut off from the Soviet and Western consumer world alike. In such a setting the merchandise reveals its allure, and the customer his inclination to buy, with a degree of coyness, as though both know that they are on extra-territorial ground. That can be shown more clearly in the case of the Beryozka bookshops. They too stock what the Soviet reader cannot obtain, or can only obtain by using connections: a selection of Diaghilev's writings, for instance, Vladimir Vysotsky's satirical ballads, or a volume of poetry by Fyodor Sologub. Books that are in short supply are quickly snapped up, and if you want particular titles, you have no choice but to keep dropping in. Customers are completely dependent on what is on offer. Although the interaction between merchandise and money functions after a fashion, it does so with all sorts of restrictions, artificial disciplines and distortions. Titles that were failing to sell last December – Brezhnev's memoirs, for instance – were still there the following year. Many of the books on the shelves keep their place not because anybody is interested in them but because of instructions from above. So nobody comes along to release them from their existence as a commodity. And yet this is one area where a good marketing strategy could do so much for an economic plan desperate for hard currency!

Another instance of the inhibitions imposed on the circulation of goods is the laboriousness of the billing and packing procedures, and the high staffing levels in shops that are anything but busy. It is true that the use of the abacus alongside the electronic cash register and the cool indifference of the saleswoman have a certain quaint charm. What is asserting itself here, however, is not an entrenched tradition that resists a rational approach to money-making, but the intrinsic inefficiency and irrationality of an economic machine that fondly imagines itself to be particularly rational and infinitely superior to the anarchy of capitalism. This supposed superiority is a source of perpetual annoyance to a foreigner, particularly as there is no one to whom he can address his dissatisfaction and complaint: it is the anonymous system that irritates him, not the individual shop assistant.

Intermediate worlds have their own specific characteristics. By placing the alien world in a highly visible position within the local context they provide, as it were, test conditions in which accustomed

habits and manners show up in even starker contrast than usual. At the same time, the apparent absence of clear-cut norms of behaviour in the intermediate domain prompts individuals to invent their own, which leads to a watering-down of the rules. The taxi-driver expects a fare to which he is not legally entitled, simply exploiting the fact that foreigners generally have more money (or so he supposes), and he tacitly claims his price by not giving any change. Foreigners are left uncertain about how much to tip. How refreshing and liberating it is once in a while, after weeks or months of abstinence, to spend some time wholly in your own world, to enjoy what is not adulterated or mixed, the genuine article instead of the surrogate – to visit German friends and listen to Brendel's recording of the Schubert sonatas or do the rock and roll, or go along to the American Embassy and watch Hitchcock and even some 'anti-American' films.

Exceptional circumstances reveal who people are, much more readily than their normal, native circumstances would do: the tourist who attracts unwarranted attention simply by being differently or perhaps better dressed than those around him; the holder of foreign currency who can afford what others cannot, just because he belongs to the sphere of the world market; the diplomat who solely because of his status is suddenly more equal than his fellow-countrymen. Moscow is a place where one can see this sort of thing and observe metamorphoses, induced by currency, dress or status, that can be highly instructive: the transformation of the little man into a generous tipper, or of the petty official into a man of self-important gestures and laboriously acquired affectations. There are, of course, some people who remain unchanged.

In the intermediate worlds dissent is a very frequent topic of conversation, sometimes prompted by a radio news item about it, sometimes because conversation on another topic has come to a dead end, and in fact only rarely because people hope that some significant points may be made about the society they live in. The arguments for which I have the greatest understanding – and sympathy – are those that openly concede that people here, as anywhere else, ought to be able to say and write whatever they like, without fear of reprisals – even if this comes at the cost of 'repressive tolerance'.

However, there is another attitude towards dissent that is very interesting and gives one a much clearer understanding of some Westerners here. It emerges when they have sat down to champagne and some exquisite meat dish and start debating the relative

merits of a holiday in Biarritz or Yalta, while simultaneously 'stressing the importance' of 'analysing' the 'true motivation' of the dissidents, of considering whether the main impetus behind their actions is not perhaps a craving for recognition or, even more basely, for material goods. The progressive consciousness has certainly come a long way. These people are happy to enjoy what they condescendingly deny others. The scandal here is not so much the double standard in itself, but the progressive face it wears without a flicker of conscience.

Probably the most uncertain and complicated of the intermediate worlds is that of the media where for professional reasons alone objectivity and subjectivity, straightforward information and unavoidable value-judgement, a willingness to try to understand the other side and insistence on one's own viewpoint necessarily go hand in hand. In this field devoted to the dissemination of ideas, and particularly in such a high-profile location, both sides tend to avoid crude stereotypes of 'the enemy', give assurances of a desire for mutual understanding, and in private conversation see many things in a more 'nuanced' light than in public discourse. One's opposite number turns out to be more flexible than he appears, or than he is made out to be. There seems to be an unbridgeable gulf between the system and the individual, and the wish to be just a human being for a while must be irresistible at he parties where vodka-drinking Western correspondents and Marlboro-smoking APN correspondents mingle freely. The parquet flooring becomes a sheet of thin ice where rigidly fixed ideas are likely to take a tumble. I suspect that the permanent state of tension and crisis that prevails between the two worlds could be dealt with more easily if each side would state, discreetly but distinctly, what it really thinks of the other; at least then we would all know where we stand.

25 Gathering evidence

Starting from buildings with a history –
The points of intersection between individual lives
and the life-story of the city – Dealing selectively with
history: unmentioned dramas and retouchings.

Cities remain, human beings die. And yet one particular approach to history maintains that cities are only the work of human beings, and that human beings somehow live on in them – a secular form of belief in life after death. This would represent a significant coming to terms with death and acceptance of it. But not all of those who lived are acknowledged to have lived, nor are all those who have died allowed to be dead. This approach to history has a category of people who live on, and another of people who never existed even though they actually lived. It presumes to decree who is to live on to all eternity, to be kept alive. Perhaps, though, what counts is not the force of the decree itself, but something else: that some individuals who were once alive were never accepted by this view of history as belonging to it, so that the decree demanding oblivion and silence effectively becomes superfluous. The victor in the battles of the past may not need to impose silence, for he is in a position to erase all memory of the defeated.

Moscow is full of places devoted to the artificial prolongation of life and the artificial silence of the grave. I am not thinking here of the 120 memorial sites connected in some way with the person of Lenin – Lenin occupies a position so indisputably above any factions, and is so much a part of the history of the Russian Revolution, that he is unassailable. It is other places that make one conscious of the artificiality of life prolonged or life consigned to silence: places where people whose part in historical events puts them in the second or third rank are deliberately dragged into the foreground, into the limelight, even though they never enjoyed such status in

247

their lifetimes and would never have felt it to be their due, while those who played the most significant and responsible roles from the outset are thrust into the background. How many monuments and memorial plaques there are in Moscow to people like Nogin, Polonsky, Meshcheryakov or Lenin's sister – outstanding organizers or writers, to be sure – while others like Mandelstam, Bukharin, Preobrazhensky or Pyatakov are still accorded no such recognition, even in the most modest location, and the victims of murder are denied even the verbal rehabilitation demanded by their descendants, an acknowledgement of them as historically existing persons! But there is an audible silence in the opposite quarter too: how is it possible, in a city whose physiognomy has been determined for all time by the great radial roads, the high-rise buildings and the metro tunnels, never to mention the name of the master builder? I am not in the least arguing for his remains to be returned to the mausoleum, but simply pointing out that a city that will not name one of its principal builders – for I have not forgotten Brecht's poem beginning 'Who built seven-gated Thebes' – has something to keep quiet about. It has unfinished business with him, business that it is probably incapable of finishing. The stone marking the grave at the foot of the Kremlin wall is too small a needle's eye for the caravans of forced labourers and the millions of enthusiastic Komsomol members who helped build the metro to pass through! Moscow does not present the appearance of an 'urban jungle': its layout and organization are very clear. Nor is it a city shrouded in silence, but there is a reticence that indicates how history is spoken about: selectively.

It is probably the case everywhere that people celebrate those individuals they remember with gratitude and talk less about what they are not so proud of, in their history as in other areas. And there are changing fashions, which from time to time give prominence to one thing while relegating another to obscurity. This kind of mobility exists here too, but not in the usual form, not in the ebb and flow of competing forces, the rivalry of pressures from below. History is presented in a way that is not just selective but secretive, tense, too closely bound up with a lack of self-confidence on the victors' part for everyone to be allowed free access to it.

Following and deciphering trails in this city – and where have trails crossed more tragically than in this Fourth Rome of the International? – is perhaps no more complicated here than in Western capital cities, where traces of the past tend to be wiped out

through indifference, demolition and a 'lack of historical awareness' on the part of new managements; but still one has to work with a certain method appropriate to the circumstances. What method is this? It is of course detective work, like any investigation into history. To 'read' these trails effectively it is necessary to know something of the lives, ways, associates, likes and dislikes of the people one is trying to trace. Where the perpetrator is, the victim cannot be far away. Normally we know less about the victims than about the perpetrators. So by following the tracks of the perpetrators or, to use a more neutral term, the main players in the great dramas of history, we will undoubtedly come upon the shadows of the unpersons.

One needs to turn to the most obvious occasions and locations to encounter the principal actors of that period – no retouching of photographs, no rewriting of the history books can alter that. Photographs taken before the mass exclusions from 'history' are often a valuable means of access to the unpersons. What aesthetic scruples must have assailed the archivist and retoucher when they had to scrap the best photographs from the very best moments, the high points of their history, and consign them to oblivion by stamping them 'For permanent storage'!

Let us take one such obvious location, the Bolshoi Theatre. Here, in June 1921, the sessions of the Third World Congress of the Communist International were held. A glance at the list of participants shows that there were many sitting in the stalls whom the later Stalinist review of the event deemed unworthy. In November 1922 there was the Fourth World Congress of the CI, followed in December by the congress that established the Union of Socialist Soviet Republics, at which Kirov was most certainly not the only speaker. Even if the first cracks were already showing – over the Treaty of Brest-Litovsk and the arguments about trade union democracy and the reintroduction of some elements of capitalism under the NEP – the original leadership team was still complete on this occasion; the faces of the underground fighters, both intellectuals and proletarians, who had now mounted the stage of history with verve, emotion, and the passion for controversy that was meat and drink to them, were all still here. And in 1928, when the Sixth World Congress of Comintern was held here, who was the dominant speaker if not Bukharin? By this stage, admittedly, the team was somewhat reduced: Trotsky had been excluded from it and was not in fact present, making less work for the retoucher.

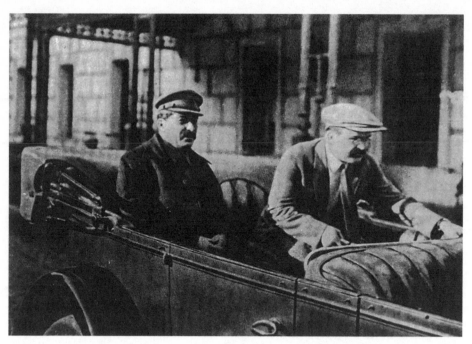

Stalin and Molotov, photographed in May 1939 at the side entrance to the Bolshoi Theatre.

'Of all the men of power that I know, Stalin gives the impression of the greatest simplicity. I spoke frankly with him about the inordinate and tasteless personality cult that has been built up around him, and he responded with equal frankness. He said that he regretted how much time he had to devote to public appearances. And I can well believe it.'
Lion Feuchtwanger, *Moskau* 1937

It is also rather doubtful whether, at the celebration of the tenth anniversary of the October Revolution held in the Bolshoi Theatre, Clara Zetkin, Paul Vaillant-Couturier, Henri Barbusse and Antoine Gay, a member of the Paris Commune, were really the most prominent guests from abroad.

The Bolshoi Theatre has also been the setting for scenes that were not deliberately staged and which turned it literally into a theatre of political events. While the Fifth All-Russian Congress of Soviets was in session at the Bolshoi, the new government found itself briefly taken prisoner by the rebellious Socialist Revolutionaries, who, by murdering the German Ambassador, Wilhelm von Mirbach, on 7 July 1918 and temporarily holding the government captive, hoped to force it to repudiate the Treaty of Brest-Litovsk.

250

More in keeping with its traditions, the theatre also saw some politically explosive musical events. On the occasion of an anniversary of OGPU in December 1935, old Bolsheviks whose faces still bore the scars of Cossack sabres had to sit and watch as the old Cossack chieftains took their seats in the boxes and Cossack music and dancing filled the stage. And from time to time the Bolshoi has served as a political barometer. When Yuri Shaporin's opera *The Decembrists* was performed on 27 June 1953 one figure was missing from the Tsar's box – Beria. This was a visible sign that the old era was over.

This theatre has also been the scene of tragic entanglements. When I saw *Das Rheingold* at the Bolshoi in a production that emphasized the mythological aspect (the programme emphatically distanced this production from 'popular-sociological interpretations of the kind prevalent in the West'), I realized that Sergei Eisenstein, the revolutionary director *par excellence*, had once rendered Wagner outstanding service. Following the conclusion of the Hitler–Stalin pact, Wagner was particularly in demand as the incarnation of the German spirit. Eisenstein interpreted him in a way that makes

Sergei Eisenstein during rehearsals for his production of Richard Wagner's *Die Walküre* at the Bolshoi Theatre, photograph, December 1939.

Patrice Chéreau's innovative production, hailed for its new insights as the '*Ring* of the century', seem markedly less original. While it is not surprising that the director of *Battleship Potemkin* should have understood Wagner better than anyone, it is appalling that in that 1939 production of *Die Walküre* his genius and Wagner's should have combined to give their blessing to that infamous pact.

Let us take another of the stock locations, the House of Unions, which formerly housed the Noblemen's Club and which provided a setting for Tolstoy's *War and Peace* as well as for the innocuous schoolgirls' leaving balls described by Marina Tsvetaeva. It was there, in the Club of the Nobility, which was handed over to the trade unions after the Revolution and thus became the focus for a new kind of 'proletarian society', that millions of workers and peasants bade their last farewells to Lenin in 1924. The Hall of Columns in the House of Unions saw Lenin's political heirs still united around his coffin. By 1953, when the great victor in the struggle for the succession was himself lying in state, scarcely any of those who had foregathered in the Hall of Columns in 1924 were still alive. The two halls, the smaller October Hall and the larger Hall of Columns, witnessed the history that unfolded between those two dates. I am not so much thinking of the appearances of Thälmann, Thorez and Van Minh at the Anti-Fascist Congress in 1932, or of Rabindranath Tagore and the speech he gave in the Hall of Columns on 24 September 1930. I am thinking – as I did when I attended concerts in the two halls – of the scenario of the Moscow show trials. It requires an effort of historical imagination, because few pictures of the trials show anything of the ambience of the halls – the gleaming white columns, the mighty chandeliers hanging between them.

Some of the less well-known trials – that of the so-called Industry Party (25 November to 7 December 1930), the proceedings against the Mensheviks in March 1931, and the trial in April 1933 of the managers and engineers of the British Metropolitan-Vickers firm, who were all accused of sabotage, economic intervention and plotting to restore capitalism – took place here in the Hall of Columns. Already there were bizarre accusations and, more significantly, the first confessions. For the great show trials the somewhat smaller October Hall was used. In August 1936, before some 150 invited guests, the military panel of the Supreme Court heard the so-called Trotskyist–Zinovyevist terrorist group case against Zinovyev, Kamenev, Bakaev, Mrachkovsky, Ter-Vaganyan and others. The

N. I. Bukharin, 1888–1938.

'It was unreal, uncanny to see the plain and unemotional manner in which these men, facing the immediate and almost certain prospect of death, gave an account and explanation of their actions and their guilt. It is a pity that the regulations in the USSR do not permit photography or making gramophone recordings in a court of law. If only the international public could have been shown not just what the accused said, but also how it was said, their tone of voice, their facial expressions, I think there would be very few sceptics left.'
Lion Feuchtwanger, *Moskau 1937*

following year, in January 1937, the same court heard the 'anti-Soviet Trotskyist group' case against Pyatakov, Radek, Sokolnikov, Serebryakov and others. And another year later, from 2 to 13 March 1938, the series reached its culmination with the case against the 'anti-Soviet bloc of Rightists and Trotskyists', in which the accused were Bukharin, Rykov, Yagoda, Krestinsky, Rakovsky and many others.

Coming to the October Hall for a concert of piano music by Scriabin, it is impossible to picture this, fact though it is. You are sitting where in those days Walter Duranty, Joseph Davies or Lion Feuchtwanger sat in order to report on what was happening in front of them. Up on the dais sat the president of the court, Ulrikh, with his shaved head and little piggy eyes, the military lawyer Nikichenko, who in later years was one of the judges at the

VOLKSKOMMISSARIAT FÜR JUSTIZWESEN DER UdSSR

PROZESSBERICHT

ÜBER DIE STRAFSACHE

DES ANTISOWJETISCHEN „BLOCKS DER RECHTEN UND TROTZKISTEN"

VERHANDELT VOR DEM MILITÄRKOLLEGIUM
DES OBERSTEN GERICHTSHOFES DER UdSSR
VOM 2.—13. MÄRZ 1938

gegen

*N. I. Bucharin, A. I. Rykow, G. G. Jagoda,
N. N. Krestinski, Ch. G. Rakowski, A. P. Rosengolz,
W. I. Iwanow, M. A. Tschernow, G. F. Grinko, I. A. Selenski,
S. A. Bessonow, A. Ikramow, F. Chodshajew,
W. F. Scharangowitsch, P. T. Subarew, P. P. Bulanow,
L. G. Lewin, D. D. Pletnjow, I. N. Kasakow,
W. A. Maximow - Dikowski und P. P. Krjutschkow*

angeklagt der Verbrechen, vorgesehen in den
Artikeln 58¹ᵃ, 58², 58⁷, 58⁸, 58⁹ und 58¹¹ des
Strafgesetzbuches der RSFSR, und gegen
Iwanow, Selenski und Subarew außerdem
der Verbrechen [gemäß Artikel 58¹³ des
Strafgesetzbuches der RSFSR.

VOLLSTÄNDIGER STENOGRAPHISCHER BERICHT

MOSKAU 1938
HERAUSGEGEBEN VOM VOLKSKOMMISSARIAT
FÜR JUSTIZWESEN DER UdSSR

Cover of the official transcript of the trial of Bukharin and others, 1938.

'And so we resolved: at once
To cut off a foot from our own body.
It is terrible to kill.
But we will kill not just others, but ourselves as well, if needed,
Since it is only by force that this murderous
World can be changed, as
Everyone living knows.
It is not yet granted to us, we said,
Not to kill. By nothing but
Our unbending will to change the world
We justified the measure taken.'
Bertolt Brecht, *Die Massnahme*

Nuremberg trials, and the state prosecutor Vyshinsky, with his grey walrus moustache, starched collar and elegant suit, sitting just where the pianist now sits. Here, in this room, Krestinsky temporarily retracted his guilty plea and Bukharin made his last stand, cunningly outwitting the public prosecutor by an eloquent deployment of the categories of Hegelian dialectics, but himself already the victim of a peculiarly cunning trick laid by the rationale of history. This place, where those eyewitnesses thought that what they saw was what was really happening, merits a very special kind of memorial. But how could one find a suitable visual image for the self-immolation of reason, the coming of that utterly modern twilight of false gods?

There was another finale, a musical one this time, in 1948 when from the front of the Hall of Columns the formalism of composers such as Shostakovich or Prokofiev was officially denounced – a decision carried 'unanimously' by the first Congress of the Association of Composers.

And now to another of these points where trails intersect, the Hotel Metropol. On its move to Moscow, the new Soviet government had made this its headquarters, with improvised canteens and accommodation, and at first the members of the government team probably carried on living here much as they had lived during their period of exile – crammed in together, queueing up in the canteen, hardly enjoying any of the advantages of their magnificent surroundings. From a footnote in a book I gather that meetings to discuss economic matters were held in Room 305, and the book's author, Yuri Larin,

names those who attended the meetings: the left-wingers Lomov and Bukharin, Lenin, Larin himself and Krzhishanovsky. Room 305 is nowadays occupied by a Finnish company. The memorial plaques on the outside of the building bear Lenin's name, of course, but the new government did not consist solely of Lenin. The Metropol is the place where for a short while they were still all together – sleeping, eating, negotiating, receiving visitors – under one roof.

A hotel like the Metropol makes one realize how right Konstantin Paustovsky was when he wrote:

> The history of buildings is sometimes more interesting than the life of a person. Buildings outlast people and are often witness to several generations.
>
> I am convinced that if one were to tell the story of almost any house, investigate the lives of the people who have lived in it, explore their characters and describe the events that have taken place there, the outcome would be a social novel of possibly greater significance than those of Balzac.
>
> If objects could come to life, how they would turn everything upside down, how they would enrich life: what stories they would have to tell!

But there is no history of the Metropol. There are stories, certainly, that take place in the setting of the Metropol; it was an almost irresistible magnet whose attraction was most strongly felt by visitors to Moscow. Here, in March 1917, as Moscow waited for the 'third bell', Ilya Ehrenburg watched desperate French liberals drinking champagne and paying the bill with great uncut sheets of Kerensky roubles. Viktor Serge came to the hotel to visit Barbusse, who had come to Moscow for the 1927 celebrations of the Revolution. Max Hölz, the anarchist rebel from the Vogtland region of Germany, is said to have stayed in the Metropol in 1929, having accepted an invitation from Stalin to come to the USSR following his release from Brandenburg prison. Considered unpredictable, he was kept under constant watch, and in May 1933 he is said to have barricaded himself into his room, number 269, with 60 bullets, so as to be able to defend himself against arrest by the OGPU. Later he disappeared, as did the occupant of the adjacent room at that time, General V. K. Blyukher, a commander of the Soviet army in the Far East. Klaus Mann, invited to Moscow in 1934 for the first All-Union Writers' Congress, felt that in the Metropol he was remote from 'Soviet

Russian life'. Oskar Maria Graf, on the other hand, seems to have taken full advantage of the pleasures that the Metropol offered. But this bourgeois enclave in Soviet Moscow has also figured as the backdrop for capital crime and spying: it was here that the Soviet colonel Oleg Penkovsky betrayed his country by handing over espionage material to the British businessman Greville Wynne on 27 May 1961.

One building whose story has been told in detail is the Hotel Luks, home to the Communist International in the 1930s. Another, the sombre Government House, diagonally across the river from the Kremlin, has even been made the subject of literature, in Yuri Trifonov's novella *The House on the Embankment*, though the reader has to discover for himself the real-life figures behind the fictional ones.

However, these eminently public places, these arenas for the demiurges of world history, have their limitations. Very often destinies, or the events that turn a life into a destiny, unfold on the fringes of the main arenas, if not completely outside them. And there is another factor: the sort of evidence you hope to find in a city depends very much on what trail you are following, on how well you already know the ways of the people whose tracks you hope to detect. A visitor from Germany will probably want to look for evidence of his German compatriots of the past, while someone coming from America is likely to be more interested in the Americans; Theodore Dreiser, Upton Sinclair and of course John Reed.

The search for clues need not be as unfocused and haphazard as one might at first suppose, given the impenetrability of a city whose rampant development is smothering the past. A city is birthplace and home to many people, so the houses where people were born and spent their youth can be located. It is not difficult to find such evidence in cases where the city can be proud of its offspring (or at any rate feels that pride today). Pushkin, as we know, was a Muscovite by birth, having been born at no. 10 in what is now Baumanskaya ulitsa. Aleksandr Herzen was another, born at 25 Tverskoy bulvar. So was Dostoevsky, who was born in the Mariya Hospital for the Poor where his father worked as a doctor, in the street now named after him – at 2 ulitsa Dostoevskogo.

Moscow is a city not only of real heroes but of fictional ones too. To visit the haunts of the characters in Tolstoy's *Anna Karenina* you

need to go to the English Club at 21 Tverskaya, or to the Leningrad railway station, formerly Nikolaevsky vokzal, where Anna first met Vronsky. To see the spot where she committed suicide, you should take the *elektrichka* on the Gorki line as far as the Zheleznodorozhnaya station. Alexandre Dumas (1802–1870) actually met the hero of his *Memoirs of a Fencing Master*, the Decembrist I. A. Annenkov, who lived at no. 48 in the old Povarskaya ulitsa, but the meeting, in Nizhny Novgorod, did not take place until 1858, years after the completion of the novel.

Moscow would not truly be the capital of this country had not the masters of its language, the shapers of its atmosphere and its conscience, lived in the city at least for certain periods, their lives becoming intimately intertwined with it. Anyone versed in literature can trace them, especially as there are tours that visit the sites associated with major literary figures, both real and fictitious. One can pinpoint the very spot where, at the precise moment preordained by Providence, Bulgakov's character Berlioz has his head severed from his body by the wheels of a tram: it is on the square surrounding the Patriarch's Pond. Each well-known name can be linked with the appropriate street: Denis Fonvizin, Gavriil Derzhavin, Aleksandr Radishchev, Nikolai Novikov, Ivan Krylov, Nikolai Karamzin, Vasily Zhukovsky, Aleksandr Griboedov (born at no. 42 in what is now ulitsa Kirova), Wilhelm Küchelbecker (born where the high-rise apartment block now stands on ploshchad Vosstaniya), Gogol (nos 10–12 Pogodinskaya ulitsa), Chekhov in the little house opposite the Planetarium (6 Sadovaya-Kudrinskaya) which is now hemmed in by multi-storey tenement blocks.

Musicians and music-lovers will be drawn to other places. They will be interested to learn that the concerts given by Franz Liszt at the Bolshoi Theatre on 25, 27 and 29 April 1843 were rapturously applauded, and that at the ensuing receptions and banquets the whole of Moscow lay at his feet. But if Moscow gained from Liszt's visit, Liszt also profited musically by becoming acquainted with the Moscow Gypsies. A year later Clara and Robert Schumann made their début in Moscow. Clara performed three concerts, on 8 April 1844 in the Maly Theatre and on 15 and 23 April in the Club of the Nobility; they stayed at the Hotel Dresden in the Tverskaya (no. 6), where the Aragvi Georgian restaurant is now (on Sovyetskaya ploshchad, opposite the Moscow city council building).

Any Wagner enthusiast will be delighted to know that he too

made an appearance here. He conducted three concerts at the Bolshoi Theatre on 13, 15 and 17 March 1863, and stayed at the Hotel Billo at 9 ulitsa Bolshaya Lubyanka. Wagner created a furore, however, not only by his music but by his manner of conducting. It is said that he was the first conductor in Moscow to conduct facing the orchestra and not the audience; as a revolutionary in theatre and music, he swept tradition aside, giving all his attention to the musicians and ignoring the public, who were probably more interested in the visual spectacle than in the music. Wagner's own impressions of Moscow seem to have revolved mainly around the financial side of his visit.

We must not forget Tchaikovsky, who lived at the house of his publisher Jürgensohn at 9 Kolpachny pereulok, and in the Hotel Rossiya at 7 Kuznetsky most. Anyone wishing to be transported back to a composer's actual surroundings will make sure to visit Aleksandr Scriabin's house at 11 ulitsa Vakhtangova; he had previously lived at no. 31 in what is now Oktyabrskaya ulitsa. Hector Berlioz came to Moscow twice, first in 1847 and then in 1867, when he conducted a concert in the Manège with a 700-strong choir and orchestra; that spectacular event attracted an audience of 12,000 people.

The list could be extended further, but simply knowing that 'x was here' is not what keeps the searcher in constant suspense. What is exciting is that the figures you consider important were not walking monuments to themselves, not noteworthy features of the city, either then or later, but active energizing elements in a living organism. Rather than the city providing them with a home, it was much more the reverse, that they made the city what it was and what it has since become. It is an interest in this world of theirs and what was produced in it that sets a visitor like me on the path of exploration.

In Moscow individual life cycles interact in a curious way with the functional spheres of a city. The structure of a life brings it into contact at particular times with the structure of the city. This is quite clear when you think of beginnings and endings, houses where famous people were born and their final resting place in cemeteries (Moscow is as rich in burial places of the famous as in their places of birth). And what comes in between? There are elementary schools, grammar schools, universities, where individual education and the social organization of learning coincide – for example the Slavonic-Greek-Latin Academy in the present-day ulitsa 25 Oktyabrya, which

was attended by the fisherman's son from Archangelsk, Mikhail Lomonosov. There is the Fourth Moscow Grammar School, an institution with a great tradition of learning, in the present-day ulitsa Chernyshevskogo, where for instance the Soviet Russian pioneer of aviation Nikolai Zhukovsky, but also the theatrical reformer Konstantin Stanislavsky, received their classical education. There is Moscow University, the oldest and most prestigious of Russia's universities, which can boast among its alumni the brightest stars in the firmament of Russian science and culture, though the first circles of the political underground movement were formed here too.

And then finally there are the hotels, that most modern medium for facilitating communication whilst providing a bearable degree of anonymity. Moscow's hotels – demolished and rebuilt, renovated, preserved, converted to other uses – what stories they could tell! Like hotels all over the world (at that time) they bear nondescript names: Hotel Royal, at 13 ulitsa Myasnitskaya; Hotel Continental, at 3/6 Theatre Square; Hotel Severnaya, at 15 ulitsa Kalanchevskaya; Hotel Luks, at 10 ulitsa Tverskaya. And the Hotel National, Grand Hotel, Hotel Savoy and Hotel Metropol, of course. The Hotel Dresden received Turgenev, the Luks the unfortunate poet Sergei Yesenin (who cut his arteries, not here but in another hotel, the Angleterre, now the Astoria, in Leningrad). Aleksandr Blok stayed at the Hotel France in the Tverskaya (no. 3) and at the Louvre and the Madrid (now at 15 ulitsa Gorkogo). Mayakovsky clearly lived more modestly, in the San Remo guest-house at 9 Dmitrovsky pereulok. Each of the more important hotels saw significant comings and goings, especially after the fashion developed for visits and pilgrimages to Russia. Anatole France was a friend of Russia long before that time, staying at the National as early as 1913. H. G. Wells also stayed at the National on 22 July 1934, Theodore Dreiser and Stefan Zweig (the latter in 1928) at the Grand Hotel, Henri Barbusse at the National and the Savoy, Rabindranath Tagore at the Grand Hotel in 1930; Bernard Shaw had rooms at the Metropol in 1931, and Julius Fučik, later hanged by the Nazis at Plötzensee as a resistance fighter, at the Hotel Europa at 4 Neglinnaya ulitsa. It sometimes happens that the city commemorates outsiders rather than one of its own: we are told, for instance, that Johannes R. Becher, Friedrich Wolff and Alfred Kurella stayed at 17 Lavrushinsky pereulok, opposite the entrance to the Tretyakov Gallery; but the fact that Pasternak also lived here for several years, and during the war kept watch on

the roof as a member of the air-raid protection brigade, is something that you have to discover by more indirect means.

There are particular spots that cause you surprise and consternation when you learn more about them. Your eye roams unsuspectingly over the Ryabushinsky mansion designed by Shekhtel, later the home of the proletarian 'stormy petrel', Maxim Gorky, with its banisters in the form of lilies and its organically shaped windows. Who could possibly mention this place in the same breath as the sphere of government, let alone a formulation of the government's ruthless demands on art? And yet that is the way of it. Here, where form and reason dreamed a fanciful dream, Gorky and Stalin conversed on 26 October 1933 and the notorious description of writers as 'engineers of the soul' was coined.

Perhaps, though, the contrast is not so very striking: it was, after all, art nouveau, liberating itself from tradition and striving after a great synthesis, that sought to unite sophisticated taste with the needs of the modern age – *but in an unforced way.* And to think that Ryabushinsky's enlightened patronage and Stalin's highly enlightening phrase were separated by barely thirty years!

And there are locations where infinite power coincides with the finite nature of the powerful. Naturally they are to be found close to places where decisions are taken. For instance in the building opposite the Alexander Gardens which now houses the Lenin Library's music department. Commemorative tablets in this building at 1 prospekt Kalinina, which formerly housed the Comintern, offer a reminder that Lenin's sister, a Party worker of outstanding merit, once lived here; a plaque, probably put up some time after the event, commemorates the visit to Moscow of Antonio Gramsci and Ho Chi Minh (I can find nothing relating to Chou En-lai, who stopped off in Moscow on several occasions when travelling to China from Göttingen or Berlin). Another of these significant locations is Government House, diagonally across the river from the Kremlin: the commemorative plaques and name-plates fixed low down by the entrances give only a slight idea of the great number of prominent past (and present) residents. Still, you can find the solid Bulgarian head of Georgi Dimitrov and the hard profile of Yelena Stasova, and even Marshal Tukhachevsky has not been forgotten – but this is by no means the whole story of the 'House on the Embankment'.

This is even more true in the case of the Hotel Tsentralnaya, the former Luks, in ulitsa Gorkogo. Any memorial to the rats in the yard,

View of the inner yard of the Butyrka prison.

'When we got out of the vehicle and looked around us at last, we recognized the
yard of the Butyrka prison, where political prisoners are interrogated. We were
back where the misery had started. This was January 1940. In the corridors and
cells dark blue light bulbs gave a ghostly illumination. Faces were the colour
of drowned corpses.'
Margarete Buber-Neumann, *Als Gefangene bei Stalin und Hitler*

the Latvian porter who tried to catch them, and the Comintern func-
tionaries and their families who lived here for longer or shorter
periods, has been erected not here but elsewhere, in the countries to
which some of them returned. Herbert Wehner would be able to give
more precise details. If such hotels have become legendary, it is for
one simple reason: that there is hardly any other place where the fate
of the residents has so faithfully and remorselessly reflected the fate
of the country. Perhaps the hotel registers are neither more nor less
than a concentrated matrix of the unfathomable processes surround-
ing disappearances and reappearances, and of attitudes – ranging
from fervent belief to utter incomprehension – towards the changes
taking place in this society in the 1930s. But regardless of the degree
of comprehension, a reality unfolded, unalterable and set in stone in
places like the Lubyanka, the large but nondescript former insurance
company building from pre-Revolutionary times. Sources of infor-

mation about these places only ever mention 'earlier times'. The Butyrka, for instance, is known to all as the place where Mayakovsky was briefly imprisoned and where the manufacturer's son and revolutionary, Nikolai Schmitt, died in 1905. But there is no trail of evidence leading from those prisons of the past to the modern period of these institutions.

It is a paradox, though a readily explicable one, that later generations should have an extremely full and detailed knowledge of Moscow's prisons, of all things. As soon as those prisoners who survived realized that their captivity had not simply been a mistake, they saw it as their duty to record what they had seen and experienced – in fact it was an expression of their very will to survive. From this, no doubt, results the minute detail of their accounts, the detective-like reconstruction of the number of stairs, the height of the rooms, the contents of the prison libraries, and so on. We know more about the interiors, the atmosphere, the furnishing of these prisons than about many a more accessible place. We gain admission to them through an immeasurably large and informative body of writing by Yevgeniya Ginzburg, Margarete Buber-Neumann, Alexander Weissberg-Czybulski, Susanne Leonhard, Anton Ciliga and Andrei Amalrik.

This is where, in many cases, the trail peters out. Who knows where the once famous names, suddenly transformed into monsters or unpersons, were taken or sent? Not every case is as clear as that of Solzhenitsyn, who was taken from the Lefortovo prison to Zurich-Kloten. If someone were to object that it is contrived and eccentric to focus attention on places of confinement in this way, I would simply answer: Berlin too has its Moabit, and Paris its Santé, and, more importantly, the history and manner of dealing with so-called social pathology, by imprisonment or some other form of exclusion from society, is not the same. Not everywhere is the process overshadowed by the 'angel of the Revolution', the figure that rears up on the square in front of the former insurance building; not everywhere is the accused automatically branded an apostle of the past of a 'historical pessimism' doomed *a priori* to failure. Leaving aside the prisoners themselves, this state of affairs must have a corrosive effect on all those who know that such prisons exist.

The organized form of social anamnesis practised here finds enormous scope in such a complicated organism as this monster of a city; on the other hand there is such a recalcitrant, chaotic body of

memories, such a mass of indestructible and easily overlooked detail, that in the long run cracks are bound to appear in the official version. The attempt to gather and secure evidence is, amongst other things, a rescue operation, a deliberate attempt to stave off resignation and prevent the levelling-out of the past. What success such an operation has will give some indication of the strength of those forces that refuse to accept forgetfulness as a way of life.

Other addresses:

> Alpenrose Restaurant, Pushechnaya ulitsa 4
> (now House of the Teacher)
> Butyrka prison, ulitsa Novoslobodskaya 45
> Jack of Diamonds (Bubnovy Valet) Exhibition Hall,
> Pushkinskaya ulitsa 11
> German Club, Pushechnaya ulitsa 9
> (now House of Art Workers)
> Herzen House, Tverskoy bulvar 25
> Interlit, Kuznetsky most 12
> Red Professorship Institute, Metrostroyevskaya ulitsa 53
> Chamber Theatre, Tverskoy bulvar 23
> Komakademiya, Miusskaya ploshchad 6
> Lavrushinsky pereulok 17, apartments of (amongst others)
> Vsevolod Vishnevsky, Fyodor Panfyorov, Mikhail Prishvin,
> Konstantin Fedin, Ilya Ehrenburg, Viktor Shklovsky,
> Johannes R. Becher, Friedrich Wolf, Alfred Kurella, Boris
> Pasternak, Erich Weinert
> Forum cinema, Sadovaya-Sukharevskaya 14
> Hotel Luks, ulitsa Gorkogo 10, where (according to Ruth von
> Mayenburg) the following stayed: Georgi Dimitrov,
> Ernst Fischer, Klement Gottwald, Ho Chi Minh, Jules
> Humbert-Droz, A. and O. Kuusinen, Arthur London, André
> Marty, Imre Nagy, Heinz Neumann, Margarete Buber-
> Neumann, Ana Pauker, Wilhelm Pieck, Mátyás Rákosi,
> Rudolf Slánsky, Ernst Thälmann, Maurice Thorez, Tito,
> Palmiro Togliatti, Chou En-lai, Walter Ulbricht, Herbert
> Wehner, Otto Winzer, Richard Sorge, Wolfgang Leonhard,
> Ignazio Silone, and others
> Moscow Children's Theatre (Natalya Sats), ulitsa Gorkogo 23
> (now the Drama Theatre, previously the Ars cinema)

Pravda editorial office (1923), ulitsa Gorkogo 18
Rosta poster workshop, Malaya Lubyanka 16
Savva I. Mamontov's Russian Private Opera, Pushkinskaya
ulitsa 6 (Operetta Theatre)
Central Committee of the CPSU, Staraya ploshchad 4

26 Zamoskvoreche

*A lively working-class district rarely visited
by outsiders – A place of artistic projection and
experience for Polenov and Lentulov – Churches,
factories, blocks of flats, a different pace of life.*

In Moscow most of what one sees seems to be the result of planning rather than simple growth, and so the visitor, not expecting to find an old-style district still preserved, is thrilled when he happens upon one. It is as though the winter and spring scenes painted by Vasily Polenov and Mikhail Larionov had suddenly appeared before him in all their luminosity and full-blooded colours; all it needs is a horse and cart coming round the corner to complete the picture of a Moscow of bygone days.

I came across a district like that today on my way from Oktyabrskaya ploshchad to the Tretyakov Gallery. The route offers a succession of new sights and vistas, unusual angles and views. The maze of small streets and lanes is impossible to disentangle even on the best street-map, and so it is better just to follow your nose. Lanes with houses as yet unvisited by any restorer, with damp creeping up them, ordinary stone-built two-storey houses with no particular decorative features. The colours are those of Larionov's paintings, harsh, eruptive. Dark brick red with snow-white ribbons of ornamentation, the dark green of fir and spruce, snow on the streets and the dark queue of people waiting at the entrance to the Tretyakov Gallery. Once upon a time the gallery was probably the same height as the buildings around it. Now that has changed. Flanking Vasnetsov's gallery on both sides are multi-storey blocks somewhat reminiscent of the wartime concrete bunkers that still survive in some West German cities. The gallery now seems to be cowering down between them. Why did anybody put up those blocks in this setting? To show that they were aiming higher than Tretyakov?

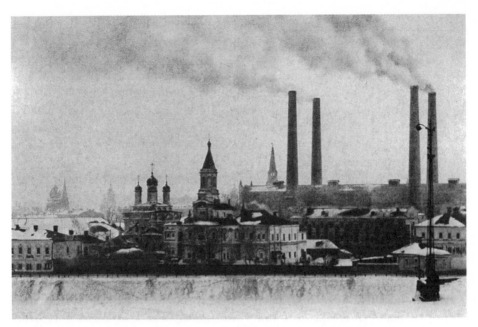

View from the Kremlin side of the river towards Zamoskvoreche, photograph, c. 1925.

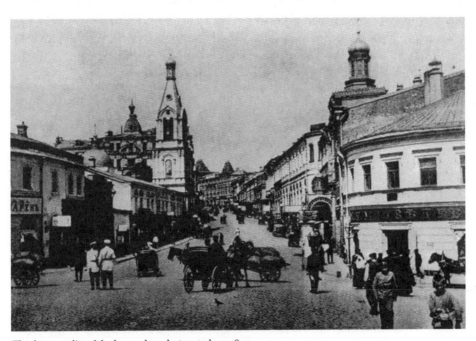

The former ulitsa Moskvoreche, photograph, c. 1850.

My other discovery in this part of Moscow was the large number of churches, many of them no longer used for worship. One that I happened to enter was serving as a warehouse for an export firm. Over the doors I could still see the inscriptions in Church Slavonic. And behind a desk at the entrance a woman attendant sat just as if she were there to take the money for the candles that people wanted to light. Further inside, in the body of the church, I could see the stacks of goods. It will not be long now before there is a change of heart and the building is restored as a church. This is already happening with most of the churches in the district. They always start with the exterior, re-gilding the domes and renovating the façades, as has already been done with the Church of the Consolation of All Sorrows and the Church of the Resurrection. Outside many small churches and chapels – which may be in the courtyard of a hospital or in the yard behind a large block of flats – there are padlocks on the doors or on the rusting railings. These churches are not simply being left to decay; you get the impression that they have merely been temporarily withdrawn from circulation, and that no one is quite unscrupulous or ruthless enough actually to do away with them. The churches look as if they are waiting expectantly for the day of their reopening. And already – together with the museums – churches are among the few public spaces inside the city where people can gather and find a respite from the officially ordered world outside.

What is it that distinguishes Zamoskvoreche from other more or less well-preserved parts of Old Moscow, the Arbat, for example, or Kuznetsky most? I think it is that, whereas those two were purely residential and business districts of an urban character, Zamoskvoreche is very different. Here there is, or so I felt, a balance of shops and businesses, residential accommodation and above all both medium-sized and quite large factories and workshops. Walking down these streets was like coming face to face with the backdrop of Eisenstein's films. I was there just as the factories were closing. Quite unlike the area around Kuznetsky most, let alone ulitsa Gorkogo – where all movement is dominated by the crowds streaming towards the shops, the milling throng of unidentifiable people who are mostly not locals but shoppers coming from some distance away – here, when work is over for the day, people stand around in groups, talking, before heading for the metro or their bus, or they may smoke a cigarette or have a beer either out in the open or

at one of the *kvass* stalls. This is a different rhythm, not the frantic chasing after permanently scarce commodities but the first minute of relaxation for people who have done a day's work. For a moment there is still a sense of community, a collective feeling; a conversation starts up. The people are pausing for a while. The district is at rest within itself, it is not a place for just passing through. The shops are different here, too. Because the hordes of shoppers do not find their way here it is quieter, almost with the feeling of a medium-sized town rather than a big city. With its broad streets, its houses no more than three storeys tall, and the wide expanse of sky above, Zamoskvoreche has something of the atmosphere of a provincial town.

What an amazing view you get from ulitsa Bolshaya Ordynka across the Moskvoretsky bridge! From here you look down on to Red Square, whereas normally you are looking up towards it from ulitsa Gorkogo and can never see over the hump in it. How calm and pleasant the view of it is from 'up here'. And now I can understand how during the October fighting the Kremlin could be bombarded from the heights of this Red district. What you only see as a back-drop when you view it from the central area of the city, as you usu-ally do, can now be explored from the other side. The power station that is visible from the windows of the Hotel Rossiya, lit up at night with Lenin's dictum 'Socialism is Soviet power plus the electrifica-tion of the whole country' really does look like a power station when seen from behind. MOGES is at work, spewing smoke and steam out of its five chimneys; one can actually hear the humming and pound-ing of the turbines behind the giant glass surfaces, for which in this instance Ivan Zholtovsky, and not a Constructivist, was responsible. The island formed by the Moskva and the drainage canal is divided up almost geometrically; there was not much land available here when G. List and F.T.K. von Einem built their factories, and their villas close by. One of the latter is now home to the British Embassy. It is where in 1968, when all over the world people were taking to the streets, Andrei Amalrik and his wife Gysel took the risky step of demonstrating here against the British engagement in Biafra.

The river lies there looking quite placid, because the ice floes pre-vent waves from forming. The floes sometimes collide, with a barely audible sound. What makes the old districts of the city so lively, and enables one to walk through them without feeling tired, is that with every step something new and unexpected comes into view. But

walk along prospekt Kalinina and you will be exhausted long before you have gone a quarter of its length or reached your destination.

Visiting factories makes one feel slightly awkward: after all, they are not monuments or lifeless museum pieces – even those that are historic sites – but still active production centres, living organisms. In addition to that, there is not just the worry of possibly having to explain to one of the factory workers what you are after – the Red past of the firm where he earns his daily bread – but also the prevailing view that many things in the city, especially production centres, should be hidden from the eyes of strangers. (And a tourist with a camera in the immediate neighbourhood of factories presents an odd sight . . .) What could a foreigner possibly want to know about, if not the present? So I set out with some trepidation, afraid of finding it difficult to explain myself – when all I wanted was to unravel the complex of red factory brickwork (mostly in the neo-Russian style), monastery walls, towers and the maze of streets.

It is not easy to escape the deep red of the factory buildings. This is the colour of factories, monasteries, monastery perimeter walls and tram depots, for instance the depots on Oktyabrskaya ploshchad, or the 'Red Proletarian' factory, which was originally the Gopper and then the Bromley works; the projecting glass frontage is all that has survived from the 1920s, and to the sides one can see the old buildings of red clinker brick.

In 1903 a Social Democratic workers' group was established here. These workers took an active part in the December fighting in Moscow and in the October Revolution. Together with the workforces of the other Zamoskvoreche concerns, they were naturally given the job of defending the bridges over the Moskva – Kamenny most and Krymski most. The factory, founded in 1857, has now been running for more than half a century under new management.

The line of old-style factory buildings continues down the street, all of them deep red, so that you wonder whether it was not the colour of the factories that became the colour of the Revolution – that seems a much more natural origin than the abstract tradition of the Red Flag. Excessively loud music can be heard coming from the factory yard. A *subbotnik* shift is being worked. In the public parks, leaves and paper are being burnt on bonfires. It somehow suggests a rite of spring, a farewell to winter. The acrid smell of burning hangs in the air. In the distance, shimmering through the smoke and heat of some of the bonfires, the forbiddingly high wall of the Donskoy

Views of Zamoskvoreche by Dmitry Sobolev.

Monastery looms up, and not far away, at the corner of ulitsa Ordzhonikidze, is the Communal House.

I take the tram along Serpukhovsky val, following the wall of the monastery, as far as the radio tower which, seen through the birch trees that are just coming into bud, itself resembles a slender birch. Surrounding the transmitter's delicate lattice of tubular steel are residential complexes built in the 1920s, some of them newly restored. From there I continue on my way to the Zamoskvoreche *univermag* on Danilovskaya ploshchad, a department store with a façade very similar to that of a store opposite the Gedächtniskirche (Memorial Church) at the lower end of Berlin's Kurfürstendamm. Crossing the road, I pass through a complex that could easily be a factory, but it later turns out to have been a barracks. This too is significant. All around Pavlovskaya ulitsa I see large numbers of soldiers with red badges carrying out their *subbotnik*. It makes me as a foreigner feel a little uncomfortable. But it is important to realize that where the cen-

tres of labour are, the army will be quartered close by. These must be the Alexandrine Barracks, whose soldiers fraternized with the workers of the district during the revolutionary fighting. I walk on past. Another factory, but with a changed frontage: the former Michelson plant, a bastion of the First and the Third Revolutions and memorable also as the scene of Fanya Kaplan's attempt to assassinate Lenin. I have lunch in the factory canteen, a building obviously dating from the 1930s. It is just on the change of shifts; the workers separate out into groups and chat. There is music playing here too.

What struck me about these industrial sites is how concentrated the world of the workers is. Most of the factories have their own arts centre, trade union organization, a well-furnished *stolovaya* and crèches. But everything revolves around production. 'Every factory is our fortress', so ran the bolshevizing slogan that communists in the West have never managed to put into effect. And it can be imagined that the focusing of people's whole lives on the workplace fosters attitudes that have very little in common with the fragmented outlook of the worker in a consumer society. A factory like this is the locus of a sense of community; perhaps it is even what is left of the *obshchina*, the old village community. However, Zamoskvoreche is not only the Red working-class district of modern times. Prior to Peter the Great's crushing of the Streltsy in 1698 it was an area where they, and before them the Tatars, were concentrated, as some present-day street names still recall, among them Ordynka, Balchug, Tatarsky pereulok and Tolmachovsky pereulok. And from the middle of the nineteenth century onwards it was a district where rich merchants lived, especially around Pyatnitskaya and Ordynka. From Pyatnitskaya there are fine views such as one now finds only in old pictures: two centuries layered upon each other, the same image that must have made Moscow appear to newcomers so strange, picturesque, varied and full of bustling activity. Above the solid bourgeois houses there are domes everywhere, Russian Baroque, pointed bell-towers in red and white in front of yellow and grass-green façades. And every so often, at the far end of a street, there is the riot of colour, which I will refrain from comparing to a circus tent, of St Basil's Cathedral. Viewed from this angle it is fully a part of the city, and not, as it looks when seen from the old Tverskaya quarter of Moscow, a contrasting element. One can imagine that from Zamoskvoreche the cathedral was not felt to be an alien Asiatic presence.

A Moscow Farmstead, oil painting by V. D. Polenov, 1878.

For the stranger to Moscow, who still tends to estimate the immense distances within the city on the basis of his accustomed coordinates of time and space, there could of course be no greater boon than the metro, which shoots along underground with the swiftness of an arrow to deliver him to his desired destination above ground. The perspective that this gives him is rather like that of a mole: wherever he surfaces he is presented with the immediate surroundings of his molehill, and peers around at them with his bright little eyes. In this way the city, as it has either grown or been deliberately structured, with its convoluted web of streets, rows of houses, and vistas, resolves itself into the series of backdrops seen from the metro stations.

But there is another means of transport – how should one describe its position in-between the super-fast metro and the pedestrian's infinitely wearisome progress? – which 'performs its duty' in an old-fashioned manner, but a manner that fully meets the requirements of modern people and modern times, and is indeed indispensable. A

273

foreign visitor to Moscow is less likely to think of using it because it is hardly in evidence close to where he normally stays. And yet a trip on the red-and-yellow-painted tram is stimulating precisely because of its reduced pace, its old-world way of slowing down and pulling away again, and the human tempo at which it covers the far shorter distances between its stops. It is not that the tram passenger sees *more*, but that he *sees*, in a way that he cannot in the metro tunnels or on the buses, which, being lower to the ground, almost always have their windows covered in a layer of dust or mud, at least at certain times of the year. The tram is to an extent raised up above the hurly-burly; its direction is predetermined by the tracks, it cannot give way and so has a right of precedence. An aristocratic survival from yesteryear, it distances itself from the mass of petrol and diesel-consuming cars but also from the underground which condemns its passengers to blindness.

The surprising thing is that, although the tram may have its ter-mini in the outer suburbs, its rails reach covertly right into the centre, from which they are otherwise excluded. They traverse dis-tricts where in a curious way the city's early years and most recent times meet. This middle belt between the centre and the outer areas was already too built up for huge new-style tower blocks to be put up as if it were a greenfield site, but at the same time it was old enough and superannuated enough to be rejuvenated by the addi-tion of some new buildings. These are the neighbourhoods where the Moscow proletariat of around 1900 lived, where the big factories came to settle in residential areas and where one sometimes also finds the factory owner's own villa (nowadays used as the 'house of culture' for that particular factory). If you open up a street map such zones show up quite clearly – former suburbs that are now enclosed by the modern suburbs built farther out.

A trip on the number 3 tram from the Kakhovskaya metro station to the start of Sretensky bulvar (ending up at the Kirovskaya metro station) allows one to gain an impression of this middle belt, which is ignored by travel agencies and visitors alike. They seem to acknowledge the existence of only two things, the centre and the outer suburbs. But the *former* suburbs were Red Moscow.

Spring has come, and the city relapses into its dirty brown col-oration, but it is not like the winter thaws – this time the end is in sight. The water is no longer stationary, it is flowing and draining away, who knows where to, and starting to evaporate in the warm-

ing sun. On this day, a Sunday, you can see that people's spirits have lifted. They have left their hats at home, it is safe to wear ordinary shoes, the schoolchildren are on holiday, and some stray dogs are lying down on the grass, which is very much the worse for wear, choosing a particular patch which probably has an underground heating pipe running beneath it. The air is different, the sky seems more expansive.

The number 3 tram rattles past one of the collective farmers' markets. Clusters of people, like the groups that you normally only see at assembly points before demonstrations, are hanging around outside the building, and propped up against the wall are poles with white pieces of paper attached to the top. It is all about exchanges of flats, so I am told. Spare parts are also being traded or exchanged. Going via Varshavskoe shosse, past the huge international post office on the right – completely deserted, on this Sunday, at any rate – and the baths on the left, the tram takes us to the river port. And here one enters a confused muddle of buildings which helps to explain why the Soviet planners tried to bring a new clarity, logic and spaciousness particularly to the design of industrial and residential buildings. Perhaps this impression of mine is intensified by the excess of brown that is so typical of the transitions between seasons in Moscow: the colour spectrum of this sombre district has not yet been brightened up by green leaves and the warm glow of sunshine on reddish brickwork.

Road, railway and river all squeeze in together here: the tracks leading to the Paveletsky railway station cross Varshavskoe shosse, the tram turns right from Bolshaya Tulskaya ulitsa into ulitsa Danilovsky val. The road narrows, you sense the desire to economize that packed the factories tightly in together; there are work sites with railway lines crossing the road, factory gates with archways in the Old Russian style that was used for nearly all factories around the turn of the century. The factories have expanded, even penetrating the walls of the Danilov Monastery. It seems strange that the walls of Russian monasteries, designed to safeguard the seclusion of Russian monasticism, should so much resemble the perimeter walls of factories built during the late nineteenth-century period of industrial expansion. Russian capitalism, even at that late date, slotted itself into the old tradition, with which it was to perish. Today the monastery gates are closed, and church land has become factory land.

Passing the Paveletsky station, where one can see the locomotive that brought Lenin's body back to the city from Gorki (now Gorki Leninskie), the number 3 tram crosses the Garden Ring and goes speeding along Novokuznetskaya ulitsa towards the metro station as though it had suddenly been let off the leash: here the character of the district is less clearly defined. On the one hand there are still some big factories, on the other this seems to have been a better-class residential area for people who could not find room inside the Boulevard Ring and had to be content with living between the Boulevard and Garden Rings. The scene changes as we cross the Moskva, and our eyes – still looking out of the wonderful number 3 tram, with its clear windows on all sides – can range freely from the golden domes of the Kremlin to the west, past the horribly grandiose Hotel Rossiya and the municipal orphanage – a building whose enormous size is alleviated only by the regular proportions of its elevations, which are not unduly tall – right round to the high-rise apartment building on Kotelnicheskaya naberezhnaya on the far side of the Yauza river, which joins the Moskva at this point. From here the high-rise building makes quite a good impression: it faces towards the centre like a patron saint, its two mighty side sections like arms protectively spread out over the heart of the city. It marks a boundary, and not only by its conspicuous size; it is not so much a skyscraper as a mountain range that actually looks right in that location.

On Pokrovsky bulvar, as the tram slows down on this uphill stretch, a different Moscow reveals itself: now we are accompanied by almost unchanged nineteenth-century façades, we are flanked by the wrought-iron railings that enclose the central reservation of the boulevard and escorted by lines of still leafless trees on our way up to the Kirovskaya metro station. I do not know if this tram line was laid later, but it runs, anyway, from the old Red City to the old White City. This tram has a sense of history.

27 Metro

Exploring the city from below – The metro as a historic event – Stations – The Protestant work ethic of the shock brigades – A gesture of triumph – Normalization – What Dushkin learned from Egyptian tombs for the building of the metro.

The core of the Moscow metro is now almost half a century old, and yet the metro still represents the means of transport and the tempo of the future. There are almost no signs of wear and tear: the subterranean halls, the magnificence of the crossovers and passages, the walls of yellow marble and white-veined red granite, the heavy bronze chandeliers placed at regular intervals, all remain unchanged. The sculptures of sportsman and sportswoman, mother and working-class intellectual, tool-maker and Komsomol brigade member have stood there, caught in mid-action, for over forty years. This opulence, harking back to the past, could easily make one forget that the decision to build the metro, and the work of its planners and architects, is still of the greatest significance for today and will remain so for many decades to come.

How leisurely, how tame the Berlin underground seems in comparison with the Moscow metro in the rush hour: in the suburbs between seven and eight o'clock in the morning, at the interchange stations at lunchtime and again in the evening, after work finishes, or at the weekend when half of Moscow is making its way to the railway stations. The platforms between the massive portals in the form of ancient pylons are black with people almost all the time; although the trains are as long as a surface suburban train and run at half-minute intervals at peak times, they scarcely manage to empty the platforms of people for even a few moments: no sooner has a train left than the space is immediately filled again. The crowds, efficiently directed by clear signposting, are piped, as it were, through one-way passages and tunnels of white light unsullied by advertising.

People in Moscow, photograph by Henri Cartier-Bresson, 1953.

There is turbulence and confusion at points where the streams of people have not yet separated out and where anyone hesitating over which way to go gets in the way of others who are heading confidently and purposefully in their chosen direction. The flow of people develops a powerful pull where the paths and channels narrow, especially at the approaches to the escalators (where there are uniformed attendants in aluminium booths at the top and bottom who can set the escalators to go up or down as required, depending on the volume of people and the frequency of trains in one direction or the other). When there is congestion on the escalators at the interchange stations the strongest individuals come into their own. They not only get on to the slow-running escalator faster but also speed up the whole mass of people. The physical pressure that the faster-moving exert on the slower creates a peculiar forward tow, which can be quite frightening if you are not used to it. When everybody is pressing forwards, it could be fatal to stand still. But nothing untoward happens, or hardly anything, and even at the weekend, when drunks try to get into the metro, they are immediately intercepted by the *militsiya*, assessed with a trained eye and put into one of the cells at the station entrance to sober up.

It is in the metro that the nature of this gargantuan city is brought home to you most powerfully, in this situation where millions are daily crammed together in the most confined of spaces and have to get along with each other if they want to reach their destinations. In the metro trains – and it is even worse on the buses – you see a kind of biomechanics in action when the passengers who are intent on getting off are working their way towards the door. While the train is still slowing down, there is a collective movement of bodies, arms, legs, and hands dragging bags along behind them, towards the exit; there has to be sufficient mass to resist the onslaught of people trying to get on.

The Moscow metro is a pioneering work of Modernism, and one that will retain that status far into the future, less because of its palatial splendour than because of the remorseless tempo it subjects its passengers to, the pace that it demands of them. It is one of the foremost institutions of civilization – and this has nothing to do with the famous reading passenger, observed by Ilf and Petrov in the days following the opening of the first line and cited to this day as the most incontrovertible proof of the special relationship that Russians have with their literature. The metro exerts a civilizing influence by

making everyone equal before the laws of its tempo and its calculated rhythm, and remorselessly habituating them to forms of behaviour without which the social organism would collapse. The instruction 'Stand on the right – walk on the left' proclaimed through loudspeakers by the escalators has a more profound significance than the ironic song by the satirical balladeer would suggest. This arrangement enabling those going faster to overtake can only work where there is a tacit acceptance that the progress of all has to be regulated. The metro is a school of discipline, an instrument of socialization which may be only external but is nonetheless necessary. As a foreign visitor to Moscow I am sometimes appalled at how ruthlessly people will fight for a seat, but I still believe that the metro and similar facilities have contributed more to the development of a culture of social interaction – of 'polite behaviour' – than any exhortations or campaigns aimed at producing 'cultivated' people.

Of course the word 'external' indicates a reservation: it means 'imposed from outside', not yet internalized. To observe this one need only go out into the Moscow streets, where the pedestrian is at a hopeless disadvantage *vis-à-vis* the car driver. The motorist, a participant in the social interaction of the streets but one distinguished from the rest by having a car, has undisputed priority and precedence on all occasions. He has not acquired the slightest hint of consideration for his fellow citizen *qua* pedestrian. Here 'might is right', in a way that is no longer possible in the metro. This will only change when the motorist himself sees the value of showing consideration, that is to say when the volume of traffic has reached a level where lack of concern for others significantly increases the risk to his own life and limb.

It would be fascinating to write a history of the Moscow metro in relation to social culture. One would have to describe the aesthetic shock that was produced by the new form of transport – and continues to be produced, judging by the faces of those entrusting themselves to it for the first time – and to analyse the new perception of time that goes with it. In the process one would probably discover that the speed, punctuality and rationality of the metro are only one side of a Janus-like experience of time. For the time gained by the extraordinary speed of the metro journey is lost again elsewhere in wearisome waiting and the infinitely sluggish organization of daily life. The maxim that 'time is money' carries no weight in this society. The Intourist guides show off the metro to visitors to the city,

Metro construction using a tunnelling shield.

'And all this
Had been built in a single year and by more builders
Than any other railway in the world. And no
Other railway in the world ever had so many owners.'
Bertolt Brecht

and with good reason: the metro will continue to be one of the sights of Moscow for as long as its 'pacemaker function' provides a corrective to the oppressively slow tempo that prevails everywhere else.

The metro is also the easiest place to gain a sense of the country as a whole. As you glide downwards on the escalator you have time to reflect on the hundred thousand faces passing you in the opposite direction. Nowhere have I seen a greater diversity of facial type, race, skin colour, costume and gait than here. And the individuality that is the dominant characteristic of these faces owes nothing to eccentric make-up or sensational headgear. It is an individuality that is still able to assert itself without needing to flout the norms dictated by fashion.

'Now we have got the metro!' – so read one of the slogans on the banners carried at the demonstration held in honour of the opening of the metro in May 1935. A demonstration celebrating the opening of a means of urban transport, or rather the opening of the metro of the metropolis: what clearer indication could there be that for a fleeting moment labour history was making history in the broader sense and marking a historic turning-point? More than other underground systems, perhaps, the Moscow metro is not simply a construction project that grew in step with the phases of urban growth, expanding quietly and without fuss as befits something as mundane and

281

practical as a mode of public transport. On the contrary, the Moscow metro has to be seen as a historic event, it has a history of its own.

When the first shaft was driven into the ground, in Rusakovskaya ulitsa, this was not, of course, done on a day chosen at random, but on 7 November 1931, the fourteenth anniversary of the October Revolution. When the first derricks were set up – on the Myasnitskaya, in Sokolniki and on Okhotny ryad – Muscovites flocked to see them. Romain Rolland, though already quite infirm, made the effort to go with Gorky to visit the Komsomol *metrostroi* workers. And unless I am much mistaken there is a photograph, with Demyan Bedny and Aleksandr Bezymensky in the foreground, on which one can make out Bert Brecht himself, in proletarian flat cap, leather jacket and horn-rimmed glasses, visiting the metro construction workers at shaft number 10 on Okhotny ryad; certainly he wrote a poem celebrating their achievement. And years later, at the victory parade on Red Square, who carried the Red Army banner that had been hoisted above the Reichstag building? The metro construction worker and Hero of the Soviet Union Konstantin Samsonov. And well before the metro was opened to the public at 7 a.m. on 15 May 1935, a report was duly made to the Seventh Congress of Soviets: 2,500 *metrostroi* workers marched in their working clothes to the closing session of the Congress on 6 February 1935, tendered their report and gave the green light for the opening. That same night, the 2,500 delegates to the Congress became the first passengers to travel on the metro, in the first eight trains, on the newly completed line from Sokolniki to Dvorets Sovetov station (now Kropotkinskaya). Just as the high-rise buildings perhaps represent the rather desperate self-projection of a historical era that was coming to an end, so the metro is a monument to its time: a monument to a battle below ground, a Magnitka beneath the surface of Moscow.

The Czech communist Julius Fučik, who observed the building of the metro at close quarters, said that while every city attempting the construction of an underground railway system had had its own particular problems, Moscow had them all. Berlin had difficulties with a high water table, London with an anarchic tangle of drains, cables and tunnels; Paris and Madrid faced problems because the tunnels ran fairly close to the surface and came up against old foundations of buildings. Moscow had all of these difficulties, plus the complicated geology of the ground on which the city is built. And

282

the name of a certain Herr Sieghart, an engineer with the Siemens-Bau-Union, is still mentioned today, simply because he refused to divulge his patent method for stabilizing the sandy subsoil.

Moscow used to consist of small local communities that had not really fused together to form a single town, but the idea of making it into a city by revolutionizing its transport was conceived before the Revolution. It was not realized, although the increase in the speed of transport even within a single generation seems to have been fairly drastic. Up to the 1870s people still went everywhere on foot; in 1872 the first horse-drawn tram ran from the Iverian Gate to the Tverskaya; in 1903 the first electric tram line was opened, though because of the chaotic traffic conditions it was barely quicker than its competitors, the *izvoshchiki* and their horse-drawn vehicles. Then in 1907 the first motor-car appeared, taxis came into fashion, and almost 20,000 drivers of horse-drawn conveyances faced ruin. Buses were introduced as a new form of mass transport in 1924. There was talk of the metro from a very early date: in 1902 the Americans applied for a concession to build it, and the Russian engineer Balinsky laid a proposal of his own before the Moscow city Duma. It was turned down. Old engineering drawings give one some idea of how the futuristically minded engineers and architects of those days saw the solution to Moscow's traffic problem: underground railways, elevated railways, even airships and aeroplanes feature in the sketches – as well as a motorized sleigh.

Then came a rapid succession of decisions – indeed, mountains were moved. In June 1931 the plenum of the Central Committee of the Communist Party passed a resolution to make an immediate start on building the metro. In November test shafts were dug and drilling derricks erected. During 1932 geologists investigated the ground conditions along the planned line of the railway. Sovnarkom proclaimed the metro construction 'the most important state construction project'.

By March 1933 the twelfth shaft was being sunk, on ploshchad Sverdlova. After 21 days it had reached a depth of 18.3 metres – two months ahead of schedule. In shaft 20 the new technique of freezing the ground was applied for the first time, to speed up the tunnelling. In May 1933 the Komsomol threw its first 1,000-strong task force into the construction. At the same time work on building the carriages began at the Mytishchinsky factory. In June 1933 tunnels 10 and 11 met under Okhotny ryad. In a single day, according to a report, no

less than 4.3 metres were built: this was four times the daily norm. During January 1934, 37,000 workers from Moscow factories joined the *subbotnik* shifts alongside soldiers and railway workers. (In May there were over 70,000 people in total working on the metro – they were sent for, or came of their own accord, from all corners of the country, particularly from regions versed in mining techniques, the Donbas, the Urals and the Caucasus.) By February the first 220-metre section of tunnel was ready in shaft 29. In May a tunnelling shield was put into use for the first time, and in June the first below-ground electrical station was operational. In October the first escalator designed and built in the Soviet Union was tested. On 15 October the first train – no. 1 – emerged from the depot and covered the 2.5-kilometre section of line between Sokolniki and Komsomolskaya ploshchad. In November the tunnel under ploshchad Dzerzhinskogo was finished. And in January 1935 the last rails were laid under the street to ploshchad Sverdlova: the line was complete. This first line, built in less than four years, comprised the following stations: Sokolniki, Krasnye Vorota (now Lermontovskaya), Kirovskaya, Dzerzhinskaya, Okhotny ryad (now prospekt Marxa), Biblioteka imeni Lenina, Dvorets Sovetov (now Kropotkinskaya), Park Kultury imeni Kominterna (now Kalininskaya), Arbatskaya and Smolenskaya.

One should not assume that it was only the militarized form of the work that made all this possible. Rather it was the huge effort put into it, the mixture of militancy with a military approach. Even linguistically this is obvious in expressions such as 'metro construction front', 'Stakhanovist and shock brigade work', 'heroes of labour' and 'the battle against wreckers'. Presumably not all the pictures lie: there really was heroism and selfless commitment on the part of tens of thousands of people, there really was an idea transformed into physical energy – the idea that this city must become the most beautiful in the world. This again is part of that 'other truth' that the epic portrayal of the Gulag does not help us to understand. It is a complicated matter, like the building of the German autobahn system, an unresolved issue that even today in Germany obscures the other, terrible, truth.

The metro is surely also a symbol of immense organizational talent and ingenuity shown in apparently hopeless situations. The commander of the 10,000-strong underground army was Pavel Rottert, who went to look at New York, Philadelphia, Detroit, Berlin

and Paris, was in charge of the building work on the Constructivist House of State Industry in Kharkov and on the Dneprogres dam project, and was a *spets* with a strong commitment to the Soviet system. As his lieutenant he had an engineer of the type whose knowledge had been acquired not so much at the academy as through practical experience: this was Yegor Abakumov from the Don Coal Basin, a *praktik* on whose technical, organizational and human management skills everything depended.

The building of the metro continued even in wartime. Novokuznetskaya and Avtosavodskaya, for instance, and also Izmaylovsky Park were built during the war years – although thousands of metro construction workers had left for the front and hundreds of factories had gone over wholly to war production. During the war years the metro quickly gained the reputation of being the safest place to shelter in. Moscow defied Hitler's armies, even if the anniversary celebrations of the Revolution were held not in the Bolshoi Theatre, as was customary, but in the Mayakovskaya metro station (on 6 November 1942). The metro also provided the headquarters for the General Staff, so that for a long time no trains stopped at Kirovskaya station. According to another source Kirovskaya station was the air-raid shelter for the diplomatic corps. The metro sheltered people fleeing from the bombing raids, as in Berlin, and between June and December, so it is said, 213 babies were born there. But the wartime history of the metro is different from that of the Berlin underground system. It is hardly surprising that the masters of victorious Moscow, in the years after the war, let it be known to the builders of the metro that from now on the construction would be grander, more beautiful, more colossal, as befitted a victorious people. Most of the Circle line was built in the post-war years up to about 1953. This was no longer the architecture of the pre-war period, strong but nevertheless beautiful: now everything was *too* beautiful, too splendid, too massive. It was a triumph of Byzantium over the ethos of 'shock brigade work', of the mosaic or ceiling painting glittering with gold over the plain coffered ceiling. But what is the sense of attempting to create a heaven on earth *beneath* the earth, in the tunnels of a modern mass-transportation system?

It was recently announced in the press that the Mayakovskaya and Kropotkinskaya metro stations, as well as Ladovsky's shell-shaped vestibule in the Lermontovskaya station, had been declared

'architectural monuments'. They are all located in the inner area of the first building phases of the 1930s. Since then the network has grown far beyond that area: there are now 114 stations, with a daily average of six million passengers using the metro (in 1976 it was calculated that up to that date there had been a total of around 40 billion passengers), and about 40 per cent of all passenger journeys are made by underground.

And the building goes on: some plans of the city already show the new north–south line (from Otradnoe in the north to Krasny mayak in the south). The new line passes under the whole of the centre and has interchanges with existing lines at the Novoslobodskaya, Arbatskaya and Dobryninskaya stations. There is still 'shock brigade work', there are still heroes being fêted, but there is also a new air of normality, the construction project of the century is now simply something useful and practical. This is most apparent in the metro stations built from the 1960s onwards, even though they still pay homage to the great example of the earlier work. The stations are still huge and decorated with glittering materials, but everything is more 'normal': the passages are shorter, the stairways leading down from the surface are not so endless, there is not always a need for escalators, and the eye is not distracted by an excess of decoration. (Among these newer stations are Gorkovskaya, Pushkinskaya, Varshavskaya and Prospekt Vernadskogo.) The metro has grown with the generations that have built this city: it is the expression of their energy, their ideas, and also their expectations of a better life. This is why, in a city where in any case the succession of historical eras has been accelerated and compressed, it seems natural to try to identify these 'generational differences'.

It would of course be possible to take a different approach, for instance to follow the literary line from Mayakovskaya station to Pushkinskaya, from Gorkovskaya to Lermontovskaya or Turgenevskaya. You could go from one station to another and see how the decoration of each reflects its catchment area. But perhaps it really does make most sense to stay on the trail of the different generations, in other words to follow the chronology of the construction, or to visit those stations that bear, in the architect's style, the signature of their era. For simplicity, I will call these groups of stations the 'shock brigade ethos' line, the triumphant general's line, and the line of normal getting around.

286

The first of these comprises the stations built before and during the war. These are, from the first phase (1935):

> Sokolniki
> Krasnoselskaya
> Komsomolskaya
> Lermontovskaya
> Kirovskaya
> Dzerzhinskaya
> Prospekt Marxa
> Biblioteka imeni Lenina
> Kropotkinskaya
> Park Kultury
> Kalininskaya
> Arbatskaya
> Smolenskaya

From the second phase (1938):

> Ploshchad Sverdlova
> Mayakovskaya
> Belorusskaya
> Dinamo
> Aeroport
> Sokol

And from the third phase (1944):

> Baumanskaya
> Elektrozavodskaya
> Semyonovskaya
> Izmaylovsky Park

Almost all of these stations have an imposing, severe beauty that is sometimes felt to be a little overpowering. The prime consideration here was not economy – the whole country contributed to their construction: the technology came from Leningrad, while Altay, the Urals and the Caucasus provided the granite, porphyry and labradorite – but the determination of the pioneers to create an aesthetic of their own. It is certainly no accident that both the strict

Staircase in the Neidhart house in St Petersburg, architect I. A. Fomin, 1913.

Passage in the Ploshchad Sverdlova metro station, architect I. A. Fomin, 1936–8.

forms of the academician Fomin and the still visibly Constructivist-inspired lines of an architect like Dushkin can be found here. Ivan Fomin (1872–1936), who had studied and worked under Kekushev and Shekhtel, the masters of art nouveau in Moscow, is the architect of the Lermontovskaya and Ploshchad Sverdlova stations. Aleksei Dushkin (1903–1977, and thus one of the 'younger' generation) built the Kropotkinskaya, Ploshchad Revolyutsii, Mayakovskaya, Avtozavodskaya and Novoslobodskaya stations. Nikolai Ladovsky, a professor at VKhUTEMAS, designed the Dzerzhinskaya, and Gontskevich the Biblioteka imeni Lenina and Kalininskaya stations. Boris Iofan, who was trained in Rome and was one of the designers of the wildly fantastical Palace of Soviets project, had a part in designing the Baumanskaya station; and Vladimir Gelfreikh joined the list of the metro builders with his vestibule for the Novokuznetskaya station. Aleksandr Deineka, an artist with similarities to Oskar Schlemmer, created the pictures for the false cupolas in the ceiling of the Mayakovskaya station. Given such very different people as Fomin and Dushkin, it is perhaps too daring to speak of a unified approach, and yet it seems plain to me – travelling along the original line – that the stations all conform to that same stylistic code of discipline and restraint.

This becomes most apparent, perhaps, where you change from that generation of stations to the following one. You can do this at

the interchange stations that link the original line and the Circle line, which was mainly built between 1945 and 1953 (the Circle line stations Komsomolskaya, Kurskaya, Belorusskaya, Kievskaya, Park Kultury, and so on). In these the ceiling vaulting does not just span the row of marble columns on each side, but creates a space in its own right, which in the Komsomolskaya station becomes a surface for the projection of history: the military exploits of Aleksandr Nevsky, Dmitry Donskoy, Suvorov and Kutuzov, and the parade marking the victory over fascism. In the Kievskaya Circle line station the pictures celebrate the 'historic' friendship between Russia and Ukraine. In other words the ceiling becomes more than just a ceiling, it becomes a place where magical processes can occur. The intention is to draw the eye upwards and to impart lessons to you as you pass by underneath. Here it becomes clear why thousands of painters, stucco artists, mosaic makers, and so on, had to abandon the work they were doing elsewhere: when the present is already taking on the mantle of history, there can hardly be enough energy left over for the conservation of actual history.

The 'normal' line, the line for simply getting around, extended outwards beyond the Circle to areas where the new city was expanding. Its builders undoubtedly learned from the earlier masters. Looking back, Dushkin, the masterly creator of the Mayakovskaya station, expressed his views very clearly: 'Optical tricks are worthless. For a windowless space like the metro, light is vital as an organic structural element infusing the material with life and accentuating the spatial solutions.' His credo, he said, was best embodied in the Kropotkinskaya station (he was critical of Mayakovskaya because the constructional potential of the plans had not been fully realized in the execution of the project). He acknowledged that he had studied the architecture of Egyptian tombs as an aid to solving the problems of metro building. The halls of columns associated with the underground labyrinths of the pyramids had provided him with a model for solving the constructional challenges. And in the severity of the style the architect expressed his respect for the metro construction workers, his respect for every centimetre that they hacked out of that Hades of stone.

28 Illustration

It is not my intention to focus on things that are eccentric or over-ambitious, or to make play with what is unusual or esoteric; nor am I being condescending towards anyone who is used to the pictures in magazines or travel brochures.

A visual image has its own value independently of the text; if it is there as evidence of something that the text itself does not tell you, then the text is weak. Illustrations, or telling examples, give the reader a little assistance, they are a marker, a clue for the imagination to follow up. The use of illustrations has no room for the didactically pointing finger ('You must see this, or you have seen nothing'). The images fit naturally into the text, which remains a fragment and in the first instance conveys only what *I* see, and perhaps what others see too.

The images are meant to capture and hold on to what we notice but tend to register only in the subconscious, in the interests of concentrating our energy on the essentials, on the broader perspective. They register the incidental, the contingent details that accompany us day in, day out. Our vision is really a kind of extended reading, but in familiar, well-known contexts we do not read every word or phrase letter by letter, syllable by syllable, we take it in at one go, as a complete whole. Often, though, the whole only becomes intelligible if we stop and examine the individual element, the sound of a syllable, perhaps, or the particular flourish of an expression. We are surrounded by signs and symbols, we cannot live or manage without them, even if we do not consciously regard them as individual ciphers: theatre posters with red lettering announcing a new show,

signs at bus and tram stops, signposts in general, department store signs (*Atelie, Univermag, Morozhenoe, Tabak, Produkty*), memorial tablets with sculpted reliefs and dates of birth and death, black plaques with gold lettering at the doorways of official bodies, and so on. The incidental ceases to be incidental if, when walking along a street, you are brought to a halt: you pause and take in these details with amazement. I think that since every detail has a historical dimension, being a product of its own time and bound up with its own time, it is in principle a valid document, a readable letter or even syllable in the great text that we call history. Every age has its own signature, its own bearing, its own manner, be it flamboyant or restrained. As we know, the reading of old texts enhances our ability to find our way into a period, to gain a degree of intimacy with it. The details are given, they are deposits of stone, marble or iron in the city's history. The text is written. We cannot change anything about it. All we can do is to approach it with due respect, just as we would take particular care in handling an ancient book. Of course a certain minimum level of knowledge is required for this kind of textual reading.

And one final point: reading a book must be enjoyable, it must be pleasurable, that is in a sense part of the truthfulness of the text. The unity that images can give a text must be evident, not forcibly imposed and not hermetic. The relationship between the images must be like the text – a series of dots indicating the outlines of a picture that remains fragmentary. I for my part would maintain that Moscow cannot be portrayed as a single, integrated whole, but only in this fragmentary way. So this is not one of those attempts to create an impressionistic mosaic. In any case, making a mosaic is all too often simply an excuse for the absence of a unifying idea running right through a work.

But as I say, one cannot deliberately produce a whole, as one would put together a notional cross-section or a set of pictures showing a little of everything. It either comes together spontaneously or not at all.

Let me give some examples. 'Every detail is time in miniature.' To illustrate this, I will choose one kind of detail, not entirely arbitrarily, namely *entrances*. Entrances tell you a great deal – how any visitor will be received, what sort of a visitor or client is expected, whether the newcomer will be invited in, turned away, intimidated, prepared for a rebuff, prepared for what is to come. Is it a private house, a

villa, a business, a public authority, a ministry, a shop, a hotel, a block of flats, a place of work (of a manual or intellectual kind)? All this can to some extent be read in the 'text' of the 'entrances'. So can the march of time, which, for instance, has done away with the varying degrees of attentiveness that the bourgeois merchant used to accord to his different customers, and has considerably increased the self-importance of the authorities (thus the requirement on doors, '*Propusk* to be held open for inspection', is almost a hallmark of the new age: without your *propusk* you are no longer admitted anywhere). The passage of time has also seen the entrances to the huge modern multi-storey buildings being set so far back from the road that nobody passing by chance would ever think of walking all the way from the pavement to the entrance door: you would only do that if you lived in one of these bastions of privilege.

'Pause the film.' This category includes the kind of things I mentioned earlier, the everyday labels that we absorb unconsciously and by which a city recognizes itself, as it were: the wording on kiosks (*Tabak, Knigi, Bukinist*), shop signs, sometimes in neon (*Produkty, Univermag*), signs showing the political path to be taken ('Long live communist labour', 'Forwards to communism', 'Peace', 'Let us fulfil the resolutions of the November plenum', and so forth). If you live here, you only need to see the first few letters to know the rest of the slogan. And the monster abbreviations – usually in gold lettering on black, metal behind glass – which also tell the initiated where they are, even though they may not know what the abbreviation stands for.

'The city speeded up.' It is not easy to explain, out of context, what I mean by this. So here to begin with are a few examples. It is often claimed, sometimes by architectural critics, that there was a sharp break in continuity between the architecture of the 1920s and that of the 1930s, and that everything after that was rubbish ('wedding-cake architecture'). A judgement of this kind fails to stand up to rigorous examination. You only have to look at the transitional buildings where Constructivism and classicism come together in highly original ways, or – instead of getting worked up about the 'wedding-cake' style – quietly contemplate the arrangement of the columns in the Ploshchad Sverdlova metro station. This is an instance where the *detail* proves that a general assumption is not correct (and often it is enough just to show this!). Or there are the covered porches over house entrances. They tell you something about

the local climate, the style in which people live and the conservation and the durability of buildings that are old, often 70 years old. Or the wrought-iron railings around the villas – almost a distinct specialism among the art nouveau generation. Or doors that out of sheer necessity have had to last without being replaced. Or the mountain range that is the Hotel Metropol – I toy with the idea that on this one building, using different effects of natural and artificial light, a succession of periods could be combined prismatically, concentrated and compressed (balconies, windows, lamps, tasteless modernization, superstructures on the roof, the inscription on the frieze, the chimneys, etc.). Or the Kremlin – because the ensemble is so overwhelming you usually do not manage to take in the elements of which it is composed: the domes, the row of crenellations on the walls, the crazy colour combinations (grass green, Habsburg yellow, carmine, blood red – the flag on the Senate building! – and the silver firs). Yet the 'enigmatic quality' of the Kremlin lies precisely in these contrasts that we find so startling.

29 Monasteries and cemeteries

What can be learned from inscriptions on tombs:
the hierarchy of the dead; the selectivity of eternal rest;
the intertwining of generations; significant dates
of death – Monasteries and convents as outposts.

The hearts and eyes of travellers who had the good fortune to see Moscow before the great reconstruction of the 1930s were overwhelmed at the sight of the '40 times 40 churches'. They would glimpse a church at the end of a long boulevard or on a hill in the distance, be surprised by a bell-tower in one of the main shopping streets or drawn towards the walls of a monastery in a park. Anyone coming to Moscow nowadays and enthusing about a city full of churches and monasteries is, in my view, misrepresenting the truth. For that erstwhile splendour has been dethroned. To avoid any misunderstanding, however, I should add that in fact one can probably still see, or at any rate find, more churches and monasteries in Moscow than in cities in Central Europe that have remained Christian.

So the point about the search for monasteries and churches here is a different one, namely that the most enduring effect of the 'change of decor' has been the loss of the old Moscow skyline that was defined by its churches. Those churches have not been pulled down, but simply overshadowed. Certainly some priceless gems of Old Russian ecclesiastical art did fall victim to the pickaxe. Obvious examples would be the Chudov Monastery in the Kremlin, or the Simonov Monastery which had to make way for the building of the Cultural Centre of the ZIL automobile works. But liquidation does not seem to have been the most common solution; ecclesiastical buildings were given a new function rather than demolished – though sometimes both: the Strastnoy Convent, which stood on the site of the present Pushkin Monument and Rossiya Cinema, was

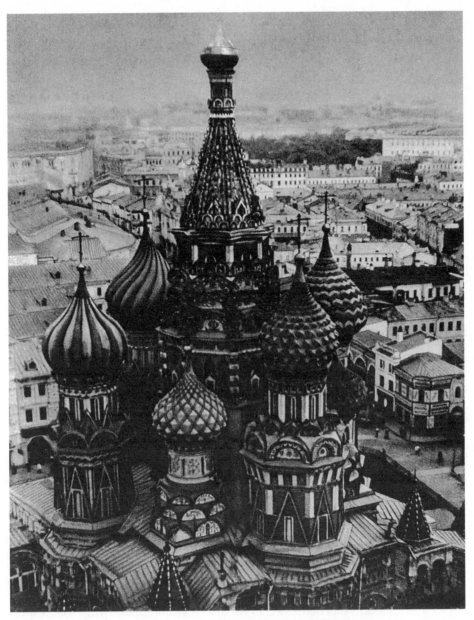

Cathedral of the Intercession of the Virgin on the Moat, known as St Basil's
Cathedral, built 1555–61.

turned into the Central Museum for Atheist Propaganda after the Revolution, but later pulled down.

Whereas in earlier times houses would be built around a monastery at a suitable distance and on an appropriate scale, today it is clear that the churches have to fight for every square metre of light and every unobstructed view. Respect for them has disappeared: churches have ended up in backyards, hemmed in by functional, multi-storey blocks of flats and thereby robbed of their position and status. You find them not where you expect them to be, but most often in the places where you least anticipate them: elbowed aside from the main thoroughfares, finding refuge in the inner areas of those districts that have so far escaped being modernized, forced into almost intimate association with factories, enclosed by the enlarged sites of big industrial concerns, sometimes even torn apart inside to accommodate an institute, a haulage warehouse, a shoe factory or a printing works. And you will sometimes find a church preserved in the shadow of looming buildings, like a dissected piece of muscle fibre cut out of a body, or the fossilized shell of a once-living creature, now exhibited as a lifeless symbol – like the little white church of St Simeon Stolpnik on prospekt Kalinina. There is much criticism of the way churches and monasteries are being neglected, deliberately left to decay or even destroyed, but usually the concern is for their architectural substance. Yet the much more crucial point – that they have been robbed of their aura, their inviolability, that the atmosphere of reverence surrounding them has been purposely destroyed or left pitilessly exposed – is seldom mentioned. I do not know why: perhaps it is because even people coming here from the West have lost any sense of the spiritual dimension of churches. The clearest sign of the death of the churches and monasteries is not their outward dilapidation but the designation accorded to them by the Soviet guidebooks: *Pamyatniki arkhitektury* – architectural monuments. That is the ultimate profanation, indeed desecration, that such places can suffer.

Buildings dedicated to ritual and worship, to a truth that is literally not of this world, cannot simply be given other functions; they vigorously resist the imposition of a purpose alien to them. The interior with its domed ceiling, still showing traces of the painted words 'Lord, have mercy' was not built to serve as a store for spare parts. The apse that once enclosed the space behind the iconostasis

296

was not intended for shelving but for something quite different, something higher.

Not everywhere was the profanation of the enemy's domain pursued as remorselessly as in the case of the churches. When it came to the mansions of the old ruling class, the new governing power evidently found it easier to observe the proprieties by placing them at the disposal of the representatives of foreign states resident in Moscow. The French ambassador in the neo-Russian mansion of the rich merchant Igumnov, the West German in a villa in ulitsa Vorovskogo, the American in the residence in the Arbat district – all this preserved decorum and style.

The reasons why precisely the churches and monasteries became the target of iconoclastic desecration are well known: they were felt to have propped up, over many centuries, a hated regime that had refused to share any of its wealth, knowledge or privileges with those who to begin with would no doubt have been satisfied with only a part, but were finally resolved on taking everything and 'being everything'. It was no accident that the monasteries and convents, attacked as 'bastions of medieval obscurantism', were to be turned into places of enlightenment after the Revolution; no accident that a nunnery, the Novodevichy Convent, was transformed into the Museum of Female Emancipation. However, measures such as these were not entirely a demonstration of the power of the new rulers to impose their superior doctrine – they also revealed their weakness. Such deliberate humiliation of one's erstwhile opponent indicates unfinished business with him, even if he has been revealed for what he is and declared dead a thousand times over. Something of this unease on the part of a victor who is not quite certain of being in the right can still be seen today in the role that the Orthodox Church is allowed to play in public life.

However, it would be wide of the mark to attribute the deliberate isolation of religion, the profanation or at least restriction of this sphere, solely to the intervention of the Soviet regime. Even around 1900 prominent architects and city planners had to take a stand for the preservation of the churches and monasteries in the face of the boom that had capitalist Moscow in its grip. The author of a travel guide of 1914 gives a wistful and emotional account of just how much of the old substance of the city, of its towers and defensive walls, the new capitalist metropolis has already swallowed up. The skyline was already under attack from the construction of railways,

tram-lines and tenement buildings, long before there was any thought of centralized socialist planning. In fact it seems ironic that the authors of the General Plan of 1935 specifically intended to enable the Moscow skyline to come into its own again, after it had been levelled out and deprived of its vertical accents – the churches and bell-towers – by all the new commercial buildings, banks and public buildings. The silhouette of the seven high-rise buildings that now dominate the city is nothing other than the restoration, in a different guise, of the vertical elements of the former Moscow, the restructuring of a city by means of new architectural dominants after those of the past had been lost to view and no longer served the purpose.

If the assault on the sphere of the sacred cannot be put down wholly to intervention from on high, how does one explain the extent of its impact? In the decades immediately following the Revolution, atheist propaganda and the exposure of the role of the clergy certainly played a considerable part. This was achieved by the use of what were often popular materialist pamphlets imported from the West: writings about the French Revolution, Dietzgen, Mehring, Kautsky. But there was another factor which was probably more effective than the Komsomol's atheistic propaganda, and that was the shortage of soundly constructed buildings. A printer working today in a factory that was once a church will have lost all sense of the original purpose of the building.

If such very deliberate flouting of propriety is a sign of uncertainty, what is the nature of that uncertainty? Perhaps the question is best answered by posing another: what prompted the authorities, and when exactly, to restore a right of existence to this previously threatened domain? How is one to explain the fact that churches are being repaired, painstakingly restored, and in some cases returned to the Church for its use? The reason is surely not only the income generated by tourism. It seems to me that the explanation lies in an increasing feeling, aside from any attitude to the Russian *Church* as such, that these are *Russian* churches and that they, like everything else that is no longer the subject of direct concern and hostility, are accepted as part of the substantial stock of national culture. Of course, this has been the official line ever since Lenin's decree of 1919 requiring that 'valuable cultural monuments' be protected. If greater efforts are now being made to conserve the past, this reflects something much more fundamental than the desire expressed by the

revolutionaries, especially men of culture like Lunacharsky, to absorb the heritage of the past: it is a sense that the modernization of the country has opened up gaps that the development of society alone will not be able to fill. There is a growing awareness that there are not inexhaustible 'resources of meaning' and that the national element in these resources is in particularly short supply; and the decaying churches and monasteries will be the beneficiaries of this, at least to the extent of being renovated externally and used as museums or other kinds of cultural institution rather than as factories and warehouses.

In fact it was partly the mortal threat to the Soviet Union from Hitler's armies that induced that most ruthless of realists, Stalin, to redefine his relationship with the Church: Metropolitan Sergii, the target of earlier atheist propaganda, was needed to mobilize people for the Great Patriotic War against Hitler. Only when he was declaring the struggle for the defence of the motherland to be a Christian duty was he allowed once more to make public appearances in his full regalia as a metropolitan of the Orthodox Church. But this calculated act of rehabilitation of the head of the Church hierarchy was not likely to have much bearing on the restoration of the physical surroundings in which Russian piety – which is certainly more than a stereotype dreamt up by Rainer Maria Rilke when he visited Moscow – has for centuries expressed itself.

Because Moscow's once ubiquitous convents and monasteries, with their fortress-like walls, bell-towers, churches and refectories, are now hemmed in on all sides, it is easy to forget what a vital part they played in the birth and growth of the city. Now that they have been absorbed by Moscow's rapid expansion and appear to be quite close to the centre, it is not immediately obvious that the city grew up under their protection – protection in the military and strategic sense. But one need only trace the line on which the important monasteries were sited to see how they shielded the city on the southern and south-eastern side. From the south-west round to the south-east runs a semicircle formed by the Novodevichy Convent and the Donskoy and Danilov monasteries, and then, on the other bank of the Moskva, the Simonov, Novospassky and Andronikov monasteries. And along the present-day Boulevard Ring stood the convents and monasteries that gave their names to the boulevards; they were located on the line of the defensive wall, demolished long ago, that surrounded Moscow on the northern side.

It was not that a desire to retreat from the world, to seek seclusion, drove the monasteries and convents out on to the edge of the grow-ing city, as the decidedly introverted tradition of the Eastern Church (in contrast to Western European monasticism) might suggest. It was a case of the city developing behind the fortified ramparts of the monasteries on its southern periphery. They stood there shoulder to shoulder, as it were, on the very front line of the Christian West. To some extent Europe has this line to thank for the fact that the assaults by Tatar and Mongol horsemen remained only an episode in history. More than once, well-fortified Moscow, and not least its monasteries and churches, had to suffer pillage and destruction as the price for protecting Christendom.

It is not entirely easy to say what business a foreign visitor to Moscow has in a cemetery, or what he hopes to find there – espe-cially in the cemetery of the Novodevichy Convent. An urge to feel the presence of the dead, to experience the proximity of their 'mortal remains', to pay his respects, or just to indulge his curiosity for no particular reason? One approach is to take a specific route through the cemetery on the basis of prior knowledge, visiting a series of graves that have a clear logical link – from Khrushchev's grave, where Neizvestny's sculpture has given the soft peasant features almost the look of a *condottiere*, to that of the writer Aleksandr Tvardovsky, on which there is just a large piece of rock worn smooth, no doubt, by glaciers; and then perhaps on to the grave of Vasily Shukshin, a little further off, which still looks almost new. One can explore a cemetery by generation or by particular disciplines: it is not hard to recognize where Academy members, famous scientists and scholars are grouped together, or artists, or military heroes. But it will prove difficult to maintain such a single-minded approach, because every grave you pass demands attention simply because it *is* a grave. You are not only distracted by the striking monuments – for instance those to the architects Fomin, Gelfreikh or Iofan, still proclaiming their commitment to their profession even in death – or induced to slow down by the symbolic immortalization of the life-time achievements of the dead – the model of a tank, perhaps, a rocket carved in granite, a prostrate swan with drooping wings (on the tomb of the great singer Leonid Sobinov, carved by Vera Mukhina), a giant marble airship set up to commemorate its crash, or the many small graves or urn niches in the cemetery wall. Nor is it just the overcrowding of the space with graves (some with a little

bench beside them) that is confusing despite the methodical layout. There are other things that delay your progress: you cannot help reading the dates that mark the limits of a life, you cannot help lingering before the portraits, and experiencing the shock of suddenly encountering among the dead someone you have known from his writings as a living person (as happened to me when I saw the modest grave of Abram Moiseevich Deborin).

These dates are like a great web in which the lives of different generations and periods are interwoven. The grave of the Russian Revolutionary Populist Mikhail Ashenbrenner, for instance, bears the dates 1842–1926 (and the Populists and the earliest generation of revolutionaries seem to be grouped near the convent wall); Vera Figner, his more famous fellow fighter in the Populist movement, who was interned for 20 years in the Schlüsselburg Fortress near St Petersburg, is also buried here. So Ashenbrenner's life-span covers the historical experiences of the 1860s, '70s and '80s, the early days of the workers' movement, the first Russian Revolution and the February and October Revolutions. A life extending from the 1848 Revolution in Western and Central Europe to the establishment of the Soviet system. How many years of this life were spent in the underground movement, in prison, in exile through banishment or emigration can only be guessed at. What we can say with certainty, however, is that there are generations whose lives would have been adequately filled with 'history' if they had experienced just one of these events, and other generations who only know of such times of accelerated history from reading about them. They have remained untouched by that kind of compression of time and events, they have been cushioned in normality. But perhaps that is an idealized picture: decisions are demanded of us in 'normal'-seeming times too, and a time that may appear to be one of standstill and undisturbed routine is often bought at a highly abnormal price.

A time of standstill is also one that produces activists without hope, and the frustrations of the 'superfluous men'. Many more sets of dates like Ashenbrenner's can be found in the cemetery, representing a generation who were able to see the Revolution as the natural conclusion to their unstinting efforts – or alternatively as the unceremonious tearing up of all their hopes. There are also other starting-points, with other endings. There is the generation born around 1890, who, all things being equal, were alive until quite recently, having played a conscious and energetic part in the October

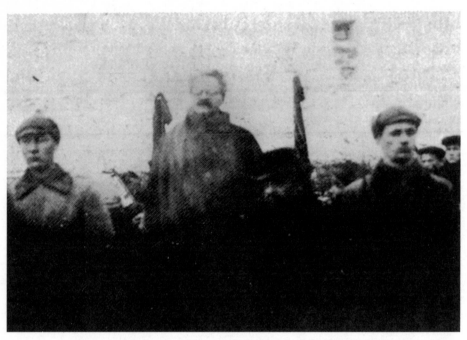

Trotsky making his last public speech in Russia – at the funeral of Adolf Joffe on
19 November 1927.

'As the procession drew nearer to the cemetery the problems started. For a moment
we marched on the spot in front of the tall, battlemented entrance; the Central
Committee had given orders to allow only about 20 people inside. "In that case,"
Trotsky and Sapronov declared, "the coffin stays outside too and we will have
the speeches out here in the street."'
Victor Serge, *Memoirs of a Revolutionary*

Revolution as active Bolsheviks, not mere eyewitnesses – 'Joined the
RKP(B)' appears on many of their headstones – and devoted the
middle years of their lives to building up the country in the 1920s
and '30s. After experiencing the First World War, they had to cope
with the Second World War too. Two wars within a single genera-
tion, starvation and the destruction of the industrially most power-
ful regions of the country – these too are disastrous experiences that
not everyone is able to survive. There are dates that reveal that some
were spared having to witness the catastrophe inflicted on Russia
from within. Mayakovsky's tomb, where the writer is shown
wearing an even more forceful expression than on his monument
on the square named after him, bears the date 1930; the grave of
Stalin's wife Nadezhda Alliluyeva gives the year of her death as

1932. The dead of those years who, like these two, took their own lives do not fully reflect what a critical turning-point the 1930s represented for so many people. Missing from among the people buried here are all those whose premature departure from the life of their generation was *not* voluntary but violent, unnatural, decreed from on high – in plain language, those who were liquidated. They will not find 'eternal rest' either here or in the graves by the Kremlin wall on Red Square. To that extent the cemetery, a place of pitilessly objective dates, is also a place of untruth in that it remains silent about the dead of those years and does not reveal who followed those already buried here, or when. But at the same time it does point to a truth by documenting the fact that that crisis is not officially acknowledged to have occurred and that the 'enemies of the people' are not allowed to rest in peace even today.

Against this background it is surprising that the lives of some important figures did extend beyond that time of crisis, in some cases by a good many years: Anastas Mikoyan, for instance, or Litvinov or Deborin. Nowadays if a grave indicates an early death, it is less likely to reflect an abrupt turning-point in history than the stresses and strains of a 'normalized' society in which heart attacks have become a mass phenomenon.

Far be it from a foreigner to criticize, given the dignity of this place both in its own right and as an embodiment of the nation's pride in its great and heroic figures! But on the other hand, it would not do to regard the signature of death purely as the mark of a natural event, when in fact the decision about who may find a resting-place here has been reached by resolution of the Central Committee.

'The grave is over there by the three pine trees', we were told by the man coming towards us. We had got off the *elektrichka* at Peredelkino suburban station, less than half an hour's ride from the Kiev main station. Peredelkino is legendary, and familiar from reporters' photographs of the persecuted Pasternak and his surroundings: the dacha, the birch forest, the gentle hills, the station, the fence around the cemetery, the wheat-field, the crowds around the writer lying in an open coffin – in death his face had lost none of its marble-like sternness and austerity. But the eyes were closed, those eyes with the large, dark pupils. Under the three pine trees we found his grave, with fresh flowers on it and two women beside it with books tucked under their arms. All down the slope are graves surrounded by blue

Bell-tower of the
Novodevichy
Convent.

or white painted fences, not just those of members of the writers'
colony but those of local people too.

We are given information, far more than we wanted, by a man
who looks after the grave, and who is sitting on a bench. Taking out
a notebook, he draws himself up to his full height, a bald man with
big eyes behind thick glasses. Of course he tells us about how
Pasternak almost became a philosopher (a Marburg neo-Kantian of
Cohen's school), and that he remained friendly with Neuhaus even
after marrying the latter's wife. That the headstone, with its amazing
relief portrait (showing Pasternak's angular and vigorous chin, his
strong lips, his sharp nose and an eye that is applied like the eye on
Nefertiti's portrait bust, not looking straight ahead but out of the
relief, towards the viewer), is made of poor material (sandstone) –
and so on and so forth. Some way off, beyond a tract of meadow
land and not visible among the birches and pines, is Pasternak's

dacha, with a new roof but an uncertain future. It must legally be handed back to the ownership of the Writers' Union, and whether it can then be preserved as a memorial to him is more than doubtful.

There is something special about the way the dead are honoured in this country. Tolstoy's death gave rise to a mass demonstration by hundreds of thousands of people; the death of Sergei Muromtsev, president of the first State Duma, provoked a rally by the 'other Russia' against the rule of terror by Pyotr Stolypin; and the funeral ceremony of the prominent Bolshevik Nikolai Bauman turned into a trial of strength. And after Lenin's death people poured into Moscow from every corner of the country to take their last leave of him in the House of Unions. When Adolf Joffe was buried in the Novodevichy Convent cemetery following his suicide, a fight broke out between Trotsky's supporters and members of the Central Committee. While Stalin's body was lying in state in the House of Unions a wave of grief, hysteria and relief washed over the city. And more recently the funerals of Pasternak, Tvardovsky, Shukshin, and above all the balladeer Vysotsky, were all demonstrations of the respect and affection felt by the people for their writers and poets. Is it because everything that happens and everything that is said here is more closely bound up with the physically real person? Is it because words continue to be more precious here than elsewhere?

Postscript, prompted by a visit to the Novodevichy Convent: How is it that Vladimir Tatlin installed his studio in, of all places, the bell-tower of this convent? (On the second floor, to be precise.) Perhaps art historians can demonstrate an inner connection between the structure of his projected Tower for the Third International and the architecture of this Russian bell-tower.

30 Knowing and seeing

Perhaps this attempt to read a city is too naive after all. There are long stretches that offer you nothing – blank areas on the map. Of course your deciphering of the traces develops a certain momentum, but often you make no progress at all. Your faith in the informational value of observed details is not unlimited – nor, quite certainly, is your ability to interpret them. When you cannot fully make sense of what you have seen with your eyes, you fall back on what you know. In such situations I notice how I tend to turn to other resources that enable us nowadays to roam at will through the centuries, making connections and suggesting associations that have some basis in the particular object of investigation but which could not be deduced directly from it.

It is all too tempting to don the seven-league boots of a later generation, to use the optical aids provided by history and cultural studies, and to adopt and cite the mediating vision of contemporaries preserved in biographies and accounts written at the time instead of training one's own eye. What militates against this temptation is, for a start, anxiety about the sheer, inexhaustible quantity of that raw material – an anxiety that is partly pragmatic, since the time that a foreign visitor can afford to spend here is finite. There are natural limits on what he can achieve, limits that he accepts only with reluctance, not out of obstinacy but because his sole aim from the outset is to measure the imaginary historical picture he already had against the reality of the city, at the risk, obviously, of having to revise his ideas. He is unwilling to forgo the freedom of discovering his city, the scenery of his virtual history-making, the dream landscape of a

new beginning that was both fascinating and tragically precarious, the stage populated with the ghosts of those who today are either accepted or have no prospect of ever being released from the limbo of the unpersons.

In his imagination they are all present, still undifferentiated, and so it is really his imagination and the freedom of his unfettered historical consciousness that make him turn his steps in one direction rather than another and give him confidence that his own eyes, roving freely around, will reveal more than the sort of knowledge contained in encyclopaedias, which takes things on its own terms and does not have the freedom – here in Moscow, at any rate – to investigate with impunity things that are kept dark, or even to shine a really strong light on things that are out in the open.

The *Moscow Encyclopædia*, published in 1980, which after initial reservations I now use with considerable anticipation and benefit, has clarified for me a problem that has to do with the way we see things. It is a big reference work, structured in the usual way: general chapters on Moscow's geographical, geological and climatic situation, its history and its artistic, scientific and sporting culture, etc., followed by alphabetical entries from A to Ya on everything of note in the city, with precise facts and figures. The *Encyclopædia* presents itself as an objective work of reference in which priorities are veiled by the imperturbable logic of the alphabetical order. Yet there is of course very clear evidence of subjectivity at work throughout, either deleting history or leaving it intact: just try finding Trotsky under 'т', for instance, or Bukharin under 'в'. In its depiction of itself, this city ignores the trail of blood associated with its birth and development; only the drops or streams of blood shed in the revolutionary struggle are preserved and sanctified. Defeat and failure are not seen in terms of great life experiences, but only as elements in a great doctrine of history; they are reduced to being no more than elements, even though the life experience and perhaps even the vital energy of a whole generation may have been crystallized in them. All that remains in the *Encyclopædia* is what is constructive, robust, fixed in stone. Even the proverbial 'waste heaps of history' figure only as part of the ascending line of progress.

The dead are not allowed to rest, they are not left in peace, even when there is a policy of not speaking of them. The only reason why one hardly notices this unnatural and artificial silence about

particular 'unpersons' is because the pulse-beat of the city is so rapid and the blood supply from all directions is more than the heart can deal with. Moscow is so full of vitality – why mention death?

And yet the deliberate silence is more noticeable here than in Western capitals. Which of us is not aware that Paris and Berlin also have unmentioned places – the spot where Rosa Luxemburg was murdered, for instance? But they are perhaps not so much deliberately left unmentioned as simply ignored, and there have always been people who have spoken out about them, and done so publicly. Such voices do not exist here, on grounds of public order. But let us return to the question of different ways of seeing – that of someone whose knowledge has been acquired from books and encyclopædias, and that of a person learning from observable phenomena. Perhaps we can systematize some aspects of this.

The man of knowledge seeks and finds in a city what he already knows or thinks he knows. The man who is simply an observer notices anything that, at first sight, strikes him as being of interest.

The man of knowledge takes hold of objects – of the city as a whole or of individual things within it: he seizes them, takes possession of them. The observer is taken hold of by the objects, he himself becomes the object of his surroundings, they portray themselves in him; he becomes, as it were, the medium through which those who are silent are enabled to speak.

To the man of knowledge the material that he finds is no more than an illustration of a world already arranged and classified, a world that he can in any case not reconstruct as a totality; the reality that has been turned into stone is, for him, an illustration of the thinking that arranges and classifies. Reality is put into place. He illustrates himself and his power. To the observer the material offers resistance and only gradually reveals the secrets that cannot be directly read from it. Seeing is like applying a gentle pressure, as opposed to the crude force of the man of knowledge to whom objects subordinate themselves.

Knowledge is to the object as the whole is to the part; it is always wiser than the thing, which is history in solidified form; it always knows better. Observing is a process of enquiry that has to be content at first with a fragment, with the surface structure. But something remarkable happens in the course of this contact between observer and object: the power of the object is transferred to the observer. The energy locked up in it is transmitted, freed, able to

express itself – whereas the man of knowledge *permits* things to express themselves, an apparently generous but in fact annihilating gesture on the part of the master.

This is, of course, an exaggeration, expressed in abstract terms and therefore false. In reality nothing is so extreme and polarized: the observer also has knowledge, the man of knowledge also observes.

And yet that polarized view can be helpful to the traveller when he has opened the *Encyclopædia* and feels that he has no hope of ever acquiring a real grasp of this city. A real grasp? But that is not what he is after!

The *Encyclopædia* has, for instance, three maps showing the distribution of the architecture of the turn of the twentieth century, the 1920s, and the '30s and '40s. The different layers that in the real city are laid one upon another are here separated as if by magic, and can be effortlessly put back together again. But something is still missing: the relationship between the different layers, the respect felt by one generation for another, perhaps also the arrogance that can only be measured in the attitude of one generation to another.

Even for the purpose of planning a 'tour' these maps can be only of limited use, because every building shown as having been preserved from the nineteenth century as a powerful piece of architecture, shaping the space, defining the wider view, forming people's taste, exists not as an isolated feature on an empty plane but only as a survival, a remnant, a ruin or a spruced-up monument. Its present condition in itself indicates what has become of it, and possibly why.

Perhaps the whole matter is much more straightforward, more trivial, indeed. The temptation to know more than one sees, perhaps even to know everything and to descend to earth and recognize oneself in it, is so great because it is so convenient. That kind of investigation does not run the risk of one-sidedness, overstatement, inadvertent omission or inappropriate subjectivity. And the foreign visitor constantly hankers after the kind of objectivity that does justice to everything and everybody, even though he knows very well that it is only his subjective way of looking at what is already familiar that may be able to find in it something different, perhaps something new.

Incidentally, the use of the third person to refer to oneself – the foreigner, the visitor – is an attempt to neutralize subjectivity. For the act of writing, the third person has the advantage of enabling one to

put down some things more directly and spontaneously, without always being tied to reflection, which literally means turning back to oneself. It is not a means of disguise, however, since the author is no less answerable for the third person.

31 In the footsteps of Walter Benjamin

*Benjamin, Reich, Lacis, Gnedin – Moscow as a place
of refuge – The Berlin–Moscow axis in the 1920s,
and the axis in 1939 – The escape route barred.*

My visit to the old lady had been fruitless. It quickly emerged that
although she had known Asja Lacis and Bernhard Reich, and in fact
seemed to have known virtually all the Berliners who had come to
Moscow in the late 1920s, she nevertheless had no memory of Walter
Benjamin. Moreover, she admitted that she did not find his *Moscow
Diary* particularly interesting. So my hopes that through her I could
make contact, so to speak, with Benjamin as a visitor to Moscow in
1926–7 were not realized. Asja Lacis, for whose sake Benjamin had
made the trip, and for whom he suffered unbearable pangs of long-
ing during the eight weeks or so of his stay, had died, at the age of
almost 90, in 1979. Bernhard Reich, whom Benjamin knew through
his association with the Deutsches Theater in Berlin, had died ear-
lier, in 1972. Despite the lack of any directly successful outcome, I
came away from that visit with a powerful impression of the old
lady, who made no fuss at all about being visited by a foreigner, but
came straight to the point of why I had come. There she sat in her
white housecoat, forming her sentences in harsh-sounding but cor-
rect German and smoking one pungent *papirosa* after another, hold-
ing it in her hand as though it were an ivory cigarette-holder, and
from time to time uttering a hearty curse when some word would
not come to mind. All this showed me a woman who had acquired
her freedom of manner and expression in another age.

While it is easy to recognize the city that Benjamin described in
the *Diary*, it is far more difficult to trace his footsteps. Even in those
days Benjamin was little regarded as a writer in Moscow, and nowa-
days his name is familiar there only to experts on the 'left-bourgeois

Cover of the guidebook published by the O. D. Kameneva Institute.

'I arrived on 6 December. On the train I had memorized the name and address of a hotel in case there should be no one at the station to meet me. (At the border I had been told that there were no second class seats to be had, and been made to pay extra for first class.) I was glad there was nobody to see me getting out of the sleeping car. But there was nobody at the barrier either.'
Walter Benjamin, *Moscow Diary*

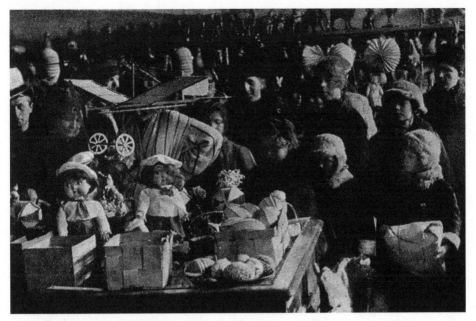

Market stall with children's toys, photograph, *c.* 1920.

'Then there are men with baskets full of wooden toys, wagons and spades, the
wagons are yellow and red, the children's shovels either yellow or red . . .
Also there is a more direct relationship here between the wood and the paint
than elsewhere. You notice this in the most primitive toys no less than in the
most sophisticated lacquer work.'
Walter Benjamin, *Moscow Diary*

interpretation of Marxism' in the West.

In Benjamin's observations and descriptions in his *Diary* that
together create a portrait of the city, Moscow springs to life with as
much immediacy and freshness as if no time at all had passed since
then to cause his images to change or to lose their sharpness under a
layer of dust – even though the city that he explored was still a
'prairie of architecture', as Reich put it. This was still years before the
great change of direction that was to bring discipline to the tumult of
NEP Moscow, freeing huge areas from wooden housing, clearing
churches out of the way and putting up high-rise buildings. A city
can change radically and still remain true to itself. In Benjamin's por-
trait this consistency or continuity is not presented as the timeless
character of the city, derived from its history or geographical situa-
tion, but is evidenced in small details. And it is clear that the
detail, and nothing else, is what interests Benjamin. He finds it in the

pattern on the lacquer box that he wants to purchase, in the face of the tram conductress, in the shape of Russian church windows. These images seem like hand-worked gems, and yet they do not exist in isolation. What Benjamin says about the doubly silent quality of Moscow beset by snow, or about the breadth of the Moscow sky, is observed with such sharpness and accuracy that it takes one's breath away.

However, the city is not really the point of the diary. Asja Lacis and his relationship with her are the dominant theme. Reading this minutely detailed account of subtle emotional shifts, resentments, disappointments, short-lived moments of hope, you become an involuntary eavesdropper on what might be described as an intimacy kept on the tightest of leashes; the reader cannot but be touched by this record of an unrequited love.

The diary entries, which run from 9 December 1926 to 1 February 1927, reveal the network of Benjamin's contacts. It is easy to make out which places served as his principal bases and his places of refuge. First there was the so-called Kameneva Institute, or Society for Cultural Relations between the Soviet Union and Foreign Countries (VOKS), which, according to the travel guide issued by the Institute in 1925, had two offices: one in the Second House of Soviets, that is, the Hotel Metropol, and the other at the Narkomindel (People's Commissariat for External Affairs), Kuznetsky most 5/15, 5th entrance, apartment 60. Judging by the routes of his walks, it was the second of these that Benjamin used to visit, on the corner of Kuznetsky most and ulitsa Dzerzhinskogo – diagonally opposite the Lubyanka. (In the inner courtyard of the building there is a statue of the Bolshevist diplomat Vatslav Vorovsky, who was murdered by the Whites.) The second constant in the topography of the diary is Benjamin's hotel, the Hotel Tyrol on Sadovaya-Triumfalnaya ulitsa, and sometimes also the Hotel Liverpool – now called the Ural – where Egon Erwin Kisch and Ernst Toller also stayed. There are also frequent references to restaurants and cafés, places to pause and rest in his wanderings around the city, for instance the Hotel Savoy, now the Hotel Berlin, on the corner of Pushechnaya ulitsa and ulitsa Zhdanova, in the shadow of the Detsky Mir toy shop, or the French café in Stoleshnikov pereulok (I was unable to discover which of the present-day cafés there might have been the French café). For Benjamin, who according to Lacis only occasionally ate any lunch, and then mostly only chocolate, cafés and pastry shops played a

major role. He did not omit to visit the cafés in the Praga and the Luks either. His third base, not to say sanctuary in the city, was no doubt the sanatorium where Lacis was convalescing and where the longed-for but usually disappointing meetings with her took place. This was the Rott Sanatorium in a side-street off the Tverskaya (the present-day ulitsa Gorkogo).

From this 'triangle' of fixed points he explored the city – on foot, by cab, by sleigh, and sometimes by car. There were disagreeable interruptions: the tiresome visits to the State Bank in the Neglinnaya to change money, or to the travel bureau in Petrovka. And of course the meetings concerning his article on Goethe for the *Great Soviet Encyclopædia*, about which Karl Radek made patronizing remarks and which Anatoly Lunacharsky assessed as 'inappropriate', though 'displaying considerable talent'. The map of Benjamin's Moscow that emerges from the diary reveals little interest in the obligatory sights of the city and wholly reflects his own tastes: the bookshops on Kuznetsky most, and time and time again the theatres.

In the Meyerhold Theatre on the corner of Tverskaya and Bolshaya Sadovaya – where the Tchaikovsky Concert Hall is now – he met Andrei Bely, Mayakovsky, Lunacharsky and the maestro, Meyerhold himself; in fact he was present when the latter was engaged in a rancorous debate there. He was able to attend both the spectacle *Europe is Ours* and Meyerhold's legendary production of *The Government Inspector*.

On 21 December he went to what he considered a very bad play at the Korsch Theatre, which is now a studio of the Moscow Arts Theatre, in ulitsa Moskvina. At the Stanislavsky Academic Arts Theatre (now the Gorky Arts Theatre) he saw Bulgakov's *The Days of the Turbins*, and at the Theatre of the Revolution – now the Mayakovsky Theatre – the performance of *Buy a Revolver* prompted him to comment, 'One could see very clearly what happens to Meyerhold's kind of theatre when an incompetent producer tries to adapt it to his own purposes.'

At the Kamerny Theatre he saw Tairov's productions of *Day and Night* and of O'Neill's *Desire under the Elms*. He was able to study Vakhtangov's directing style at the offshoots of the Proletkult Theatre in the old building on the Arbat and in the Morozov mansion, now the House of Friendship, on prospekt Kalinina. Benjamin knew that he could not ignore the revolutionary Soviet cinema. He went to see the then famous film *One-Sixth of the World* at the Arbat

cinema. Of the museums that either instinct or conscious decision prompted him to visit, only a small number are still located where they were at that time. He had to go twice to the Tretyakov Gallery, since on the first occasion it was closed for repairs – *Na remont* – as it quite frequently is nowadays. As a passionate collector of toys he was particularly delighted with the Toy Museum and the Museum of Arts and Crafts. Major discoveries for him were the former Morozov art collection, then called the 'Second Museum of Modern Art of the West' at ulitsa Kropotkina 21, and the former Shchukin collection, then known as the 'First State Museum of Modern Art of the West' both collections have been incorporated into the present-day Pushkin Museum of Fine Arts.

There was as yet hardly any of the new architecture for Benjamin to see, but on a trip to Zamoskvoreche he saw the 'Moscow radio transmitter, whose shape is different from any other I have seen'. This way of getting close to Benjamin through concrete places and experiences could easily suggest some kind of personality cult. But I was not mentioning the places for their own sake. They are just clues that a historically inclined imagination, using the advantage of familiarity with the location, can follow up in order to find answers to questions: what motivated him and many others of his generation and outlook to come here, and what knowledge did they bring with them to help them understand what was happening in this city? There is another trail, apart from the physical one, that leads both backwards – to before 1926–7 – and forwards towards the present day. Between these lies a chasm deeper than any that might be opened up in the course of rebuilding a city. Or one might say that between them there rises a mountain of historical experience that still, to this day, blocks the rays of enlightenment, so that what is on the other side remains in darkness.

The trail laid by Benjamin's diary discloses other trails leading in different directions. Asja Lacis, his lover at rare moments, has recorded her memories in her autobiography, *Revolutionär im Beruf* (Professional Revolutionary). They had first met on Capri in 1924.

Her companion and future husband Bernhard Reich gave his own 'memoirs from five decades of German theatrical history' the significant title *Im Wettlauf mit der Zeit* (*A Race against Time*). Between Reich, who had moved from Vienna to Berlin in order to work with Max Reinhardt, and Benjamin, there was a closeness based not just on ties of friendship but on their shared background in the Berlin theatre.

However, I missed the most important trail of all in Moscow. There was still someone living there who had spoken face to face with Benjamin. In the diary he is described as 'clever and congenial' and as the 'advisor for central European affairs at the Foreign Ministry'; on one occasion Benjamin arranged to meet him at the Proletkult Theatre but failed to find him there. However, it was not just chance that prevented me from easily locating this man, Yevgeny Gnedin. His memoirs, entitled *Catastrophe and Second Birth*, appeared in 1977 as Number 8 of the *Samizdat Library* series published by the Herzen Foundation in Amsterdam – in Russian, though not in Russia. He died (as I learned while I was correcting the proofs for the original edition of this book) on 12 August 1983, at the age of 84.

Benjamin's association with Gnedin, like his relationship with Asja Lacis, pre-dated his stay in Moscow by two years. When they first met, Gnedin was a member of the Soviet trade mission in Berlin, and thus part of the extremely active group of Soviet diplomats based at 7 Unter den Linden, who not only maintained flourishing contacts with the communist organizations, but also had good lines of communication with Berlin's cultural scene, especially with what was at the time the largest colony of Russians outside the Soviet Union. Gnedin's full name was actually Yevgeny Aleksandrovich Gnedin-Gelfand (or Helphand), and he was the son of Aleksandr Parvus-Gelfand, who emigrated from Russia in the 1890s and then, together with Karl Liebknecht and Rosa Luxemburg, led the left wing of the German Social Democratic movement. As became a Social Democratic household, an announcement of Yevgeny's birth was placed in the Dresden *Sächsische Arbeiterzeitung* of 1 December 1898. Parvus-Gelfand took an active part in the Russian Revolution of 1905, but then changed tack, becoming a financier and entrepreneur; in this capacity he helped to organize Lenin's return from Switzerland at the behest of the German General Staff, and from then on saw his role as that of developing modern capitalism. Yevgeny's mother Tatyana separated from Parvus-Gelfand, came back to Russia and dissociated herself from him.

On his death in 1924 Parvus-Gelfand left a not inconsiderable inheritance, part of which was to pass to Yevgeny Gnedin. Gnedin went to Berlin to arrange the settlement of the estate and to secure for the Soviet government that part of the Parvus legacy above all that even today seems avant-garde – the 'Institute for Investigating

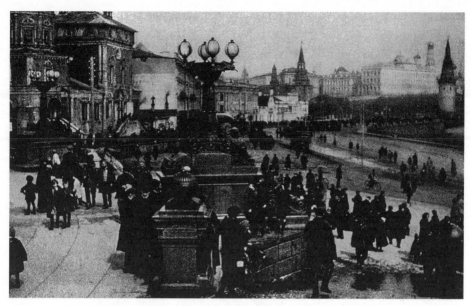

Kropotkinskaya naberezhnaya, photograph from the mid-1920s.

'For anyone coming from Moscow, Berlin is a dead city. The people in the street seem quite wretchedly isolated, each person a long way from the next, all alone with a big area of street around him. Moreover, when I was travelling from the Zoo station to Grunewald, the part of the city that I had to pass through struck me as scrubbed and polished, far too clean and comfortable. What is true of the image of the city and the people applies equally to one's image of the intellectual climate here: the new perspective one gains is the most tangible benefit of a stay in Russia. However little one may actually get to know Russia, what one does learn is to observe and judge Europe with a conscious awareness of what is going on in Russia.'
Walter Benjamin, *Moscow Diary*

the Causes and Effects of the World War' that Parvus had founded. As disputes about the inheritance dragged on until 1927, Gnedin became very familiar both with the tangle of rival interested parties – other family members, Berlin speculators, some of Parvus's fellow Social Democrats, the party leadership of the SPD, etc. – and with the city. Much to the satisfaction of Bukharin, who was aware of the value of the Parvus archive, the materials did eventually reach Moscow. Barely ten years later, Parvus's villa on the island of Schwanenwerder in Berlin became the residence of Joseph Goebbels.

The paths that cross in the *Moscow Diary*, the circle of figures who appear, all have their own background and reasons for being there. Whatever may have been Benjamin's motive for giving the *Moscow*

Diary the disturbing and suggestive secondary title of *Spanish Journey*, the reader who has experienced the laboriousness of dealing with daily communication in Moscow today is struck by the effortless way he adapts to being there, the ease with which he, as a visitor from Berlin, settles into the Moscow milieu and seems tacitly to understand it. This effortlessness can only be attributed to the fact that there was a vigorous and equally unforced intellectual exchange going on between Weimar and the young Soviet culture, precisely because they saw themselves as sharing crucial problems and fighting in a common cause. The 1920s owed their character far more to the Berlin-Moscow axis than to the Paris-Moscow one – and it was the Berlin-Moscow axis that was to shatter far more dramatically in the years that followed. And if, up to now, more attention has been paid to the relationship between Paris and Moscow than to that between Berlin and Moscow, this has had less to do with the facts themselves than with the historical events that intervened to obscure them

A number of identifiable factors contributed to this obvious harmony between Berlin and Moscow in the 1920s. The 'spirit of Rapallo' had united the two countries, a Germany humiliated at Versailles and a Soviet Russia also still prostrate. In Berlin there was a Russian colony that brought together many of the celebrated names of Russian and Soviet culture: Berdyaev, Bely, Pasternak, Pilnyak, Fedin, Tynyanov, Aleksei Tolstoy, the Ehrenburg, and Marina Tsvetaeva. Berlin's Russian colony had its own newspapers, publishing houses, bookshops, clubs, concerts – in short, an organic life of its own that could not but lend its colour to the cultural life of the city. There were guest productions by Tairov, showings of films by Eisenstein, exhibitions of work by Malevich and Lissitzky. Someone like Piscator was readily understood by a Moscow public accustomed to Meyerhold, but no longer caused a sensation; and for a shock-hardened Berlin public, Soviet dramaturgy was just one more shock of many. There was something akin to a shared basis of experience that extended from the Landgraf Café in the Kurfürstenstrasse or the Café Leon on Nollendorfplatz to the Café Luks in Moscow's Tverskaya.

Even so, the delineation of this almost tangible sphere of shared experience is not enough to explain what started the trend towards what was often condemned, by people who had no personal axe to grind, as revolutionary tourism. Precisely because Benjamin's diary

is more cautious in its judgements than the fervent praises sung by the Communist Party sympathizers among the visitors to Moscow, one of the things it reveals is a topography of other people's covert motives, even if they show through only in the form of questions.

The intellectuals who came to Moscow from the 1920s and '30s onwards – and Sartre's visit in the '50s marked the end of that trend – were, for their part, already inheriting the legacy of their times. What drew the Western left-wing intelligentsia here was not just the surge of revolutionary feeling or the boldness of the experiments in almost every sphere of culture and everyday life, but something more deep-rooted, articulated in Spengler's phrase, 'the decline of the West': it was the unspoken idea that the East still possessed the vitality to rescue us from our cultural malaise, from the disjunction between *ratio* and emotion, between body and spirit. Significantly, this too developed an aura of myth, and like any myth it contained an intensity of experience and longing that craved satisfaction. This tendency was not aligned with either the Western-oriented or the slavophile camp – men like Rolland, Anatole France, Gide, Benjamin or Hoetzsch were hardly likely to adopt either of those positions. Although for them Moscow, standing in this context for the incarnation of Russia, was never the Third Rome, nonetheless the hope existed that this was a country not yet exhausted, one with a potential of human resources that could be released to bring about a humanization of our culture – and this hope was shared by all of them, even if one had come only to meet Gorky, another to win Asja's love after all.

This expectation vested in the East was a phenomenon found for the most part in intellectual circles and not so prevalent among the working classes, except perhaps at certain particular moments – when word spread among the trenches that the Russian workers 'wanted to end the war' (which was true, and the information was conveyed by word of mouth all the way to Kiel and Berlin), or perhaps when during the world economic crisis millions were out of work, while in Soviet Russia skilled workers were in demand. Thousands migrated to the Soviet Union at that time. The attraction for Western intellectuals was a different one: they sought here what was denied them in their own country – the sense that they could be at one with the manual worker and bridge the gulf between establishment and literary figures and the ordinary people; the idea that they could escape the deadly isolation of the writer's individualistic

320

A. A. Morozov house, architect V. A. Mazyrin, 1895–9.

'Then I stood watch in the entrance lobby for an hour. But I waited in vain.
A few days later I heard that Gnedin had been in that very room, waiting for me.
I cannot understand how this can have happened. It is conceivable that, exhausted
as I was and with my poor memory for faces, I may have failed to recognize
him in his coat and hat, but that the same thing should have happened to
him seems incredible.'
Walter Benjamin, *Moscow Diary*

existence, that it might still be possible here to convert ideas and
reason into practical action on the part of the masses. It is probably
not easy to find a common denominator for the different attitudes
and party allegiances of these visitors to Moscow. Certainly it was
not just change and modernity *per se* that drew the Western intelli-
gentsia here: in these they saw essentially no more than a reflection
of themselves. What fascinated them so much about Malevich,
Tatlin, Golosov, Mayakovsky and others was not primarily the revo-
lution in form, the new kind of sound, but the fact that their form,
their sound had a wider reach and resonance, seemed to be liberated
from the merely aesthetic speculation of an elite, and had the capac-
ity to influence society and gain general recognition. The attraction
of the East, the decisive motivation for going there, did not lie, then,
in bringing together Petrograd's and Moscow's artistic milieu and
that of Berlin, nor in the encounter between El Lissitzky and mem-
bers of the Bauhaus, fruitful and stimulating as those contacts no

Russisch - Deutsche Luftschiffahrt - Gesellschaft
„DERULUFT"

Regelmäßiger täglicher Personenverkehr zwischen Moskau-
Königsberg-Berlin-London in komfortablen Sechssitzer-
Aeroplanen Fokker III, mit Rolls-Royce 360 PS-Motoren

Flug- und Fahrplan

Eisen-bahn	Aero-plan	Mitteleuro-päische Zeit		Mitteleuro-päische Zeit	Aero-plan	Eisen-bahn
	6.00	Abflug	Moskau	Anflug	4.45	
	3.15	Anflug	Königsberg	Abflug	7.30	
7.37		Abfahrt	Königsberg	Ankunft		5.52
6.48		Ankunft	Berlin, Schl. Bahnhof	Abfahrt		6.15
7.14		Ankunft	Berlin Fried. Bahnhof	Abfahrt		5.49
	10.00	Abflug	Berlin	Anflug	4.30	
	11.30	Anflug	Hannover	Abflug	3.00	
	12.00	Abflug	Hannover	Anflug	2.30	
	1.35	Anflug	Amsterdam	Abflug	11.35	
	2.05	Abflug	Amsterdam	Anflug	11.05	
	4.30	Anflug	London	Abflug;	8.00	

Auskünfte: Deutschland: Hamburg-Amerika-Linie, Berlin W 8, Unter den Linden 8; Deruluft, Berlin NW 7, Sommerstraße 4. Union d. S. S. R.: Deruluft, Moskau, Neglinnyj Projesd 10. Qu. 8a. Stadtbureau

'31 January. My departure was now irrevocably fixed for the 1st by the seat reservation that I had made on the 30th. But I still needed to get customs clearance for my luggage.'
Walter Benjamin, *Moscow Diary*

doubt were, but in the prospect of seeing Lissitzky's theories being taken up by the young people of the Komsomol, or the over-ripe bourgeois theatre culture, together with the destructive forces developing inside it, being seized upon by a Russian public thirsty for knowledge and eager to learn, and turned into revolutionary practice. In a sense it was an escape from a world they felt was dying to a world they hoped would make them whole again.

But what a narrow circle they moved in! They visited cities that resembled their own; they visited studios no different from their own (except perhaps shabbier); some of the fellow intellectuals and artists they called on were those whom they had already met at exhibitions in Berlin, Munich or Paris, or who had been in exile there at the time. The new government, the young ministers, were of their own generation, their own kind, and anything that might be considered disagreeable could still quite properly be attributed to the inexperience of the new young republic, for which their sympathies were wholly engaged. You only have to read the jottings made by

Benjamin, Toller or Oskar Maria Graf: with what childlike naïvety they responded to every impression, found sensational what they would not even have noticed anywhere else. And they could use the kind of language that was still current here too; everything could still be communicated in readily understood terms that did not require special interpretation. How else during these years could Soviet Russian theatre, Russian films, or the exhibitions in Cologne and Hanover have found a public in the West, and such an enthusiastic one, at that? The revolutionary art and culture tapped into the critical bourgeois intelligentsia's sphere of experience, but then opened up new vistas in the shape of the grandiose experimental laboratory represented by Petrograd/Leningrad and Moscow. At that time it was not so much Soviet Russia that resisted contact, but rather the bourgeois powers, because they felt threatened.

And yet the territory that the left-wing intellectuals chose to explore fell far short of encompassing that whole laboratory of radical social change, let alone the immeasurably vast areas that were being collectivized and industrialized. The imagined synthesis of hand and head, art and revolution, individual and masses, as it was actually realized and experienced, briefly, in the streets and the workers' clubs of Leningrad and Moscow, was no more than a transitional phenomenon, soon to be swallowed up by far more powerful forces in a new constellation. Moscow in the 1920s was a kind of refuge for the bad conscience of the left-bourgeois intelligentsia, who witnessed here all that they had failed to achieve in their own countries, but who, on returning home full of good intentions, found it impossible to apply the lessons they had learned.

The tracks that cross in the *Moscow Diary* diverge thereafter. Asja saw Benjamin again in Berlin two years later, but by 1935, when Gnedin was posted to the Soviet Embassy there for another year, Benjamin had already been forced into exile. (It is, however, possible that Gnedin met Benjamin's sister-in-law, Hilde Benjamin, who was a legal adviser to the Soviet trading organization up to 1939 and was later to become Minister of Justice in the GDR.)

The tracks do converge once more, however, albeit figuratively and in an unexpectedly brutal fashion. During the first year after Benjamin's return to Berlin, Gnedin in his capacity as rapporteur attended the first great show trial, the so-called Shakhty affair, held in 1928 in the Hall of Columns of the House of Unions. Similarly he witnessed at first hand the show trials against the so-called industry

party and against the Mensheviks. (As it happens, Benjamin had met Sofiya Krylenko, the sister of one of the state prosecutors involved in these trials, first in Capri in 1924 and then again in Moscow.) In 1937 and 1938 Gnedin watched the two big show trials in which Radek and Bukharin were the chief accused.

Catastrophe overtook Gnedin on 2 May 1939, at the very place where he had arranged to meet Benjamin in January 1927 but had not turned up: in the Morozov mansion, the home of Eisenstein's Proletkult Theatre. On the evening of 2 May Gnedin was there at the invitation of the Japanese *chargé d'affaires* in Moscow. Recalled by telephone, he made his way back to the People's Commissariat for Foreign Affairs – straight into an interrogation directed by Molotov, Beria and Malenkov. At issue was the imminent dismissal of Maksim Litvinov, the Foreign Minister and a strong advocate of the anti-fascist foreign policy directed against Hitler. Litvinov, who to make matters worse was a Jew, had become a liability – and on 21 August, barely four months later, the Hitler-Stalin pact was signed in Moscow. Gnedin was arrested on 10 May 1939; from his place of work in the Narkomindel he needed only to cross the road. As Benjamin had noted in his diary entry for 19 January 1927: 'On my way to Gnedin's and back I passed the Cheka building. There is always a soldier with a fixed bayonet patrolling up and down in front of it.'

With the conclusion of the pact between the Nazis and Stalin, the last dams also burst in France, where Benjamin had taken refuge. Anti-fascists were interned in their thousands. At roughly the same time – February 1940 – German communists and anti-Nazis who had fled to the supposed safety of the Soviet Union, only to be arrested there on the most far-fetched of charges, were being held in Soviet camps prior to deportation. Among them was Carola Neher, who had played the role of Polly in Brecht's *Threepenny Opera* and whom Benjamin knew well. She died while still in Soviet captivity; the others were transported from the Soviet camps in August 1940 to German concentration camps – the writer Margarete Buber-Neumann, for example, was taken to Ravensbrück.

With Asja Lacis already deported to Kazakhstan, and Yevgeny Gnedin a prisoner in the Lubyanka pending the bizarre confessions that would be extracted from him, the refugee Walter Benjamin left Marseilles on the last stage of his bid for safety. On 27 September 1940, under the threat of being betrayed to the Gestapo, he took his own life near Port Bou, on the Spanish border.

The terrain from which Benjamin had set out on his journey in the 1920s, and which he had had the courage to explore in all directions, was being rolled up from two sides – in a frontal attack and in full view by the National Socialists, and covertly by Stalin's henchmen, by means of the self-accusations they forced out of their victims. Although Moscow in the 1930s continued to be a place to which refugees fled for safety, this does not alter the fact that it had ceased to be a haven for visions of a better world. Moscow may subsequently have become the capital of an empire on which the sun never sets, but it long ago forfeited its claim to be the sanctuary for the 'humiliated and insulted'. The flow of people is if anything in the opposite direction, and takes place under conditions that are the opposite of what they once were. It is strange but also unsurprising that the former refugees cannot understand the present-day ones. It seems almost impossible to find a common denominator or a common language for the movement of refugees then and now. Perhaps it was in Arthur Koestler, himself a fugitive who shared an iron ration of morphine with Benjamin, that the four characters whose fates I have outlined here found their author. The 'darkness at noon', forcing the eye accustomed to light to adjust to the dark, was evidently not dark enough or long enough for the full truth to be revealed. Benjamin's image of the Angelus Novus, on the other hand, precludes any attempt to talk in terms of an aberration, a series of events that are only temporary interruptions of normality.

> He has turned his face towards the past. Where *we* think we are seeing a chain of events, *he* sees one single catastrophe, which endlessly heaps ruins upon ruins and hurls them before his feet. He would like to linger, to awaken the dead and put together again what has been shattered. But a violent wind blowing from Paradise snatches at his wings, so powerfully that the angel can no longer fold them. This tempest drives him inexorably towards the future, to which his back is turned, while the heap of ruins before him mounts up to the heavens. What we call progress is nothing other than this tempest.

Conclusion

Ideally one would like to be a stranger, knowing nothing of Moscow and just jotting down one's impressions exactly as they strike the retina. That kind of ignorance can sometimes be an advantage, but it is one that I do not have. I wrote this book in the early 1980s. That was a long time ago, and since then Moscow has changed almost beyond recognition.

At that time I wrote about the power of the eye, and about Moscow as a place where the constant reproduction of views of the city prevents you from seeing then afresh. And I wrote about starting with the surface layer; the city as a geological deposit and a quarry, and the ambivalence of modernization and of ground clearance. Every era offers its own specific insights. *Moscow* was written at the moment when late socialism had reached its point of greatest maturity, when the stagnation of the system was driving the most sensitive individuals to madness or suicide, when, although the rituals of power were still intact and their continuation was not in doubt, there was a sense that it was only their own momentum that kept them going. Television viewers listening to Brezhnev giving a speech knew that he could no longer tell one page from another. It was a time when people were holding their breaths, living with a sense of unreality, listening to a distant rumbling. A time of melancholy at parting from a *belle époque*. A moment marked by a new mood of toleration that was almost indistinguishable from powerlessness, and by a climate of apathy and fatalism that greatly assisted the course of history. It is that critical moment that Hegel, himself a fatalist and the apologist of time which comes at its own

326

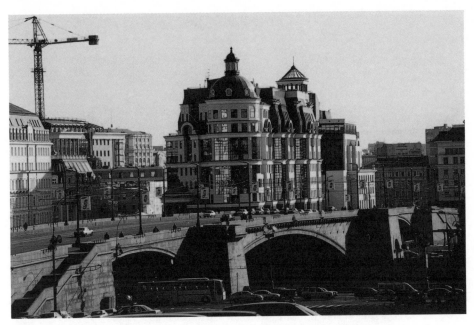

View of commercial buildings of the 1990s and 2000s opposite the Kremlin (around the Baltschug Kempinski hotel), 2004.

pace and cannot be hastened, so admirably characterizes in the preface to his *Philosophy of Right*: 'When philosophy paints its grey on grey, then a mode of life has grown old, and that grey on grey cannot make it young again but can merely understand it; only with the coming of dusk can Minerva's owl begin to fly.'

A mode of life had indeed grown old. Now it lay there, all its tempestuous, rebellious blood long since slowed and thickened. Lives had run their course, the revolutionaries had become Party functionaries and the functionaries pensioners, the heroes of the Civil War were figures of legend, and the soldiers of the Great Patriotic War were invalids and veterans whose achievement no one questioned. It was a time of clarity, when all the ideological battles had been fought out long ago and everything had reached its conclusion. A dull, heavy time, when the rebels of the 1950s and '60s had grown prematurely old and the younger generation had taken to drink or become martyrs, when the Voice of America or Radio Liberty news could be heard blaring out through open windows. When for a foreigner in the city the sale and exchange of much-coveted jeans in public lavatories was a regular part of life; when you would queue

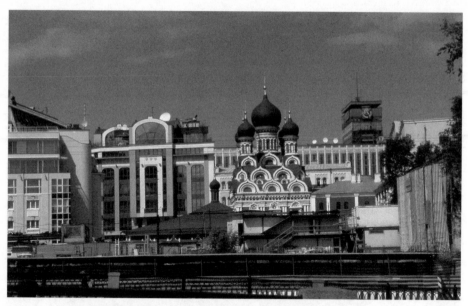

The Zamoskvoreche district with new and old buildings, 2000s.

for five hours at the Central Telegraph Office in Gorky Street waiting for your telephone call home to be connected; when you were stopped and checked on the train or at a station because the 'organs' of the law had nothing to do but monitor the movements of foreigners. A time of death by suffocation, and of lesser or greater escapes – to a concert at the Conservatory, to the wide-open spaces of Karelia, or into conversations on every conceivable subject in people's kitchens; a time of standing in queues and of the remorseless slowing down of every movement, every sign of life.

Because life stood still and the way to the outside world was barred, another place of escape, for countless people and in an extraordinary variety of ways, was the past, where one could encounter not only the magnificent, celebrated figures of Russian culture, but also the unpersons who had been erased from the encyclopædias and history books. Moreover, in the early 1980s, despite the vast number of violent deaths that the twentieth century had known, Moscow was still full of people in whom the past lived on. This was time brought to a halt, to a standstill; a time of clarity of the kind that occurs only when all battles have been fought and all victories savoured to the full, when the victors have grown weary and the vanquished are waiting only for the end. Quiet, stillness, the silence

The towers of Gazprom,
late 1990s.

of the grave. A time in which the batting of an eyelash or the flutter of a butterfly's wing can put an end to an epoch. And the epoch did indeed end. Since then, people's predominant experience has been that of time furiously accelerated – and, one is tempted to say, finding its natural channel once again – together with the rediscovery of time as an adventure: in a single second things can happen that would normally take a decade, in a single moment one phase of history is over and another begins.

My second chapter described the Stalinist high-rise buildings in the 'wedding-cake' style, which are such prominent accents in the cityscape of Moscow and which were intended to provide stability and recognizable landmarks for ever, to remain as fixed, defining features far beyond the foreseeable future. But then came events that could never have been conceived of in the early 1980s, and that brought about the fall of that silhouette, the most lasting impression we retain of a city. One day the Stalinist façades were suddenly

The Red Square with the circus fair pavilions, late 1990s.

bathed in light – towers, windows, all the ornamentation and ostentation were blanked out, and only the outlines remained. Overnight, America had arrived in Moscow, the wedding-cake buildings had become art deco, with a touch of the Chrysler Building and Radio City. Advertising appeared on the high-rise buildings, the insignia of commerce on the cathedrals of knowledge and power. Desecration. The dispelling of an aura. Now the whole stone landscape was set in motion. The entire city was given a new *mise-en-scène* and a new orchestration. The surviving churches and monasteries are becoming resplendent again, newly coated with gold leaf or painted in deep blue with golden stars. Often in the most inconspicuous places. In remote little streets and in the back courtyards of prefabricated concrete buildings, hidden gems sparkle once more. A whole city that had been lost in the general greyness re-enters our horizons. Restored and highly coloured buildings – banks, commercial buildings, restaurants, villas, blocks of flats, grammar schools. The city is stretching itself, testing out how far it can go, how strong it is. The drab stage-set that we had known for decades suddenly has the vibrancy of El Lissitzky's 'Beat the Whites with the Red Wedge'.

There are many new features: the glass tower at the back of the Moscow Mayoralty, the McDonald's building on the corner of

The Hotel Moskva
(1930s–1950s) on
Maneaya Square
near the Kremlin,
which was demolished
in 2004.

Tverskaya, the Meyerhold Cultural Centre, hotel buildings on
Stoleshnikov, the cluster of new and refurbished commercial and
office buildings around the Baltschug Kempinski Hotel, and also,
further from the centre, the glass towers of Gazprom. The large
vacant tracts of land that no one had bothered about for decades are
awaking from their slumber. Suddenly they are valuable, people
fight over them, they have come to life, they attract money and shine
with the promise of gold. Moscow's period of entrepreneurial
expansion around 1900, which in the later years of socialism could
only be seen in one's imagination, now has a successor, a new, real
period of growth and enterprise. The building boom of 1900–14 was
followed by the new boom of the 1990s. It has swept almost simulta-
neously across the whole city. Postmodernism has taken the place
both of the *style moderne*, as art nouveau is called in Russia, and of
the classical Modernism of the 1930s. There are things to be seen here
and now, not just in beautiful photograph collections of the turn of

The Cathedral of Christ the Saviour, 2002.

the century or in historical exhibitions. No one expected this. Is it good or bad? The city is testing its strength, and will find its style in due course. For Moscow the hectic beginning of the twentieth century, which Aristarkh Lentulov conveyed through the wild confusion of lines and colours in his avant-garde paintings, has been matched by an equally hectic end.

'A *mise-en-scène* for the moment. The most turbulent times leave the fewest traces behind. Decor, not rebuilding.' When I wrote this, I was referring to the feverish dreams of revolutionary architects and city planners after 1917. But it is also applicable to the first years of *perestroika* after 1985. Like the period of storm and stress immediately following the Revolution, *perestroika* was a phenomenon built on ideas and words. Its battles were fought largely through the radio and television stations and the newspapers, which started up in their dozens and folded in their dozens. Other than at meetings and demonstrations it had no physical presence. *Perestroika* created no institutions and no buildings, neither parliaments nor monuments to victims, nor banks. Revolutions do not build; if anything they demolish, or take possession of what is already there. And yet in those years, when the spoken and written word was savouring its new-found freedom, Moscow was newly encoded. Manège Square, that dauntingly vast expanse on which the columns of tanks and marchers formed up before entering Red Square, became a place of assembly, and the entrance to Shchusev's Hotel Moskva became a speaker's platform. Red Square, as a kind of forecourt to the Forbidden City, did not quite become a marketplace, but it did lose its aura of sanctity. The Revolution and the era of *perestroika* were times for limbering-up exercises, for experiments and flights of the imagination, for paper architecture, while real building remained in the hands of the professionals with their indispensable skills. After 1917 there was work for the graduates of the St Petersburg Academy of Arts who eventually went on to build the Moscow of Stalin's General Plan of 1935, and it was the same after 1991 when the Mosproyekt people were commissioned to carry out Mayor Yuri Luzhkov's grand projects.

The seventh chapter tells how the Moskva Swimming Pool came to occupy the site of the abortive Palace of Soviets and the demolished Cathedral of Christ the Saviour. The swimming pool is no longer there. In its place, now, is the new Cathedral of Christ the Saviour, looking as though it had always been there. Massive, a

strong element on the skyline, holding its own against the Kremlin complex, and standing in a clear relationship to the 'House on the Embankment' diagonally opposite. A cathedral of this size, built in less than two years, gives some idea of the acceleration of time in post-Soviet Moscow. When I wrote about the empty space that had been turned into the Moskva Swimming Pool it was still a big secret – like a blank area on the map – that the cathedral had once been there and that in the 1930s the Palace of Soviets was to have been built in its place as a focal structure, 470 metres high, in the very centre of Moscow. Now there is no secrecy about it any more. The dome gleams through the dullest Moscow autumn or spring day, and on sunny days it shines with an almost brazen splendour, as if it were, covertly, the true centre of the city. It is as if those who favoured a monument to the Russia that is now dead – as a warning for the future – had had their reservations simply brushed aside. Instead, the resurrected Russia was to be represented here. And so it is. But the vision of the tallest tower in the world, the ancient vision of Babel, has not gone away. This time, at least, it is to become a reality: the Tower of Russia that is to be built in the planned new 'City' district in Krasnaya Presnya.

Speaking of the railway stations, I wrote of 'Moscow as the centre of the empire. Different times and cultures coalesce. The station and the railway viewed in terms of cultural history.' But one thing is now clear: in Russia too the railway age is nearing its end. Hardly anyone now enters the city through this gateway. Take the Belorussian Station, once the point of arrival for all of us coming from the West – who arrives there now? Travel has become expensive for ordinary Russians, and the queues in front of the ticket windows have vanished. You can get a ticket at any time, without ordering it in advance. But the new breed of affluent Russians do not have the time to travel by rail. Time is money. They fly everywhere. The currents of movement have changed direction. The streams of travellers now head for distant destinations – Cyprus, Antalya, Miami, Abu Dhabi, the United Emirates. If ever the railways cease to operate, then the integrity of the country will be in danger. On the other hand plans are afoot to build a motorway from Moscow to St Petersburg.

On the subject of bookshops, I noted that in the final years of socialism, second-hand bookshops were like nature reserves for endangered species, refuges for titles that were forbidden and no longer printed; places where you could find things of true signifi-

cance, not merely satisfy a collector's hunger for first editions. Now that Russia is a free country and anything can be said or printed, second-hand bookshops are out of fashion, or rather they can at last become what they are supposed to be: second-hand or antiquarian bookshops, plain and simple. People in general are drawn to the ordinary bookshops or bookstalls, where you can get everything. There has been almost an orgy of new editions and translations. Spengler, Freud, Nietzsche, Rozanov, the once-proscribed books by Solzhenitsyn, the manifestos written by Sakharov. The demand for the living word, the absolutely up-to-the-moment utterance, means that the book market is possibly the only market in post-Soviet Russia that really works. Newspapers and periodicals processing the flood of untrammelled new ideas have barely been able to keep up.

Yet despite all this, Russia is a country that has lost its devotion to books. It sits in front of the television set, which it sees as purveying images of the present that are more attractive and gripping than the heroes and anti-heroes of the Russian classics. The irruption of reality has freed the country from its imprisonment in literature. There is much complaining about the spread of trash, pornography and tabloid journalism. But there is no reason why Russia should be spared any of the blessings of mass culture. So today the second-hand bookshops are frequented only by lovers of antiquarian books. Many have closed down, or have been driven out of their former central situations, on the Arbat, around the Metropol and along Tverskaya, to the locations where antiques and antiquarian bookshops are always to be found in big cities: in side-streets and at hidden addresses known only to the initiated. For a long time the Moscow antiquarian bookshops were rather like journals of the luxuries and intellectual fashions of pre-Revolutionary times. Now Moscow has its new journals and fashions, and the salons where they are produced. The Moscow of the new Russia can join in the bidding at Sotheby's, send its children to Swiss boarding-schools and advertise in *Le Figaro* for tutors and governesses.

The strong man of the post-Soviet world is different from before. The iconic images of Lenin have been ousted by Arnold Schwarzenegger. The badges of the new lifestyle also include jogging, Kettler exercise machines and the Golden Gym from America. The manager – indeed the new Russian in general – is subject to stress and needs time-management skills. He does not drink, he is stone-cold sober when he concludes his business deals. Russian

335

capitalism is virile, muscular, fit, quick on its feet. In the early days it liked to be seen in reflective sunglasses, track-suit and Reeboks. It has an athletic spring in its step.

Moscow once again has directories, and now Yellow Pages too. Back in the 1980s I wrote: '*Vsya Moskva*. Directories as historical documents. The Revolution reflected in the directory, unpersons who became persons, and persons who became unpersons. The body attached to the freely soaring intellect and the interior decor of power. Not to mention advertising, restaurants, hotels, salons.' Yes, that was all correctly observed. And the disappearance of the Moscow directory in 1937 marked the definitive victory of the all-powerful state over society. Conversely, the following is also true: for some time now Moscow has had a directory again, and it is once again becoming transparent to itself, which is the basic prerequisite for unobstructed contacts and communication. You no longer have to hunt for the unpersons, their names are in every reference work and encyclopædia. And people who have ceased to be of any significance are now simply insignificant, no more and no less. When you have found their telephone number, you can ring them.

I wrote, back then, about the Kremlin and Red Square complex. At one time Red Square was a thoroughfare for trams, buses and cars. Before it became hallowed ground it used to have street cafés. Now the citizens have reclaimed the domain of the 'Forbidden City'. Now we know rather more about the inner life of power, and about the holders of power as people and not just as officials. Red Square, which had been turned into Holy Square, has once again become a square for people. There are concerts with Pavarotti or Monserrat Caballé; Mick Jagger and laser shows; a Konchalovsky blend of Russian folklore and Hollywood. A circus festival has been held within earshot of the Lenin Mausoleum. It is incredible to hear the sharp snap of Coca-Cola cans being opened in an area where people used to talk in hushed tones.

I also wrote: 'Inscriptions on a black background. The labelling of the city, emblems of power in a code for the passer-by to decipher.' Every revolution brings a mass of name changes with it. Organizations and institutions that are not swept away survive under new names. Forces that have already formed 'in the womb of society' suddenly crystallize into a concept and acquire a name. What had been informal becomes formal, and takes on actual form. The industry that produces brass plates must have enjoyed a real

boom in post-Soviet Moscow. The need to rename things was immense. Everything had to be new, at least in name. Everything of importance – organizations, institutions, directorates and representative bodies – has been reassembled to form a new universe. Moscow has been given a new, post-Soviet corporate design. Moscow is being newly encoded.

The Conservatory will presumably survive the new Russian capitalism, as it has survived so much else. And yet something has happened there that never happened before: the *nouveau riche* audience, eager to attend a concert with Claudio Abbado as guest conductor, neglected to switch off its mobile phones. It will be some time before the new class acquires a respect for beauty, truth and excellence and puts an end to the orgies of bleeps and ringtones. But here, as elsewhere, the status of the classics has been undermined once and for all. There is still an interested minority, but the masses are attracted to MTV, discos and videos, while the *babushkas* enjoy the Soviet-style open-air shows and folk music.

And what of the proletarian stronghold? By the 1980s Moscow had long ceased to be the city of workers and had become one of bureaucrats and officials. But now even the working-class myths are under attack. The statues of the 'humiliated and insulted' and the monuments to the barricades of 1905 are still standing around, but as pieces of folklore rather than embodiments of the modern Prometheus. The representative figure now is not the worker but the dealer; what counts is not manual labour but brainwork. Money has supplanted the concept of value-creating physical work. People's longing for something solid and reliable which capitalism is unable to provide shows itself in a nostalgia for the 'work of honest hands', for sweat rather than compound interest. So it is rather telling that the Tower of Russia is to be built in the very district of Moscow that has the strongest working-class traditions.

Museums are slow and ponderous, they need time to rearrange and reorder the objects of memory. While the country was being swept by an onslaught of revelations and freshly published archive materials, the museums were firm and united in holding the line. For the moment, at any rate. But in fact a great deal was going on. A new hierarchy of what is significant was being formed. Values were being reassessed and history rewritten. The 'small truth' of detail was gaining ground at the expense of the 'great truth'. The museums were bursting under the pressure of newly released documents and

archives. The deposited material overwhelmed all resistance. The museums capitulated in the face of such a volume of material: they could only display and describe. Any organizational rationale was swamped, so that what has been rather randomly revealed includes both episodes of cruelty and actions that affirm the honour and dignity of human beings.

On another peculiarity of late Soviet Moscow I wrote: 'Intermediate worlds. What kind of "culture" comes into being at the points of contact between the Western and the Soviet modes of life? Hybrid forms on the border-lines: hotels, hard currency shops, communities of foreigners, the ambivalence of self-relativization.' Nowadays the opposition of 'them' and 'us', of internal and external, of Moscow and the rest of the world, is dissolving. As a foreigner you no longer stand out in this city which keeps up with the latest fashions and has taken on the laid-back manner of people who set the tone. A privilege at last: being able to become invisible. By now many Muscovites have experienced the outside world – Paris, Rome, New York, or perhaps only Helsinki or Berlin. They know how things work or don't work there. For quite some time now there has been a preponderance of foreign makes of cars on the streets. People expect petrol pumps and car washes to work. The sense of wonder has been lost. The amazement factor is disappearing. The Muscovite is 'cool', the children are 'kids' who dress in the 'colours of Benetton'. The fax and email revolution has made everyone equal. Now the great divide is between those who know about such things and those to whom they are a mystery. There are no foreign currency stores any more, but *bureaux de change* on every corner and in every moderately large shop. One notices how easy it is now to get money and to spend it. But what is equally obvious is the collapse of everything when the flow of money is interrupted – as it was on 17 August 1998, which was as significant a turning-point for post-Soviet Moscow as the shelling of the White House parliament building in the autumn of 1993. Moscow has caught up with other great world cities and acquired everything that goes with that: the self-importance of a cosmopolitan city, the blasé attitude of a populace confident of its city's status as one of the focal points of the world.

'Gathering evidence. Starting from buildings with a history; the points of intersection between individual lives and the life-story of the city. Dealing selectively with history: unmentioned dramas and retouchings.' What was once hidden and forbidden is now in all the

newspapers, magazines and scholarly articles. In the House on the Embankment, once known as Government House and in 1937 the waiting-room for the candidates for execution, a small museum has been created. Monuments have been moved from their sites and safely disposed of in historical parks. This was sometimes done as a symbolic public act – like the removal of the statue of Dzerzhinsky by a Krupp crane from in front of the Lubyanka. But overall the Russians' relationship with the past has become more relaxed. Dealing with today, coping with life, is more important than thinking about yesterday, which after all cannot be changed. Coping with the present is the first priority, coming to terms with the past is a luxury reserved for those who have already established a firm footing for themselves in life.

I devoted a chapter to Zamoskvoreche. 'A lively working-class district rarely visited by outsiders. A place of artistic projection and experience for Polenov and Lentulov. Churches, factories, blocks of flats, a different pace of life.' For a long time this district tended to be overlooked, and it survived for that very reason. Russian capital, some 70 per cent of which is concentrated in Moscow, has an eye for central locations and has recently turned its attention to this district, which is so close to the Kremlin. Almost at a stroke, within an astonishingly short time, whole streets and neighbourhoods have been renovated. The classical-style villas and town houses of the 1830s have been mostly taken over by banks, insurance companies, sports shops, bars and restaurants. One can only suspect that these buildings have paid a high price for being rescued in this way, and that their elegant interiors and decorative tiles and banisters have been lost for ever. Here the urge to return to the centre is at its most obvious. Affluent Moscow, which in the 1960s and '70s was eager to move to the districts of new building on the city's margins, is now returning to the centre. A way of life is dying: the *kommunalka*, the communal apartment block. Mirror glass has been set in the huge windows so that no one can look in. There are bodyguards everywhere, automatic garage doors and cameras above the gates. The privatization of what used to be the most intensively used urban space is proceeding apace.

As for the metro, the main effect of the post-Soviet period has been to demote it from being the preferred form of transport. Anyone who can afford to do so now goes by car. The overcrowding that used to occur in the metro has been transferred to the roads. The

rush hour jostling that used to take place, body to body, in the passages of the metro is now to be seen on the Garden Ring, Tverskaya and the main thoroughfares: bumper to bumper, moving at walking pace, four or five abreast, with drivers who lose it and overtake on the wrong side of the road. People have had enough of being forced into close proximity. In the eyes of many Muscovites the metro means unpleasant and unwanted contact, an intrusion into their personal space that they are no longer prepared to accept. As a result there is more room in the metro; the unremitting rhythm of working hours and leisure time has become more relaxed. Also, because the shops now almost always carry huge stocks of everything, there is no need to go shopping all the time. There is also no need for two to three million people a day to come streaming into Moscow from the provinces, from near and far, now that the same goods can be obtained in their own regions. Whereas Moscow always used to be bursting with people, all pushing and shoving each other, now it suddenly feels less crowded. There is empty space between people. This is an unheard-of luxury and makes moving around in public places here just the same as in the major Western cities. The cost of a metro ticket, which was once 5 kopeks and is now around 1,500 roubles, is another contributory factor. The days of travelling on the metro to little purpose and at minimal cost are over.

In the 1980s I wrote: 'What can be learned from inscriptions on tombs: the hierarchy of the dead, the selectivity of eternal rest, the intertwining of generations, and significant dates of death. Monasteries and convents as outposts.' The churches and monasteries have been returned to their priests and monks. The cemeteries in which Russia's great figures lie buried have gained in importance. But, altogether, dying has become a major problem for the average citizen. There is not enough burial space, and the providers of the various elements of a funeral charge high prices. The finest gravestones are now those of the new Russians. Studying the graves, you can see that in the cemeteries at least a new age of entrepreneurs has decidedly arrived.

In my chapter tracing the footsteps of Walter Benjamin, I described Benjamin, Reich, Lacis and Gnedin as four characters in search of an author. 'Moscow as a place of refuge. The Berlin-Moscow axis in the 1920s, and the axis in 1939. The escape route barred.' In Moscow too they now know who Walter Benjamin was. His *Moscow Diary* has appeared in Russian. People are becoming

interested in Benjamin's contemporaries and the Moscow of those days. But a new intellectual to-ing and fro-ing has started. Umberto Eco, Peter Stein, Derrida, Robert Wilson – they have all visited Moscow on at least one occasion. There are cafés again, and that buzz in the lobbies of the big hotels which is a sign of belonging to the wider world. Moscow has become one of the main destinations on the international conference circuit. And it is to Moscow's credit that the conferences are taken for granted as part of the life of the city. Moscow has latched on to the intellectual fashions and what are called 'discourses'. It speaks the academic pidgin English which is the true lingua franca of the beginning of the twenty-first century, or sometimes a form of American that is more American than that spoken by the Americans themselves.

In the chapters of *Moscow* there is no mention of many things that simply could not be conceived of or foreseen in the 1980s, however knowledgeable or imaginative one was: for instance, the transformation of the great sports arenas into gigantic bazaars, the magic of unhampered free speech, the computer kids, or the tanks in the city centre. Or the fact that in the Moscow of the new century there are halls and stairwells that are kept clean and do not stink of urine, and outer doors that can be locked, indicating that the house once again has an owner, instead of everything belonging to everyone, in other words to no one. The residents of the new Moscow are 'cool', that is to say calm, circumspect, not inclined to hysteria or panic. Moscow is continuing to write the text 'I was, I am, I will be'. If all goes well, the next chapter of that text will be about everyday sensations, the final victory of the banal over the sublime, and the transformation of Moscow into an ordinary, normal metropolis.

In Lieu of a Bibliography

The following pages are a compilation of significant historic buildings in Moscow which, taken together, represent something like the original text of the city. I have not aimed at completeness. The main emphasis is on Moscow as a city of the late nineteenth and early 20th centuries, and the 1920s and '30s. The arrangement is chronological. The details given are normally the building, its address and its architect(s).

THE SOURCES FOR THIS COMPILATION INCLUDE:

Moscow Encyclopædia (Moscow, 1980) (in Russian)

Kunstdenkmäler in der Sowjetunion. Moskau und Umgebung [Art and Architecture in the Soviet Union. Moscow and its Surroundings], (Moscow and Leipzig, 1978)

Moscow: Architectural Monuments, 1830–1910 (Moscow, 1977), (in Russian)

S. O. Chan-Magomedov, *Pioniere der sowjetischen Architektur* (Dresden, 1983), published in English as S. O. Khan-Magomedov, *Pioneers of Soviet Architecture* (New York, 1987)

Catherine Cooke ed., *Russian Avant-Garde Art and Architecture* (London, 1983)

BUILDINGS UP TO THE BEGINNING OF THE SEVENTEENTH CENTURY

Cathedral of the Assumption (Uspensky sobor), Kremlin; 1475–9

Cathedral of the Annunciation (Blagoveshchensky sobor), Kremlin; 1484–9

Church of the Deposition of the Robe (Tserkov Rizpolozheniya), Kremlin; 1484–5

Faceted Palace (Granovitaya palata), Kremlin; 1487–91

Church of St Trifon Naprudny (Tserkov Trifona v Naprudnom), Trifonovskaya ulitsa 38; 1492

Cathedral of the Archangel (Arkhangelsky sobor), Kremlin; 1505–8

Bell-Tower of Ivan the Great (Kolokolnya Ivana Velikogo), Kremlin; 1505–8

Church of the Conception of St Anne on the Corner (Tserkov Zachatiya Anny chto v uglu), Moskvoretskaya naberezhnaya 3; 1530

Church of the Ascension at Kolomenskoe (Tserkov Vozneseniya v sele Kolomenskom); 1532

Cathedral of the Intercession on the Moat, known as St Basil's Cathedral (Sobor Pokrova chto na rvu), Krasnaya ploshchad; 1555–61

Church of the Trinity at Khoroshevo (Troitskaya tserkov v sele Khorosheve), Kamaryshevskaya naberezhnaya 15; 1598

Danilov Monastery (Danilovsky monastyr), Danilovsky val

New Saviour Monastery (Novospassky monastyr), Krestyanskaya ploshchad

Andronikov Monastery (Andronikov monastyr), Pryamikova ploshchad 10

New Maidens' Convent (Novodevichy monastyr), Novodevichy proezd 1

Simonov Monastery (Simonovsky monastyr), Vostochnaya ulitsa 1/3

Donskoy Monastery (Donskoy monastyr), Donskaya ploshchad 1

BUILDINGS OF THE SEVENTEENTH CENTURY

Church of the Intercession at Medvedkovo (Tserkov Pokrova v Medvedkove), Kolskaya ulitsa; 1640

Church of the Intercession at Rubtsovo (Tserkov Pokrova v Rubtsove), Bakuninskaya ulitsa 83b; 1619–26

Church of the Assumption in Pechatniki (Tserkov Uspeniya v Pechatnikakh), ulitsa Sretenka 3; 1695

Refectory Church of St Sergius of Radonezh in the Upper Monastery of St Peter (Trapeznaya tserkov Sergiya Radonezhskogo), ulitsa Petrovka 28; c. 1690

Church of the Trinity in Troitskoe-Lykovo (Tserkov Troitsy v Troitskom-Lykove), Lykovskaya 3-ya ulitsa; 1698–1703

Church of the Nativity of the Virgin in Putinki (Tserkov Rozhdestva Bogoroditsy v Putinkakh), ulitsa Chekhova 4; 1649–52

Church of the Intercession at Fili (Tserkov Pokrova v Filyakh), Novozavodskaya ulitsa 47; 1690–94

Palace of the Boyar Troekurov (Palaty boyarina Troekurova), Georgievsky pereulok 4; late seventeenth century

Church of the Trinity in Nikitniki (Tserkov Troitsy v Nikitnikakh), Nikitnikov pereulok 3; 1628–51

Church of the Presentation in Barashi (Tserkov Vvedeniya v Barashakh), Barashevsky pereulok 8; 1688–1701

Church of St Nicholas in Bersenevka (Tserkov Nikoly na Bersenevke) and Chambers of Averky Kirillov (Palaty Averkiya Kirillova), Bersenevskaya naberezhnaya 20 and 22; 1650–77

Church of the Resurrection in Kadashi (Tserkov Voskreseniya v Kadashakh), 2-oy Kadashevsky pereulok 7/2; 1657

Church of St Gregory of Neocaesarea (Tserkov Grigoriya Neokesariskogo), ulitsa Bolshaya Polyanka; 1662–9

Church of St Nicholas in Khamovniki (Tserkov Nikoly v Khamovnikakh), ulitsa Timura Frunze 1; 1679–90

Church of the Assumption in Veshnyaki (Tserkov Uspeniya v Veshnyakakh), ulitsa Yunosty 2; 1644–5

Church of Sts Boris and Gleb in Ziuzino (Tserkov Borisa i Gleba v Ziuzine), Perekopskaya ulitsa9; 1688–1704

BUILDINGS OF THE EIGHTEENTH CENTURY AND FIRST HALF OF THE NINETEENTH CENTURY

Baryshnikov Mansion (Dom Baryshnikova), ulitsa Kirova 42; architect M. F. Kazakov; 1797–1802

Menshikov Tower (Menshikova bashnya), Telegrafny pereulok 15a; architect I. P. Zarudny; 1704–7

N. F. Apraksin Mansion (Dom Apraksina), ulitsa Chernyshevskogo 22; architect unknown; 1766–8

Little Theatre (Maly Teatr). ploshchad Sverdlova 1/6; architect A. F. Elkinsky, O. I. Bove (Beauvais); 1821–4

Large Theatre (Bolshoy Teatr), ploshchad Sverdlova 2; architect O. I. Bove (Beauvais), A. A. Mikhailov; 1825 and 1855–6

Club of the Nobility (Dom Blagorodnogo sobraniya), Pushkinskaya ulitsa 1/6; architect M. F. Kazakov; mid-eighteenth century

Manège (Manezh), ploshchad 50-letiya Oktyabrya 1/9; architect A. A. Betancourt; 1827

University (Universitet), prospekt Marxa; architect M. F. Kazakov, 1782–4, and D. Gilardi, 1817–19

Pashkov House (Dom Pashkova),

prospekt Marxa 26; architect V. I. Bazhenov; 1784–6

Lunin house (Dom Lunina), Suvorovsky bulvar 12a; architect D. I. Gilardi; 1818–22

Gagarin house (Dom Gagarina), ulitsa Vorovskogo 25a; architect D. Gilardi; 1820

Demidov mansion (Dom Demidova), Gorokhovsky pereulok 4; architect M. F. Kazakov; 1779–91

Church of St John the Warrior (Tserkov Ivana Voina), ulitsa Dimitrova 46; architect I. P. Zarudny (?); 1709–17

Church of the Consolation of All Sorrows (Tserkov Bogomateri Vsekh Skorbyashchikh Radosti), ulitsa Bolshaya Ordynka 20; architect V. I. Bazhenov, 1783–91, and O. I. Bove (Beauvais), 1828–33

The Lopukhins' house (Dom Lopukhinykh), Kropotkinskaya ulitsa 11; architect A. G. Grigorev; 1817–22

Khrushchev house (Dom Khrushchova), Kropotkinskaya ulitsa 12/2; architect A. G. Grigorev; 1814

Dolgorukov house (Dom Dolgorukova) Kropotkinskaya ulitsa 19; architect M. F. Kazakov; 1780

Golitsyn Hospital (Golitsynskaya bolnitsa), Leninsky prospekt 8; architect M. F. Kazakov; 1796–1801

Senate Building, Kremlin; architect M. F. Kazakov; 1776–87

Military Commissariat (Krigskommissariat), Naberezhnaya Maksima Gorkogo; architect N. N. Legran; 1778–80

Sheremetev Pilgrims' Refuge (Strannopriyomny dom), Bolshaya Kolkhoznaya ploshchad 3; architect E. S. Nazarov and G. Quarenghi; 1794–1810

Church of the Metropolitan Philipp (Tserkov Filippa Metropolita), ulitsa Gilyarovskogo 35; architect M. F. Kazakov; 1777–8

Razumovsky house (Dom Razumovskogo), ulitsa Kazakova 18–20; architect A. A. Menelas; 1799–1802

Neskuchny Palace (Neskuchny dvorets), Leninsky prospekt 14–20; architect P. Iest; 1756–1830s

Kuskovo country palace (Usadba Kuskovo), Kuskovo; architect included the serf architect F. S. Argunov and M. F. Mironov; 1740–80

Palace ruin at Tsaritsyno Tsaritsyno; architect M. F. Kazakov, V. I. Bazhenov, I. V. Yegotov; 1787–93

Ostankino Palace (Usadba Ostankino), 1-ya Ostankinskaya ulitsa 5; architect F. Camporesi, P. I. Argunov and others; 1791–8

Guardians' Council Building Opekunsky sovet), Solyanka ulitsa 14; architect D. Gilardi and A.G. Grigorev; 1823–6

Provision Warehouses Krymskaya ploshchad 2; architect F. M. Shestakov and V. P. Stasov; 1829–31

Usachev-Naidyonov estate house (Dom-Usadba Usachevykh-Naidyonovykh), ulitsa Chkalova 53; architect D. I. Gilardi and A. G. Grigorev; 1829–31

Church of the Great Ascension (Tserkov Bolshogo Vozneseniya), ulitsa Gertsena 36; architect A. G. Grigorev or F. M. Shestakov; 1827–40

Widows' Home (Vdovy dom), ploshchad Vosstaniya 1/2; architect I. D. Gilardi, 1775, and D. I. Gilardi, 1823

Leningrad Railway Station Leningradsky vokzal), Komsomolskaya ploshchad; architect K. A. Thon; 1849

Great Kremlin Palace (Bolshoy Kremlevsky dvorets), Kremlin; architect K. A. Thon; 1838–49

BUILDINGS OF THE SECOND HALF OF THE NINETEENTH CENTURY AND THE EARLY TWENTIETH CENTURY

Kiev Railway Station (Kievsky vokzal), ploshchad Kievskogo vokzala; architect I. I. Rerberg, V. K. Oltarzhevsky, V. G. Shukhov; 1912–17

Kazan Railway Station (Kazansky vokzal), Komsomolskaya ploshchad; architect Yu. F. Dietrichs; 1899

Tretyakov Gallery (Tretyakovskaya Galereya), Lavrushinsky pereulok 10; architect V. M. Vasnetsov; 1900–05

Hotel Luks, ulitsa Gorkogo 10; architect N. A. Eichenwald; 1911

Hotel National, ulitsa Gorkogo 1; architect A. I. Ivanov; 1903

Hotel Metropol, prospekt Marxa 1; architect W. F. Walcot; 1899–1903

Pushkin Museum of Fine Arts (Muzey izobrazitelnykh iskusstv imeni Pushkina), ulitsa Volkhonka 12; architect R. I. Klein and P. Boitsov; 1898–1912

Polytechnical Museum (Politekhnichesky muzey), Novaya ploshchad 3/4; architect I. A. Monighetti, N. A. Shokhin, P. A. Voeikov, V. I. Yerameshantsev; 1877–1907

Historical Museum (Istorichesky muzey), Krasnaya ploshchad 1/2; architect V.O. Sherwood; 1875–81

Central Lenin Museum (Tsentralny muzey V.I. Lenina), ploshchad Revolyutsii 2; architect D. N. Chichagov; 1890–2

Muir and Merrilees Department Store, Petrovka ulitsa 2; architect R. I. Klein; 1908–10

Petrovsky Passage (Petrovsky Passazh), Petrovka ulitsa 10; architect S. M. Kalugin and B. V. Freidenberg; 1903

Nikolsky Passage (Nikolsky Passazh), ulitsa 25 Oktyabrya 5; architect L. N. Kekushev; 1899–1900

Voyentorg Department Store, prospekt Kalinina 10; architect S. B. Salesky; 1911–13

Yeliseev's Food Hall, ulitsa Gorkogo 14; architect G. V. Baranovsky; 1898–1901

K. T. Soldatenkov Hospital, 2-oy Botkinsky proezd 5; architect I. A. Ivanov-Shits; 1910–13

Shanyavsky University, Miusskaya ploshchad 6; architect I. A. Ivanov-Shits; 1910–13

Municipal Elementary School, Bolshaya Pirogovskaya ulitsa9; architect A. A. Ostrogradsky; 1909

School for Higher Women's Courses, Malaya Pirogovskaya ulitsa 1; architect S. U. Solovev; 1910–13

Commercial College for Men and Women, Stremyanny pereulok 28; architect S. U. Solovev and A. V. Shchusev; 1911–12

Central Post Office, ulitsa Kirova 26a; architect O. R. Munts, L. I. Novikov, V. A., L. A. and A. A. Vesnin; 1911–12

Moscow Arts Theatre, Proezd Khudozhestvennogo teatra 3; architect F. O. Shekhtel; 1902

International Merchant Bank, Kuznetsky most 15/8; architect S. S. Eibushits; 1898

J. W. Junker & Co. Bank, Kuznetsky most 18; architect A. E. Erikhson, L. A., V. A. and A. A. Vesnin; 1913

Khomyakov office building, Petrovka ulitsa 3/6, Kuznetsky most 6/3; architect I.A. Ivanov-Shits; 1899–1900

Moscow Merchants' Society Building, Novaya ploshchad 2, Maly Cherkassky pereulok; architect F. O. Shekhtel; 1909

International Merchant Bank, ulitsa Kuybysheva9 (on the left); architect A. E. Erikhson; 1910–11

Commercial building, Staropansky pereulok 6/8; architect A. V. Ivanov; 1898–9

Arshinov Company Building, Staropansky pereulok 5; architect F. O. Shekhtel; 1899

Ryabushinsky Brothers Bank building, ploshchad Kuybysheva 2; architect F. O. Shekhtel; 1903–4

Business Court (Delovoi dvor), ploshchad Nogina 5; architect I. S.

Kuznetsov; 1912–13

Merchants' Club building, ulitsa Chekhova 6; architect I. A. Ivanov-Shits; 1907–9

Utro Rossii Printing House, Proezd Skvortsova-Stepanova 3; architect F. O. Shekhtel; 1907

A. A. Levinson Printing House, Tryochprudny pereulok 11; architect F. O. Shekhtel; 1900

I. D. Sytin Printing House, ulitsa Gorkogo / Pushkinskaya ploshchad; architect A. E. Erikhson; 1905–7

Stroganov School apartment house, ulitsa Kirova 24; architect F. O. Shekhtel; 1904–7

I. E. Kuznetsov apartment house, ulitsa Kirova 15; architect B. M. Velikovsky, A. N. Miliukov, A. A. and V. A. Vesnin; 1910

First Russian Insurance Company apartment house, Kuznetsky most 5/21; architect L. N. Benois and A. I. Gunst; 1905–7

Sokol apartment house, Kuznetsky most 3; architect I. P. Mashkov; 1902–3

Moscow Insurance Society Building, Staraya ploshchad 5; architect F. O. Shekhtel; 1901

Moscow Trading Company apartment house, ulitsa Solyanka 1; architect V. V. Sherwood, I. A. German, A. E. Sergeev; 1912–15

I. P. Isakov apartment house, Kropotkinskaya ulitsa 28; architect L. N. Kekushev; 1906

F. I. Afremov apartment house, Sadovaya-Spasskaya ulitsa 19; architect O. O. Shishkovsky; 1904

Shamshin apartment house, ulitsa Frunze 8; arch F. O. Shekhtel; 1909

Mindovsky house, ulitsa Vorovskogo 44; architect L. N. Kekushev; 1903

S. P. Ryabushinsky house, ulitsa Kachalova 6/2; architect F. O. Shekhtel; 1900–02

Tarasov house, ulitsa Alekseya Tolstogo 30; architect I. V. Zholtovsky; 1909–12

Bakhrushin house, ulitsa Gorkogo 12; architect K. K. Hippius; 1901–2

Korobkov house, Pyatnitskaya ulitsa 33; architect L. N. Kekushev; late 1890s

I. E. Tsvetkov house, Kropotkinskaya naberezhnaya 29; architect V. M. Vasnetsov; 1897

S. G. Morozov house, ulitsa Alekseya Tolstogo 17; architect F.O. Shekhtel; 1893–8

Shekhtel house, ulitsa Zholtovskogo 28; architect F. O. Shekhtel; 1896

Shekhtel house, Bolshaya Sadovaya ulitsa 4; architect F. O. Shekhtel; 1909–10

P. I. Shchukin house, Malaya Gruzinskaya ulitsa 15; architect B. V. Freidenberg; 1898

V. Vasnetsov house, Pereulok Vasnetsova 13; architect V. M. Vasnetsov; 1892

A. A. Morozov house, prospekt Kalinina; architect V. A. Mazyrin; 1895–9

Igumnov house, ulitsa Dimitrova 43; architect N. I. Pozdeev; 1889–93

P. N. Pertsov apartment house, Soymonovsky proezd 1; architect S. V. Maliutin, N. K. Zhukov; 1905–7

L. N. Kekushev house, Metrostroyevskaya ulitsa 25; architect L. N. Kekushev; 1902–3

Derozhinskaya house, Kropotkinsky pereulok 13; architect F. O. Shekhtel; 1901

Yakuntsikov house, Pereulok N. A. Ostrovskogo 10; architect W. F. Walcot; 1902

Gutheil house, Pereulok N. A. Ostrovskogo 8; architect W. F. Walcot; 1900

Kekushev house, ulitsa Lunacharskogo 8; architect L. N. Kekushev; 1898–9

Borodino Bridge, connecting Smolenskaya ploshchad and ploshchad Kievskogo vokzala; architect R. I. Klein; 1909–12

Krasny Oktyabr factory, Bersenevskaya

naberezhnaya 6; est. 1867 by F.T.K. von Einem

Krasnaya Presnya sugar refinery, Mantulinskaya ulitsa 7; est. 1859 by W. P. Berg

Krasnaya Presnya factory, Presnensky val 14; est. 1879 by I. Koss 'Dukat' tobacco factory, ulitsa Gasheka; est. 1891

'Bolshevik' confectionery factory, Leningradsky prospekt 15; est. 1855 by Siou & Co.

Borets compressor factory, Skladochnaya ulitsa 6; est. 1897 as 'Gustav List' works

P. A. Babayev confectionery factory, Malaya Krasnoselskaya ulitsa 7; est. 1804 as A. I. Abrikosov factory

Tryokhgornaya Manufaktura (Tryokhgorny Factory), Rochdelskaya ulitsa 15; est. 1799 by V. I. Prokhorov

Calico print works, Derbenevskaya naberezhnaya 7; est. 1823 by Bucher; E. Tsindel textile company from 1847

'Hammer and Sickle' factory, Zolotorozhky val 11; est. 1883 as Yu. Guzhon firm

N. D. Balakirev button factory, Bakuninskaya ulitsa 74; est. 1888 by B. Rontaller

'Krasny Fakel' factory, ploshchad Repina 14; est. 1863 as G. List engineering company

'Kompressor' factory, 2-ya ulitsa Entuziastov 5; est. 1869 by A. K. Dangauer

Worsted factory, ulitsa Osipenko 82; est. 1863 by Schrader A. with Söhnen & Co. (Schrader and Sons)

'Krasny Bogatyr' works, Krasnobogatyrskaya ulitsa 2; est. 1887 by L.S. Polyakov and others

Pump factory, named after M. I. Kalinin, ulitsa Zemlyachky 13; est. 1864 as Dobrov and Nabgolz firm

Cotton factory, named after M. V. Frunze, Varshavskoe shosse9; est. 1867

Electro-Mechanical factory, named after Vladimir Ilich, Partiny pereulok 1; est. 1847 as V. Ya. Gopper firm; from 1916 L. A. Michelson factory

'Krasny Proletari' factory, Krasnoproletarskaya ulitsa 16/1; est. 1869 by I. N. Kushnerev

Textile factory, named after Pyotr Alekseev, Mikhalkovskaya ulitsa 48; est. 1835 by V. I. Yokish

First Model Printing Works, named after A. A. Zhdanov, Valovaya ulitsa 28; est. 1876 as Sytin printing works

BUILDINGS OF THE 1920S

Dubrovka housing complex between Krutitsky val, 1-ya Dobrovskaya ulitsa and Sharikopodshipnikovskaya ulitsa; architect M. I. Motylyov and N. Molokov; 1925–8

Usacheva housing development, ulitsa Usacheva; architect A. I. Meskov; 1925–7

Shabolovka housing complex, ulitsa Lesteva 18; architect G. Ya. Volfenzon; 1926–30

Sokol Garden City, between ulitsa Alabyana, Volokolamskoe shosse, ulitsa Levitana, Surikova, Polenova, Vrubelya; architect V. A. Vesnin, N. V. Markovnikov and others; 1923–30

Narkomfin (People's Commissariat of Finance) apartment house, ulitsa Tchaikovskogo 25b; architect M. Ya. Ginzburg; 1928–30

Gosstrakh apartment house , Malaya Bronnaya ulitsa 21; architect M. Ya. Ginzburg; 1926

Palace of Culture for the Proletarian District of Moscow, Vostochnaya ulitsa 4; architect A. A., L. A. and V. A. Vesnin; 1931–7

'Hammer and Sickle' Factory Club, Volochayevskaya ulitsa 11/15; architect I. F. Milinis; 1929–33

Railway Workers' Club, Komsomolskaya ploshchad 4; architect A. V. Shchusev; 1925

'Burevestnik' Shoe Factory Club, 3-ya

Rybinskaya ulitsa 18; architect K. S. Melnikov; 1929

Pyotr Alekseev Factory Club, Mikhalkovskaya ploshchad 64; arch L. A. Vesnin; 1927

Zuev Club, Lesnaya ulitsa 18; architect I. A. Golosov; 1928

Rusakov Club, Stromynskaya ploshchad 10; architect K. S. Melnikov; 1927–9

'Kauchuk' Factory Club, ulitsa Plyushchikha 64; architect K. S. Melnikov; 1927

S. P. Gorbunov Club in Fili, Novosavodskaya ulitsa 27; architect Ya. A. Kornfeld; 1930–8

'Kompressor' Factory, 2-ya ulitsa Entuziastov 5; rebuilt 1929–40

'Krasny Proletari' factory, Malaya Kaluzhskaya ulitsa 15; expansion in the late 1920s

Automobile factory, named after the Lenin Komsomol, Volgogradsky prospekt 32; 1930

'Dinamo' Electrical Factory, named after S. M. Kirov, ulitsa Leninskaya Sloboda 26

Moscow State Electrical Power Station (MOGES-1), Raushskaya naberezhnaya 10; boiler house 1924; architect I. W. Zholtovsky

Factory kitchen, Leningradsky prospekt 7; 1929

Government House apartment complex, Ulitsa Serafimovicha 2/20; architect B. M. Iofan and D. M. Iofan; 1928–31

Communal House, ulitsa Ordzhonikidze 8/9; architect I. S. Nikolaev; 1929–30

Communal House, Gogolevsky bulvar 8; architect M. O. Barshch, V. N. Vladimirov, I. F. Milinis, L. S. Slavina, A. L. Pasternak; 1929

Department store on Serpukhovskaya ploshchad, Dobryninskaya ulitsa 1/3; architect K. Yakovlev; 1928–9

Mostorg department store, ulitsa Krasnaya Presnya 48/2; architect L.

A., A. A. and V. A. Vesnin; 1927

'Dinamo' Stadium, Leningradsky prospekt 36 w; architect A. B. Langman and L. Z. Cherikover; 1928

V. I. Lenin Institute, Sovetskaya ploshchad 1/3; architect S. E. Chernyshev; 1925–7

Central Institute of Mineralogy, Staromonetny pereulok 29; architect V. A. Vesnin; 1925–9

Lenin State Library, prospekt Kalinina 3; architect V. A. Shchuko and V. G. Gelfreikh; 1928–41

Planetarium, Sadovaya-Kudrinskaya ulitsa 5; architect M. O. Barshch and M. I. Sinyavsky; 1928–9

'Dinamo' Society Building, ulitsa Dzerzhinskogo 12; architect I. A. Fomin and A. Langman; 1928–9

Office building, ulitsa Kuybysheva 11; architect V. M. Mayat; 1927–8

Mosselprom Building, Kalashny pereulok 2/10; architect D. Kogan; 1923–4

Gostorg (State Trade Agency) Building, ulitsa Kirova 47; architect B. M. Velikovsky, M. O. Barshch, G. Vegman, M. Gaken; 1925–7

Narkomzem (People's Commissariat for Agriculture) Building, Orlikov pereulok 1/11; architect A. V. Shchusev; 1928–33

Tsentrosoyuz (Central Union of Consumers Cooperatives) Building, ulitsa Kirova 39; architect Le Corbusier and N. Ya. Kolli; 1928–35

Central Telegraph Building, ulitsa Gorkogo 7; architect I. I. Rerberg; 1925–7

Comintern radio transmitter tower, Shabolovka ulitsa 53; architect V. G. Shukhov; 1922

Izvestia Building, Pushkinskaya ploshchad 5; architect G. B. Barkhin; 1925–7

Pravda Newspaper headquarters, ulitsa Pravdy 24; architect P. A. Golosov; 1931–7

Club of the Society of Tsarist Political

Prisoners, ulitsa Vorovskogo 33; architect A. A., V. A. and L. A. Vesnin; 1931–4

Lenin Mausoleum, Krasnaya ploshchad; architect A. V. Shchusev; 1924–30

Buildings of the 1930s to 1950s

Apartment houses in ulitsa Gorkogo
No. 35, architect D. N. Chechulin; 1936–8
No. 64, architect M. I. Sinyavsky; 1936–48
Nos 4-6, 8, 15–17, architect A. G. Mordvinov; 1937–40
No. 25, architect A. K. Burov; 1938
No. 48, architect M. Ya. Ginzburg; 1949
No. 56, architect I. E. Rozhin and others; 1954

Apartment houses in leningradsky prospekt
No. 60, architect B. V. Yefimovich; 1938
No. 62, architect S. M. Kravtsev; 1938
No. 56, architect Z. M. Rozenfeld; 1939
No. 27, architect A. K. Burov and B. N. Blokhin

Apartment houses in kutuzovsky prospekt
Nos 22, 24, 25, 29, 30–32, architect Z. M. Rozenfeld; 1938–50

Apartment houses in sadovaya-triumfalnaya ulitsa
Nos 4–18, architect Z. M. Rozenfeld; 1949

Apartment houses in leninsky prospekt
No. 42, architect A. V. Vlasov; 1937
No. 55, architect A. V. Shchusev; 1937
Nos 18, 20–21, 23–26, 28, architect A. G. Mordvinov, 1939–40
Nos 12, 16, architect D. N. Chechulin; 1939–40

No. 11, architect I. V. Zholtovsky; 1949

Apartment house, Prospekt Marxa 16; architect I. V. Zholtovsky; 1933–4

Apartment houses in sadovaya-kudrinskaya ulitsa
No. 8, architect A. V. Varshaver; 1939
Nos 28–30, architect L. V. Rudnev, V. O. Munts, V. E. Ass; 1947

Hotel ukraina, Kutuzovsky prospekt 2/1; architect A. G. Mordvinov; 1957

High-rise administrative and apartment building, Lermontovskaya ploshchad; architect A. N. Dushkin and B. S. Mezentsev; 1953

Ministry of Foreign Affairs high-rise building, Smolenskaya ploshchad; architect V. G. Gelfreikh and M. A. Minkus; 1948–52

High-rise apartment building, ploshchad Vosstaniya; architect M. V. Posokhin and A. A. Mndoyants; 1950–4

High-rise apartment building, Kotelnicheskaya naberezhnaya; architect D. N. Chechulin and A. K. Rostovsky; 1948–52

Hotel Leningradskaya, Kalanchevskaya ulitsa 21/40; architect L. M. Polyakov and A. B. Boretsky; 1953

Lomonosov University (Moscow State University), Leninskie gory (Lenin Hills); architect L. V. Rudnev, S. E. Chernyshev, P. V. Abrosimov; 1949–53

Hotel Moskva, prospekt Marxa 7; architect A. V. Shchusev, L. I. Savelev and O. A. Stapran; 1935

Hotel Sovetskaya, Leningradsky prospekt 32; architect I. I. Loveiko, V. V. Lebedev, P. P. Shteller; 1950–2

Hotel Pekin, Bolshaya sadovaya ulitsa 5/1; architect D. N. Chechulin; 1956

ploshchad Sverdlova metro station, architect I. A. Fomin and L. M.

Polyakov; 1938

Mayakovskaya metro station, architect A. N. Dushkin, Ya. G. Lichtenberg, Ya. P. Afanasev; 1938

Kropotkinskaya metro station, architect A. N. Dushkin and Ya. G. Lichtenberg; 1935

Vestibule of Kirovskaya metro station, architect N. Ya. Kolli; 1935

Lermontovskaya metro station, architect I. A. Fomin and N. N. Andrikanis; 1935; vestibule by N. Ladovsky; 1935

Komsomolskaya-Koltsevaya metro station, architect A. V. Shchusev and others; 1952

Komsomolskaya (Kirov-Frunze line) metro station, architect D. N. Chechulin; 1935

Bolshoy Kamenny most (Great Stone Bridge), architect V. G. Gelfreikh, M. A. Minkus and V. A. Shchuko; 1938

Bolshoy Moskvoretsky most, architect A. V. Shchusev; 1938

Exhibition of Economic Achievements (previously All-Union Agricultural Exhibition), architect V. A. Shchuko, V. G. Gelfreikh, K. S. Alabyan and others; 1939–41 and 1954–8

Northern River Terminal, Leningradskoe shosse 89; architect A. M. Rukhlyadev and V. F. Krinsky; 1937

Udarnik Cinema, ulitsa Serafimovicha 2; architect B. M. Iofan; 1931

Tchaikovsky Concert Hall, Bolshaya Sadovaya ulitsa 20; arch D. N. Chechulin; 1938–40

House of architect, ulitsa Shchuseva 7; façade redesigned in 1940 by A. K. Burov

Gosplan (State Planning Agency) Building, prospekt Marxa 12; architect A. Langman; 1932–6

M. V. Frunze Military Academy, proezd Devichego Polya 4; architect L. V. Rudnev and V. O. Munts; 1937

Vakhtangov Theatre, ulitsa Arbat 26; architect P. V. Abrosimov; 1946–7

Central Theatre of the Red Army, ploshchad Kommuna 2; architect K. S. Alabyan and V. N. Simbirtsev; 1934–40

I. A. Likhachev automobile factory, Avtozavodskaya ulitsa 23; architect E. M. Popov, A. A., V. A. and L. A. Vesnin; early 1930s

First Ball-Bearing Factory GPS-1, Sharikopodshipnikovskaya ulitsa 13; est. 1932

Photographic Acknowledgements

The author and publishers wish to express their thanks to the below sources of illustrative material and/or permission to reproduce it.

From K.I. Albrecht, *Der verratene Sozialismus* (Berlin/Leipzig, 1939): p. 175; P.A. Aleksandrow/S.O. Chan-Magomedow, *Iwan Leonidow* (Moscow, 1971): p. 59; *Architektura SSSR* (1982:4): pp. 65,96, 141, 267 (foot); W.N. Beloussow/O.W. Smirnowa, W.M. *Semenow* (Moscow, 1980): p. 62; *Bolschaja Sowetskaja Enziklopedija* (vol. 39, Moscow, 1938): p. 281; Henri Cartier-Bresson, *Menschen in Moskau* (Düsseldorf, 1955): p. 278; S.O. Chan-Magomedow, *Pioniere der sowjetischen Architektur* (Dresden, 1983): pp. 61, 69 top, 87 (foot),92; photo dpa: p. 12; *El Lissitzky - Proun und Wolkenbürgel, Schriften, Briefe, Dokumente* (Dresden, 1977): p. 23; *Führer durch die Sowjetunion* (Moscow, 1925): p. 322; René Fülöp-Miller, *Geist und Gesicht des Bolschewismus* (Vienna, 1926): pp. 84, 87 (top), 233, 313; *15 Eiserne Schritte. Ein Buch der Tatsachen aus der Sowjetunion* (Berlin, 1932): p. 179; *Grosse Sowjet-Enzyklopädie* (Berlin, 1952): p. 191; P. Grossmann/ J. Knöbel, *Führer durch Moskau und Umgebungen* (Moscow, 1882): p. 164 (top, left and right); *Istorija Moskwy*: pp. 216, 273 (vol. IV, Moscow, 1954), p. 218 (vol. V, Moscow, 1955); *Istorija Sowetskoi architektury 1917-1958* (Moscow, 1962): p. 68; H.R. Knickerbocker, *The Soviet Five-Year Plan and its Effect on World Trade* (London, 1931): p.95; W. Kostotschkin, *Drewnerusskie goroda* (Moscow, 1972): pp. 36, 183, 184; A.J. Kowalew/W.A. Kowalewa, *Promyschlennaja architektura Sowetskoi Rossii* (Moscow, 1980): p. 222; Jay Leyda/Zina Voynow, *Eisenstein at Work* (New York, 1982): p. 251; *Literaturnaja Enziklopedija* (Moscow, 1929): pp. 128, 142; *Memorialny kabinet A.W. Lunatscharskogo* (Moscow, 1975): p. 229; M. Minkus/ N. Pekarewa, *I.A. Fomin* (Moscow, 1953): p. 288; Allan Monkhouse, *Moscow 1911-1933* (Boston, 1934): p. 74; *Moskau. Das Gesicht der Städte* (Berlin, 1929): pp. 212, 267 (top), 295, 304, 318, 321; *Moskwa-Pamjatniki architektury 1830-1910-ch godow* (Moscow, 1977): pp. 18, 45, 46, 49, 56, 125, 144; *Moskwa. Planirowka i sastroika goroda 1945-1957* (Moscow, 1958): p. 101; Daniela Mrazkova/Vladimir Remeš, *Early Soviet Photographers* (Oxford, 1982): p. 150; *Neue Illustrierte* (April, 1955): p. 128; *Pamjatniki architektury Moskwy* (Moscow, 1982): p. 182; private collections (including collection of the author): pp. 113, 126 (foot), 139, 201, 243; *Rheinische Post* (5 August 1950): p. 26; M.I. Rzjanin, *Pamjatniki russkogo sodtschestwa* (Moscow, 1950): pp. 105, 107,109, 185, 189, 304; B.S. Semenkow, *Pamjatnye mesta Moskwy* (Moscow, 1959): p. 126 (top); photos Ekaterina Shorban: pp. 327, 328, 329, 330, 331, 332; *Sowetskaja architektura* Vol. 1 (Moscow, 1951): pp. 24, 25, 64; *Die Sowjetunion* (1954): p. 240; *Sowjetunion heute* (1967): pp. 157, 209, 210, 225; Charles Spencer, *The World of Serge Diaghilev* (New York, 1974): pp. 52, 224; *Spisok politsakljutschonnych SSSR* (Brussels, 1983): p. 262; *Stalin k 60-letiju so dnja roshdenija* (Moscow, 1939): p. 250; photo Ullstein Bilderdienst, Berlin: p. 253; L.W. Warsar/J.S. Jaralow, *M.A. Minkus* (Moscow, 1982): p. 69 foot; *Wsja Moskwa 1926*: p. 169; Francis Wyndham/David King, *Trotsky: a Documentary* (Harmondsworth, 1979): p. 302.

351